The Werkbund

Design Theory and Mass Culture before the First World War

The Werkbund

Design Theory and Mass Culture before the First World War

Frederic J. Schwartz

Yale University Press
New Haven and London

For
Pauline and Alvin
Judith
Carin
Julius and Benjamin
Schwartz

Designed and typeset in Futura and Sabon by Sally Salvesen
Printed in Hong Kong through World Print

Library of Congress Cataloging-in-Publication Data
Schwartz, Frederic J.
 The Werkbund : design theory and mass culture before the First World
 War / Frederic J. Schwartz.
 p. cm.
 Includes bibliographical references and index.
 ISBN 0–300–06898–0
 1. Deutscher Werkbund. 2. Decorative arts – Germany – History –
 19th century. 3. Decorative arts – Germany – History – 20th century.
 4. Art and industry – Germany. 5. Art and society – Germany.
NK951.S375 1996 96-14708
745.2'0943'09041–dc20 CIP

Contents

Acknowledgements

For funding that made possible the research and drafting of the thesis on which this book is based, I am indebted to the Andrew W. Mellon Foundation, Columbia University, the Center for Advanced Study in the Visual Arts of the National Gallery of Art in Washington, the Deutscher Akademischer Austauschdienst, and the Mrs. Giles Whiting Foundation.

In Germany, the following individuals and institutions provided invaluable assistance, and to them I am most grateful: Angelika Thiekötter of the Werkbund-Archiv, Berlin; Magdalena Droste of the Bauhaus-Archiv, Berlin; Michael Fehr and Sibylle Wilhelm of the Karl Ernst Osthaus-Archiv, Hagen; Winfried Nerdinger of the Architektursammlung, Technische Universität München; Wolfgang Wolters of the Technische Universität Berlin; Heidrun Himpel of the still very vital Deutscher Werkbund e.V., Frankfurt am Main; Kurt Junghanns; the late Julius Posener; and the staff of the Kunstbibliothek, Berlin. Five friends generously shared their time, energy, and considerable expertise: Bernd Nicolai, Paul Betts, Carol Scherer, Faustyn Plitzko, Katharina Kurras.

In New York, David Rosand was unsparing in his support since my first days at Columbia University. For the interest David Freedberg, Jonathan Crary and Rainer Crone have shown in my work I shall always be grateful. As this project took shape, Barry Bergdoll, Andreas Huyssen and Mark Anderson were careful listeners and readers, generous with criticism and assistance – as was Rosemarie Haag Bletter, who, along with Rose-Carol Washton Long, gave me the opportunity to present some of my findings in their session at the 1994 College Art Association conference. For help in many ways I owe much to Joseph Masheck, Moira Ariev, Claudia Swan and Paolo Berdini. Nina Rosenblatt was the first reader of every section, and I would like to thank her especially. And perhaps the greatest satisfaction in writing this book has been that Molly Nesbit found it worthy of the careful reading and sensitive criticism she so generously gave. The result may not always live up to the standards she set, but most of what is good about it has resulted from the example of her work. She has my deepest thanks.

In England thanks are due to David Bindman, Andrew Hemingway, and the rest of the Department of History of Art at University College London for the extraordinary warmth of their welcome; to Jeremy Aynsley and the tutors of the V&A/RCA MA Course in the History of Design for invitations

to present parts of this book; and to John Nicoll for his faith in this project and to Sally Salvesen for seeing it through. A timely grant from the Dean's Travel Fund of the School of Social and Historical Sciences, University College London, allowed for final last-minute research.

Alvin D. Schwartz and Pauline W. Schwartz have never ceased to believe in my work and have supported it in ways too numerous to remember and too important ever to forget. From Judith D. Schwartz and James L. Weil I learned why to write and perhaps a bit of how. And this book would not have been finished nor even started had it not been for Carin B. Schwartz. Her energy is here, on every page.

Introduction

Capitalism is *not*, in the first place, an economic system of the distribution of property, but an entire system of *life* and *culture*.

<div align="right">Max Scheler[1]</div>

Capitalism is . . . capable of intellectual achievements of a scope that would not be possible under other conditions.

<div align="right">Aby Warburg[2]</div>

By 1923 at the latest, the situation in Germany seemed clear. The issue was the relation of the architect and applied artist to modernity, the blueprint for the intersection of culture and economy. 1923 was the year of Walter Gropius's proclamation of a new program for the Bauhaus, the school he founded in 1919 and headed until 1928: "Art and technics – a new unity."[3]

"Art and technics": with this motto the Bauhaus seems to bring the work of the artist into the twentieth century. Gropius's proclamation and the writings in which he elaborated on it define design as an art that would make common cause with industrial production – adapting to its criteria, accepting its dictates, partaking of its power. This definition of design as the linking of art and technology is the statement that has come to stand for the artist's final and unequivocal affirmation of modernity: art, it seemed, was no longer threatened by the emergence of the modern world or irrelevant to it, but would achieve its goals as part of this grand process.

Yet as a motto that might finally lead the artist into an industrial age, "art and technics" is a curiously limiting constellation of ideas. While linking the artist with the productive forces of modernity, it says nothing, for example, about the politics under which these forces would unfold – whether the "industry" the artist would be allied with would be capitalist, communist, Fascist, socialist, even anarchist. For along with their stance in relation to modern means of production, this was one of the most important questions facing artists in the first half of this century. The affirmation implicit in Gropius's unproblematic fusion of "art and technics" was, in effect, an affirmation of the social system in which the artist encountered technology. Despite the left-wing cachet that accompanied the school (and was an important part of its history), the policy of the Bauhaus under Gropius came to be that art did not demand political revolution but could work hand in hand with modes of production as they actually existed, achieving transcendence in tandem with objects that would remain capitalist commodities. That was indeed the plan, yet this accommodation with society as they found it was neither argued nor

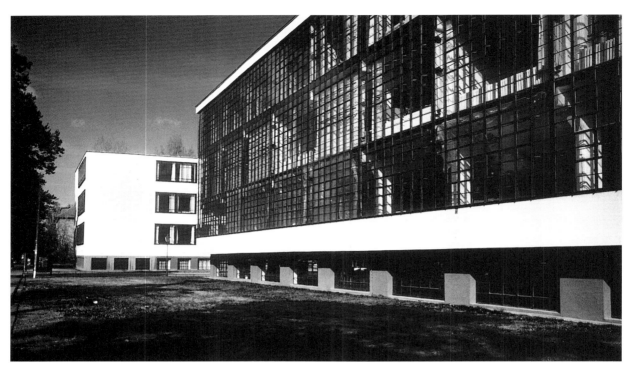

1. Walter Gropius, Bauhaus, Dessau, workshop wing, 1925/6, present state (Frederic J. Schwartz)

theorized in the Bauhaus discussions.

The situation was complex; perhaps the alliance was only tactical, or structurally determined, or the fate of any avant-garde movement. Yet Bauhaus theory also ignores other important aspects of the system it embraced so shyly, with averted eyes. For while Gropius chose to work within this set of existing economic practices, he and those who followed him saw only part of it as worthy of cultural consideration. Modern production was defined as "technics," and the other moments of the mode of production into which the Bauhaus artist was to be integrated were bracketed out. If Bauhaus theory concentrated on the production of commodities, it did so with a willful blindness to the rest of the object's life: its distribution, exchange and consumption.[4]

In other words, Bauhaus theory *technologizes* both modernity and capitalism. Even use, redefined narrowly as "function," is considered only according to the criteria of modern production, of means-end rationality. Certainly the artists of the Bauhaus had cultural goals that were far more ambitious and wide-reaching than the clichéd concern with "function." Yet the work of the institution after 1923 asks that its validity be judged in relation to its modernity, and that its modernity be judged in its relation to techniques of production and function. By and large, critics and historians have obliged. Narratives of the modern movement trace a genealogy of reform by following the adaptation and acceptance of economic imperatives defined in terms of production technique. Architecture is reduced to a matter of construction (or the artistic potential of construction), and the design of everyday goods is considered against the the artistic and economic imperatives of mass production. Hence the landmarks that help map the terrain of modern architectural and design history in perhaps the best-known account, that of Nikolaus Pevsner: William Morris, who gets points for his rejection of the attempt to mimic the look of the hand-made in machine-made goods, but loses them for his ambivalence

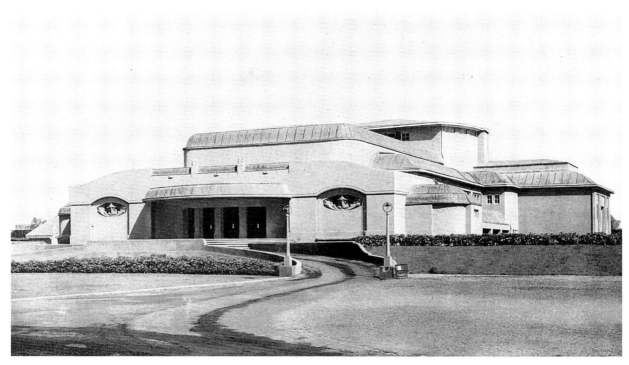

2. Henry van de Velde, theatre, Werkbund Exhibition, Cologne, 1914 (*JDW* 4 [1915])

over the machine; the German Werkbund's 1914 debate over the issue of standardized "types" versus "individuality" in design and its interpretation as a matter of production only; and the commanding position of Gropius, whose work at the Bauhaus makes him both protagonist and historical telos.[5]

The technologized modernity of the Bauhaus quickly became the yardstick by which the developments that seemed to lead there have been measured. In particular, it is the work of applied artists and architects in the early years of the German Werkbund which are judged by the extent to which they seem proto-modern, proto-Gropius, or proto-Corbusier. The standard against which their work is judged is perhaps best illustrated by Gropius's Bauhaus buildings in Dessau of 1925–6 (fig. 1). Here, writes Sigfried Giedion, "major endeavors of modern architecture are fulfilled" through the "conscious realization of an artist's intent," clarifying and articulating aesthetic advances that were, in lesser hands, merely the "unconscious outgrowths of advances in engineering."[6] The signature flattened Jugenstil curves of Henry van de Velde's theatre for the 1914 Werkbund exhibition in Cologne (fig. 2) are then compared to such right angles and machined forms, and are found wanting. Taking their cue from van de Velde's position in the debate that took place at that very exhibition, critics label this artist's work "individualist" and see in it a rejection of the lightness, impersonal rectilinear geometry and standardization of forms expressive of new building materials and technologies. On this interpretation, van de Velde's work, despite its purely formal merits, represents a misunderstanding of the relation of art to economy and an obsolete mode of design.[7] No one asks whether this "individualism" could be any more than the solipsistic center of an artistic universe, whether it might not have valences that were just as modern if measured in ways other than the visual signs of construction technique. Peter Behrens's Turbine Factory of 1909 for the electrical concern AEG (fig. 21), for example, fares better due to the dramatic

3. Walter Gropius and Adolf Meyer, Fagus-Werk, Alfeld an der Leine, main building viewed from the southeast after additions of 1914 (Bildarchiv Foto Marburg)

exhibition of its steel frame (but tends to lose points for the concrete cladding of the corner pylons which imitate traditional stone architecture).[8] Bruno Taut's Glass House (figs. 84, 85), also built for the 1914 Werkbund Exhibition, presents a problem: it is hard to reconcile its steel-and-glass constructive modernity with the strong scent of the nineteenth-century *Gesamtkunstwerk* surrounding the waterfall and colored light show within it; its technical daring seems to clash with the crystal mysticism that is now recognized as a central aspect of the design.[9] Like Behrens's Turbine Factory, this building is canonical but nonetheless acknowledged as a riddle; and with the circular logic of architectural historiography, the seeming contradictions of such pre-1920s work serve to confirm their incipient nature, their tentativeness, their irresolution as forerunners of the modern movement. Gropius's own pre-World War I work is also looked at in terms of the concerns that seem to guide the architect's work of the following decade. The stunning Fagus-Werk (1911–14, with later additions; figs. 3, 87), with its radical stereometry and transparent volumes seeming to express the lightness and thinness of a steel frame and to exploit it aesthetically, is similarly compared to the design work of the Bauhaus, which sought prototypes for industry based on timeless geometry and modern technique. The judgement here is positive: the later ideals seem already essentially fulfilled; Pevsner could write that "the new style, the genuine and legitimate style of our century, was achieved by 1914."[10] Yet the Fagus-Werk does not use a self-supporting steel frame, a fact often overlooked with the single-minded search for correspondence between technique and form; and Gropius was, with van de Velde, the most committed of the "individualists."[11] Clearly, the modernity of the Fagus-Werk exceeds its construction and needs to be considered apart from it. As compelling and seemingly self-evident a notion as it is, the technologized modernity that emerged as the cornerstone of design discourse in the 1920s can not explain its own prehis-

tory. To understand pre-war work on its own terms, in fact to find these terms at all, we must look for other, earlier reference points.

1923 also marks the date of another influential theoretical statement, another monument of twentieth-century thought that has also seemed to observers to be self-evident, inevitable, primary. This is in the realm of critical theories of culture: the publication of Georg Lukács's important work of Marxist theory, his famous essay on reification.[12] Gropius and Lukács seem to converge on a central, fundamental problem: the relation of the modern economy to the life of the mind, of the commodity to culture. The answer Lukács offers here is every bit as ambitious as Gropius's solution. Breaking with the usual practices of institutionalized Marxism, Lukács sought to analyze not the social nature of capitalist production but its cultural conditions. As different as his project was from that of Gropius, he too concentrated on the mass-produced commodity, though he used it to study alienation, not transcendence. In Lukács's account, the fetishizing nature of commodities – their objectification of social relations – has become the paradigm for all ways of acting and thinking under modern capitalism. The inanimate nature of the commodity and the measurement of its worth only in terms of its quantified exchange value have obscured the social dynamic of its making and selling, and all of social life is understood with the passive acceptance of physical facts that the commodity seems to present.

Like Gropius's intervention in his own field of competence, the theory of reification has long seemed to be one of the very first self-conscious attempts within philosophy to relate capitalism to culture. Yet as fundamental as Lukács's analysis still is, in its rush to make and seal its important epistemological point, it ignores entire areas of experience it would seem to raise when he writes that "the problem of commodities must not be considered in isolation or even regarded as the central problem in economics, but as the central, structural problem of capitalist society in all its aspects" and when he seeks to use the commodity to explore "the objective forms of bourgeois society together with all the subjective forms corresponding to them."[13] Lukács's omissions are without doubt a knowing part of his argument, but he nonetheless ignores some of the cultural complexities involved in the way the commodity mediates human subjectivity in a money economy, the way it functioned as a means of sociation and provided shared cultural reference points for an entire class.

The theoretical omissions of both Gropius and Lukács – whatever their complex causes and immediate contexts – should not blind us to the importance of the issues they ignore or choose not to take up, nor should they be projected back on their own prehistory. Yet in the primacy commonly accorded these influential formulations, this is precisely what has happened. It has produced the widespread assumption that it is to the 1920s that we must look to find the first sophisticated and systematic confrontations of artists and thinkers on culture with a modern economic machinery, and that projects leading up to Gropius's and Lukács's were at best provisional or incomplete.

Through an investigation of the German discussions of the applied arts before the First World War, I would like to problematize accounts of the history of design and of theories of culture which are based upon this assumption. I hope to show that statements of the sort made by Gropius and Lukács in the 1920s represent "solutions" to problems of design and culture whose full complexity is to a certain extent repressed in the finality of these formulations. To put it another way, these positions represent the conclusion to

important earlier debates, the *end* of a story that is longer and more complex than it is usually taken to be; they look back on an earlier theoretical endeavor as much as (and perhaps more than) they give guidance in understanding a later stage of modernity. I hope to draw attention to a set of debates and discussions which we must understand in order to assess later positions properly, and in comparison with which these later positions become, perhaps, problematic. The central question of the earlier discussions was similarly the nature of culture in a money economy, but what characterizes them is the unstable but exciting sense that capitalist culture was not closed or inevitable but rather an open field whose nature could still be altered, shaped, and negotiated. It is the theoretical richness that grew from this belief that was distilled out of the positions of the 1920s, turning them into somewhat arid axioms but also giving them their finality and closure. This optimism was no doubt unfounded, and the richness was bought at the price of omissions of its own, but the result was a set of debates whose intellectual ambition and complexity fully match those of later and more familiar theories. And though I will be writing here much more about Gropius than about Lukács, I think it will become clear that they can, in fact, be compared as I have (perhaps a bit mysteriously) done here. For their public statements of 1923 represent in fact less a coincidental convergence of interest on the issue of modern culture than a *divergence* of approaches to analyzing and acting upon it. Before World War I, Lukács and Gropius moved in intellectual circles that were very close to one another and which regularly intersected; they were both protagonists in related attempts to analyze and alter the conditions of modernity. Much more than in the 1920s, they spoke the same theoretical language, addressed the same issues, took part in the same discussions, addressed the same public.

If a fundamental theoretical terrain since the 1920s seems to be marked by the positions of Gropius and Lukács, the theoretical terrain across which this earlier dialogue on modernity took place had different landmarks, and they are a generation older. By looking to one of Lukács's teachers and one of Gropius's guiding spirits, we find two events, roughly concurrent, that can serve to orient us here. The first is the publication in 1901 of *Spätrömische Kunstindustrie* (Late Roman Art Industry) by the Viennese art historian Alois Riegl; the second is the publication of *Philosophy of Money* in 1900 by the Berlin sociologist Georg Simmel.[14] Both works sought to illuminate the relation of certain cultural forms to the society that surrounded them, and the texts took part in the debates over the nature of culture ca. 1900 or provided direction for others who participated in them. Surprisingly many people read *both* of these seemingly specialized works, and found them to be equally relevant to their concerns. More than a few such readers were members of, or interested observers of, the German Werkbund – an alliance of architects, applied artists, critics, businessmen and applied arts reformers which played a public and pivotal role in the discussions of culture in Germany in the years leading to World War I. The positions developed in that forum concerning the nature of culture in general, and visual form in particular, under capitalism are the subject of this study.

<p style="text-align:center">* * *</p>

My concern in this book is primarily to explore the development of modern design in Germany, to follow the intense theoretical efforts of a group of artists who sought to redefine the nature of their work and to bring it in line with the cultural conditions of modernity by renouncing the "fine" arts in

favor of the spaces of everyday life and the industrially mass-produced objects that filled them: tables and chairs, books, posters, teapots. While the artists and debates discussed here are hardly new subjects of historical inquiry, I shall try to frame my account of this much-discussed episode by reinterpreting the question that the protagonists asked themselves: rather than simply trying to determine the relation of "art" to "industry," I will argue that the artists and thinkers of the time sought to understand the relation of "form" to "economy." I am aware that the terms I have settled on in this regard are not intuitively satisfactory, and that this revision might seem as superficial as it is awkward. Yet the members of the Werkbund themselves were uncomfortable with the notion of "art": they often put it in quotation marks, scoffed at it, and in general recognized its inadequacy to the concerns that they shared, concerns which usually brought them far from the space of the salon, the gallery, or the museum. They sought to trade the artist's traditional access to these sites for those of the workplace and the marketplace. And in doing so, they became aware that they were not dealing only with "industry" or production, but with forces which took their products to points far distant from their origins and into realms where production was no longer an obvious, visible, pressing fact. They were aware that they were producing for a capitalist economy, that their products were the result of the division of labor, that they would first be seen after they had made their way through the system of commodity distribution and exchange, and by subjects whose understanding was determined by the simple fact that they were *consumers*. And they knew by bitter experience that form was *trans*formed during its lengthy path from producer to consumer. In their efforts to understand their own work, they needed to think far beyond the category of "industry." When they did invoke this term, it was often with a polemical purpose.

The discussions of these issues around the turn of the century in Germany had their own terms, texture, and tone. I would like to recover these qualities, and to that end I will often let the historical figures speak for themselves. Yet the very same issues are pressing today, and the account presented here is of course a product of the way they are currently addressed. First of all, this study seeks to engage with concerns of Frankfurt School Critical Theory – the work of thinkers such as Theodor Adorno, Max Horkheimer and Walter Benjamin – at the same time as it explores the origins of certain aspects of this tradition. And it has also been informed by the work of theorists such as Guy Debord and Jean Baudrillard. Anyone trying to think today about the relation of economy to culture is indebted to the notion of "spectacle," by which Debord seeks to define a specifically capitalist form of representation.[15] For Debord, spectacle is the dominant form of representation today, a disciplinary mode of visuality in which social relations and techniques of power are hidden behind the unified spectacle of the pseudo-world of commodities. Roughly contemporaneous with the publication of Debord's *Society of the Spectacle*, Baudrillard began a series of publications addressing similar issues but from a point of view informed by – though critical of – structural linguistics and semiotics. His work from the late 1960s to the mid-1970s represents, for all its problems, a sophisticated exploration of modern culture based on the insights that commodities are not merely economic facts but that they also *signify*, that they themselves constitute culture, and that culture and economy do not merely intersect or reflect each other but are, at certain stages of capitalism, one and the same thing.[16]

How the development of the spectacle should be dated is an open question,

but the scenario described by Baudrillard, both in his early work on the "political economy of the sign" and even more so in his later discussion of "simulation," is clearly a product of a later stage of capitalism. Yet in the discussion of form and economy in and around the Werkbund, we see that many of the phenomena characteristic of this later stage were noticed early on, at a time when they were only emerging, when they were not wrapped in the cloak of familiarity and self-evidence, when they still stood out in sharp relief against older patterns and practices of production and consumption. Thus this study could be considered in part as an attempt to sketch out some of the historical background to the spectacle and to a commodity culture. The events and debates discussed here can also serve, I hope, to suggest some of the mediations sorely lacking in the work of Baudrillard and Debord, for they occurred at a time when the economic institutions, legal frameworks, and class context of commodity culture were not yet fixed but instead fluid, still reacting to developments by concerted and occasionally desperate means. It was the time when the stage was being set for the later developments, and when the issues were discussed openly and in great detail. We thus have access to the fears, arguments, wonder and difficulties involved in bringing the chaotic growth of a modern consumer society within the realm of knowledge.[17]

At the same time, I would be pleased if this historical study will help us come to grips with some other problems that have emerged in accounts of commodity culture such as Baudrillard's (and especially the turn taken in his later work). In particular I hope to cast some critical light on the tendency to fetishize signification, to make it a metaphysics. There will certainly be much talk of the sign here, and representations will be chased across the surfaces of monuments, buildings, objects, and pages. And though they will never be caught for long, I hope we will be able to focus on them long enough to see that they do not have their own isolated economy. Even as the circulation of signs, both in earlier modernity and now, simultaneously borrows from, pushes on, and exceeds the circulation of exchange values, the material base of that system of society remains. While one could, with Baudrillard, challenge the epistemological monopoly of production as a way of knowing modernity, the brute physicality of the economy and the social relations it presupposes and recreates are still fundamental and necessary categories of analysis. We see this clearly in the case of the Werkbund, as the invasion of culture by commodities was recognized and ultimately (if critically) accepted, and as the cultural content of the commodity form, what objects should in fact *say*, was debated openly. The members of the Werkbund were trying to set up a world in which art and economy would speak the same language. But as members of the bourgeoisie, a social class whose dominance in Germany was not secure, they were experimenting in the open, trying to define their own world before presenting it as a coherent set of representations to other classes as the only world, the true world, the modern world.

* * *

Since the chapters that follow do not seek to provide a chronological or monographic account of the Werkbund's early years, a few words about the history of the organization are in order – a history marked primarily by the events surrounding the founding of the Werkbund in 1907 and the controversy surrounding its de facto demise in 1914.[18]

Long before the establishment of the organization, the figures who later became prominent in the Werkbund were members of a loose alliance that

understood itself as a *Kunstgewerbebewegung* or "applied arts movement." Already by the turn of the century, artists and architects such as Hermann Muthesius, Peter Behrens, Henry van de Velde and Richard Riemerschmid; critics such as J.A. Lux and Karl Scheffler; entrepreneurs such as Karl Schmidt; and politicians such as Friedrich Naumann were not only producing or promoting innovative work but were actively agitating for a large-scale reform of the artistic and economic practices that prevailed in the German applied arts. Their program can be described in terms of intersecting artistic and business aims. They rejected, in the first place, the use of the historical styles as inappropriate in the decorative arts of a modern age, advocating instead artists' designs based on new formal principles that would both express and take into account modern conditions of production and use, modern objects and materials, in short modernity in general. And second, they sought to bring about the direct involvement of artists in the production of objects of everyday life, not only supervising the craft execution of items for an exclusive market, but delivering designs for the industrial production of goods for a mass market.

The reformers were given the opportunity to promote their ideas before a large public when one from their ranks, the architect Fritz Schumacher, was asked to organize the Dritte Deutsche Kunstgewerbeausstellung (Third German Applied Arts Exhibition), which opened in Dresden in 1906. By means of a selection process and mode of display that favored the work of the new artist-designers of the *Kunstgewerbebewegung* at the expense of firms producing handicrafts in the historical styles, this exhibition presented a picture of what the reformers thought the applied arts should be at the same time as it sowed the seeds of conflict with more traditional producers. The conflict erupted in 1907, when Hermann Muthesius opened a series of lectures on the applied arts at the Berlin Handelshochschule (Business School) with a pointed and polemical attack (which he then published) on the firms that had been excluded in Dresden. Muthesius's provocation was intentional, and it had the desired effect. The leading applied arts trade organization called for Muthesius's dismissal from a government post he held; Muthesius's supporters provoked a confrontation at the group's annual meeting a few months later and noisily seceded; a few weeks later invitations to the founding ceremony of a new applied arts association were distributed by twenty-four artists and firms allied with the reformers; and on 5 October 1907, the association was founded as the German Werkbund.

The purpose of the alliance was to improve the quality of goods manufactured in Germany by encouraging cooperation between producers, tradesmen and art professionals. It sought to represent artists and architects by leading commissions their way, and to serve businessmen who saw a competitive edge in the use of artists' designs. But the Werkbund appealed to circles far beyond those who were joined by narrowly professional or business considerations. It drew support from groups within and outside of government who saw the artistic reform of German production and trade as a source of national prestige and economic prosperity; and it spoke also to the many groups, so characteristic of Wilhelmine Germany, who furthered cultural reform of all kinds.

The six or so years following the founding of the Werkbund were marked by steady success and growth. The government's refusal to censure Muthesius was taken as tacit support of the group's aims, and when Werkbund members were asked to represent Germany at international exhibitions, the group cultivated and gradually assumed a semi-official character. It came to be synonymous with (or managed to represent itself as) all that was progressive in Ger-

man architecture and applied arts at the time. Due no doubt to this increasingly important role as clearinghouse for both ideas and commissions, the Werkbund's membership increased rapidly, from slightly under 500 in 1908 to nearly four times that in 1914.

Beyond the practical assistance it could offer members simply by bringing them together through the bond of mutual interest, the activities of the Werkbund in its early years involved chiefly making propaganda for its cause. The organization sponsored lectures, organized exhibitions, helped to found a museum of contemporary applied arts, and, beginning in 1912, published the Werkbund *Jahrbücher*, an important series of yearbooks with texts on a wide range of subjects and extensive illustrations that served to give the Werkbund its public profile. As much as they pursued practical aims, the members of the group were concerned with establishing a theoretical basis and justification for them; and it is here that some of the most important concepts for the theoretical discussion of architecture and design in the twentieth century emerged: "*Sachlichkeit*," for example, or "types." The Werkbund became one of the preeminent forums for discussions concerning the role of art and artists in a modern society, and it is to this that it owed its appeal to such a wide cultural audience at the time.

It was on this theoretical level that, in the years following 1911, a sort of polarity began to emerge from the set of remarkably pluralistic practices that characterized the group. Behind this division lay the attempts of Hermann Muthesius to institute a specific, single Werkbund policy that privileged relations with large-scale industry and sought to encourage the establishment of standardized products or "types" that were (so the argument went) more efficient to produce. The issue came to a head at the annual meeting in July 1914, which took place in the midst of the Werkbund's first and only major pre-war event, a vast exhibition on the banks of the Rhine in Cologne. Muthesius presented his ideas on *Typisierung* in the form of ten theses and tried to put them to a vote, but he met violent opposition from a faction led by Karl Ernst Osthaus and Henry van de Velde which insisted on the primacy of individual artistic creation.

A month before the outbreak of World War I, the supporters of types and the defenders of individuality anticipated the trench warfare that would soon prevail: beyond some tactical maneuvering, neither side budged. The lengthy debate in Cologne did not represent any irreconcilable differences between the camps of "art" and "industry"; those who spoke there were for the most part artists. At issue were differing conceptions of the role of artistic work in a modern capitalist economy. As it proceeded, the debate served only to reveal the lack of common ground between the two camps. Only the war and the end of the Wilhelmine world of which the Werkbund was a part saved the organization from the pain of declaring its own dissolution: such a declaration had lost any meaning in a country which suddenly had very new and very pressing concerns. The Werkbund remained, papering over differences for the duration and doing its part for the war effort. Yet when it reemerged after the war, the Werkbund was a very different institution operating in a very different world; and the ambitious program of the pre-war years, between the founding and near-disintegration of the group, was part of a distant past.

* * *

Rather than trying to provide a more complete or correct account of Werkbund activities or studying its role in a morphology of modern design, this

study will investigate, thematically, the area in which the Werkbund was most prolific: the production of words and ideas, of theories. My strategy will be to put these ideas in a series of discursive contexts and to study these discourses not in isolation but in light of the academic disciplines, economic developments and legal issues which were inscribed in them.[19]

The first of these contexts is the common ground of concepts shared within the Werkbund concerning the nature of culture, its pathological forms under modernity, and the possibilities of strategies of reform. These terms can be traced to the sociology and the cultural criticism of the time, whose relation to the reform movement will be examined in some detail. Yet very different positions concerning both theory and practice emerged from this common ground, positions that ultimately (though perhaps not inevitably) solidified into the opposing camps of the 1914 controversy. The so-called type, I will argue, grew out of an ill-fated attempt to fix the relation between form and economy, one informed more by cultural concerns than by a realistic appraisal of the production and distribution of mass-produced commodities. This program will be considered on the one hand in terms of the prevailing economic discourse of the time – that of the Historical School of Political Economy – and on the other in light of certain structural shifts between traditional sectors of manufacturing and trade taking place in Germany. And just as I hope, in this way, to revise prevailing technical and architectural interpretations of the type, I will also challenge the usual characterization of the individualist position as a rear-guard attempt to revive a craft aesthetic in opposition to the demands made on artists by the capitalist market. The "individualists'" own practical relation to the modern economy will be looked at in the context of certain laws which regulated the way visual forms functioned in the economy, laws which did, in quite concrete ways, negotiate the relation between visual production and production in general.

My aim is to map the discursive terrain out of which grew some of the most significant and ambitious theories of art, architecture and design in the twentieth century. I think it is safe to say that the picture that will emerge will be, even for readers with knowledge of the subject, an unfamiliar one, one that is moreover at odds with most accounts of the development of design theories and practices. But there will be, I expect, flashes of *déjà-vu*, though they will not bring to mind well-known developments in the history of modernism. Rather they will accompany the exposition of the social experiences, the business practices, and the legislative problems that Werkbund theory sought to take into account. These flashes will appear in the margins of the various Werkbund accounts of seeing, buying, and using objects – experiences that are in no way the same in the 1990s as they were before 1914, but which are not, for all that, completely foreign, not yet, not by a long shot. By the time Gropius and other Werkbund members regrouped in the 1920s, more than one of these issues seemed to be a dead letter, and they have been written out of historical accounts drafted from that perspective. But now that 1920s modernism has long since begun to show rust and wear (though perhaps less than some would claim), it is possible to look closely at these exclusions. Among them we find notions that, when they crop up here and there, look very modern, postmodern. But they have been with us a long time, *déjà*.

Style Versus Fashion

The Werkbund and the Discourse on Culture in Germany

1. Culture

> The Werkbund is an alliance of laymen, dilettantes, scholars of art,
> art critics, and a very particular kind of younger architect. . . .
>
> contemporary description[1]

In the years before World War I, the trademark arose in Germany as a symbol of redemption. Or, to begin with, perhaps we should say simply the commodity, but removed from the factory and clothed for polite company, for culture. The commodity came to be the emblem of only one utopia among many in a cultural market starved for signs of redemption. But precisely what they needed redemption from was quite clear to all: it was capitalism as Germans had experienced it, and few critics of culture, from the left or right, made any bones about that.

 The scars of industrialization and the market economy ran deep in German society at the turn of the twentieth century. The development from small, originally feudal states to a unified, industrialized nation with urban centers of power occurred more quickly and completely than in any other European state, as did the growth of a large urban proletariat and a deeply unsettled bourgeoisie. This situation was theorized in two essentially competing ways. One was based on an analysis of labor and came to be centered on the issues of production and property, and on the figure of Marx. Its rival theorization can not be so easily categorized, but its analytical terms were certainly more widespread and ultimately more influential in the projects of cultural reform of which the German Werkbund is a prime example. This line of thought sought to subsume and transcend (as well as neutralize) the analysis of capital, taking as its starting point commodity production and the division of labor, but moving quickly to center on the crisis of *Culture*. It is in these terms that the Werkbund described its own project. As he called the group into existence in 1907, the architect Fritz Schumacher did not speak of professional concerns or aesthetic programs; rather he declared "the reconquest of a harmonious Culture" to be the Werkbund's ultimate goal.[2]

The analysis of Culture was a central theme of the bourgeois thought of the time and as such cannot be isolated from the manifold effects of the rapid modernization of Germany. Through the concept of Culture, the bourgeoisie sought to analyze the disturbing conditions of modernity without (like Marx) addressing issues of class and prophesying its own demise. But Culture should not be over-hastily equated with a specific class position, simply ascribed to a social group as ideology, for the bourgeoisie itself was not a stable or homogeneous group with a single, uniform politics. Many diverse social phenomena were inscribed in Culture as it was discussed in Germany at the turn of the twentieth century: the social decline of the traditional educated bourgeoisie or *Bildungsbürgertum*; the rise of a nouveau riche seeking legitimation; the political marginalization of both in the new German Reich. In different ways by both these groups, Culture was identified as the area of social life most immediately threatened by the ramifications of industrialization, and this led to discussions characterized by extremes of pathos which have been discussed by scholars in terms of "cultural despair." Yet to the extent that such a realm could be asserted to exist – either in the past or in the future – the bourgeoisie was also laying claim to a field under its own hegemony. In this context of feelings of loss and opportunity, Culture became another growth industry; as a concept constituted by academic disciplines, the bourgeois press, and institutions of the so-called Reform Movement (*Reformbewegung*), it became one of the most powerful ways of analyzing the effects of capitalism, of producing and disseminating knowledge about it.

The intellectual roots of the discussions of Culture – or, more accurately, the authority on which they drew – can be traced back to the German Romantics, to their privileging of a unified and transcendent type of artistic production as a reaction to a form of social life whose field had become the open market. Or alternatively, they can be traced to a German tradition of historiography whose understanding of the present resulted in a compelling but willful reading of the past, and whose view of history need only be read against the grain for a powerful critique of the modern to emerge in sharp relief. With origins in the late (or post-) Enlightenment historical thought best exemplified by Herder, theorists of history from Schleiermacher to Dilthey rejected the Enlightenment notion of the natural sciences as a model of human knowledge and sought to comprehend human history instead from within. The object of their study came to be the relative values and unquestioned communal forms binding a society – the *Geist* that was seen to integrate a culture, a spirit around which life assumed meaning and form, an organic principle that structured experience. But there was a hidden theme, a subtext to this definition of Culture and indeed to the entire historiographic tradition that came to be known as the *Geisteswissenschaften* or "cultural sciences": it is the disintegration of precapitalist social forms, for in the violent wake of industrialization, precisely what seemed to be disappearing from social life was posited as the very condition of historical existence. The concept of Culture is one of the most significant forms in which the Romantic critique of capitalism took root in writings on history, and through it a very particular kind of historical knowledge was generated by the transcendence of the contingencies of the modern mode of production in reified spheres of the past.[3]

This retrospective problematic, a longing for the precapitalist past as a more or less radical critique of modernity, was the common core of the discussions of Culture in Germany. The problem of Culture was most influentially elaborated and given its most explicit coordinates by the sociologist Ferdinand

Tönnies, who saw it as the core of the *Gemeinschaft* or "community," the pre-capitalist constellation of small town and agricultural or craft production.[4] Culture is defined in explicit opposition to *Zivilisation*, the instrumental, quantitative, profit-motivated sphere of urban, capitalist life, termed *Gesellschaft*. Within the terms of this problematic – called romantic anticapitalism by the later Lukács[5] – Culture is the idealized field of non-alienated existence.

Kultur versus *Zivilisation*, *Gemeinschaft* versus *Gesellschaft*: these dichotomies implied all the ills of modernity without having to spell them out – the presumed loss of a common spirit, the alienation and isolation of the individual, the fragmentary character of modern life. They quickly became the common currency of turn-of-the-century German cultural criticism.[6] They were also, quite explicitly, the shared reference points behind the discussions of the reform of architecture and the applied arts in the German Werkbund. There the import of these terms was regularly articulated beyond the mere invocation of the leitmotifs of bourgeois cultural thought, for instance by Hermann Muthesius, who is often, and with good reason, considered the key force behind the founding of the organization.[7] While Muthesius can not be described as a "typical" Werkbund member – there was no such thing – he is nonetheless emblematic of some of the many tensions in the social and political field that fed into the rich and varied writings on Culture. An artist (as architects were considered in the Werkbund) with aspirations to high social status, Muthesius, in his position as a high civil servant, had ambitions of political influence as well. Yet with a personal background in the *Mittelstand* or petty bourgeoisie, and as a graduate of a technical academy, he was not a member of the traditional university-educated *Bildungsbürgertum*; and in his cultural activities he occasionally ran afoul of state policy. On orders from the Ministry of Trade, as it turns out, Muthesius did not attend the founding meeting of the Werkbund in October 1907, but had he been there, we know exactly what he would have said:

> The fragmentation and confusion that can, for the moment, still be observed in our economic life are only a reflection of the fragmentation of modern life in general. The freedom that the opening of the world has brought to the individual has also . . . ended the tranquil development of mankind. . . . To achieve once again this inner harmony of the soul is . . . the most fervent quest of our age.[8]

In his keynote address at the annual Werkbund meeting of 1911, Muthesius went into greater detail. He revealed, perhaps, his *Mittelstand* roots by invoking Julius Langbehn's *Rembrandt als Erzieher* (Rembrandt as Educator), a popular account of cultural crisis and Bible of the *völkisch* right,[9] but then moved into a more measured attack on the Enlightenment tradition and the ideology of progress in Western thought, standard elements of the critique of the soullessness of modernity, *topoi* of German romantic anticapitalism:

> We can observe that from the eighteenth century on, the attention of man has been fettered to rational knowledge, . . . subordinated to the principle of the Enlightenment. . . . Born at the end of the eighteenth century, scientifically grounded technique completely monopolized the thought of the nineteenth century. . . . [T]hrough this one-sidedness, certain activities that had previously rounded out and harmonized human achievements were laid fallow. Spiritual matters which could not be reduced to a mathematical for-

mula, . . . emotional values inherent in the religious, the poetic, the tran-
scendent were neglected. In this neglect, the indifference to these matters,
lies the distinctive character of the man of today in comparison to earlier
epochs.[10]

The state of spiritual disorientation Muthesius describes was, to many, very
real, but Culture itself was a phantom, a figure of longing. But there is
nonetheless one way in which we can treat Culture as a fact, and indeed we
are obliged to do so: as a body of writing produced by a large but discrete
number of journals, institutions, and individuals of the educated German
bourgeoisie around the turn of the twentieth century which took the issue of
Culture as we have described it as its central problematic. This highly uniform
and to a certain degree self-contained discourse on Culture emerged from a
complex but quite identifiable web of people and projects, the threads of
which will occasionally be delineated here. This network includes the bour-
geois cultural press (journals such as *Der Kunstwart*, *Der Morgen* and *Die
neue Rundschau*, and publishers such as Eugen Diederichs); the various orga-
nizations of the *Reformbewegung* (the Goethebund, the Dürerbund, and the
Werkbund); and the *Geisteswissenschaftler* after Dilthey in academic history,
philosophy, the history of art, as well as those in the new discipline which
arose at precisely this time, sociology. The emergence within the Werkbund of
the terms of *Kulturkritik* (as this discourse was called at the time) is not hap-
penstance: the Werkbund did not simply borrow or adapt these terms, but
developed them further, and its members were not merely influenced by the
discourse on Culture but were very active participants in it.[11] The Werkbund
encompassed not only the artists and businessmen of the applied arts but the
very same publishers, politicians, and academics who belonged to the other
reformist groups; and the artists of the Werkbund were themselves active at
many other points of this web of affiliations.

At the intellectual center of this discourse stood the sociologists – the most
prominent were Max and Alfred Weber, Ferdinand Tönnies, Georg Simmel
and Werner Sombart.[12] The cultural press welcomed their activities more than
the state-run educational system did, and the reformist organizations took
them gladly into their fold. These bourgeois institutions provided the sociolo-
gists with new venues and granted them authority at the same time as they
helped them redirect their attention to subject matter slightly afield of that of
the traditional academic disciplines (until they could establish their own). Thus
it is no surprise that the sociologists introduced some of the most important
concepts of this discourse: Tönnies provided the influential terms; Georg
Simmel explored most explicitly and popularly the presumed "tragedy of
Culture"; and Werner Sombart brought the concept of capitalism from radical
or academic into bourgeois circles. The achievement of the sociologists was to
turn the presuppositions of the *Geisteswissenschaften* into analytic tools for
the study of contemporary society, and to apply them systematically and con-
sequentially.

The personnel of the Werkbund and the sociological circle intersected.
Most importantly, Werner Sombart was a member of the Werkbund in its
early years and contributed to its literature a book whose title is nothing if not
emblematic – *Kunstgewerbe und Kultur* (Applied Art and Culture);[13] and
Georg Simmel followed closely the developments of the *Kunstgewerbe-
bewegung* and commented on them. But what justifies the attention that will
be paid here to these connections is the way the projects of the two groups ran

parallel. The sociologists transformed a diagnosis of modernity as crisis into an investigation of the historical development of the social and cultural forms of the capitalist present; similarly, in the Werkbund the terms of contemporary *Kulturkritik* were transformed into a highly self-conscious attempt to analyze the development of visual form under differing conditions of culture.

It is the thesis of this study that the theoretical activity of the Werkbund circle was not only directed toward an exploration of the functional, artistic or symbolic potential of industrial technique as a way out of artistic decline, but was a sustained and at times sophisticated attempt to determine the very nature of the cultural field under conditions of modern capitalism; to discover the way form acts in, and reacts to, a market economy; and to redeploy form under these conditions as a utopian force, as a carrier of Culture. In the course of their project, they came to the conclusion that the banal, everyday object in its modern form as commodity could be saved for Culture, that it could, in fact, serve to summon a shared spirit back into the alienated everyday life of the modern age. Commodity production was to be redirected: from the cause of social chaos and alienation, it would function to recreate Culture as it was believed to have existed in precapitalist eras, but within the social parameters determined by industrial production as it had developed in imperial Germany.

In tracing the role of the Werkbund in the larger discourse on Culture (and, in subsequent chapters, its recourse to other discourses), my focus will not, for the most part, be specific objects or major monuments produced by Werkbund members at the time, works that have long commanded the attention of architectural and design historians. Instead I will concentrate on the disproportionately large, indeed staggering theoretical production of the Werkbund circle.[14] For if, defying all appearances, Muthesius could proclaim in 1911 "a triumph of the new German art," he immediately had to qualify his statement: "it is, however, only a *theoretical* triumph."[15]

4. Ferdinand von Arnim, boudoir in "late-classical taste" for the Villa von Arnim, Potsdam, 1859 (TU Berlin)

5 Ludwig Hoffmann, Märkisches Museum, Berlin, 1899–1908 (Landesbildstelle Berlin) Eclectic combination of local brick Gothic and Northern Renaissance architecture

2. STYLE

We believe in the unity of this new art, and recognize the unity of all earlier art.

Karl Ernst Osthaus[16]

As the call for a new style grows loud in our time, one asks to what extent the fundamental prerequisites exist. And only when one realizes that not a single such condition is unambiguously present does one fathom the utopian, desperate nature of this cry.

Karl Scheffler[17]

In the Werkbund, visual corollaries to the terms of contemporary cultural philosophy were defined and explored. The corollary of Culture was *Style*: in a lecture of 1910, Peter Behrens, architect and industrial designer and a founding member of the Werkbund, spoke of "the goal which I earlier termed Culture, and which has found, throughout history, perceptible expression in Style."[18] By Style was understood – or rather posited – the quality of unity between form and the spiritual imperative of a time. This "sense of visual unity," said Behrens in the same lecture, "is at the same time the precondition for, and the evidence of, a Style. For by Style we mean nothing but the unified formal expression, the manifestation of the entire spiritual life of an epoch. Unified character, not the particular or the peculiar, is the decisive factor."[19]

To Behrens and his audience, the visual consistency of Style was the sign of an integrated culture, the aesthetic evidence of a life free from alienation. Such a unity was conceived in opposition to the supposedly fallen state of culture which was considered to coincide with a general decline of intuitive spiritual values and a rise of rational and material ones in the nineteenth century. In

6 Design for a neo-Rococo
bedroom (Jean Pape,
Musterzimmer, 1887)

architecture and the applied arts, this spiritual decline was seen to be mirrored in Historicism, the endless repetition of elements of the previous styles of the Western tradition – Classical (fig. 4), Romanesque, Gothic, Renaissance (Italian and German), Baroque, Rococo (fig. 6), Biedermeier – or their eclectic recombination (fig. 5). The most authoritative and sustained attack on Historicism in these circles was the book *Stilarchitektur und Baukunst* (Style-Architecture and Building-Art) of 1902, in which Hermann Muthesius argued for a new critical hygiene either by a cleansing of the now debased concept of Style or (his solitary preference) its outright rejection. He wrote of Historicism's semantic overabundance as a fall from grace – he spoke else-where of the contemporary "Tower of Babel"[20] – in which self-conscious historical reference displaced an unconscious but authentic harmony:

> The superficiality of the nineteenth-century architecture racket . . . is shown clearly by the meaning attached to the word Style at the time. Earlier, there had been no styles, merely a single predominant artistic tendency to which everything was subordinated in a perfectly natural way. Not until the nineteenth century was mankind banished from this artistic paradise, having eaten from the tree of historical knowledge. Then people divided themselves into parties, supporters of the *different* styles.[21]

Despite later differences with Muthesius over practically every aspect of Werkbund policy, Karl Ernst Osthaus, a philanthropist and patron of the arts who was also a major voice in the group, fully concurred with this diagnosis of Historicism as an affliction of the modern soul:

> In the nineteenth century, art approached its utter disintegration. This is signalled by the fragmentation of Art into the arts, of Style into styles. . . . Not until the turn of this century did art orient itself toward Style, i.e. toward harmony. . . . Will we ever again possess a universal Style? . . . Only if [we] returned to unified thought could we expect that the visuality of our existence [*die Sichtbarkeit unseres Daseins*] will again assume a homogeneous form.[22]

In general, the usage of the term "Style" within the Werkbund is consistent with that of the popular cultural criticism of the young German Empire. Julius Langbehn, for example, wrote of Style – "self-contained spiritual character which reveals itself to the senses" – as "part of the very heart of a *Volk*. . . . the deepest core of [its] personality."[23] Here Langbehn seeks to enlist Style into the service of the radical *völkisch* right. In the lectures, articles and projects of the Werkbund, however, the discussion of Style developed in a direction that had little to do with the clichés of *völkisch* thought. The concept opened up other avenues of inquiry. It was, for example, a category that was explored in some depth by the early German sociologists. Compare Muthesius's and Osthaus's remarks on Historicism with Simmel's in the *Philosophy of Money* of 1900, on "the multitude of styles that confronts us when we view the objects that surround us, from building structure to book design, from sculptures to gardens and furniture."[24] He too sees this "bewildering plurality of styles" as a reflection of spiritual dissipation, of alienation from the self:

> If every style is like a language unto itself. . . , then as long as we know only a single Style that forms our environment we are not aware of Style as an autonomous factor with an independent life. No one speaking his mother tongue naively senses the objective law-like regularities that he has to consult, like something outside of his own subjectivity, in order to borrow from them resources for expressing his feelings – resources that obey independent norms. Rather, what one wants to express and what one expresses are, in this case, one and the same, and we experience not only our mother tongue but language as such as an independent entity only if we come to know foreign languages. In the same way, people who know only one uniform Style which permeates their whole life will perceive this style as being identical with its *contents*. Since everything they create or contemplate is naturally expressed in this Style, there are no psychological grounds for distinguishing it from the material of the formative and contemplative process or for contrasting the Style as a form independent of the self.[25]

Muthesius characterizes the loss of the "artistic paradise" of Style with the Biblical imagery of the Fall; Simmel finds corresponding ontological terms: "The fact that the entire visible environment of our cultural life has disintegrated into a plurality of styles dissolves that original relationship to Style where subject and object are not yet separated."[26]

The metaphor of the visual forms of everyday objects as a language caught on, though it was rarely more than a figure of speech and never applied rigorously. The politician and publicist Friedrich Naumann, a central figure in the discourse on Culture and the political voice of the Werkbund, wrote, "We . . . are reaching out for an art that is not a foreign language to us, but rather a mother tongue."[27] (Naumann, though, could do nothing with this idea but turn it into a clumsy image: "This language is only being developed, but the Werkbund would like to be its linguistic society [*Sprachverein*]."[28]) But to look to Simmel as a source of Werkbund ideas, a direct one anyway, would be premature (as would any analysis of his remarks here). As we shall see, Simmel knew what was going on in the Werkbund, and members of that organization knew what Simmel was writing. For the moment, he can serve us by providing a kind of extended epigraph, a model for the kind of discussions of visual form which could develop using the analytic concepts developed in the sociological orbit. But to talk about form in ways helpful to them – to begin

talking, anyway – the Werkbund did not need these concepts. Those of art were already rife with possibilities.

<p style="text-align:center">* * *</p>

To take the clearest example, Walter Gropius and Peter Behrens regularly framed their theoretical statements in the terms established by the Viennese art historian Alois Riegl, a pioneer in the scholarly study of the applied arts. In a lecture of 1911 at Osthaus's Folkwang Museum in Hagen, Gropius told his audience that "the beauty of a work of art is a function of an invisible law inherent to the creative will [*Willen*], not of the natural beauty of the material; and that all material things are only subordinate mediating factors with whose help a higher state of the soul – the *Kunstwollen* – is given material expression."[29] The term Gropius borrows from Riegl to identify "the higher state of the soul" is the *Kunstwollen* – "artistic volition" is perhaps the best English rendering. It was a concept developed by Riegl as a replacement for the debased, positivist sense of "style" identified by Muthesius in academic discussions of art and architecture. In his coining of a new word, Riegl expresses, polemically, two important ideas. One was historicist: he posits a unique and common "volition" (*Wollen*) as the shaping force of human activity at a particular point in history. The other point was formalist: he asserts that art or visual production is a perfect and unmediated expression of this volition.

The *Kunstwollen* was a useful concept in the Werkbund, for Riegl spelled out with scholarly authority a number of points already present in the reformers' notion of Style. First, Riegl provided an alibi for drafting art into the service of a new "Idealism," which is how bourgeois thinkers characterized their desire to break through the forms of technological Civilization to a transcendent Culture. The art historian asserted the priority of human will over factors of external necessity, identified by Behrens (following Riegl) with "the dogma of materialist metaphysics."[30] On this point, Behrens takes the step, for him unusual, of quoting the art historian directly in his lecture of 1910. From Riegl's *Spätrömische Kunstindustrie* of 1901, he chooses the following passage, a polemic against nineteenth-century positivist notions of the development of form in the applied arts:

> As opposed to [Gottfried] Semper's mechanistic conception of the work of art, we need a teleological one, in which the work of art can be seen as the result of a definite and purposeful *Kunstwollen*, which makes its way forward in the struggle with function, raw material and technique. Thus the latter three factors no longer have those positive creative roles attributed to them by Semper's theory but rather restraining, negative ones: they are, so to say, the coefficients of friction within the entire product.[31]

Ideal factors, not material ones, determine the appearance of the work of art. Muthesius, though a proponent of no-nonsense "*Sachlichkeit*," is nonetheless in full agreement and echoes this theme: the *Kunstgewerbebewegung* is an "intellectual movement," and as such is "based on the only eternal, supreme historical principle: the spiritual. The spiritual alone governs and alters the times; the great world-historical powers run in its currents. It is the Idea which gives cultures their stamp."[32]

Beyond an assurance of the priority of spirit over matter, the Werkbund circle found in Riegl's work an assertion of the unity of this *Wollen* throughout the life and production of an epoch, a move already implicit in the transposition of Culture into Style: "The *Kunstwollen*," writes Riegl, ". . . is practically

identical with other major forms of expression of the human *Wollen* during the same period. . . . The character of this *Wollen* is always determined by what may be termed the conception of the world at a given time [*Weltanschauung*]."[33] Interestingly, the somewhat idiosyncratic phrase "unified *Wollen*" as a desideratum crops up in the second, 1903 edition of *Stilarchitektur und Baukunst* – time, perhaps, for a reading of Riegl.[34]

Finally, Werkbund readers found in Riegl the strongest scholarly critique to date of the autonomous, isolated work of art (painting, sculpture, representative architecture) as the appropriate object of artistic or art-historical attention.

> Basic laws are as common to all . . . media, as is the *Kunstwollen*, which rules them all; but these laws cannot be recognized with the same clarity in all media. The clearest case is architecture, next to the crafts [*Kunstgewerbe*], particularly when they do not incorporate figurative motives: often architecture and these crafts reveal the basic laws of the *Kunstwollen* with an almost mathematical clarity.[35]

For Riegl, spirit assumed form most perfectly in precisely those works unencumbered by manifest content. The shift of attention from the "fine" to the "minor" arts was a very current idea, but hardly a new one; it could be found just as well in the late nineteenth-century idea of the *Gesamtkunstwerk* or in Jugendstil theory. By the time the Werkbund was founded, however, these contexts had become suspect. In his assertion of the privileged role of the *Kunstgewerbe* – the applied arts, or the production of everyday objects – in the creation of the visual totality, Riegl gave an old idea a new name and authority, freeing it from stale Wagnerian rapture, deriving it from history, and removing the idea of "art."[36]

In short, the *Kunstwollen* – "the universal laws in effect in all media," the "inner determination . . . which one calls 'Style'" – signalled the aesthetic and spiritual activation of all of visual production, "art" as well as "non-art."[37] This idea, echoed by Heinrich Wölfflin's well-known comparison of the Gothic cathedral with the Gothic shoe – a tour de force of historical holism put into formalist terms[38] – lay behind the standard trope through which Muthesius described the Werkbund's ambitions: "Church or ballroom" was one version; more resonant was "From the sofa cushion to city planning."[39]

Behrens's and Gropius's invocation of Riegl has been noted often enough. Here I hope to shed light not on his role as a source but rather as an authority, on how that "very particular kind of younger architect" in the Werkbund found formulations in the art historian's work which confirmed a sense of the nature of form developed in the discourse on Culture. For one thing is clear: Riegl himself was not writing for this audience, and the appearance of his terminology there represents its transposition into a very different project. The concept of the *Kunstwollen* was defined in the examination of antique art and ornament, and any recourse to it in discussions of the artistic activity of the modern age involved a reception, an interpretation. And furthermore, the interpretation current in the Werkbund was one which ignored some obvious tensions in the work they cited. Their Riegl was grandly unproblematic – the last thing one can say about the texts themselves, which are notoriously nebulous and deeply embedded in debates which were not the Werkbund's. Riegl's ambition was to establish a methodological justification for the autonomous study of images on the basis of principles of idealism and historicism, and his work has to be considered here briefly in that light. For this project founders, ultimately falling prey to the traps of historicism in general, and his term

Kunstwollen incorporates contradictions that are relevant here. He combined a negative argument, an extreme and consequential rejection of a normative view of form, with a positive one, the search for transcendent laws in and through history. These laws were found by two related moves: first, a hypostatization of the philological series, which is given its own life and made into an immanent force, a subject of history; and second – and most important here – a hypostatization of the heuristic concept of style, of the formal individuality and simultaneity of an era. Each is a by-product of the act of historical interpretation, but each is given the status of unmediated fact.

The result is a tension between – or at least an unmediated juxtaposition of – diachrony and synchrony inherent in the concept of the *Kunstwollen*. This created a situation in which there were, so to speak, different Riegls, each of whom could find corroboration in the texts.[40] In buttressing their idea of Style, Gropius and Behrens *chose* their Riegl, and they chose the synchronic one who saw the historical meaning of form in the fundamental interconnectedness of the artistic (and non-artistic) products of a single given age. They were not alone in doing so. The architects echoed the interpretation Riegl's work received among the circles of the *Geisteswissenschaften*, the historical scholars and philosophers of the hermeneutic tradition who similarly ignored the diachronic aspects that smacked of Hegelian determinism. Weber and Simmel, we know, were reading Riegl before the war,[41] but their students and followers give us our cue here. As late as 1923, Georg Lukács included Riegl, along with Dilthey and Max Dvorák, among "the really important historians of the nineteenth century." Casting the art historian as the Dilthey of art historiography and not its Hegel, Lukács cites the same aspect of Riegl's work singled out by the theorists of Style: the study of "those *structural forms* which are the focal points of man's interaction with the environment at any given moment and which determine the objective nature of both his inner and his outer life."[42] And in one of the central documents of the Riegl reception, Karl Mannheim equates the *Kunstwollen* both with the concept of Style and with Weber's notion of *Geist*.[43] The Riegl who appeared in the Werkbund was the same one taken up within the circle of the sociologists: he was a shared reference point in the discussions of Culture, a common concern of theorists of history and professionals of art.

<p style="text-align:center">* * *</p>

If, when they spoke about Style, members of the Werkbund quoted Riegl, they were at the same time paraphrasing Nietzsche. In Behrens's characterization of Style as the "the unified formal expression, the manifestation of the entire spiritual life of an epoch," there is more than a chance echo of Nietzsche's definition: "Culture is above all unity of artistic style in all the manifestations of the life of a people."[44] And a reception of Nietzsche was by no means incompatible with a reading of Riegl: in transforming the kind of historical knowledge that was one aspect of Riegl's own brief into principles of action, the applied arts reformers were putting into practice the relation to the past advocated in Nietzsche's second "Untimely Meditation."[45] In the 1914 Werkbund *Jahrbuch*, Gropius writes of "The Style-Forming Value of Industrial Building Forms," implying that the state of spiritual harmony which seemed to exist in the past could be summoned into modern life. Echoing both Riegl and Nietzsche, he describes this as a matter not of material conditions but of will:

The beginnings of a strong and unified will toward Culture are unmistake-

able today. To the degree that the ideas of the time rise above material conditions, the longing for unified form, for a Style, has also been newly awakened in the arts. People recognize once again that the will to form [*Wille zur Form*] is always the true value of the work of art. As long as the spiritual conception of the time hesitates and falters in the absence of a single, firm goal, art will not have the opportunity to develop Style, i.e. the unification of the creative will into a single conception.[46]

Behrens read Riegl for himself, but Gropius, it seems, picked him up second hand, and in a form in which Nietzsche was already inscribed. For when Gropius wrote of the "will to form," he was repeating the paraphrase of Riegl's concept of the *Kunstwollen* made popular by the young art historian Wilhelm Worringer in his *Abstraktion und Einfühlung* (Abstraction and Empathy) of 1908.[47] Worringer's term turns *Wollen* into *Wille*, "volition" into intention or "will" – the key concept of the popular Nietzscheanism of the time. The conflation of terms was electric: it invested concepts developed for the study of history with an Expressionist energy and pathos – a central though insufficiently recognized aspect of Werkbund theory.

In the concept of Style, the anti-Enlightenment epistemology and antimodern subtext of the contemporary *Geisteswissenschaften* were thematized and given expression by the transposition into the present of the principles of analysis of the past, themselves a negative reflection of modern conditions. In this, the theorists of Style echo the most articulate of the pre-war anticapitalists, the cultural prophets who shared many of the reference points of the Werkbund writers and who bridged the gap between the human sciences and sociologists on the one hand and the Expressionists on the other. One such figure was Lukács before his conversion to Marxism. In 1912 he described Culture as "the unity of life; it is a unifying force. . . . Every culture is a conquest of life, a forcible unification of all phenomena of life. . . . [T]hat is why we will always find the same things at the deepest level of analysis, no matter which part of the totality of life we may single out for consideration."[48] Culture is defined by Lukács as a totality, a necessary interconnectedness of all expressions of the human spirit. And in defining, as he does here, "the possibility of a life free from alienation,"[49] Lukács has ultimately no terms to resort to but those of the hermeneutic, for these "part[s] of the totality of life" are nothing but the circumference of the hermeneutic circle, Dilthey's figure for the epistemological process of the cultural sciences.[50]

In fact, Karl Ernst Osthaus heard Dilthey's lectures as a student in Berlin.[51] There he might have heard the philosopher speak on historical knowledge, something to the effect of the following:

The germinal cell of the historical world is the experience in which the subject discovers himself in a dynamic relationship with his environment. The environment acts on the subject and is acted upon by him. It is composed of the physical and cultural surroundings. In every part of the historical world there exists, therefore, the same dynamic connection between a sequence of mental events and an environment.[52]

In any case, Osthaus adopts Dilthey's concept of *Zusammenhang* ("connection" or "connectedness") and inscribes it in the topography of everyday life, closing the parts into a circular whole: "In the modern Style-movement. . . . we seek to create art by producing connections [*Zusammenhänge*] and relationships. The curtain gains a new meaning through its relationship to the car-

pet, the garden through its relationship to the house, the house through its relationship to the street and the city."[53]

Time and again in the discourse on Culture, the principles of historical interpretation were elided with the objects of interpretation; and with the increasingly desperate search for signs of "connectedness," the historical past was emptied of mediations and filled, a bit hastily, with spirit. Max Weber must have realized the ambiguity that obtains between the process of interpretation and the view of the past it yields, for in 1904, just as the *Kunstgewerbebewegung* was gathering steam, he called the synthetic picture produced by the cultural scientist (he is writing here about his "ideal type") a "utopia."[54] Style was just such a utopia. It presented a picture of the past, as tangible as it was unreal, that allowed members of the Werkbund to dismantle, in theory, the hierarchy of high and low art, to shatter the boundary between art and life, and to posit a common spirit uniting a culture. Through the concept of Style, they transformed the study of the past into a visionary quest: to change the debased language of Historicism, which could only adorn Towers of Babel, into a set of signs that would summon back the lost voice from inside the hermeneutic circle.

3. Fashion

> Let me speak to you today about a subject which presents as many problems to the psychologist, the aesthetician and the cultural historian as to the economist, and one with which everyone today has his own experiences – about *Fashion*, which has in recent decades entangled culture deeper and deeper in its web.
>
> Walter Troeltsch[55]

> With a little imagination, anyone can envisage the connections within the triumvirate Fashion-Female-Capitalism, the clear dynamic of their individual effects.
>
> Bruno Rauecker[56]

The members of the Werkbund longed for Style, and many even prophesied its imminent advent. But no one at the time of the founding of the Werkbund asserted its existence. Instead, they complained with Nietzsche of the "stylelessness" of the age, of the "jumble [*Durcheinander*] of styles."[57]

Usually, however, their terms for describing the aesthetic ills of the era were much more pointed, but these terms were often in code, in the shorthand of the time. When, for example, Peter Behrens said in 1910 that "there can be no individual Style,"[58] he was not merely referring to the posited collective nature of past life, but contrasting it in a specific way to his present age. Similarly, Walter Gropius wrote: "In the obsession with singularity and difference from one's neighbor, stylistic unity has been sacrificed for the eternal search for the novel."[59] To the turn-of-the-century German, the quest for "singularity and difference" was not the positive assertion of the self: it was the sin of refusal to submit to the higher authority of a common spirit, the form of subjectivity of *Zivilisation*, and the philosophical concomitant of nineteenth-century capitalism. The fact that the rapid development of a capitalist economy in the second half of the nineteenth century coincided with the era of Historicism in the arts was not lost on the writers on Culture; they saw in fact a causal relation between the two. The art historian Fritz Hoeber, Werkbund member and both friend and biographer of Behrens, describes the art of antiquity in a way that makes explicit the aspect of modern life the reformers' notion of Style served to critique: "Greek art is collectivist in its innermost essence. . . . The modern, thinking man can hardly find this characteristic objectionable, as did those antiquated advocates of an art-historical Manchesterism, for whom a lawless and licentious individualism was, quite incomprehensibly, the chief prerequisite of healthy artistic production."[60] Manchester was the home of Adam Smith and classical political economy; Hoeber contrasts the collectivism of the Greeks, the basis of their Style, to the ethical principles of laissez-faire capitalism. This was no isolated metaphor. In *Der Kampf um den Stil* (The Battle for Style) Walter Curt Behrendt gathers together even more of the clichés of anti-Manchesterism when he writes that the "battle for Style" was "called forth by a natural, nearly instinctive reaction to the culturally hostile influences of capitalism,"[61] and when he describes these influences: "Economic competition took place within the free play of [economic] forces, without plan or foresight, driven only by the ruthless private interests of an unbridled individualism. The tranquility and stability of social life gave way to an uncontrolled struggle of all against all."[62] Now Fritz Hoeber was writing in the *Sozialistische*

Monatshefte, the organ of revisionist socialism;[63] and Behrendt's book, though largely finished in 1912, was not published until 1920, and might thus be seen to contain a strong dose of post-war Expressionism. However, these terms were not unusual; more to the point, they were not, within the Werkbund, polemical. Heinrich Waentig, for example, an economist and sociologist whose politics would place him at the center of the Werkbund spectrum, wrote that "the modern *Kunstgewerbebewegung* appears . . . at first as a spontaneous, then as a conscious reaction against the aesthetic character of the capitalist commercial economy in which we live today."[64]

If Style was a figure of longing, it was also a theory of form under precapitalist conditions of culture. This becomes quite clear through an exploration of Style's discursive opposite, a concept which had, for contemporaries, everything to do with the rampant industrialism and commercialization of the nineteenth century. For in the eyes of the Werkbund members, capitalism did not merely lead to "junk" (*Schund*), to goods which were "cheap and nasty" (*billig und schlecht*)[65] but to a very particular constellation of the production of visual form and its diffusion throughout culture. They called this *Fashion*.

The concept of Fashion was an obsession of the time. Aestheticians such as Friedrich Theodor Vischer and Julius Lessing wrote the first widely read German discussions of the topic in the second half of the nineteenth century, and these were couched in a style of indulgent mockery of human folly. Around the turn of the century the topic assumed a greater gravity and a wider scope. Fashion was no longer discussed simply as a matter of clothing style, but came to be a blanket term used to describe the appearance of saleable objects of any sort; the phenomenon of changing clothing styles was taken as the model for describing the behavior of consumer commodities in general. Of the scholars who called themselves sociologists, two – Georg Simmel and Werner Sombart – made important contributions to the discussion.[66] These served as the basis of an ever broadening contemporary debate addressing the issues of the origin of fashions, their social meaning, psychological mechanisms, and historical development. These were also matters of interest to economists, who studied trends in the contemporary art industries as fashions and published their findings in the major journals of the reform movement. If the argument of this section relies heavily on quotations from this rich material, it does so in order to suggest the central role of this concept in the contemporary debates of the applied arts; it is a term that must be understood before turn-of-the-century ideas of Style can assume meaning.[67] To the sociologists, Fashion allowed the study of the novel habits of consumers in a world now overflowing with commodities. To economists, it demanded the investigation of the economic significance of the consumer sector of the economy, a new issue in a discipline which had traditionally concentrated on heavy industry and international trade but was now faced with the new reality of overproduction. And to the members of the Werkbund, Fashion came to be the central concept of a theory not only of the loss of Style, but of the decadent nature of visual form under conditions of laissez-faire capitalism. In other words, in their attempt to reform the production of everyday commodities and to make the consumer market the site of their intervention, the members of the Werkbund were armed with a nascent, if crude, theory of mass culture.

✳ ✳ ✳

Culture was not the only context in which fashions were discussed;[68] like the

problem of luxury in general, debates about fashions have a long history before the nineteenth century. They figured, for example, in discussions of morals and critiques of the court culture of the aristocracy. In its modern form, however, Fashion – both as phenomenon and concept – followed the development of consumer cultures. A full-blown consumer economy with the availability of a wide range of consumer commodities beyond life's essentials to a broad range of people had emerged in England by the turn of the nineteenth century; and so too had modern debates about Fashion that echo those that will be discussed here. In Germany – the perenially "late" European nation – both the emergence of a consumer culture and of discussions of Fashion must be dated nearly a century later.[69] In Gottfried Semper's theory of dressing or cladding [*Bekleidung*], earlier architectural discourse too foreshadows the Werkbund members' attention to Fashion in the context of building and design. Semper's widely read writings on the origins and development of architectural forms, culminating in his unfinished *Der Stil in den technischen und tektonischen Künsten* (Style in the Technical and Tectonic Arts, 1860–3), posit the original development of architectural enclosures as being separate and distinct from structures. While the roof – one of Semper's four prototypical or archetypal "elements of architecture" – was a tectonic matter, enclosures developed from textile wall hangings suspended between structural members. Woven or braided textiles "dressed" or enclosed the structure and have left traces of their origin in the ornamental motifs applied to elements that may later have become load-bearing. After Semper, it was clear that an interest in clothes was not necessarily so far from the concerns of architecture as it might seem.[70] Semper, interestingly, was one of the many German travellers to England to write with fascination and alarm of the cultural disruption caused by commercialization.[71] But it was only with the development of a consumer economy in Germany that Fashion came to be widely discussed, by both architects and cultural critics, as a native phenomenon. It is this specific context that I would like to sketch out here: the meanings attached to the concept, the problems negotiated through it, the discourse of art and Culture it helped to structure.

For precisely like Culture/Civilization and *Gemeinschaft/Gesellschaft*, Style/Fashion was a discursive pair in which each element implied the other and defined it by opposition. The pair represents, in fact, these more widespread dichotomies transposed to the critical vocabulary of art. Thus Fritz Schumacher asks as early as 1899, "Is that which we see as a conspicuous spectacle really a Style, or is that which we are shown as Style perhaps only a Fashion? . . . Style or Fashion, that is the question."[72] His article is titled, typically, "Stil und Mode." Writing ten years later on "Stil oder Mode," critic and art historian Curt Glaser stresses the theme of individuality versus universality which structures the dichotomous concepts of the contemporary cultural discourse: "The characteristic of a Style – as opposed to mere Fashion – is not to be sought in the originality of form, but rather in the universality with which a Style encompasses all the life-forms of an age."[73] Arthur Bonus gives a nearly untranslateable battle cry: "*Los von der Mode, hin zum Stil!*"[74]

Commentators on Fashion were unanimous and explicit about one matter: "Fashion" was not merely a question of clothing style, but was a general social phenomenon of modernity, the phenomenon of the chaotic behavior of consumer commodities on the mass market. F.T. Vischer, whose *Mode und Zynismus* (Fashion and Cynicism) was one of the standard nineteenth-century points of reference for these discussions, considered Fashion "a general con-

cept for a complex of temporarily prevailing cultural forms."[75] In *Wirthschaft und Mode* (Economy and Fashion), a chapter excerpted from his monumental *Der moderne Kapitalismus*, Sombart wrote of "the intensive development of fashionability in our time, the infusion of the entire social life of the present with Fashion."[76] To critic Johannes Gaulke, "all spiritual values, all everyday objects, indeed Man himself in his forms of life and sociability [*Lebens- und Umgangsformen*], as well as in his external habits, are subject to the unwritten law of Fashion."[77] That also meant, without a doubt, the forms of everyday objects. In the words of another commentator, "The worst thing is that these changes in Fashion not only dominate clothes design but also the applied arts."[78]

From the publication of Sombart's *Der moderne Kapitalismus* of 1902, Fashion came to be understood not merely as a widespread social phenomenon, but as the unique product of the modern economy. In the vast literature on the topic produced in this period, not a single voice was raised in refutation of Sombart's conclusion that "Fashion is the favorite child of capitalism: it has emerged out of the innermost essence of capitalism and reveals its nature like few other phenomena of the social life of our age."[79] In the circles of the *Kunstgewerbebewegung*, Fashion represented the objects of artistic and craft activity turned into mere commodities: "Craftsmen and artists have lost their influence on the character of production," writes the critic Robert Breuer. "They are nothing but the blindly obedient executive agents of a mighty will" – a will he identifies as that of "capital and its assistant, Fashion."[80]

Sombart isolates three characteristics of the pheonomon of Fashion. First, "the vast profusion of everyday articles to which it applies."[81] Second, "the absolute *generality of Fashion*, which first developed in our age."[82] These create a tendency toward the "unification of demand" whereby ever larger markets are created for the very same objects, a vast demand which can be supplied with maximum efficiency and profit.[83] The third characteristic, however, was seen as the most striking: "The frantic speed of changes in Fashion."[84]

It was the theme of speed and change which fascinated contemporaries and signaled to them the essence of the phenomenon: "Fashion is the transient, Style the lasting."[85] Temporality could be related to the broader context of culture in various ways; Johannes Gaulke, for example, begins his discussion of the issue by implying a sort of reflection theory: "The mercantile attitude is behind the lack of Style in our era. . . . The urge for change in the formal language of art corresponds completely to the restlessness in economic and cultural life."[86] Gaulke is here invoking the concepts of "nervousness" or "irritability" [*Reizsamkeit*] as developed in Karl Lamprecht's *Deutsche Geschichte* and his student Willy Hellpach's *Nervosität und Kultur* in the attempt to isolate a common denominator of the economy and psychology of modernity;[87] he also echoes Simmel's well-known discussion of the "intensification of nervous stimulation" in modern urban life.[88] Most commentators, however, did not hesitate to assert a more instrumental relationship between capitalism and change. To them Fashion represented not merely an increasing fickleness on the part of consumers, but the artificial creation and maintenance of a market for new goods, the result of the vast manufacturing capacity which had developed in Germany since the middle of the nineteenth century, a solution to the problem of overproduction. The economists said this straight out: "Change of Fashion appears as the precondition for an increase of production"; "Trade and industry count . . . on this change to such an extent that they have learned to accelerate it and to capi-

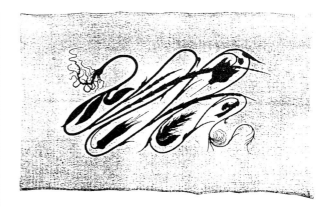

7. Henry van de Velde, color lithograph poster for Tropon, 1897 (FU Berlin)

8. Hermann Obrist, embroidered wall decoration, 1895 (Pevsner, *Pioneers of Modern Design*)

9. Richard Riemerschmid, table lamp, 1898, Werkbund-Archiv, Berlin (Frederic J. Schwartz)

talize on it in advance"; "Demand is increased to the extent that the population submits to Fashion. The whole business world extols Fashion as a stimulant to turnover."[89]

It is in these economic terms that nineteenth-century Historicism and the more recent Jugendstil – the twin anathemas of form in its fallen state – were most often analyzed. The word "Fashion" was key to the discussions. "Style has become a matter of Fashion," wrote Gaulke.[90] Muthesius combined the two words, calling Historicism – "the superficial rehearsal of all the styles of the past" – the *Stilmoden*, the "style-fashions."[91] Or alternatively, underscoring the tempo of change, the "style-hunt . . . in which late Renaissance, Baroque, Rococo, Neoclassicism and Empire were systematically butchered, and after a short period of blood-sucking, cast in the corner."[92] Art, wrote Karl Widmer in *Deutsche Kunst und Dekoration*, had been dragged into the unhealthy atmosphere of the factory:

The "historical tendency" was a true child of our Steam Age. Artistic capacity could not keep pace with the breakneck speed of modern mass production, with the thousands and thousands of products of industrial ingenuity. . . . [But] any danger that Fashion's perpetual need for change would ever create difficulties for the art industry seemed out of the question: the museums were inexhaustible, and the copying of older models could proceed at the rate required by industry and the market.[93]

Like Widmer, Muthesius seemed sometimes to give the architects of the nineteenth century the benefit of the doubt, attributing the style-hunt to a mere impoverishment of the intellect, to an atrophy of the artistic imagination. He saved the full force of his wrath for Jugendstil or German Art Nouveau, the reform tendency of the final half-decade of the nineteenth century which immediately preceded, and to a certain extent overlapped with, the movement which led to the founding of the Werkbund. Muthesius was in full sympathy with the attempts of Jugendstil artists – Henry van de Velde, Behrens, Hermann Obrist, Richard Riemerschmid and others who later became important Werkbund members – to bring their artistic work into the realm of everyday life (figs. 7-9), but when form moved from the studio to the factory, the battle for Style was lost:

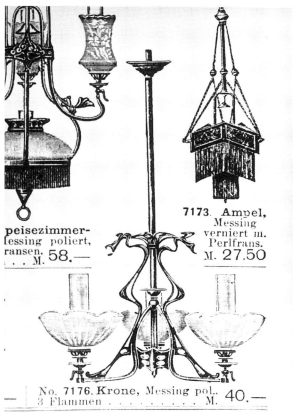

10. Chandelier in the A. Wertheim mail-order catalogue (Warenhaus A. Wertheim, *Haupt-Preisbuch 1903/1904*)

> Fashion took the whiplash line [of the Jugendstil] as the chief characteristic of the new Style they seem to have waited for so long. And as soon as this was the case, industry moved as quickly as it could to capitalize on this new Style. This principle of the whiplash line seemed so simple, so easy; finally there was something tangible that could be used, that could be manufactured. In the blink of an eye, the world was given Jugendstil. . . .
>
> Perhaps it is a good thing that this formalism of the whiplash line . . . was taken up by the gears of industrial production and took over a role in the Fashion market. That is the guarantee that it will soon be used up. . . . Compared to the last styles that industry held in its clutches, Jugendstil is no improvement, that is clear.[94]

Again, an economist soberly concurs with this view of Jugendstil as art's sacrifice to a seemingly voracious economy: to Heinrich Waentig, Jugendstil represented "the new art turned too quickly into Fashion . . . under the influence of capitalist business interests."[95]

These accounts of the appropriation of Jugendstil are not hyperbole. In the years after the turn of the century, the asymmetric swinging line had indeed wandered far from the artist-designed objects and had strayed from the formal principles that held it in check there. By 1902, for example, it was available through mail-order houses, as the A. Wertheim catalogue shows. The single sweep of Riemerschmid's table lamp (fig. 9), for example, could be found multiplied, symmetrically disposed and at somewhat loose ends as a chandelier with distinctly non-Jugendstil glass lampshades (fig. 10); we also see the

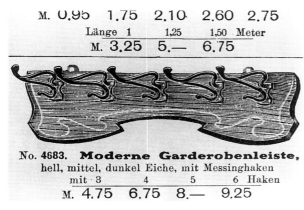

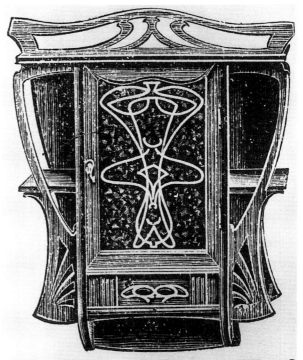

11. Coat rack in the A. Wertheim mail-order catalogue (Warenhaus A. Wertheim, *Haupt-Preisbuch 1903/1904*)

12. Wall cabinet in the A. Wertheim mail-order catalogue (Warenhaus A. Wertheim, *Haupt-Preisbuch 1903/1904*)

whiplash line on a coat rack (fig. 11), framing a wall cabinet (fig. 12), and in imitation walnut under a bargain-priced starter kit of literary classics (fig. 13).

The presence of styles in commercialized form gave rise to a certain confusion of terminology, the only wrinkle in an otherwise remarkably consistent discussion. Because of the exploitation of the superficial aspects of the historical styles, Muthesius sought to "banish the concept of Style entirely."[96] This suggestion met with only limited consensus; it sparked a series of synonyms for Style (*Sachlichkeit*, for example, or "Taste," or "Quality"), but the concept of Style was too embedded in the cultural thought of the period to be renamed simply by fiat. The confusion also prompted repeated attempts at clarification of terms, feats of exegetical reasoning.[97]

The words "new" and "modern" had left behind, if anything, more bitter an aftertaste, for they were the words of advertising. Artists of the Jugendstil such as van de Velde had described their project as the search for the "new style," and this vocabulary had been appropriated by the market as completely and quickly as the superficial formal characteristics of these artists' work. The Jugendstil objects in the 1903 Wertheim catalogue were often described simply as "modern"; nine years later, clocks in the Stukenbrok catalogue had to be "extremely modern" (*hochmodern*) and they now show a mixture of stylistic elements that resists any classification, even within the individual items (fig. 14). Even in the cultural review *Der Morgen*, whose "cultural philosophy" pages were edited by Werner Sombart, we find an advertisement with the following text: "The New Style: distinctive, not too flashy now, based on the traditional, functional, artistic . . . is represented in many superior models at W. Dittmar Furniture Factory. Visitors welcome. Free illustrations. Cheap prices."[98]

The "new" or the "modern" as the artificial construction of capital was a theme the writers of the day never tired of. Joseph August Lux writes, "It is merely a business necessity; novelty is sought because it is new, not because it

is more beautiful, more practical or more tasteful. The great machinery needs fodder, it has to be kept in motion; the great wheel has to be kept turning, and the more water that comes to the mill, the faster it turns."[99] That the "new" was turned not by the wheel of fortune but itself turned the cogs of industry was of course a truism of the economic studies of the time; they were echoing, among others, Sombart:

The entrepreneur, whether manufacturer or tradesman, is forced by the competition to present his customers with the very newest [merchandise]; otherwise he may lose them. . . . Thus the widespread effort . . . always to have the latest merchandise, the newest patterns. This is the reason for the spread of Fashion. And to the extent that there exists a whole category of businesses which seeks to surpass this minimum, to move the customers, through seductive novelty, to buy – and to buy from them – capitalist competition produces . . . the tendency of quick change. . . . They suck the blood from their fingernails, rack their brains in order – this is the heart of the matter – to throw something new onto the market again and again.[100]

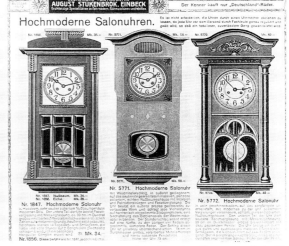

13. Classics library and shelf in the A. Wertheim mail-order catalogue (Warenhaus A. Wertheim, *Haupt-Preisbuch 1903/1904*)

14. Wall clocks in the A. Stukenbrok mail-order catalogue (August Stukenbrok, Einbeck, *Preisliste 1912*)

Wind in the sails of capital, or water on its mill-wheel: we find many such images. The need for constant change was a signal that visual form had come under the control of capital and was subject to its dictates. This seemed so abundantly clear that certain of Marx's analytical terms were unavoidable in considering the matter, even in a discourse that approached them with considerable suspicion. In 1915, Alexander Schwab took some pains to point out that under commodity production, the items of the Werkbund's interest – here furniture – were produced not according to criteria of use value but of exchange value: "Manufacturers do not identify the needs of consumers and thereby hope to achieve economic gain. Instead, they identify the availability of investment capital and then search for an opportunity that seems to offer a good return. That the fulfillment of some consumer need or other is achieved in the process is to a certain extent [merely] a by-product of the process."[101] Need, narrowly construed, no longer organized the production of everyday objects. This development in the sphere of production clearly required a corresponding change in buying practices. According to the economist Walter Troeltsch, fashions had the effect of conditioning consumers, in effect redefining needs to serve the new organization of production. "Fashion," he writes, "undermines the habit of moderate consumption based on individual need; it stimulates the passion for constant change, even when this is not objectively

necessary; it directs demand toward objects whose often dubious merit con-
sists in being modern; it seduces and trains people to apply an entirely new
standard to commodities."[102]

Let us try to define this "new standard," the signs of the new, as precisely
as possible. For turn-of-the-century commentators, the fashion sign is defined
diacritically, by difference. The theme of this threshold of distinction, the mini-
mum of the "modern," is often raised, for example by Sombart in *Der mod-
erne Kapitalismus*:

> It is of course possible for one competitor to try to outdo another by the
> superior quality or lower price of a product otherwise similar in form and
> material. Why then by a change in fashion? First of all, no doubt, because
> in that way it is most possible to create a fictive advantage where a real one
> is not possible. It is after all easier to produce an item *differently* than it is
> to produce it better or more cheaply. Then there is the notion that the incli-
> nation to buy is increased when new items display *small variations* com-
> pared with earlier ones: an item is replaced [by the buyer] not because it is
> in any way worn out, but because it is no longer "modern."[103]

Troeltsch in fact defines "fashionable products" by their tendency toward dif-
ference: they are precisely "goods which deviate from earlier ones through
form, design, or material."[104] And in their resistance to stability and custom,
the forms of Fashion seem senseless and incoherent: to Troeltsch, these ten-
dencies were characterized by "their brevity, their fluctuation, and their *irra-
tionality*."[105] Johannes Gaulke put it in a revealingly different way: "Fashion is
not the expression of the need for beauty or variety on the part of the individ-
ual, or on the part of consumers in general, but rather an *arbitrary [willkür-
lich], usually minimal alteration* . . . by the manufacturer, made to stimulate
the public incessantly to buy."[106]

Thus, the Fashion sign – the latest historical style, perhaps, or the swinging
line of the Jugendstil – could be described as arbitrary as well. The "meaning"
it expressed was not intrinsic, but extrinsic; it invoked the "new" merely by
deviation from those signs which had become, however briefly, accepted,
expected, customary. Yet as appealing as it would be to recast the analysis of
Fashion into Saussure's terms (as I have begun to do here), it is a temptation
that should be resisted. Certainly critics were beginning to experience the mar-
ket as a field where not only goods circulated but where meanings were palpa-
bly being expressed. Yet they saw no stake in exploring these representations
as any sort of signifying system; their notion of system was economic, not lin-
guistic. Artists and critics, we shall see, did indeed talk of signs (and I will too);
but their sense of the sign and of signification in general was resolutely unsci-
entific. Sometimes this understanding was vulgar and empirical; sometimes it
had a radiant, Romantic glory; sometimes, even more surprisingly, it implied a
redemptive mixture of the two.

In the analysis of Fashion, in any case, the generation of meaning was con-
sidered under the category of the generation of profits. The design reformers
were less concerned with timeless laws of signification than with historically
developed mechanisms of capitalist production. And here the simplistic
rhetoric that opposed the voice of spirit to the voice of capital had a certain
explanatory power. Gaulke wrote that "the mass production characteristic of
capitalism, in tandem with the 'modernizing' . . . tendency of industry . . . has
turned all aesthetic values on their head. The everyday object seemed to exist
only for the sake of its ornament."[107] Here the core of the reformers' critique
of the use of historical ornament emerges, and it is different from the one we

15. Apartment blocks under construction in Berlin, before the application of surface ornament, ca. 1910 (W.C. Behrendt, *Die einheitliche Blockfront als Raumelement im Städtebau*)

usually associate with the Werkbund. They interpreted the shifting surfaces of applied ornament not as any sort of technical or aesthetic superfluity but rather as economic appropriation; they saw the everyday object as reduced to the status of a blank field on which ornament was displayed in arbitrary, and arbitrarily changing, ways, generating meaning at a rate proportional to and determined by production capacity and warehouse stocks. Ornament, to them, was the group of visual forms with *exchange value*. Visual form itself had become a commodity, and the useful object served to a large extent as the mere carrier of these forms.

Discussions of architecture also stress the commodity character of surface form and show how decoration was divorced from the rest of the construction precisely because ornament was so closely linked to the commodity's exchange value. Semper had led the way, seeing in his theory of dressing a separation of surface from structure. Yet he searched for its cause in the historical past, without invoking the category of the commodity, which was now central to the critical vocabulary. Walter Curt Behrendt describes the urban dwelling as "a product for many people, a market commodity, a mass good," the surface or facade of which displays "an unprincipled egotism . . . which takes as its supreme goal the outshouting of its neighbor in order to assert itself."[108] Like the minimally but constantly shifting forms of ornament affixed to everyday objects, those of mass-produced architecture are "not dictated by artistic idealism, but by prevailing market conditions."[109] For Karl Scheffler, the facade exists only "for the external display of the commodity."[110] He describes the disjuncture of surface and structure as the logic of commodified ornament (figs. 15, 16): "Apartment building facades are differentiated only when the decorators and stucco workers arrive with their cornices, their stucco decoration in the taste of some period-style or other, when roofs and towers are arbitrarily attached and the familiar orgy of proletarianized ornament begins."[111]

Finally, in *Kunstgewerbe und Kultur*, Sombart dispenses with academic niceties and minces no words. With "capitalism's conquest of the applied arts,"[112] he writes, the task of the artist is merely "to play along with the historical fashion and to translate the styles of the past into Capitalese."[113]

※ ※ ※

"Capitalese": if Style was the mother tongue, Fashion was the language of capital. In the Werkbund, ornament was discussed as visual form isolated equally from structure and spirit and deployed in the mass market as mere commodity – interchangeable, divorced from use value, expendable, "proletarianized." But Werkbund thought (to homogenize, for the moment, a group of heterogeneous voices) was nothing if not dialectical. For as much as Sombart's chapter in *Der moderne Kapitalismus* served as a starting point for the analysis of a "culture industry" *in nuce*, some of its more polemical statements – for example that "the participation of the consumer is reduced to a minimum, that the driving force behind the creation of modern Fashion is, through and through, the capitalist entrepreneur"[114] – were seen as oversimplifications. When the economist Walter Troeltsch published a study of Fashion that amounted, in essence, to an elaboration and substantiation of Sombart's argument, Bruno Rauecker of the Werkbund reviewed it in the *Kunstgewerbeblatt* and took issue with precisely this point:

> Troeltsch handles the question of the *importance of the consumer* in this process from a standpoint which is psychologically and economically disputable. According to him, producers and merchants are the factors out of whose accord the waves of taste develop and run their course. I don't think so. . . . Sellers do not create Fashion, and not buyers either [but rather] the collaboration of the two.[115]

The Werkbund did not see its site of intervention only as the seemingly voracious realm of mass *production*; their work had also to take into account the presence of mass *consumption*. In their analyses of the behavior of visual form in its fallen state, they were just as concerned with the use of form by the consumer as with its manipulation by the manufacturer.

In the writings of the *Kunstgewerbebewegung*, the theories of the consumer's manipulation of visual form echo the other most important contribution to the turn-of-the-century debate, Georg Simmel's *Philosophie der Mode* (Philosophy of Fashion). Simmel's discussion of the role of Fashion in the production process is perfunctory; his concerns clearly lay elsewhere. He was interested not merely in the generation of cultural phenomena by the economic system, but in their interplay with a form of subjectivity that developed under these conditions – the way an economic given is mediated by the human subject and the way human subjectivity is in turn mediated by economic realities as these realities become integral components of cultural forms. To Simmel, Fashion was just such a cultural form. In addressing this aspect of the modernity of fashions, Simmel can be seen as trying to provide a necessary complement to Sombart's argument; it was part of Simmel's project of "constructing a new storey beneath historical materialism,"[116] and there is no doubt that just such a Marxist materialism was an important element of Sombart's thought at the time.

Simmel discusses what happens to fashions in the hands of the consumer. Like the discussions of form under the control of the entrepreneur, he encourages us to talk about Fashion in terms of signs. His conception of the arbitrariness of Fashion is clearly stated:

> In countless cases, not the slightest reason can be found for its forms in objective, aesthetic or other functional criteria. For example, while our clothes are generally adapted to our needs in an objective way, no trace of functionality governs the decisions dictated by Fashion – whether wide or narrow jacket, pointed or broad coiffures, colorful or black neckties shall be worn.[117]

16. Apartment building facade, Dresden, ca. 1900 (courtesy Prof. Kurt Junghanns)

Yet while the forms of Fashion are arbitrary, they are not without purpose. For needs are not merely technical or "objective": "Fashion is a product of *social* . . . needs."[118] And when he raises the issue of the way Fashion generates meaning in a social and not merely economic field of signification, a new term emerges: meaning lies not only in the signs of difference, but in those of *identity* as well. Fashion develops out of the joining of two social requirements which it meets simultaneously, "the need, on the one hand, of belonging, and that of distinction on the other hand," the desire for both "connection and differentiation."[119] Fashion is form as sign, sold as difference, but bought to display both identity and distinction, belonging and exclusion. In particular, to display the signs of class: "Fashions are always *class* fashions."[120]

For Simmel, the consumer's manipulation of signs of class is just as implicated in the constant change of fashions as is the entrepreneur's manipulation of signs of the more neutral "new":

> Social forms, apparel, aesthetic judgement, the whole style of human expression, are constantly transformed by Fashion, in such a way, however, that Fashion (i.e., the latest fashion) in all these things affects only the upper classes. Just as soon as the lower classes begin to copy their style, thereby crossing the line of demarcation the upper classes have drawn and destroying the uniformity of their coherence, the upper classes turn away from this style and adopt a new one, which in its turn differentiates them from the masses; and thus the game goes merrily on.[121]

Much the same game was played with everyday objects, whose forms were being called on to signify in the same way as clothes. In 1912 Bruno Rauecker described a pecking order that he calls "a fact . . . basic to every sociologist's experience: the middle class [*Mittelstand*] seeks to acquire the same home environment, the same decorative appointments as the highest social strata just as eagerly as the worker is concerned with acquiring the furniture of precisely this middle class."[122] But while the basic signifying practices were similar, some of the details and mechanisms were different. For here mimicking the consuming habits of the upwardly adjacent class involved not only feigning ownership of the same object forms but also of the same materials. This is how critic Johannes Gaulke moves from clothing fashion to Fashion in general:

> beyond offering new merchandise [which] displays small deviations from the previous supply. . . . [t]he circumspect entrepreneur knows how to exploit these weaknesses of the public in still other ways: through all sorts of tricks, he makes his goods appear more costly than they in reality are. While maintaining external appearances, the most expensive material, the most complicated form can be reproduced with surrogate materials at a fraction of the original price.[123]

The widespread use of surrogates – cheap, machine-made reproductions of more expensive handcraft processes and materials – allowed prices for traditionally durable goods to be set low enough to draw them into the cycle of needless replacement. Here we will let some of Hermann Muthesius's remarks in his 1907 speech before the Berlin Handelshochschule (which sparked the controversy leading to the founding of the Werkbund) stand for the scores of complaints by reformers about the use of the machine to deceive the eye. The second half of the nineteenth century, he writes, "with its quickly changing style-fashions, was at the same time the age of the worst aberrations in preposterous finery and material simulation of all kinds. Surrogates and imitations

celebrated their triumph."[124] Muthesius is clear about the nature of the decep-
tion. If paper could be used to imitate wood, or brass to imitate gold, this was
only a first order of reference; the ultimate referent of the surrogate sign is
class:

> Social pretension arose in the battle for class supremacy. As the bourgeoisie
> achieved importance, it experienced a certain need for pomp which it could
> only satisfy by inexpensive superficial means, but which it considered neces-
> sary to compete with, if not to outdo, the previously privileged classes. . . .
> Pretension, the passion for appearing to be more than one is, became a
> habit in bourgeois circles in the nineteenth century.[125]

The misuse of the machine as the producer of surrogates and the call to "truth
to materials" (*Materialgerechtigkeit*) to counter it are standard themes of the
Werkbund critique of the turn-of-the-century status quo. It is worth clarifying,
however, that surrogates were not considered merely the result of the death of
the crafts and the ignorance of the entrepreneur about his materials and his
production methods, but also of consumers' demand for objects that would
help them nullify the distinction between themselves and "the next higher
class."[126] The name of this (caricatured) consumer of the visual signs of wealth
and prestige was the *parvenu*, a word of contempt which appeared throughout
the literature of the Werkbund as well as in that of the general "mandarin"
cultural criticism of the time: "Usually, like the barbarian, he fell for the shiny
and coarsely conspicuous, and often enough the desire to flaunt his cultivation
of art and to show his wealth was also involved. There arose the symptom so
characteristic of our time – ostentation, the taste of the parvenu."[127] Nor was
the problem of the parvenu simply that of cheap material. It was also the
problem of Historicism: the elements of the architecture of the past were the
bid of new money to look old. If Historicism was a style, it was the "parvenu-
style."

My point here is not just that pretension and the search for profit were, to
the Werkbund members, behind the decline of taste witnessed throughout the
second half of the nineteenth century, but that these issues were brought up
under the category of Fashion and thus as part of a broader discussion whose
purpose was to determine the way form acts under, and reacts to, conditions
of a market economy. As such, the issue is not merely taste but rather signifi-
cation itself under conditions of capitalist production and in the social config-
uration of the turn-of-the-century mass market. The attention paid to the con-
sumer's share reveals that Fashion, in its guise as Historicism, the surrogate, or
the "new," was culturally destabilizing in its creation of signs of distinction
and identity. At the upper end of the market, Fashion was the distasteful asser-
tion of the class power of the upper bourgeoisie; as Fashion trickled down, the
same representations were deployed, more disturbingly, as claims to cultural
entitlement.

Fashion raised the specter of class. It unmasked the field of the mass market
as an arena of class conflict: "The social guerrilla warfare which is incessantly
waged in the field of Fashion, which swings forever between social differentia-
tion and imitation, is the true economic hallmark of Fashion and thus the
secure base of capitalist exploitation," wrote Alexander Elster in the
Kunstgewerbeblatt.[128] The nature of Werkbund member J.A. Lux's aversion
to Fashion is clear: "Fashion provides taste for Everyman. For the tasteless as
well. It levels. It lives for the masses and from the masses. That consolidates its
dominance, its tyranny."[129] But for the most part, the project of the

Werkbund was not to preserve the domain of culture for the social elite, but to diffuse it, to erase the clues to class and thus to remove the visual traces of, and incitement to, class conflict. For in Germany, the late and only partial empowerment of the bourgeoisie – and the visible assertions of this power in the *Gründerzeit* which are at issue here – was quickly followed by the presence of a large, vocal, organized, and thus threatening socialist movement.

The goal of the Werkbund was, in political terms, the creation of a sphere of culture in which class played no visible role. This gospel of the transcendence of class conflict was the main impetus behind much of the liberal-progressive politics of the period, especially that of Friedrich Naumann, the main political voice of the Werkbund.[130] Judge it as one may, it was a bid to avert revolution. So too, in its smaller way, was Style. Thus Heinrich Waentig on the social potential of the *Kunstgewerbebewegung*: "What would it mean for social policy if not the noblest and most perfect bridging over of class differences in society?"[131] Here an important quality of Style emerges in contrast to its Other, Fashion. While Fashion was defined as the realm of forms which were classed, mobile, and endlessly manipulable, Style was classless, or at least the visual reflection of a stable class structure; it represented, to the Werkbund, visual form not dragged into the struggle for class power as they witnessed it.

Fashion raised not only the specter of socialism, but other specters as well. The energies of production and the claims to class identity are also erotic energies, or so wrote Elster: "Alongside the *drive to imitate* and the *desire for social differentiation* through Fashion, the most important moment of all is the *erotic need for variation*, . . . not only the forms of Fashion, but precisely the tendency to change is a specifically erotic phenomenon."[132] As capital mixed with and remapped culture, wrote critics, it also released erotic energies in order to appropriate them. Gaulke equates the perennial modifications which generate the "new" with the way changes in clothing styles regularly shift emphasis from one of the female "secondary sexual characteristics" to another: from hips to breasts to waist to buttocks. "Industrialism," he concludes, "accommodates all instincts, sexual desire as well as the urge for variation, to make its products desirable."[133] The critics of Fashion thought they discerned a primitive beat behind the cyclical changes in the visible form of consumer commodities, and it alarmed them. The drive for profit was seen as the modern equivalent of the "savage's" "battle over the male" or "battle over the female," depending on the commentator – and the weapons were the same.[134] With few exceptions, reformers sought to anathematize desire in the name of Style, a goal implicit in Karl Scheffler's statement of the need to establish the "masculine reason" of Culture.[135] Fashion represented not only form creating and crossing class lines; the libido too was implicated.

And the id even crossed national borders, for Fashion was not only classed and gendered but had a political topography as well. Though the phenomenon of Fashion extended beyond apparel, women's clothes were always the reference point, and few commentators failed to point out that fashions were developed in Paris (and there launched within the *demi-monde* – the world of café singers, actresses and prostitutes). These connections so captivated Werner Sombart that he devoted a book to the subject, published in 1913. In *Luxus und Kapitalismus* (Luxury and Capitalism, a title which was edited by his publisher from the original "Love, Luxury and Capitalism") he claims to trace the development of capitalism out of the demand for luxury goods (especially in France) to be used for purposes of "illicit love."[136]

The constellation of Fashion can be seen as the collective anathema of modernity facing the German *Bildungsbürgertum*: it represented the destructive effects of industrialization, the deformations of rampant commercialization, class conflict, an attack on the patriarchal order, the revenge of the French. The hysteria mounts; voices are often shrill. But Fashion is of interest to us for more than its function as a figure for the sum total of threats to the male ego of the Wilhelmine bourgeoisie. Despite its hysterical note, the discussion led to a powerful interpretation of the nature of form under modernity.

Fashion was understood as a state of semiotic chaos that developed in the nineteenth century as a direct result of capitalist production and speculative commerce. It was form out of control, the dystopia of the commodified sign. Form had been drawn into the vicious cycles of capital which generated profits by destabilizing the controlled state of Culture. Signification itself was running rampant, the result of the coupling of visual form and exchange value under the conditions of a mass market created by mass production.

<p style="text-align:center">* * *</p>

Often naive in its wide-eyed and fearful wonder, the analysis of Fashion as commodified form is nevertheless unsurpassed to this day in matters of detail. And while it has been written out of the histories of modern architecture and design that are read today, it was the theoretical context of all the practical attempts in the Werkbund to find a means of redeploying the visual within a cultural space defined as the capitalist marketplace. With this in mind, perhaps it would be a good idea at this point to return briefly to the familiar territory of Werkbund theory as it is usually discussed in order to draw some very tentative conclusions.

Let us take the notion of *Sachlichkeit*, often seen as the key Werkbund concept in the theoretical discourse of the architecture of the pre-war period. *Sachlichkeit* can be translated as "objectivity," "practicality," or "sobriety," and it was, in important ways, Muthesius's alternative to the concept of Style, a word he no longer used for reasons we have discussed; it is also an important aspect of the theoretical development of what has come to be called the "machine aesthetic."

In a well-known passage of *Stilarchitektur und Baukunst*, Muthesius writes as follows:

> In seeking a new Style, the Style of our age, one is most likely to find hallmarks in those new creations that serve newly developed needs: in our railway stations, exhibition halls, giant assembly buildings; further in the realm of engineering [*auf allgemein-tektonischem Gebiete*], in our giant bridges, steamships, railroad cars, bicycles, etc. In fact it is precisely here that we see manifestations of truly modern ideas and principles of creation that give us much to think about. We note a rigorous, one is tempted to say scientific, *Sachlichkeit*, an avoidance of external decoration, a design [*Gestaltung*] precisely adapted to the function that the work is to serve. And that notwithstanding, who would deny the agreeable impression of a sweeping iron bridge, who is not pleased by today's elegant landau, the trim battleship, the delicate two-wheeler? . . .
>
> In such modern creations, cues are given that indicate the direction of our aesthetic progress. This can only be sought in the tendency toward the rigorously *sachlich*, the elimination of merely affixed decorative forms and formation according to the particular requirement of function.[137]

Muthesius was writing in a spirit that has since been termed "functionalism": he proposes the rejection of applied ornament and its replacement with a "clean spareness of form"[138] growing naturally out of an object's function.

In developing his idea of *Sachlichkeit*, however, Muthesius does not really have much to say about function. Instead, as in nearly all German writing on design at the time, Style and Fashion are the reference points here. Style is present by name in this text, and Fashion appears as the "merely affixed decorative forms," the explicit Other of *Sachlichkeit*. In this passage, Muthesius defines *Sachlichkeit* twice, and he does so each time in the same telling way that highlights the theme of Fashion. The first moment of his definition is a negative one: the "avoidance of external decoration," the "elimination of merely affixed decorative forms." The positive moment comes second, and is secondary: "design . . . adapted to the function," "formation according to . . . function." That this could create an "agreeable impression" is nearly an afterthought to an argument that seeks to present function as a principle allowing an architect or artist merely to avoid applied ornament.

My point is this: Muthesius's oft-invoked text cannot be understood apart from the contemporary discussions of Fashion, to which it was in fact a notable contribution. The problematic around which the argument turns is that of the semantic aspect of form; his treatment of function and of the beauty of technical products – seen for decades as the interesting, progressive, "modern" aspect of the book – is incomplete and subordinate to a very different issue. For in light of the emphatic way in which he defines his term, it is clear that Muthesius is not proposing some abstract sense of logic, the aesthetic self-evidence of material and function. His point about technics is put primarily in negative terms, and is itself negative: *Sachlichkeit* is not the aesthetic payoff of functional form (and functionalism as such was widely discussed and rejected in the Werkbund[139]); it is, rather, the avoidance of form as Fashion, and thus a certain *semantic neutralization* of the surfaces of the everyday object and environment.

At various times, Muthesius also discusses truth to materials, another theme of the constellation of ideas implied in the word *Sachlichkeit*, in terms of the concern to hold the semantics of the commodity in check. In contrast to the surrogate's function of establishing and crossing class lines through its semantic potential, "the rejection of . . . imitation and surrogates became the leitmotif of the new *Kunstgewerbe*. No imitation of any kind, each object appears as what it is, each material comes forth in its own character. In this way, one of the most important principles of industrial design [*gewerbliche Gestaltung*] developed: that of inner truthfulness."[140] The honest expression of materials, machine production and function all serve – at first – to factor out signification from the design process. As Muthesius describes them, machine forms, forms derived from function, do not signify; at best, they are merely "agreeable," perhaps also vague symbols of modernity in general. Before the First World War, forms derived from machine production might *represent*, for example, modernity or capitalism, but they were nonetheless to circumvent its "language" as it was discussed in the Werkbund.

Sachlichkeit is the key to a new culture which Muthesius defines openly in class terms: it is a bourgeois culture. In its avoidance of historical or other ornament, functionality is simultaneously classed and classless:

> In the place of an aristocratic culture, which relinquished its leading role with the end of the eighteenth century, an independent bourgeois culture

developed that saw its essence no longer in representative etiquette but in simple *Sachlichkeit*. . . . We see clearly here the trend toward the practical and unornamented which coincides with the engineer's principles of creation [*ingenieurmäßigen Bilden*] A bourgeois culture is also developing in our interior furnishings, which is tending increasingly toward the functional, the *sachlich*, the appropriate [*Sinngemässen*]; a simplifying tendency is also strikingly evident in the design of our smaller utensils.[141]

Sachlichkeit would represent the elimination of both moments of the consumer's manipulation of signs of class – both the upper classes' visual assertion of difference and the lower classes' imitation of these forms. The new cultural aristocracy is marked by reticence, a "dignified restraint" which Muthesius opposes to the current "parvenu-taste"; and the more modest citizen, the true burgher, should follow this example:

When one examines the financial situation of this group more closely, one learns that their pretensions are disproportionate to their means. The money that they spend dictates the simplest things, while they want the most pretentious. Industry . . . has accommodated these desires through the manufacture of an inferior variety of pretentious junk which is the hallmark of almost the entire commodity market. For 2$\frac{1}{2}$ marks, one can get an object that would cost 25 marks if it were decently made. . . . But almost without exception, the classes with modest means reach not for the simple but for the pretentious object. A bourgeois dwelling . . . should look completely different from the way it does today. It should have the simple, modest stamp that we find in the bourgeois dwellings of our great-grandfathers.[142]

Couched in the terms of a quaint *Vormärz* aesthetic are the same principles as those behind the aesthetics of machine form. It is, we could say, a fetishization of the *lack* of ornament: fetishization in that signs of class, of the relations of production, are obliterated by the very means of the signs of production itself.

We should not push this point too far. The design reformers were not willing fully to relinquish the signifying potential of the commodity, and their goal was not the creation of mute objects. But the theories of the utopia of Style grew out of analyses of the dystopia of Fashion, which provided the common element of the discourse of form in the Werkbund: a profound resistance to the commodification of form, a repugnance at – or at least suspicion of – the saleable sign.

4. Commodity, Culture, Alienation

> Amongst the manifold signs of the decline of that order of life
> under whose force and orientation we still live, I see none more
> convincing than the *deep alienation* that . . . fills the best minds
> and strongest hearts of today.
>
> Max Scheler[143]

> What makes the content of cultural criticism inappropriate is not
> so much lack of respect for that which is criticized as the dazzled
> and arrogant recognition which criticism surreptitiously confers on
> culture.
>
> Theodor W. Adorno[144]

The analysis of Fashion is not merely the background to the sudden pathos in the discussions of Style around 1900, to the treatment of Style as the essence, and not a mere attribute, of an object. As a model of the nature of visual form under conditions of commodity production it was, crude as it may often have been, a significant achievement in its own right. The writings on Fashion were part of a huge outpouring in the years following the turn of the century within the magazines and books as well as lectures and pamphlets that constituted the discourse on Culture, one whose subject was the new practices of mass consumption. The goal of these writings was to negotiate the relation of the new activities and institutions of commodity exchange to Culture at large – either to exclude this realm from the spiritual space of Culture or, despite it all, to find some sort of spot for the mass market there.

Before such lines could be drawn, however, the new spaces of the commodity which appeared prominently and inescapably across the landscape of everyday urban life had to be represented and analyzed. And before the turn of the century, discussions in the bourgeois cultural press bear witness to a struggle to understand, a difficulty in arriving at adequate terms with which to describe this realm. In 1896, for example, two men who would later take part in what I would call the "Werkbund circle" – Friedrich Naumann, a guiding spirit of the group, and Georg Simmel, an interested observer – wrote thoughtful reviews of the 1896 Berlin Trade Exhibition in the general press which reveal this difficulty.[145]

Both writers are up-front about their bewilderment when confronted with the monumental spectacle of commodity display, the hallmark of these exhibitions which were, in Benjamin's words, "the sites of pilgrimage to the commodity fetish."[146] Naumann opens his review with a breathless description of the fairgrounds that moves quickly to a note of anxiety: "He who tries to comprehend it all will lose his sanity."[147] Simmel uses an image that is uncharacteristically violent: "Every sensitive soul will feel violated [*vergewaltigt*] and disoriented by the mass effect of the presentation."[148]

Simmel is more successful than Naumann in thematizing his confusion and turning it into the object of his attention. He underscores the problem of incomprehension: "The quantity and diversity of what is presented," he writes, ". . . the close proximity in which the most heterogeneous industrial products are brought produces a paralysis of perception, a veritable hypnosis."[149] Simmel searches for the source of this "hypnosis" in the sharply growing contrast between the spheres of production and exchange, between the division of

labor and the unity of the exhibition spectacle: "While cultural advance leads to ever greater specialization and greater one-sidedness of labor, to ever narrower restriction to a specified domain – this differentiation of production in no way corresponds to a similar differentiation of consumption."[150]

In seeking to relate causally the changes occurring at the two poles of commodity production, Simmel analyzes the way in which the commodity was moving into a new realm, a representational space which isolated it from the social, technical and cultural facts of its production; he calls this the "shopwindow quality of things."[151] Naumann's analysis of the situation is not so insightful, but his characterization of it is certainly more striking:

> A building is missing from the exhibition, the "Hall of Labor". . . . Without such a hall, the exhibition is incomplete.
>
> In the exhibition, one does not think about the worker. He is the foundation, but remains hidden. Now and then a worker stands and demonstrates his machine for the audience, but on the whole the worker is conspicuously absent. It is truly scandalous that one is so unconcerned with the worker at a trade exhibition as in Berlin. Not a single business gives even the number of its workers, the hours and the average wage of its workforce. One has eyes for everything, but not for people. In this sense, the Berlin exhibition is as inhuman as capitalism itself.[152]

17. Ludwig Sütterlin, color lithograph poster for the Berliner Gewerbe-Ausstellung, 1896 (Deutsches Historisches Museum, Berlin)

Naumann registers alarm at the way the new realm of exchange had begun to monopolize the understanding of the commodity, or was at least developing forms of presentation that, like ideology in Marx's terms, obscured the base, the "foundation" of production (and this echo of Marxist terms of analysis is certainly not fortuitous). He had found that labor did not figure in the realms of exchange and consumption.

The reviews by Naumann and Simmel are criticism at a high level: though the strain and frustration of the endeavor are evident in the unexpected images of confusion, madness and violence, the two critics manage to articulate quite precisely the difficulty in describing the cultural appearance of the commodity in the sphere of exchange. Before the turn of the century, failure was more common. Let us look, for example, at the official poster for the exhibition Naumann and Simmel were reviewing, which bears eloquent witness to the awkwardness they identified in signifying this realm, to the inability to assimilate new economic forms to culture. For while Naumann complains that Labor was missing from the show, the signs of labor were, paradoxically, the only ones available to represent this prominent institution of the consumer market. The prize-winning design by Ludwig Sütterlin (who would later join the Werkbund) shows nothing of the "shopwindow" quality of the spectacle that greeted the viewer: neither the objects of the show nor the pavilions themselves (fig. 17). Instead, framed by allegorical symbols of science (an owl) and

18. Alfred Messel,
Warenhaus A. Wertheim,
Leipziger Strasse, Berlin,
interior, 1896/7 (Warenhaus
A. Wertheim, *Haupt-
Preisbuch 1903/4*)

industry (bees), the poster shows a bifurcated landscape with representations of the economic and political might of imperial Berlin: to the left, Paul Wallot's new Reichstag and the *Siegessäule* (victory column) commemorating the Prussian victories leading to national unification; to the right, smokestacks and industrial buildings. And in the main motif, Labor reappears in monumental form: in the foreground, the earth has been parted by the emergence of a hand grasping a crude hammer which towers over the surrounding landscape, the muscles of the forearm rippling in a harsh chiaroscuro.

The consumer market could not be represented in its own terms.[153] Instead, the signs of labor were regularly called upon to represent the sphere of exchange, precisely when the connections to the facts of work were becoming progressively more attenuated. The metonymy evident in Sütterlin's poster was the usual trope. Even when the market did achieve its own representation, signals remained mixed. Precisely contemporary with the Trade Exhibition on the banks of the Spree at Treptow, for example, Alfred Messel's Wertheim Department Store arose in the center of town. Messel's building was seen as both the architectural event of the decade and as a definitive solution to the problem of developing a representative architecture specifically for new retail institutions.[154] In the interior, however, the problems returned. Or so wrote Paul Göhre, clergyman turned politician and labor advocate, ten years after the completion of the original building: "Whoever enters Wertheim's for the first time is struck by the impression of overwhelming confusion. At almost any time of day, people in uninterrupted streams; immeasurable rows of sales counters; a sea of merchandise."[155] As Göhre describes the huge central hall of the building (fig. 18), we recognize what this confusion was all about:

The gaze of most [customers] remains fixed on this ground floor and the wares displayed there, handkerchiefs and gloves in every type and size. The wise architect has installed conspicuous decoration for them: two huge candelabra in the form of gilded laurel trees, whose branches glow with electric light bulbs; and between them, higher still, a giant female figure, leaning on monumental machine parts, a shopping basket [*Warenkorb*] in her arm, covered in bronze.[156]

19. Ludwig Manzel, *Die Arbeit*, 1896/7, in Warenhaus A. Wertheim, Leipziger Strasse, Berlin (*Deutsche Kunst und Dekoration* 2 [1898])

Already in 1907, this figure was seen as inappropriate, as a paradox: as he continues, Göhre can only discuss it in formal, not iconographical, terms. For while he has alluded to the identity of the sculpture, Göhre can not bring himself to name it: it is an allegorical figure of *Labor* by the sculptor Ludwig Manzel (fig. 19). When forced to find a monumental representation appropriate to the space of mass consumption, Messel could only try to turn his department store into the "Hall of Labor" that Naumann so sorely missed in the Berlin Trade Exhibition. All the sculptor could do to bring his subject up to date was to add, incongruously, a shopping basket.

There are good reasons to attend to Göhre's discomfort and to try to make sense of it. Göhre was, like Naumann, interested in the problem of the proletariat and, also like Naumann, an intimate of Max Weber and other members of the Verein für Sozialpolitik (Social Policy Association), one of the institutional homes of the sociologists. As such, he represented the interests of labor as they were seen from the discourse on Culture.[157] And though not a member of the Werkbund, he certainly moved in the same orbit of institutions and venues: his book (published in 1907) was designed by Peter Behrens, his publisher (Rütten & Loening) a corporate member of the Werkbund, and his editor (Martin Buber) anxious to enlist as many Werkbund members as possible in the rather exclusive publishing venture called *Die Gesellschaft*.[158] Even Göhre's career itself is emblematic of the instability of terms used to discuss the effects and cultural forms that arose in the wake of industrialization. He made his name as a workers' advocate in 1891 by going underground, working in a factory and publishing an inside account of proletarian life.[159] By 1907, Göhre had found what seemed to him the appropriate arena in which to consider worker interests: consumer cooperatives and department stores.

Before the turn of the century, the traces of production were fast disappearing from the actual (bourgeois) experience of the commodity, but the commodity did not yet have its own image. To represent the cultural fact of mass-produced merchandise the idea of labor was still necessary. This would change. But before it did, the commodity could still be represented in two ways. For the poster of the 1896 Trade Fair, the realm of the commodity was pulled back to that of labor. That this attempt failed is made clear by contemporary responses to the exhibition itself. Messel and Manzel's solution was similar, but showed that the trope had other, perhaps more wide-ranging possibilities, in which production could be reinterpreted in a way more understandable to the bourgeoisie: at Wertheim's, Labor, like the upper-middle class customers there,[160] had just gone shopping.

* * *

Naumann, Simmel, and Göhre were all familiar with Marx's published work; they were well aware that what they were writing about was the fetishism of commodities. But the goal of their writings here was not the economic truth that Marx had found and which these writers, to a significant extent, accept-

ed. For clearly, in a time whose politics were characterized by the presence of a powerful labor movement, there was relatively little chance of the fact of labor being simply forgotten across the board. The ideological moment of the fetishism of commodities was instead mediated by the constitution of the realm of Culture, and it was knowledge of this realm – which was in no way exhausted by Marx's analysis of the commodity – that the design reformers of the Werkbund sought. And in trying to analyze the relation of the commodity to the realm the bourgeoisie had cordoned off for the spirit, the same confusion arose which was evident in the attempts to describe and represent the new spaces the commodity was organizing. The issue was whether the commodity was to be understood – culturally – in terms of its production, or in terms of its acquisition (as well as consumption). In a strange and incomplete way, the Werkbund moved beyond Marx's analysis in its search to understand and influence the relation of mass production to culture, exploring the phenomonology of fetishism and finding there a new, alarming, and specifically bourgeois form of alienation

In the discourse on Culture, the alienation of the modern subject was seen as the result of commodity production, and the accounts of alienation began with the recent development of a strict division of labor. For Tönnies, the division (or "specialization") of labor was, along with the money economy, the economic precondition of modern *Gesellschaft* and its attendant fragmentation; for Max Weber, the "limitation to specialized work," the "renunciation of the Faustian universality of man" was the "iron cage of capitalism."[161]

In the Werkbund too we find discussions of alienation framed by descriptions of the fragmentation of the production process. When he addressed the Werkbund at its second annual meeting, Peter Bruckmann, a manufacturer of silver goods for the luxury trade and a founding member of the organization, discussed the problems of modern production in the following terms which were thoroughly typical for the period:

> We have a large number of so-called unskilled workers who can operate their machines or other equipment in a strict division of labor but who lack any understanding of the nature of the object for which they produce parts. They do not know how an object must look if it is to fulfill the demands of function and taste. Through the division of labor, the other processes which will be performed on the same object by other workers are unknown or, at least, of no concern to them. They perform mechanically what is assigned to them.[162]

Thus the worker is estranged from the totality of the production process and from the product of his labor. Fritz Schumacher spoke similarly at the founding of the Werkbund of the "estrangement [*Entfremdung*] of the executive [*ausführenden*] from the creative [*erfindenden*] spirit."[163]

Schumacher's formula was a nod to John Ruskin, who made the same distinction in *The Stones of Venice*.[164] And it is interesting to note how not only Schumacher but Muthesius, Henry van de Velde and others in the organization regularly invoke the leaders of the English Arts and Crafts movement, situating themselves as the legitimate heirs to this tradition. This lineage has become a standard narrative element of the historiography of modern design. But as has often been pointed out, the core of the Arts and Crafts position – the radical reform of machine production, if not its complete elimination – was rejected as outdated romanticism in the Werkbund, which was firmly, if critically, committed to modernity. "The separation between creator and

executor as we have it today did not earlier exist," Schumacher continues in his important address. "Nonetheless it has come to pass, inescapably. Although this was recognized quite clearly, no one has been able to prevent this development."[165] The division between the divided moments would thus remain; the road to a "harmonious culture" would involve the search for connections across, and not the elimination of, this distance: "The danger [of this estrangement] can not be concealed; never will we be able simply to banish it. As long as there is industry, one must try to overcome it by trying to bridge over the existing separation. . . . We must regain joy in work."[166]

The phrase "joy in work" was one slogan among many that circulated through the many articles, reports, pamphlets and lectures occasioned by the Werkbund. Yet despite certain halting attempts to bridge the gap between the act of design and those of craft production, estrangement at the point of production was absent, or quickly dropped, from the discussions. One searches in vain through the theoretical works of the Werkbund for a sustained analysis of the alienation of labor, of the way the objects of daily life once mediated an experience of cultural totality through the acts of their production, or even (something we might more realistically expect) how they had since ceased to do so. Instead, the relation between commodity production and cultural crisis was redefined in the Werkbund and explored along different and somewhat unexpected lines. We can follow this in the way Schumacher's early formula – "the estrangement of the executive from the creative spirit" – was altered and transformed as it was repeated.

Theodor Fischer began his keynote speech at the second annual Werkbund meeting, less than a year after Schumacher's programmatic address, as follows:

> What we call the "modern form of production" needs no lengthy explanation here. It is, so to speak, a cluster of threads so knotted together that neither the beginning nor the end of each individual thread can be identified. Machine work simplifies mass production; this latter, in turn, requires and brings about the former; both together bring about the division of labor, not only the division of labor within production itself, but rather, what interests us most, *the division of the work of the inventor [Erfinder], the producer [Erzeuger] and the salesman [Verkäufer].*[167]

The division of labor is the problem, says Fischer – but not the division of labor "within production." He closes his speech on this same seemingly odd note: "Mass production and the division of labor are not, it seems to me, harmful in themselves. . . . That division of labor which is evident in the separated effects of the *inventors, producers and salesmen*, however, lies most heavily on our hearts."[168] Here the division of labor is equated with estrangement, with the fragmentation of experience as a result of the modern mode of production, but labor itself is implicitly redefined in such a way as to make comparisons with the humanist critique of capitalism rather off-target, despite a similarity in vocabulary. For labor is not, as in the works of Ruskin, Morris, and the early Marx, considered a matter of human creative drives and potentials, but rather one of economic functions; instead of a picture of human wholeness, we are presented with a totality narrowly defined by the different moments of commodity production and exchange. Now Ruskin's views on the division of labor were, within the Werkbund, well known:

> We have much studied and much perfected, of late, the great civilised invention of the division of labour; only we give it a false name. It is not,

truly speaking, the labour that is divided, but the men: – divided into mere segments of men – broken into small fragments and crumbs of life; so that all the little piece of intelligence that is left in a man is not enough to make a pin, or a nail, but exhausts itself in making the point of a pin, or the head of a nail. . . . It is not that men are ill fed, but that they have no pleasure in the work by which they make their bread, and therefore look to wealth as the only means of pleasure. It is not that men are pained by the scorn of the upper classes, but they cannot endure their own; for they feel that the kind of labour to which they are condemned is verily a degrading one, and makes them less than men.[169]

Within the Werkbund, however, the division of labor was not only accepted as unavoidable; it was redefined, or at least traced by a very different route from production to Culture. Thus when Walter Gropius invokes an image of precapitalist labor in which the shattered pieces of humanity under capitalism are still whole, the pathos of the traditional descriptions of creative work from Rousseau through Schiller to the early Marx is strikingly absent as he echoes Fischer's account: "The old craftsman," he writes, "united all three aspects of labor in one person – *the technician, the salesman, and the artist.*"[170]

If labor was being redefined within the Werkbund, so too, then, was alienation. The way labor was discussed foreshadows this reworking of terms: beyond the distinction between creative work and merely repetitive activity, between Ruskin's medieval workmen and Adam Smith's pin-makers, the definition of labor in Germany is extended into the very realm that was as problematic as it was unavoidable at the time: to sales. In the Werkbund, the inclusion of the salesman in the definition of the division of labor is a clue to the contemporary understanding and exploration of commodity exchange as a locus of alienation.

With the development of mass production, the economic contact between the consumer and the "producer" – now a corporate identity composed of fragmented parts – is no longer between the user and the creator of an object, but between the user and the salesman, who may now have very little to do with the production process per se. In the Werkbund, this seemingly mundane reconfiguration of economic functions was discussed as a cultural fact of paramount importance, complete with the vocabulary of cultural despair. Thus Bruno Rauecker, a young economist in the Werkbund who specialized in social policy, wrote of "the enormous damage . . . created by the estrangement of the producer from the consumer in the wake of mass production which has found expression in the sharp decline of taste."[171] And in the words of Hermann Muthesius:

A danger of mass production consists in the new relationship which it introduces between producers and consumers. Whereas earlier craft manufacture was always carried out according to the specific, precisely formulated wishes of the customer, mass suppliers produce for a large, unknown public, whose desires the manufacturers can only guess at. With craft production . . . an exchange of views between buyer and manufacturer always took place. The manufacturer advised the customer about technical correctness. . . . But through mass production a complete estrangement [*Entfremdung*] between producer and consumer has developed. The two are no longer acquainted with one another.[172]

The crisis of artistic culture following in the wake of industrialization was

more often than not identified with this new distance which appeared between the consumer and the site of production. It is worth noting the remarkable fact that this is the chief context in which the word "alienation" or "estrangement" (*Entfremdung*) appears in the discussions of the Werkbund.

Thus alienation – no longer a stable or helpful concept in the rather thin discussion of labor in the Werkbund – disappeared from the assembly line only to reappear at the cash register. Or rather at the shopwindow, which was the site at which Werkbund members (like Simmel in 1896) commonly explored the commodity's assumption of visibility. "Das Schaufenster" (The Shopwindow) is also the title of an important article by Karl Ernst Osthaus in which the author traces the decline of form under capitalism to the alienation of consumption.

For Osthaus the shopwindow is a figure for the isolated position of the commodity between producer and consumer; as such, it is a product of the modern economic system and a symptom of the cultural decline it brought. Osthaus transposes the precapitalist utopia implicit in the discourse of Culture to an imaginary Orient, but it is a utopia that has little to do with that of the Arts and Crafts movement.

> The Orient knows no shopwindows. There the stalls of handcraftsmen and traders are lined up in roofed bazaars. . . . The whole store is, if you will, the shopwindow.
>
> But it is also the workshop. . . . The weaver, shoemaker, tinker, and innkeeper go about their work before everyone's eyes, and even the miller pours his corn into the trough which his harnessed donkey goes round and round. The fascination of the bazaar is the result of the interest we take in creation and production. By watching, we understand and learn, and herein lies the ultimate reason why the Orient, like earlier Antiquity, never lost Style in any of its crafts.[173]

Here the saleable objects of everyday life are seen as central to Culture, but their position there is nonetheless ambiguous: totality is equated with production, it would seem, but not in the same way as it was for Ruskin and Morris. More accurately, the *experience* of totality is equated with the *knowledge* of production, and the access to this totality is achieved through the act of, or within the spaces of, commodity exchange. Style is considered from the perspective of the act of buying, not making.

Under precapitalist conditions of production and exchange, in this account, the sphere of Culture overlapped with that of the market. Osthaus juxtaposes this situation to the alienated consumption of early twentieth-century Germany:

> The shopwindow of the North shows us the commodity, and not [its] production. What is missing is the fascination of becoming [*des Werdens*], which makes the Oriental bazaar so attractive. One thinks only of the function of the commodity, not of the work it involved. Becoming is completed in a closed workshop, and only the privileged have the opportunity to observe it. In this way the most important source of the interest in work is lost to most, the most indispensable foundation of the feeling for Style is taken away.[174]

Production as a site of fragmentation or alienation effectively disappears from Osthaus's account; it is mythicized, not analyzed. Abstracted from a social plane to a metaphysical one, production occurs in the realm of Idea: labor

turns into "becoming," and access to this realm is limited to (in a particularly unfortunate phrase) a "privileged" few. Alienation, on the other hand, is situated on the *far* side of the assembly line, outside the walls of the factory; it is now the lot of the consumer.[175]

This (presumed) loss of the social experience of totality due to the estrangement of consumers from producers in a modern, rationalized economy stood at the center of the Werkbund discussions of the nature of culture under capitalism and of their various analyses of the possibility of cultural interventions. It was also a commonplace of the sociology of the time. In his essay "The Metropolis and Mental Life," Simmel points out that "it is of importance that under primitive conditions production serves the customer who orders the good, so that the producer and the consumer are acquainted. The modern metropolis, however, is supplied almost entirely by production for the market, that is, for entirely unknown purchasers."[176] In his *Philosophy of Money* of 1900, Simmel takes up in greater detail the problem of consumption under the rubric of alienation, tracing the loss of Style from the changes within the factory walls in a way that lays bare certain key discursive strategies in the German discussions of Culture at the time, strategies we recognize as central in the debates of the Werkbund.

Simmel's discussion of the development of alienation out of the division of labor is couched in his personal version of the vocabulary of romantic anticapitalism: he sees the "tragedy of culture" as the irreconcilable confrontation of "subjective" and "objective" culture, of the individual on the one hand and the increasingly estranged products of culture – the material, technological and bureaucratic forms of modern life – on the other. He opens by identifying the two poles of modern experience between which the phenomenon of alienation was to be analyzed: "If we wish to confine the cause [of the divergence of subjective and objective culture] and its present magnitude in a single concept, then it is that of the *division of labour*, in terms of its importance within production as well as consumption."[177]

Simmel briefly develops the scenario of labor estrangement well known at the time. "The product," he writes, "is completed at the expense of the development of the producer" and is "of little value for the total personality." Without the experience of the entirety of a task, the self is no longer invested in labor: "Where the work is based on a marked division of labour and achieved with an awareness of this division it thrusts itself inherently towards the category of objectivity. It becomes more and more plausible for the worker to consider his work and its product as purely objective and anonymous, because it no longer touches the roots of his whole life-system."[178] The analysis, however, moves quickly away from the psychic state of the producing subject and, at first, to the thing itself, which now has a "decidedly autonomous character":[179]

> The internal nature of our achievement is bound up with parts of achievements accomplished by others which are a necessary part of the totality, but it does not refer back to the producer. . . . Because of its fragmentary character, the product lacks the spiritual determinacy that can be easily perceived in a product of labor that is wholly the work of a *single* person. The significance of the product is thus to be sought neither in the reflection of a subjectivity nor in the reflex of a creative spirit, but is to be found only in the objective achievement that leads away from the subject.[180]

The discussion is thus far in line with the Marxist-humanist critique, but

Simmel soon shifts his attention to the point of exchange and consumption, to the reaction of the consuming subject to the isolated (or "objective") products of commodity production. "The division of labour," he writes,

> . . . separates the working person from the work produced and endows the product with objective independence. Something similar happens in the relationship between production based on the division of labour and the consumer. . . . Custom work, which predominated among medieval crafts-men and which rapidly declined only during the last century, gave the con-sumer a personal relationship to the commodity. Since it was produced specifically for him, and represented, as it were, a mutual relationship between him and the producer, it belonged, in a similar way as it belonged to the producer, also to him. Just as the radical opposition between subject and object has been reconciled in theory by making the object part of the subject's perception, so the same opposition between subject and object does not evolve in practice as long as the object is produced by a *single* per-son for a *single* person.[181]

"It is obvious," he summarizes, "how much this objectifies the whole charac-ter of transactions and how subjectivity is destroyed and transposed into cool reserve and anonymous objectivity once so many intermediate stages are intro-duced between the producer and the customer that they lose sight of each other."[182] For Simmel, as for Osthaus, the market was no longer a transparent realm. And for Muthesius as well, who echoes Simmel, removing only the more obvious idealist vocabulary: the producer and the consumer "no longer know one another; between them stands a line of instances (merchant, agent, salesman) who render any rapprochement impossible, and who do not take the same interest in the commodity as the producer."[183]

In Simmel's account, the relation between estranged labor and estranged buying is not left intact in a symmetric relation: the move from the one to the other represents a shift of models for alienation in general, which is now con-sidered the confrontation with the alien objects of objective culture and not the loss of the subjective extension of the self onto the world of objects through labor specifically. In its reconsideration of alienation, the discussion of the division of labor in *Philosophy of Money* is a key moment in Simmel's attempt to assimilate the economic to the cultural in a quite specific way: as consumption (or, more accurately, buying) achieved analysis and representa-tion, it came to be the cultural face of the commodity. For Simmel, the analy-sis of exchange served to provide a new ground for a discussion of the relation between commodity production and modern experience. This was clearly a pressing issue in the discussions of Culture at the time. In the middle of the nineteenth century, the key context of the commodity had been the pole of production; the commodity then entered, as we have seen, an unstable discur-sive space in which it could only be described in terms of shifts and tropes. In the *Philosophy of Money*, Simmel reestablishes coordinates for a discussion of the commodity by making consumption the basic social fact of its existence.

This move allows the description of the changing way modern subjects experience the objects which surround them and leads to insights that, I think, fully justify the pathos with which Simmel surrounds the matter. But there was a theoretical price to pay. In describing the bourgeois relation to commodities, Simmel is forced to relativize the experience of those who do not approach products as consumers. He does so by denying the division of labor in indus-trial production its earlier privileged status as the originary site of analysis and

interpreting it as merely a single, if revealing, case of specialization in general.[184] Simmel is consequential to a fault: he pushes the strategies of cultural criticism nearly to their breaking point and in the process reveals weak and awkward joints in the construction of Culture. Here the logical conclusions of these discussions which were built and bent on the assertion of totality come off, to us, as a cheap and clumsy cynicism. For Simmel seeks to reinterpret Marx through the lens of Culture: he sees the relations of production themselves in capitalism as a kind of specialization: "The process that is characterized as the separation of the worker from the means of production . . . is itself also a kind of division of labour. . . . [I]t is the function of the capitalist to acquire, organize and allocate the means of production."[185] The owners of capital are themselves equally estranged parts of a rationalized system: work does not "belong to someone else" but rather "to an objective organization of labour."[186] Thus Simmel seeks to overturn

> the simple notion that generally prevails, derived from earlier forms of production, that the lower strata of society work for the upper strata. . . . This notion, however, is totally wrong nowadays since the needs of the subordinate masses are satisfied by large enterprises which have engaged countless scientific, technical and managerial energies of the upper strata in their service. . . . There are innumerable examples today of this feed-back of services, whereby the lower classes purchase the labour products of the higher classes; they affect our whole culture. . . . This inversion of the typical relationship between the upper and lower strata of society indicates most clearly that the division of labour causes the upper strata to work for the lower strata. . . . This inversion is nothing other than a final consequence of the relationship that exists between the division of labour and objectification of culture.[187]

The capitalist, we read, works for the proletarian every bit as much as the proletarian works for the capitalist.

We would be mistaken to read Simmel's discussion of the nature of the division of labor simply as a sophistic rationalization of the social status quo of 1900. It is instead what was called "cultural philosophy," and we must – at first – take this classification seriously. That what we might read as social obfuscation was seen as a set of valid statements within the context for which they were intended is revealing not in the first place at the level of ideology or political position but at the level of discourse. For all the bourgeois discussions of Culture we have looked at here have the same characteristic feature. It can be described as the self-conscious attempt to cast a conceptual net wider than that of Marx's critique, to create a kind of knowledge more fundamental than that which would be revealed by the analysis of the relations of production. This analysis, which Simmel confronts here directly, seemed first of all reductive, scientistic, in short a symptom of the kind of thinking that (they thought) had brought on the crisis of modernity. Second, it could not adequately account for their experiences, or it could do so only negatively, by attention to those aspects of social life which they did not directly engage in (and which like Osthaus they occasionally chose to idealize). And third, it would bring the facts of class rule and the possibility of its violent end within the purview of knowledge. The alternative social field that the bourgeois thinkers on Culture constructed in order to analyze was one in which relations were mediated by spirit, not power – even if this new object was to be investigated by the most exacting and meticulous materialist means. As an object of knowledge, it must

be said that Culture could sustain a rich discourse indeed, containing as we have seen an entire theory of history and the hope of a life free from alienation. But in order to be submitted to this kind of knowledge, alienation itself had to be considered in a way that could be called transcendent. It was the fact of labor that had to be transcended, a strategy of the relativization (and neutralization) of non-bourgeois experience in the search for a larger totality that was key to the construction of Culture and to the kind of knowledge it would produce.

The result is that the cultural subject in the discourse on Culture could only confront commodities as a consumer: socially, as Simmel writes, because "a broadening of consumption corresponds to the specialization of production";[188] and discursively, because labor as a central experience had been factored out of the analysis in order to establish Culture as a transcendent realm and to submit it to analysis. Since the writings of the Werkbund circle took place within this same discursive space, it is not surprising that we find there these very same moves. Having been thematized by Ruskin and Morris, the problems of the industrial worker could not be ignored, but they could be redefined according to the same principles of analysis revealed by Simmel's account of alienation and the division of labor.

Let us look, for example, at Walter Gropius's now notorious comments on the "social question" in his various discussions of industrial architecture. In an address held at Osthaus's Folkwang Museum, Gropius hovers unstably between a consideration of the estrangement of labor and the realm of "Idea." The result is a nearly incoherent admixture of the themes of the day, a frantic attempt to wrest labor into a transcendent sphere of Culture. In Gropius's manuscript, the following statements are all contained within the same paragraph:

> In contemporary life, a higher idea of modern labor . . . is everywhere evident. In place of individual craft work, industrial organization, centralization and the division of labor has arrived. . . . Problems of an economic and ethical nature are demanding resolution. The social question has become the true ethical center of our day, the great problem of all to which art too must turn. . . . The art of previous centuries was likely so stagnant because it lacked a moral center, the cultural ideal of general significance that creates the necessary inspiration for art. Today there are signs that the great technical and scientific epoch will be followed by an age of inwardness, Civilization by Culture. . . . The ideas of the age are striving for architectural expression; the monumental necessity of work needs a form which can with earnest pathos characterize the inner dignity of the method of labor. Palaces must be erected to Labor which give the factory worker, the slave of modern industry, not only light, air and cleanliness, but which also let him sense something of the dignity of the great common idea which is carried by the totality. Only then can the individual, the personal, subordinate itself to the impersonal idea without sacrificing the joy in the common creation of great, collective values which were previously unachievable to the power of the individual. This consciousness, awakened in the individual worker, could perhaps avert a social catastrophe, which with the ferment of today's economic life threatens us every day. Far-sighted organizers have long recognized that with the satisfaction of the individual worker, the morale and therefore the efficiency of a business grows. The subtle factory owner will exploit all means to enliven the deadening monotony of factory work and to alleviate the burden of labor. In other words, he will not only

provide for light, air and cleanliness but will take into account the innate sense of beauty, which even the uneducated worker possesses, in the creation of his industrial buildings and rooms.[189]

This is not what we can call eloquent testimony. Yet Gropius's text nonetheless convincingly indicates the complex negotiation of terms that had to take place in any Werkbund discussion of labor and alienation. And this passage is certainly impressive in its ambition. Like Simmel's account of the division of labor, all the concepts involved are put here into play: Culture, labor, spirit, totality. Gropius does not try to hide the moves from one to the other, as if to soothe a bad conscience; he seeks instead to articulate them (though he is not very successful). This is the discursive matrix in which commodity production could be talked about in the same speech in which Gropius invokes both Riegl and Worringer. Totality, Gropius is clearly saying, can no longer be regained through the relation to labor, but only through a larger transcendent field of Culture that subsumes production.

In the version of this address that made it to print two years later in the Werkbund *Jahrbuch*, Gropius drastically curtails his discussion of industrial labor and eliminates all mention of a human relation to work itself:

> From the social standpoint, it is not inconsequential whether the modern factory laborer carries out his work in bleak, ugly industrial barracks or in well-proportioned spaces. Where his workshop is perfected by the artist so that it corresponds to the innate feeling of beauty everyone has and where it enlivens the monotony of mechanical work, he will work more joyously on the cooperative creation of common values. Thus with increasing satisfaction the work spirit [*Arbeitsgeist*] and efficiency of the business will increase.[190]

In this revised version, we miss Gropius's struggle with the problem of the relation of industrial labor to Culture; nor is his equation of business efficiency and transcendent will given enough flesh to be as convincing as it earlier was. But the position of the worker in Culture is clarified considerably. The worker is asked to achieve joy in work not by any change in the material relation to the totality of production, but instead by being presented with a building as a piece of Culture, a symbol of transcendence – an object that is supposed to represent totality rather than concretely mediate it. This is a relation to objects that has nothing to do with their production. It is an alienated confrontation with things that must be accepted ready-made, providing aesthetic pleasure instead of offering tangible access to totality via the phenomenology of craft production (and certainly not social access via ownership of the means of production). In this sense it is the consumer's relation to the object, even if the worker does not own it. In Gropius's vision of cultural labor, the worker is turned into a consumer of his own site of production.

In his discussion of the cultural potential of factory architecture, Gropius was referring not only to the factories he designed himself (figs. 3, 20). He most often cited those which his teacher, Peter Behrens, built for the AEG (*Allgemeine Elektricitäts-Gesellschaft*) (figs. 21, 22), the German General Electric Company which had in 1907 engaged the famous architect as "artistic adviser" with responsibility for the appearance of everything from the firm's factories to its promotional material. Behrens's buildings for the concern were regularly talked about in terms of the shift from labor to Culture. Thus Karl Scheffler wrote that

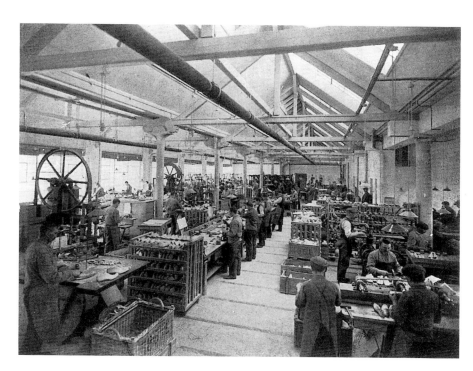

20. Walter Gropius and
Adolf Meyer, Fagus-Werk,
Alfeld an der Leine, main
factory room in 1912 (*Der
Industriebau* 4 [1913])

21. Peter Behrens (with Karl
Bernhard), AEG Turbine
Factory, Huttenstrasse,
Berlin, 1909 (Bildarchiv Foto
Marburg)

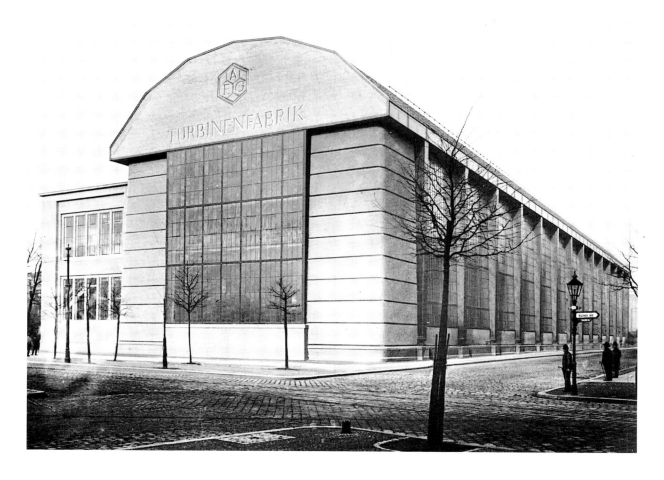

22. Peter Behrens (with Karl Bernhard), AEG Turbine Factory, interior (courtesy Siemens A.G.; reproduced by permission)

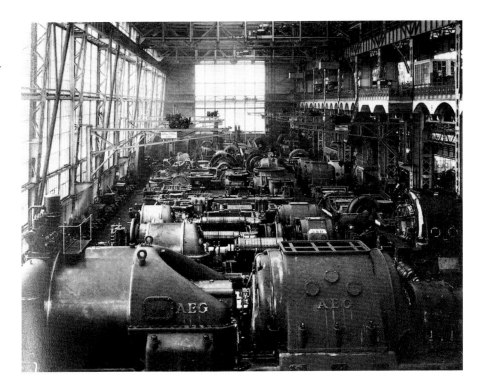

In the bright, high-ceilinged rooms of the new factories, the workers of the AEG must have a completely different feeling for their work and their dignity as do those many industrial workers who spend their working life in horrid barracks and cheap makeshift structures. . . . A great mind [*Sinn*] was necessary, not only to give these buildings the architectural form that they have, but also simply to accept them as a patron. It took a higher concept of labor; the leaders of the AEG must have a monumental sense of industry, they must feel themselves culturally responsible and yield to a certain feeling of sovereignty.[191]

On the occasion of the fourth annual meeting of the Werkbund, this time in Berlin, members were treated to a tour of the Behrens factories. Adolf Vetter took the opportunity to invoke the authority of Ruskin, but in a context that would have been utterly foreign and certainly repellent to the English reformers:

I would like to remind you of an idea of Ruskin's, who distinguished between two kinds of toil: on the one side joyously performed, both requiring and developing skill, which he called "work"; and on the other, oppressive, neither requiring nor developing skill, which he called "labor." In Ruskin's eyes the social cause had no other goal than increasing the sum total of "work" and decreasing that of "labor." "Work" is naturally nothing other than *Qualitätsarbeit* [quality work].
 What you have seen today in the trip to the AEG represents Ruskin's words come true and shows you how much the ideas of the Werkbund help us better understand the great economic processes [of the age].[192]

We can assume, I think, that the visitors to the factories attended to matters of architecture and not to the technology of heavy industry. Vetter is describing "joy in work" not in terms of the worker's relation to the objects of produc-

tion but as the alienated, aesthetic relation to an architectural object which the worker does not himself make – a relation I have described as the consumer's relation. As Vetter continues, the logic of this line of thought becomes explicit:

> I would like to touch on another important social aspect of *Qualitätsarbeit*: its significance in consumption [*Gebrauch oder Genuss*]. Do you not believe that the proletarian's disgust with the state originates to a large extent with the fact that nearly all necessary or pleasurable things that he consumes are junk, are lies inflicted on him? And do you not believe that the loyalty of citizens to the state . . . is supported and nourished by the self-evidence with which his expectations are met in the consumption of things [*beim Gebrauch der Dinge*]?[193]

Let me offer one final example in which the construction of the cultural subject involved in Werkbund theory is made explicit through a discussion of labor. Bruno Rauecker, the applied arts economist, writes: "If we consider the goal and meaning of all social policy to be the liberation of the *human being* in the worker, and not the mere *objective* functions of his work life, then we could characterize the part the Werkbund and its aspirations of *Qualitäts-arbeit* can play in this task in a double sense: with regard to 1) the producing [*schaffende*] and 2) the consuming [*verbrauchende*] worker."[194] Here Rauecker clarifies the bifurcation of the subject into the two separate functions – one economic, the other cultural; one producing, the other buying – that Simmel described. Rauecker does see a certain tendency to alleviate the division of labor in the production of high-quality craft goods, but his discussion of the "creative" or "producing" worker addresses primarily working conditions. Under the category of the "consuming worker," he returns to the recognizable terms we have explored: "In capitalist mass production, the worker who produces tasteful things . . . can also consume them."[195] Echoing Vetter, he concludes: "Through this opportunity of consuming objects of impeccable taste, the antipathy toward the shaken capitalist system on the side of the worker will necessarily be reduced."[196]

The dream of the clean, well-lighted factory and of the shopping worker were mainstays of the Werkbund's social position; they amount to mundane versions of Friedrich Naumann's more nuanced socialized (and imperialist) liberalism.[197] These dreams represent ways in which politics were negotiated through the concept of Culture. What I have tried to establish is that the consideration of labor we have been dealing with here represents one fundamentally different from that of Marx, Ruskin and Morris. In the Werkbund, work was not Culture. As questions of production (including class relations) were displaced into a newly defined problem of alienation, labor was refigured in Culture as consumption, the subject as consumer.

<p style="text-align:center">* * *</p>

At the turn of the century, it seemed that the domestic object had forfeited the privileged role it held in pre-modern life as the site at which one could discern the spiritual essence of the age "with almost mathematical clarity," as Riegl wrote in 1901 of the late Roman crafts; it had lost, in Simmel's words of 1900, its "spiritual determinacy." The domestic object in its form as mass-produced commodity represented this fallen state, at once symptom and victim of the fragmentary character of modern life. This was not the solitary plaint of isolated aesthetes but a central point of concern at a time when the changes of modernity were discussed in terms of Culture by a class which approached commodities as consumers.

The theoretical monument to this state of affairs is the section on the division of labor in Simmel's *Philosophy of Money* which we have examined here, in which the everyday object emerges as the center around which the discussion of alienation turns. Starting with the well-known account of the estrangement of labor, Simmel moves quickly to the estrangement of consumption as the more revealing cultural fact of commodity production; and in passages we have not looked at he concludes with a brief taxonomy of the fallen object. After a consideration of the vending machine and the five-and-dime store, he frames his discussion in terms more familiar to readers of Werkbund publications. The section on alienation is where Simmel chooses to situate some remarks on Fashion, which he presents as the model of the alienated commodity. The conclusion of the sub-chapter on alienation is Simmel's remarkable discussion of Style which I quoted earlier but balked at interpreting, where he equated the decline of Style into styles with the separation of subject and object. These were the philosophical stakes which are the background to the astonishing authority wielded by, or claimed by, the Werkbund in its quest to change the physiognomy of everyday life.

As Simmel moved from labor to consumption to Fashion, it was almost, one could say, these things themselves which had become alienated. So, in any case, wrote Friedrich Naumann: "Either a household object has a soul, or it does not. If it is without a soul it is dead forever, neither loved nor mourned. . . . Only one thing is missing [today]: spirit in household furnishings [*Hausgestühl*]."[198]

Worker to buyer, subject to (household) object: these shifts must be borne in mind when considering the Werkbund project, the characterizations of which were always framed around concepts that were clearly intended to encourage the kind of troping we have examined. The first Werkbund motto, for example, was "*Die Veredelung der Arbeit,*" or, complete and in translation, "the ennoblement of industrial work through the collaboration of art, industry and handicrafts."[199] But this motto was soon dropped in most of the Werkbund's publicity material, and we might make some reasonable conjectures as to why. First, the problem of handicrafts could not be addressed as either an economic or cultural issue within the Werkbund. Second, the term *Veredelung*, fine as it may have sounded, fails to link the realms of labor and Culture because it had too established a meaning in an ordinary trade context: that of economic value added, the further processing of raw materials.

The Werkbund then settled on the phrase "*Die Durchgeistigung der deutschen Arbeit.*"[200] The word *Durchgeistigung* is straightforward enough: we can translate it as "spiritualization." But the word *Arbeit* could mean two very different things: either "labor" or the *product of labor.*[201] By virtue of this shift, the little phrase came to imply far more than its five words would indicate: it says that spirit could be accessed either by making or by buying. In the context of the discourse on Culture, it was clearly the latter that was meant, even as an echo of the former remained as an alibi in the Werkbund's extraordinary project of spiritualizing the German commodity.

5. THE DIALECTIC OF THE COMMODITY

> Style is connection.
>
> Julius Meier-Graefe[202]

> In our age, everything seems pregnant with its opposite.
>
> Karl Marx[203]

In the decades before the First World War, cultural criticism and the *Geistes-wissenschaften* developed concepts (Civilization, Culture, alienation) by which certain – and, it was posited, fundamental – aspects of modernity could be analyzed. In and around the Werkbund, these terms were adapted to allow the consideration of the appearance of everyday life (Style, Fashion). At issue were the negative effects of capitalist mass production on the life of the spirit. Within this discourse, the meaning and importance of these terms were never seriously questioned, nor was the existence of the phenomena they simultaneously constructed and described. The terms created both a common plane of reality to which writers on Culture could refer as well as a field on which differing possibilities and scenarios for the future could be mapped out.

There were, in fact, different scenarios; it would be a mistake to be misled by the fatalistic resignation that seems to set the tone for the historical analysis of the fall from Style to Fashion that we have examined. For in the writings on Culture, the relation between past and present was highly complex and did not end with the mere construction of an idealized past as a critique of a problematic present. The projects of bourgeois reform presupposed the search for ways to theorize forms of intervention while remaining within the parameters of both capitalist society and the romantic anticapitalist consideration of culture. The discussions of Culture, in other words, revolved around a single, fundamental question, one which could be stated quite simply, and was so by Heinrich Waentig: "Is Culture possible," he asked, "on the basis of a capitalist economy?"[204]

There were negative answers to this question, even from within the Werkbund. In 1909 the economist and Werkbund member Helmuth Wolff told members of the Kunstgewerbeverein in Halle that the everyday production of necessary goods could be an organic expression of the spiritual life of a people only when "labor was not a *source of economic gain*, when no *contractual wage* was earned and had to be earned to survive yet another day, but rather . . . when saleable commodities did not have to be produced, because there was *no market*."[205] The negative answer to the central question of the applied arts movement is developed more fully by Werner Sombart in *Kunstgewerbe und Kultur*, where he describes in great detail the scenario that has been outlined in this chapter – that of the decline of form from Style to Fashion under the pressures of the capitalist's quest for profits, the public's manipulation of form as signs of class, and the methods of mass production. His conclusions are bleak: he sees in capitalism "the most bitter enemy of the applied arts"[206] and considers attempts at artistic reform of the everyday article to be in outright contradiction to prevailing economic logic:

> One must always bear in mind that the interests of the artist and those of the entrepreneur are in no way the same, that they are more often than not diametrically opposed. . . . Now should it happen that the commodity that the artist has designed according to his intentions is the one which produces

the greatest profit, then joy and harmony reign. But that is mere coincidence. Instead, a tendency toward disharmony of interests will turn out to be the rule: the "marketable" commodity will not be the one beloved of the artist.[207]

If earlier, as he writes, "the unified spirit of the *Gemeinschaft* produce[d] the unity of Style in creative production,"[208] he can only see capitalism, as he experienced it, to be completely incompatible with Style.

Sombart's critique was neither surprising nor original for the period. What distinguishes it from other writings in and around the Werkbund was not his account of modern decay but rather his unwillingness to find the seeds of some utopia, the clues to redemption that balanced nearly all accounts of the fate of modernity.[209] His concluding section on the future of the applied arts is perfunctory; offering only a few remedial measures in a spirit of resignation, he stops half-way.

So it is not surprising that the book did not get great reviews in the applied arts press (nor is it surprising that Sombart left the Werkbund in 1911, and that Helmuth Wolff, who stayed on, changed his tone considerably). Here is the response of Robert Breuer, a social democrat and extraordinarily prolific cultural journalist, writing in *Deutsche Kunst und Dekoration*:

> How can the curse of capitalism be banished from art? By the elevation of the general level of Culture. When we no longer just speak and write about the applied arts, . . . when out of the rush of forms a Style crystallizes, then the artist will prevail; "like a circus tamer, he will hold the two dangerous beasts, entrepreneur and public, under control." The formation, the development of the new Style is what is most important: that is what Sombart has overlooked.[210]

Breuer states the issue in all the clarity with which it was experienced at the time, but which can only mystify us; he invokes "Style" as an answer as if it were somehow self-evident. So it must have been. The concept of Style, we have seen, represents the hypostatization of a heuristic tool of historical inquiry so that the concept became, in the eyes of its users, an essential fact; and as the hermeneutic central to the discourse on Culture hovered unstably (and unlike Heidegger's, for the most part uncritically) between epistemology and ontology, the historical category of Style was given the chance of having a present tense. But what remains to be explored is precisely how Style was understood in the Werkbund as a tangible *modern* phenomenon, how, using the terms of analysis which had revealed the manipulation of form as commodity by capitalists and alienated consumers, the utopia of Style could still be imagined.

In trying to establish what could have been understood under the seemingly paradoxical notion of a Style of the commodity, I propose to examine another text by Georg Simmel, an article known and discussed in the Werkbund in which the sociologist seeks to establish how Style could be achieved – what, in fact, it would *be* – in a world whose surfaces were determined by visual form produced and circulated largely in the form of commodities. The article was published in *Dekorative Kunst* and was titled simply and emblematically "Das Problem des Stiles" (The Problem of Style).[211] This essay can be considered a sort of pendant to Sombart's little book on the applied arts; between these two texts, we have not only nuanced statements of the two answers to the question of the possibility of Culture but also, I would argue, the responses of two

important sociologists to the founding of the Werkbund. Like Sombart's
Kunstgewerbe und Kultur, which appeared when its author was a member of
the Werkbund,[212] Simmel's essay was published in 1908; it was also the only
article he chose to publish in a journal of the *Kunstgewerbebewegung* (and he
could choose). *Dekorative Kunst* was, along with *Deutsche Kunst und
Dekoration*, the semi-official organ of the *Kunstgewerbebewegung*, the
mouthpiece of the Werkbund; it was here, for example, that Muthesius's lec-
ture "Die Bedeutung des Kunstgewerbes" (The Importance of the Applied
Arts), which led to the formation of the group, was published. And the
chronology is quite close: "Das Problem des Stiles" was first given as a lecture
to the Berlin Verein für Kunst on 29 October 1907, just three weeks after the
highly publicized founding of the Werkund.[213]

More to the point, however, than such circumstantial evidence is the seam-
less way this essay fits into the Werkbund discussions on the cultural role of
mass-produced consumer goods. As in the Werkbund, Style is the term under
which Simmel writes about the everyday environment; it is a concept which
allows him to discuss the alienation of the individual from the social totality
and the relation of this problem to visual form. Rehearsing the scenario of
decline central to Werkbund theory, he contrasts the "exaggerated subjectivity
of our time" with the pre-lapsarian state of Style:

> Earlier eras, which posessed only a single and therefore self-evident Style,
> were in a completely different position with regard to these difficult ques-
> tions of life. When only one Style is in question, each individual expression
> grows organically out of it; it need not first seek its roots; the universal and
> the individual come together in this achievement without conflict. What we
> envy in the uniformity . . . of ancient Greece and many epochs of the
> Middle Ages is a function of the self-evidence of the general foundation of
> life, i.e. of Style, which created a relation to individual production that was
> much simpler and less contradictory than our own.[214]

"Exaggerated subjectivity" is Simmel's formula for the state of alienation, the
opposite of the harmonious relation of the individual to totality whose visual
expression is Style.

Simmel proceeds to refine his terms, moving toward a description of the
visual characteristics of Style:

> Style is always that creation of form which . . . negates its individual signifi-
> cance. By virtue of Style, the particularity of the individual work is subject-
> ed to a general formal law which also applies to others; it is, so to speak,
> relieved of its absolute self-responsibility because it shares with others the
> kind or a part of its form [*Gestaltung*] and therefore refers to a common
> root that lies beyond the individual work.[215]

In philosophical idiom, Style is the conformity of form to "law," its obedience
to a principle beyond the individual work; it is the common or the universal.
Simmel opposes this to the individuality and self-referentiality of "art," which
he defines as "works which grow completely out of themselves, out of the
enigmatic, absolute unity of the artistic personality and its self-sufficient
uniqueness."[216]

Here too Simmel is rehearsing commonplaces of the *Kunstgewerbe-
bewegung*. The first is the anti-"art" rhetoric: speaking at the Werkbund's
third annual meeting, for instance, Osthaus reminded his audience that "Style
and art are two different things, and that the presence of a style by no means

indicates the presence of art, that within a particular style works of art can be created but also buildings which have absolutely nothing to do with art, and [conversely] that the production of a work of art is far from synonymous with having a Style."[217] J.A. Lux wrote similarly (though he chose to call the healthy, everyday state of form "Taste") in a way that reveals, behind this distinction, the ever-present theme of contamination by capital: "The artist does not ally himself with industry in order to bring forth art, but rather to spread the culture of good taste. I repeat: Art has nothing to do with industry."[218] This aversion to the easily debased concept of art has as its most immediate background the highly publicized attempt of Jugendstil artists to unite the formal and economic potential of industrial production with the claims of the traditional notion of art, the program which had so quickly degenerated into a mass-market fad. Simmel's distinction thus grows out of the anti-Jugendstil polemic of the time after 1903, the date of the turn of the movement's critical fortunes;[219] addressing the issue of Jugendstil directly (though, characteristically, not by name) he contrasts Style with "those artistically formed objects of everyday use which, through their design, reject the importance of Style and strive toward the semblance of individual works of art or even in fact succeed. And I would like to register the sharpest protest against this artistic tendency."[220]

Simmel is circumspect in the way he introduces the issue of industrial production and its relation to Style, ultimately the most important issue in the applied arts at the time. Under Style Simmel understands the abstraction of form. His example is the modernist rose:

> As opposed to the individual reality of the specific rose, a stylized rose should present what is common to all roses, the rose-type. Different artists will seek to achieve this by very different means. . . . With an Indian artist, a Gothic or a neoclassical artist, such stylization will lead to quite heterogeneous appearances. The *essence* of each, however, is to make tangible not the individual rose but the formative law of the rose, the unifying, common root of its form that is in effect despite all the variability.[221]

The rigor of Style is its paring away of the particular, and the result is a form of reference beyond the individual to qualities shared by all examples of a species of object. Simmel, however, does not follow a line of thought which sees the *technical* criteria of machine production dictating such simplified forms (and the discussions of Fashion showed that they do not). Instead of relating stylized form and mass production by technological determinism, Simmel invokes an analogy: both, by denying uniqueness, imply a principle beyond themselves, a "supra-individual formal law."[222] If Style points to forms shared by many objects and thus to an "essence" beyond the particular, so too does mass production in its reference, beyond the particular object, to a shared *model*:

> The principle difference between the applied arts [*Kunstgewerbe*] and art [is that] the essence of the applied art object is that it exists in multiples; its distribution is the quantitative expression of its functionality, for it always serves a need that many people have. The essence of the work of art, on the other hand, is uniqueness: a work of art and its copy are something completely different from the model and its serial production – a fabric or decorative object manufactured according to a pattern. That countless fabrics and ornaments, chairs and bookbindings, candlesticks and drinking glasses

are produced identically according to a model – this is the symbol that these things have their law outside of themselves, that each one is only the random example of a universal; in short, that the meaning of its form is Style, not individuality.[223]

"Because its essence is Style," he writes of the design object, ". . . to be reproduced is its meaning."[224] This is the aesthetics of German Idealism brought into the age of mechanical reproduction. In this philosophical tradition, form was seen as a pure and unmediated manifestation of the workings of the mind; thus shared form could be construed as the sign of a transcendent spirit. The same referential potential of Idealist aesthetics is here asserted as the core of industrial aesthetics: the model becomes the "universal" by virtue of its repeated and identical evocation in the hands or homes of countless users. In the absence of the unmediated relation of spirit to Style which characterized premodern ages (or was assumed to do so), Simmel sees the possibility of the generation of Style by the serial reproduction of identical forms.

By finding the principle of Style in the logic of industrial production, Simmel completely and surprisingly reverses the terms with which capitalism was usually considered in the discourse of Culture, even as theoretical alternatives were sought. Recall that one of the characteristics of Fashion, of form as commodity, was its unification of demand, its paradoxical ability to exploit simultaneously production volume and consumers' quest for distinction by channeling desire for identical form through a demographically differentiated market (albeit at a regular, predictable rhythm). Waentig begins a characterization of the "character of the commodity, the tendency of market production" using quasi-Idealist terms faintly reminiscent of Simmel: "Oriented toward supplying mass demand, it avoids all individualizing form. It forces the development of typical usable forms which, to a certain extent, strive toward the expression of the concept of an object, toward its 'idea.'"[225] But Waentig's description was heading in a very different direction. He continues: "For obvious reasons. For the more typical, objective, neutral a thing is, the more consistently it is adapted to the needs and taste of the 'average man,' then the more it can expand its potential market share and enlarge, for the producer, the field from which he can reap, regardless of whether he has a monopoly or must share the market with others."[226] This was a standard analysis of the particular demands capitalist production placed on the appearance of the commodity, and a far cry in tone from Simmel's discussion of Style. Waentig and Simmel, however, are discussing the very same phenomenon: the activity of consumer goods with abstracted, generalizing or reduced ornament on the market. We find Simmel describing as Style what others speak of in terms of market share, and their vocabulary and concepts are by and large the same.

Simmel goes on to conflate completely the prevailing negative analysis of disenchanted commodity production with the retrospective element of the discussions of Culture, the economic logic of the one with the pathos and clichés of the other. In light of the fragmentation of existence and the "deep-seated need to give the acutely individual life a supplement of calm breadth, of typical conformity to law,"[227] Simmel sees the mass-produced everyday object as performing a utopian function:

> The constraints of the applied arts in no way imply a disparagement of them. Instead of the character of individuality, they should have the character of Style, of broad universality . . . ; thus a different vital principle from that of true art, but one in no way inferior, enters the aesthetic sphere. . . .

> From the fact that Style speaks in the viewer to levels beyond the purely individual – to the categories of feeling that are subject to the broad, universal laws of life – stems the feeling of calm, security and undisturbedness that the rigorously stylized object accords us. In the face of stylized form, life ascends from the agitated points of *individuality* (to which the work of art so often appeals) to more peaceful realms in which one no longer feels alone, and where . . . the transcendent lawfulness of objective creation finds in us its counterpart in the feeling that we respond with the supra-individual, transcendent in ourselves and thus redeem ourselves from self-responsibility, . . . from the narrowness of mere individuality.[228]

Considered as either philosophy or prose, this intense and intricate passage is a tour de force. Contradictory images are counterposed – constraint and release, individuality and transcendence – and all are put into motion by the image of ascent. Simmel was aware, it seems, that he was describing a dialectic, one which we can identify as the sublation of the antithesis between the commodity and Style.

Simmel's argument is complex and original, but only because it spells out the logic behind the Werkbund's program of the "reconquest of harmonious Culture" through the "spiritualization of German production," a belief implicit in all of the organization's projects and one which we could call, following Simmel's lead, the dialectic of the commodity. It can be described, tentatively, somewhat as follows. The first moment is negative, and it is this moment which the romantic anticapitalist critique defines most clearly and which writers such as Sombart maintain: the mass production of commodities causes the decline of Culture, the lapse of Style into Fashion and the alienation of the subject; capitalism and Culture are incompatible. The second moment is positive and reverses the first: capitalism can work out its own internal contradictions, for in the commodity itself and the logic of its production can be found both the problem of the decline of Culture *and its potential solution.* The basic principles of both the industrial production and the mass distribution of consumer goods provide the potential for recreating – *aesthetically* – the lost totality of precapitalist societies through the new possibility of creating a transcendent formal law, one produced by the diffusion of shared, identical form. Commodities (carrying Style) would redeem (through visual form) the fragmentation of modern existence.

"In the end," writes Simmel, "Style is the aesthetic attempt to solve the great problem of life: how a single work or action, which is in itself a closed totality, can at the same time belong to a higher totality, an all-encompassing, unified context [*Zusammenhang*]."[229] We can take this as a description of the Werkbund's project, which is no doubt exactly what it was meant to be.

* * *

A few matters are worth noting with regard to this essay. The first is the pathos of Simmel's text, which is only explicable in the context of pre-war Expressionism. Simmel signals his reception of this contemporary current by his use of the concept of *Erlösung* – "redemption" or "salvation" – to describe the goal of Style. The redemption of man from the fragmentation of modern being was an important theme in Schopenhauer, Wagner and especially Nietzsche, and had come to be a catchword to the pre-war Expressionist generation.[230] The equation of Style and redemption is a predictable one in the context of the time, and as such needs no specific source. Nonetheless, it seems

KEILSCHNITT-BRONZEN
Nr. 1–6 Museum Spalato

to have had one: Wilhelm Worringer's *Abstraktion und Einfühlung*, published the same year as "Das Problem des Stiles" but, it turns out, read by Simmel as a dissertation the year before.[231] Worringer writes of abstract form serving the same function for "primitive" man that Style does, in Simmel's account, for modern man: "primitive" artistic tendency, writes Worringer, "strives toward pure abstraction as the only possibility of relief within the confusion and obscurity of their life-view and creates out of itself, with instinctive necessity, geometric abstraction. Abstraction is the complete and the only humanly possible expression of emancipation from the contingency and temporality of this view of the world."[232] And "abstraction," Worringer tells us, is his term for Style.[233] The terminological and thematic similarities are striking, as when Worringer invokes not only rigorous simplification under his concept of abstraction/Style, but also conformity to law: "In the contemplation of abstract conformity to law, man is redeemed [*erlöst*] from the tension" of the differentiated, individual forms of organic nature.[234]

Worringer writes of primitive man's need for *Selbstentäusserung* or "self-negation";[235] Simmel of the need for "unburdening of the personal" that "drives *modern* man so strongly to Style."[236] For Worringer, the psychological condition man sought to transcend via abstract form was the state of fear before an incomprehensible world; for Simmel, however, it is the alienation of modern urban life under the money economy and the division of labor. Simmel has clearly adopted Worringer's notion of the use of inorganic, impersonal ornament as transcendent form, substituting the transcendence of an alienating socio-economic system for the transcendence of an alienating nature; his equation of Style and salvation represents the transposition of the energies of negation and transcendence Worringer describes as "primitive" to the realm of the capitalist mass market.

The notion of the use of abstract, inorganic form as a visual response to the problem of alienation was current: this is precisely how Riegl discusses the emergence of art in early antiquity in his *Spätrömische Kunstindustrie*, which was the acknowledged source for Worringer's discussion of abstraction.[237] And not only Simmel (via Worringer) made the jump from premodern abstraction to mass production, and thus from "primitive" alienation to its modern version: so too, in his work, did Peter Behrens, the Werkbund artist

23. Peter Behrens, endpaper for Georg Simmel, *Die Religion*, in the monograph series *Die Gesellschaft*, 1906

24. Late Roman chipcarving illustrated in Riegl, *Spätrömische Kunstindustrie*

25. Late Roman gold brooch with garnet inlay illustrated in Riegl, *Spätrömische Kunstindustrie*

26. Peter Behrens, electric fire for the AEG, hammered sheet metal, 1907/8 (courtesy Torsten Bröhan, Düsseldorf)

27. Peter Behrens, slave clock for the AEG, ca. 1910 (*AEG-Zeitung* 12 [1910])

28. Peter Behrens, electric kettle for the AEG, nickel-plated brass, 1909, Werkbund-Archiv, Berlin (Frederic J. Schwartz)

most actively involved in the design of consumer goods for industry. I would like to suggest that it is precisely this kind of relation between abstraction and transcendence that is behind Behrens's extensive formal borrowings from the antique examples illustrated in Riegl's *Spätrömische Kunstindustrie*. Some of these sources have recently been noted in the realm of typography, but their rationale has not been explained, nor their extension from the late antique craft objects to the analogous surfaces of the mass-produced consumer goods of the AEG.[238] We could add to the list of typographical borrowings the motif of compressed, paired spirals in Behrens's endpapers for Martin Buber's monograph series *Die Gesellschaft* (whose relation to the Werkbund we have discussed) and their source not in the Ionic volute but in Riegl's illustration of late antique chiseled bronzes (figs. 23, 24); but we should also consider the ring of ovals radiating from a circle in the screen of a sheet-metal space heater and a similar configuration from Riegl's illustrations (figs. 25, 26). Equally noteworthy is the repeated motif of the regular, jewel-like circular studding around the geometric forms of this heater, a wall clock (fig. 27), and an electric tea kettle (fig. 28), as well as the occasional circular accents at the corners of these objects, and the similar motifs from Riegl's book (figs. 29, 30); also the play of tangent

circles in and around lozenge forms on the front of a convection heater for the AEG and in late Roman enameled bronze fibulae (figs. 31, 32).[239]

As much as he studied Riegl, however, Behrens probably refers to Simmel's article on Style in one of his earliest writings on the aesthetics of mass production, published in the AEG's in-house magazine, in which he discusses the sort of geometric form he found in *Spätrömische Kunstindustrie* and spells out his reasons for adopting it. Echoing Simmel, he writes that "in our age, which tends toward the individual . . . an all-too-rich use of ornament should be avoided."[240] He moves similarly from the isolation of the individual to the logic of mass production as opposed to that of hand-made decoration: "In machine production . . . it would be intolerable to find everywhere in the masses the same pretentious forms. One would experience the contradiction between rich design and easy machine-manufacture as quite unpleasant. *Ornament should therefore always have something impersonal about it*. So-called geometric abstraction comes closest to meeting this requirement."[241] Like Simmel, Behrens comes to abstraction not via the technical demands of the machine but by the spiritual imperative of the age to assert the universal in accordance with the serial logic of commodity manufacture and distribution. The abstract, geometric, impersonal forms did not fit better into the production process but were, instead, *to compensate for its social effects*. If the machine and the division of labor had led to "exaggerated subjectivity" and cultural chaos, the visual counterpart of which was the overabundance of Historicist and Jugendstil ornament, industrial production could be retooled to produce, instead, a spare geometry which would function as a sign of transcendence.

If Behrens did not mention Simmel by name, his academic mouthpiece, Fritz Hoeber, did, citing Simmel's essay on Style and calling the sociologist's (earlier) thoughts on the matter "completely analogous" to those in Behrens's article quoted here.[242] Hoeber went further in trying to claim Simmel's considerable prestige for Behrens's work – in this case the dramatically simplified classical forms of his

29, 30. Late Roman earring; late Roman onyx fibula in gold setting, illustrated in Riegl, *Spätrömische Kunstindustrie*

31. Peter Behrens, convection heater for the AEG, cast-iron housing, 1909 (Fritz Hoeber, *Peter Behrens*)

32. Late Roman enamelled bronze fibulae illustrated in Riegl, *Spätrömische Kunstindustrie*

15

architecture – using Simmel's texts in a particularly revealing way in his attempt to specify just what Style should look like. In his article titled "Der kollektivistische Charakter der griechischen Kunst" (The Collective Character of Greek Art), Hoeber invokes Simmel's essay on the applied arts, and claims to quote from it: "It is the inner essence of the classic that . . . a *stable center* is inherent to it, a certain composure which offers few points of attack at which modifications, disturbances, destruction of equilibrium can occur."[243] Now these seemingly unoriginal lines lead to an interesting point, for Simmel did not treat the issue of the classic at all in his 1908 reaction to the Werkbund; the lines Hoeber reproduces are instead paraphrased from Simmel's earlier text on Fashion. Hoeber's strategic surgery on Simmel's text is significant: in trying to define Style, he refers back to Simmel's famous essay on Fashion, a touchstone for discussions of form under capitalism. At first glance this move even looks quite innocent, for in the Fashion essay, Simmel writes of the classical as the *opposite* of Fashion: "Everything that might be termed 'classic' is relatively far removed from, and alien to, Fashion."[244] Hoeber was trying to use Simmel to assert the commonplace diametric opposition between Style and Fashion – but this is an opposition which, surprisingly, Simmel's text on Style does *not* support. For in trying to define Style under capitalist conditions of production, Simmel, like Hoeber, referred back to the concept of Fashion, but in a very different way.

In seeking to define the possibility of a modern Style, Simmel reverts to his earlier essay in that he defines Style, like Fashion, as a matter of the manipulation of signs. This elision of the spiritual ideals of Culture and capitalism's remarkable capacity to produce representations is the core of Simmel's argument. Echoing his own earlier discussion of Fashion as well as Riegl's anti-Semperian characterization of the *Kunstwollen*, Simmel discusses Style as sovereignly independent of the contingencies of function, material and technique.[245] And though the signs of Style assume their meaning through their subordination to a common visual principle and their elimination of random or willful deviations from this norm, Simmel nowhere asserts any relation between the formal character of an object and its function. With the divorce of form from functional and technical considerations, the signs of Style, like those of Fashion, were to be carried by ornament – in other words, by the *surface* of the mass-produced object.

Ornament was the concept on which the analysis of Fashion in the *Kunstgewerbebewegung* centered; it was discussed as visual form reduced to its manipulable minimum of surface and circulated as a commodity. And so too, in fact, was Style as Simmel describes it. If the arbitrary, surface quality of Style was hinted at in his article in *Dekorative Kunst*, it is made explicit in a precisely contemporaneous essay published in Sombart's journal *Der Morgen* in which Simmel again engages issues of the applied arts, returning to the site at which Fashion was usually identified in order to argue for the cultivation there of Style. The subject of this article was "Psychologie des Schmuckes" (The Psychology of Ornament).[246]

"If ornament," writes Simmel, "is to broaden the individual through something supra-individual that extends to all and that is comprehended and valued by all, it must, beyond its mere material effects, have *Style*. Style is always something general that brings the contents of personal life and creation into a form shared with many and accessible to many."[247] Function figures in Style neither as the determinant of form nor as its referent, but as its *vehicle*: "For everything that we call *Kunstgewerbe*, which due to its function addresses a

diversity of people, we demand a general, typical form. In the applied arts, a soul oriented towards its own uniqueness should not be voiced, but rather a broad historical or social attitude and spirit; this makes possible its incorporation into the life-systems of a great many individuals."[248] Simmel makes the same point in his essay on Style by calling the distribution of the domestic article "the quantitive expression of its functionality": by being used, the everyday object can carry the signs of connection – affixed to the object, but arbitrarily so – into all aspects of everyday life. As in the Fashion scenario, function serves as the carrier of signs, but it is now representations construed as Style that are to be distributed in this way. If the contemporary critique of Fashion had shown how ornament was a matter of facades subject to endless manipulation, Simmel, again turning the tables, shows the utopian potential of these shifting surfaces of everyday life: "The work of art is something for itself; the work of applied art is something for us. The essence of the former is the intensification to a unique center; the essence of the latter is *circulation, general accessibility and practical recognition.*"[249] In other words, in its distribution as commodity, ornament represents the social form of form.

When Simmel writes of "the vital needs that can only be satisfied by stylized, not artistic-individual, utensils,"[250] he is following Riegl's lead in discussing the needs served by the object not as physical but, like those finding outlet in the *Kunstwollen*, social or spiritual. The difference is that the needs fulfilled by Style are expressed and satisfied within the consumer market. Style, as social form, connects one *consumer* to the other by the visual expression of identity and thus community; it is the deployment of marks of (the phrase can hardly be translated) "the with-many-shared,"[251] but their deployment through the channels of commodity distribution and exchange, a field whose contours were, at the time, first being drawn. And it is not only the manipulation of ornament as sign that connects Simmel's 1908 concept of Style with contemporary notions of Fashion. Beyond implying the function of the consumer market as a central cultural space, the deployment of ornament Simmel calls Style is put in the service of the kind of social interaction that was identified in his earlier work as Fashion and subjected to critique by others under this label. In writing on Style, Simmel takes over one of the two central points of his Fashion essay and renames it: Fashion, he had written, was a way of asserting individuality (given a negative valence in the Style essay) but also served as a "carrier of the general, of unity, of comforting sameness of forms and contents of life."[252] These are the terms we recognize from Simmel's remarkable passage on mass production and redemption. If, in 1905, the "moment of homogeneity in Fashion" was "particularly important for contemporary life with its individualistic fragmentation,"[253] then in 1908, after the founding of the Werkbund, this very same "unburdening of the personal" would drive modern man instead to Style. In seeking to define the possibility of a modern Style, Simmel reverted to his own earlier essay on Fashion and found there the most powerful way of talking about the social manipulation of form in an alienated cultural sphere.

With these points in mind, we are in a position to recharacterize the dialectic of the commodity which Simmel describes and which served, articulated or not, as the theoretical fulcrum on which the Werkbund project turned. We have seen earlier how commodity production was seen to be a source of alienation, severing the ties to the social totality which formed around the communal production of necessary goods; and how mass production was seen nonetheless to carry within itself the seeds of a new totality (this time an aes-

thetic one) by its ability to unify through the dissemination of visual form. We can now go one step further. The dialectic depends on a redefinition of the cultural role of the commodity, one presaged by the shifting terms of alienation in the discourse on Culture. The negative effects of the commodity in the factory or workshop were transcended as it was brought into the *intérieur,* either the department store or the upper-middle-class salon and its lower social equivalents. In Marx, Ruskin and Morris (who first set the terms for the discussion), the cultural impact of the commodity was seen at the level of production (the closed social circle defined by the production of objects or their use in further production); with the Werkbund, the mass-produced objects of everyday use came to be considered (and both criticized and celebrated) in their cultural effects as a matter of the surface appearance of objects bought at a far remove from the sphere of labor. From figuring culturally in pre-industrial societies as a product of labor, the commodity would, under capitalist conditions, perform its cultural role of spiritual closure *as a carrier of signs.* The way to Style led through, and transcended, Fashion.

<p style="text-align:center">✳ ✳ ✳</p>

We are right, I think, to find this all a bit disappointing: a few moves, it seems, and some very serious problems of experience in modernity and some very sincere attempts to come to terms with them might seem to be simply turned on their head in a sort of sophisticated parlor game. Simmel's essay, moreover, raises more questions than it admits to: how one logic of the production of form under capitalism could give way to another; how, beyond the "drive to Style" among the bourgeoisie, consumers could be moved to deploy symbols of identity in a society still stratified by embattled lines of class and conflicting claims to cultural privilege. We are used to expecting a bit more from Simmel, who elsewhere provides some of the best accounts of the interplay between subjectivity and the world defined by the constellation of changes we call modernity.

We can explain away this lingering disappointment in one of two ways. First, we could see the problems plaguing the dialectic as the result of ingenuousness on Simmel's part; perhaps we are witnessing him in a hopeful, not critical mood, describing a project and even standing behind it. Improbable as it sounds, Simmel did at times give in uncritically to the passions of the day; there are indiscreet episodes in his oeuvre.[254] In this case, the articles Simmel wrote directly after the establishment of the Werkbund, with their celebratory (though inadequate) transformation of Fashion into Style, are simply the other side of the ambivalence toward signification we have identified in the early modern period: the recognition of the entropic and alienating effects of representations in a class society fed its forms by capitalist industry coupled with the hopes that form could be harnessed to function in a responsible, properly cultural way. This would put Simmel squarely in the camp of the bourgeois reformers whose projects were, in equal measure, utopian and defensive, constituted of both horror and hope.

Or perhaps Simmel was simply being sly. Maybe he did not intend to describe a utopian scenario at all but instead the actual process of the manipulation of form, the way consumers already dealt with the variety of styles on the market (of which Werkbund *Sachlichkeit* was but one of many). Simmel's otherwise inexplicable advocacy of a plurality of styles, and his refusal to see this plurality as incompatible with Style,[255] would support this view (though the fact that the article appeared in *Dekorative Kunst* indicates that the editors

did not consider this the core of Simmel's argument). In this case, Simmel, using the language of reform, would be in effect subverting the Werkbund project; he would be advocating a certain kind of laissez-faire, arguing that culture arrives at an equilibrium of expression without the interference of artists (or, for that matter, reformers). In other words, consumers, among the myriad forms available to them, were already manipulating signs in a way that constitutes Style; the constellation of the abstracting tendency of capitalism and the modern subject's response to this situation was adequate to produce a field of Culture in which signs could be deployed in a transcendent manner.

Whatever the case may be, Simmel's 1908 text on Style exhibits the characteristics and the limitations of the discourse in which it takes part with a clarity matched by few others. We recognize clearly the standard discursive strategies of the construction and analysis of Culture in the consideration of commodity production in realms distant from production itself; in the implicit and unquestioned definition of the cultural subject as consumer; and in the constitution of an ideal realm by the bracketing out of non-bourgeois social experience. We should not, however, be too harsh, for Simmel's text – at first glance a relatively straightforward, if marginal, example of proto-functionalist thinking – reveals on closer examination shifts and sutures between the discursive mainstays of the discussions of Culture and the critique of modernity which lead to fundamental insights into the nature of the cultural field under conditions of capitalism. Simmel *conflates* the sphere of Culture with that of the consumer market instead of opposing them; his recognition that the market was a field of representations was free of the despair haunting the critique of Fashion and led to the extraordinary suggestion that the space of the commodity and its representations could function, in fact, as Culture, or in any case that Culture would henceforth have to take the mass market into account. In trying to describe Culture under conditions of the division of labor and capitalist production, Simmel in effect redefines Culture in a way that echoes and clarifies the Werkbund's attempt at the "reconquest" of cultural harmony through the spiritualization of the commodity. For in seeking to exploit capitalism's ability to produce and distribute a certain kind of sign, the members of the Werkbund also brought Culture into the realm of mass consumption; they too had discovered the seemingly paradoxical fact that the search for Culture under capitalism led straight to the marketplace.

Neither Simmel nor the members of the Werkbund considered their theoretical work to be in any way complete with the consideration of Culture. With the concepts of sociology and *Kulturkritik*, they brought contemporary theories of visual form face to face with the unavoidable social fact of the mass market for consumer goods; they were able to articulate a theory and a critique of the nature of form under industrial capitalism as well as the outlines of a strategy of reform. To explore the cultural potential of the capitalist economy, however, new categories were needed with which to think about culture, and for these, different bodies of knowledge were pressed into service.

The Spiritualized Economy and the Development of "Types"

1. POLITICAL ECONOMY

> As a science political economy . . . lies on the boundary of the most varied academic fields; it leads directly to the history of culture and ideas, as well as to philosophical problems.
>
> Marianne Weber[1]

I have discussed at some length the role of the early German sociologists in the discourse on Culture and in the Werkbund. At the time of the founding of the Werkbund, however, sociology as a discipline can hardly be said to have existed. When in 1909 scholars calling themselves sociologists founded the Deutsche Gesellschaft für Soziologie (German Sociological Society), they did so by seceding from an organization of economists, the Verein für Sozialpolitik (Social Policy Association); and though the sociologists came from various academic backgrounds – jurisprudence and philosophy, among others – all were, in one way or another, economists.[2] The earlier organization, the Verein für Sozialpolitik, was the political forum for academic economists in Germany, and the connections between the Verein and the Werkbund were numerous and close.

The Verein was founded in 1872 by professors of political economy who espoused the very political principles that the Werkbund would later take up: simultaneously anti-laissez-faire and anti-revolutionary, anti-Manchester and anti-Marx.[3] This earned members the ambivalent label of *Kathedarsozialisten* or "lectern socialists." The Verein opposed what its members perceived to be the shared failing of the positions they rejected: an abstract sense of the nature of economic activity. In the classical political economy of the Manchester School, they attacked the consideration of the economy as a phenomenon separate from historical and social factors, the presupposition of a universal *homo oeconomicus* whose activity would lead to a systemic equilibrium as if by natural law. And while they accepted Marx's critique of this economic liberalism, they rejected his tendency to view the economy in terms of an equally abstract logic of history. The members of the Verein had roots in an intellectual tradition that rejected such conceptions of economic activity on method-

ological grounds. Borrowing the principles of the German Historical School of Jurisprudence, political economy in Germany had long since adopted an historicist approach that sought to study economies in their individuality, as the result of unique constellations of historical and social factors. The first Historical School of Political Economy emerged in the 1840s, the second or Younger Historical School a generation later. The founding of the Verein was the attempt of the Younger Historical School to take the political consequences of its antiliberal intellectual position, for with the social crises of Germany's rampant industrialism, this was no longer a merely methodological issue. Beyond the academy, the Verein sought to exert influence on the state to act as a brake on the deleterious effects of unchecked economic growth.

In the first decades of its existence, the commanding figures of the Verein were Gustav Schmoller (who taught in Berlin) and Lujo Brentano (who taught in Munich); around the turn of the century, a younger generation of left-liberal economists formed around Brentano and Karl Bücher of Leipzig and assumed an ever larger role in the affairs of the organization. The most prominent of this younger group were Max and Alfred Weber, Sombart, Naumann and Gerhard von Schulze-Gaevernitz.[4] Now Alfred Weber did not join the Werkbund until after World War I and Max never did, but Sombart, Naumann and Schulze-Gaevernitz were all members at some point between 1907 and 1914. And while Brentano never joined, Naumann was his close associate, even disciple, for years,[5] and four of Brentano's students were prominent in the Werkbund: Bruno Rauecker, Theodor Heuss, and the first two managing directors of the organization, Wolf Dohrn and Alfons Paquet.

We could continue with such matters of personnel: other political economists staff the early membership lists of the Werkbund; Muthesius taught at the Berlin Handelshochschule (Business School) at the same time as Sombart; and Sombart's home in Schreiberhau was designed by Fritz Schumacher (whose brother, Hermann, taught economics in Bonn and was active in the Verein).[6] What is more important is that the members of these groups at the time perceived a special relationship, an elective affinity between social and aesthetic reform. Naumann writes that

> Practice has shown that intellectual associations [*Vereine . . . auf geistigem Gebiet*] can achieve very real things. One need only think of the Verein für Sozialpolitik, which has been for several decades the center of all productive energies in economics and which has noticeably influenced the course of intellectual and legislative life. We must think of associations of this sort as we now make the step to the German Werkbund.[7]

Heinrich Waentig, like Sombart active in the Verein, the Werkbund *and* the Deutsche Gesellschaft für Soziologie, saw reform in the realm of practical aesthetics as the "most noble and perfect" way of achieving the Verein's goal of "bridging over class differences in society."[8] Beyond equating the projects of the two groups, he also traces a common lineage to the Arts and Crafts movement in England:

> Among the achievements of the Historical School of Political Economy, we usually point first to the introduction of "ethical pathos" into modern social policy. . . . If this is the case, then it applies only to Germany. In the history of the entire discipline, it is the British who enjoy this distinction. For already at the beginning of the 1860s Carlyle and Ruskin had stated the core of what was preached as a new gospel by the founders of the Verein für Sozialpolitik ten years later.[9]

Waentig points here to an important term of the period: the Verein was commonly seen to represent an "Ethical School" of political economy. This was a label that Werkbund members sought to adopt as a description of their own project: "We must understand our movement as an *ethical* one," said Osthaus in the 1914 *Typisierung* discussion.[10] Muthesius felt so strongly about the need to appropriate this term that he risked making it look trivial: in his inaugural address to the Berlin Handelshochschule, he spoke of artistic decline as the result of the categorical refusal of the (applied arts) manufacturer to "combine ethical or moral goals with his business," borrowing here the formula usually used when speaking of the exploitation of labor to describe the plight of visual form.[11]

At the very least, then, economists and applied art reformers shared a common spirit and vocabulary of reform. But they shared more than that. It will be argued here that key Werkbund ideas were deeply rooted in the contemporary discourse of political economy. My point was a common one at the time: in 1910 the Werkbund economist Helmuth Wolff warned that while "we speak and write about art and economy , . . . art and industry and so on," the need to address the "theoretical level" of "aesthetics and economics" was being neglected.[12] His admonition certainly applies to most research on the subject: we are accustomed to discussing the Werkbund in terms of unexamined abstractions such as "mass production," "industry," "monopoly capitalism" or simply "capital." Both our terms and our points of reference need considerable refinement. When Wolff wrote those lines, though, they were only half true: by 1910, political economy was already a discourse available to, and pressed into service by, professionals of culture. But the issue Wolff raises is a central one, for, as I hope to show, the Werkbund's contribution to design aesthetics is quite incomprehensible when considered in isolation not only from the economy of the period, but from its *economics*.

* * *

Rather than any specific reforms proposed by the Verein für Sozialpolitik, it was the basic assumption of the Historical School of Political Economy, the very way it defined its object of study, that paved the way for a fruitful overlap of the study of visual and economic form in the Werkbund. If the consideration of the visual effects of the capitalist economy was the starting point of the Werkbund's analytical project, it was capitalism itself in all its complexity which was the object of study for the members of the Historical School. When in 1911 Naumann reviewed the work of Sombart, Weber, Troeltsch, Schulze-Gaevernitz and Simmel – scholars we know as sociologists – he came to the conclusion that "the search for the essence of capitalism . . . [is] the theoretical problem of the German present."[13] And while it cannot be clear to us whether he was speaking of culture or economics, his readers would probably have made no such distinction.

Naumann was addressing the work of the generation Schumpeter calls the "Youngest Historical School," which moved beyond the work of its mentors in defining and describing capitalism and began to explore its historical origins.[14] These scholars saw the origins of capitalism behind the loss of Culture, which they described variously as "rationalization," "disenchantment" (*Entzauberung*), or the predominance of "objective culture." Their use of the concepts of the discourse of Culture was not incidental: it signals the centrality of the hermeneutic approach to their work in economics as well as to their writings on Culture. To the political economists, the chief characteristic of

their discipline was that it was a "science of culture," a *Geisteswissenschaft* in the strictest sense of the word; Weber and Sombart, who both held chairs in economics, traced their intellectual roots not to the likes of Smith and Ricardo but rather to Dilthey. In the first so-called *Methodenstreit* in the 1870s, the Historical School defined its identity by opposing claims that economics should be a deductive science, a *Naturwissenschaft*, claiming instead the status of an inductive, historical study of human behavior.[15] In a late text, Sombart made explicit the Historical School's debt to Dilthey by calling their kind of economics "*Verstehende Nationalökonomie*";[16] and Max Weber's methodological writings in the hermeneutic tradition are well known (indeed more in the humanities than in present-day economics). In a programmatic statement in the journal he coedited with Sombart, Weber wrote that "we are concerned with psychological and intellectual [*geistig*] phenomena the empathic understanding of which is naturally a problem of a specifically different type from those which the schemes of the exact natural sciences in general can or seek to solve."[17]

Such was the essence of economics at the time, but this says little about the importance contemporaries attached to it. Political economy was a not only a cultural science: it was, according to its practitioners, the *preeminent* cultural science. Max Weber wrote that the task of his generation was to study "the fundamental process of transformation experienced by our economic life and thus by our cultural existence as a whole through the advance of capitalism,"[18] and that "the domain of such subjects extends naturally . . . through the totality of cultural life."[19] For Naumann political economy was simply "the master science of our age."[20] And Johannes Buschmann, writing in Ferdinand Avenarius's cultural journal *Der Kunstwart* (both men were Werkbund members), told his audience that – the emphasis is Buschmann's – "*without an education in economics we simply cannot understand our cultural situation.*"[21]

In 1902, the first edition of Sombart's *Der moderne Kapitalismus* appeared; one of its most important (and controversial) chapters was on the "Genesis of the Capitalist Spirit [*Geist*]."[22] In 1904 and 1905, Weber published his *Protestant Ethic and the 'Spirit' [Geist] of Capitalism.*[23] Together these were the clearest formulation not only of the presence of "spirit" in the economy, but of this spirit as the driving force and the causal factor of economic developments. In his 1913 book *Der Bourgeois* Sombart clarified his views, devoting an entire chapter to arguing that spirit does not grow out of an economy but precedes it; it was not secondary, merely an interrelated phenomenon, or part of some loosely defined world view or *Weltanschauung*.[24] ("Whoever wants a 'view' [*Anschauung*]," Weber is reported to have remarked on this matter, "should go to the cinema."[25]) No: as in the Idealist discourse of Culture, *Geist* was the central causal category in the study of economics. The generation of Sombart and Weber not only viewed economic matters in a cultural context; the economy itself was a cultural realm.

When Schmoller wrote in 1897 that "contemporary economics has arrived at an historical and ethical perception of state and society, in contrast to rationalism and materialism," we get the sense that the Historical School was making its case against both classical political economy and Marxism in much the same way that Riegl defined his position against Semper at precisely the same time.[26] The sociologists, we saw, shared points of reference with contemporary art historians, and so, it turns out, did (other) economists. Max Scheler, a generation younger than Schmoller, makes some familiar moves in a detailed

review of Sombart's *Der Bourgeois*. He first lauds Sombart's assertion of *Geist* as the "primary cause" of economic developments;[27] and when he discusses various stages of the mode of production as matters of *Wollen* instead of *Können*, he was probably referring to Riegl, or to the contemporary reception of his ideas,[28] as well as responding to the extraordinarily Rieglian line on the first page of Sombart's book: "All production . . . is the working of nature, and in all work we find, of course, the spirit [*Seele*]."[29]

Wollen over *Können*, the causal role of spirit, its expression in everyday production: we are quite explicitly put in the same conceptual sphere as both the *Kunstwollen* and Style. Mannheim makes the connection between Riegl's concept and the work of both Sombart and Weber in his important article on the state of hermeneutics between the wars.[30] Sombart too was self-conscious about the affinities between contemporary art historiography and economics: in describing the object of the historical economists' study, he finds no alternative to the concept of Style (though he admits to a nagging dissatisfaction). Referring to an essay by Wölfflin, he writes that the economist must lay bare the "stylistic context" of economic systems, much as art historians had identified the "spirit of the Gothic."[31] And Scheler writes that Sombart described the "strict inner stylistic unity [*Stileinheit*]" of historical economies.[32] In the discourse of political economy as well as in the discourse of Culture, the economy was inscribed in the concept of Style.

The Historical School of Political Economy posited the existence of – and the Werkbund sought access to – a realm that can only be described as a *spiritualized economy*. Contemporary economics provided theoreticians of the applied arts with concepts that allowed the analysis of certain cultural problems of the capitalist economy and opened up the possibility of concrete interventions to address them. This is a point worth emphasizing, for it shows that the Werkbund's attempts to secure a role for the artist in the modern economy were, at a theoretical level, neither blindly utopian nor even terribly original, for the conflation of culture and economy that is the most striking aspect of Werkbund theory mirrors, and was prepared for by, the fundamental conviction of the hegemonic economic thought of the time. The separation of these realms which is so characteristic of much European thought since the Romantics was not nearly so monolithic in Germany, which was unique in having a strong academic tradition of historical economics.[33] The premise of a complex and complete interrelationship of the two spheres allowed an important strain of thought in the Werkbund (certainly the dominant one) to sidestep the prophecies of cultural doom, to refine its understanding of the cultural nature of the capitalist market and to develop very specific strategies of reform.

* * *

A few last words on economics in Wilhelmine Germany. The very existence of sociology (tentative though it was) shows that the distinction between the discourses of political economy and of Culture is not always clear. There are, however, indices that not only allow us to draw such a distinction but which also show that the difference was keenly felt at the time. Sombart stated repeatedly that the articles he wrote as editor of *Kulturphilosophie* for the journal *Der Morgen* had nothing to do with his work as an academic economist. Similarly, his articles on the applied arts were not published in a scholarly forum but in *Die neue Rundschau*, the preeminent journal of the general cultural press; and when they appeared in book form, it was in a bibliophile

series called *Die Kultur*. Even his study of Fashion became famous not as a chapter in his *Der moderne Kapitalismus* but only when it was excerpted for a series of cultural monographs. Simmel, whose *Philosophy of Money* consists to a large extent in a critique of Marx's theory of value and was first presented in outline form in Schmoller's economics seminar, felt compelled to point out that "not a single line of these investigations is meant to be a statement about economics."[34] At times it was artists who had to draw the line, insisting that they were not economists. Muthesius, trained as an architect but employed by the Prussian Ministry of Trade, was asked by Schmoller to review Waentig's *Wirtschaft und Kunst* (Economy and Art) for the *Jahrbuch für Gesetzgebung*.[35] Muthesius declined on the grounds that he was a "layman."[36] Muthesius, it seems, got cold feet: Schmoller's *Jahrbuch* was the most prestigious journal of economics in Germany at the time, and Schmoller's personal invitation was a great honor. Yet the invitation had not come out of the blue, for Muthesius had previously written articles on the applied arts for two successive issues of the yearbook *Die Weltwirtschaft*, edited by the economist Ernst von Halle.[37]

Thus, despite close and intense cooperation between practitioners of the two discourses, and the fact that one person could take part in both, Culture and political economy remained separate bodies of knowledge. Members of one group often felt that the other realm fell within their area of competence, which led to misunderstandings and corrections (Naumann, a publicist and politician, was often chastised for holding eccentric economic views, as was Sombart for his cultural criticism); but on the whole economists and professionals of Culture recognized what separated them as well as the common interests that brought them together.

As blurry as the distinction between economics and criticism occasionally was, the authority of political economy and its power to exclude other economic discourses in the Werkbund was very clear. A case in point is the journalist Johannes Buschmann's address to the Werkbund at its 1909 meeting in Frankfurt. Buschmann had joined forces with the Institut für exakte Wirtschaftsforschung (Institute for Exact Economic Research) of the Rostock University to investigate the "economic conditions of quality work"; it was his intention to study "dispassionately" the business of the applied arts, to "remove the issue from the polemical sphere and to determine the causal connections between artistic demands and the resistance to them."[38] Buschmann's report was not well received. Artists and an economist attacked nearly all aspects of his proposed study – research methods, definition of concepts, the very value of the investigation.[39] Wolf Dohrn, the managing director of the Werkbund chairing the session, noted the "indignation" with which Buschmann's address was met and sought to calm nerves.[40]

The source of this indignation is not noted in the minutes of the meeting, but it is, I think, clear enough. For the Institut für exakte Wirtschaftsforschung was run by Richard Ehrenberg, an economist who was trying to establish a new kind of economics, neither ethical nor historical but "exact," practical and empirical (today it would be called "microeconomics"). This was a challenge to the hegemony of the Historical School of Political Economy in Germany. In contrast to this "Ethical School," Ehrenberg asserted his alleged distance from political issues and engaged in regular polemics with the Verein für Sozialpolitik, polemics which had exploded just a few weeks before the Werkbund meeting.[41] Letters between Muthesius and Robert Breuer, two of the more "economically minded" of the Werkbund members, reveal that they

were even more anxious than the architects at the meeting to sever any connection to this new school of economics (and this is what happened): Breuer calls Ehrenberg "childish" and a "dilettante," and writes, revealingly, that he had simply "skipped over" any mention of Buschmann's address in his reviews of the Werkbund meeting (he had written eight).[42] Muthesius responded that he would "consider it a victory to get rid of Ehrenberg" and agreed in full with Breuer's strategy of omission.[43] "Exact" economics was given the silent treatment.

This is a minor episode in the history of the Werkbund, but it is significant that tempers flared, for once in unison. It shows how a certain discourse was marginalized and not allowed a voice; how the means-end rationality of actual business and industrial production would not be listened to; how certain statements about the empirical experiments of capital simply could not be uttered. Some gritty aspects of the generation of profits were rendered beyond the pale of discussion. The reformers cannot have found the topic as threatening as class difference and the thought of revolution; they probably found it simply reductivist and vulgar. Yet the way the Werkbund shied away from contact with capital in its concrete and empirical forms makes it clear that despite all claims to the contrary, there was relatively little desire in the Werkbund to consider the actual role of production in a social totality larger that the spiritualized realm of Culture. We find here that the very category of the economy was just as much a construction as was Culture; it was an object of discourse divorced from certain aspects of reality, a concept that was carefully sculpted. The spiritualized economy was jealously guarded against bodies of knowledge that sought to map modes of production in ways other than history or human destiny, and in terms other than spirit or Style.

2. EXCHANGE AND DYSTOPIA

> Old-fashioned commerce [*Handel*] is characterized by tranquility, ease, contentment; modern commerce by restlessness, instability, nervousness.
>
> Werner Sombart[44]

The problem of culture under capitalism led, inevitably, to the market. With the tools of *Kulturkritik*, the consumer market was identified as a realm of Culture – a fallen realm but one ripe for redemption. Political economy helped the thinkers of the Werkbund deepen their understanding of its cultural nature.

In Germany the identification of the market as a *problem* was something new around the turn of the century. One must search far and wide for a serious description of form as an object of exchange in the literature of the applied arts before this period, and when one finds such an account, the market, in a strange way, seems hardly to be there. Consider the following passages from Cornelius Gurlitt's aptly titled *Im Bürgerhause* (In the Bourgeois Home) of 1888. If after 1900 the act of exchange was a symbol and symptom of alienation, it was earlier a self-evident and perfectly adequate substitute for production:

> When you . . . want to create a home, to become an artist yourself, you should take only yourself into account. . . . Do not seek to surround yourself with things you do not understand. Since you cannot yourself make house and furnishings, appliances and decoration, you should choose what seems most convenient, most agreeable in use. Seek out things whose form and decoration is most pleasing to your eye. If you . . . do not allow yourself to be influenced by anyone else's taste, then you will have a house which is as stylish [*stilvoll*] as can be. The style is perhaps a bit bewildering, but it is *your* style. Many people like you make up the *Volk*. And our taste – that is the long-sought Style of the day. It will be precisely as good or as bad as our age.[45]

This is a picture of unproblematic consumption. In the long passage that follows, Gurlitt develops a liberal model of the relationship between culture and economy. It is a description that would have been impossible to write only a decade later.

> So too did the ancients, as they created their styles, the English and the French as well. . . . And with regard to many objects of everyday use, that is how the evolution of style moves forward. One can consider for example the manufacture of furniture upholstery, wallpaper and the like. In these it is not the draftsman, not the manufacturer, not the merchant and not the consumer who speaks the decisive word; rather all four confer about how fashion should develop in the next year. The draftsman gives his sketches to the manufacturer, who orders the execution of a number of patterns which please him especially. As soon as the goods are ready, pattern cards are distributed to merchants. The merchant knows his customers and chooses in turn that which seems appropriate. From one kind of pattern many are sold, from another few. Then the consumer makes a third selection of the various products. The manufacturer soon notes which are the most pleasing from the orders he receives. He speaks with the draftsman and requests "replacements" for the most marketable goods. The draftsman then seeks to establish what taste, what style of the previous year was the preferred one; he takes that and develops it, artistically, further. Thus the multitude of buyers direct him, while he seeks to express their taste anew. . . . Little

by little, the talented draftsman becomes a leader of the *Volk*, in whose soul and inclinations he has educated himself, whose pulse he feels, whose wishes he anticipates and thus can steer in the right direction.[46]

Gurlitt describes a benign, domesticated form of natural selection in which changes in taste are viewed as progress, not pathology. But more interesting in this context are two related assumptions: first, that the free play of economic forces produces an equilibrium of supply and demand of both commodities and signs; and second, that the subjectivity reflected by these signs exists prior to the market, that it is not formed on it or by it. Thus the economy of visual form is not itself part of or merely a function of the capitalist economy, though it does take place across this field. The economy is presented as a transparent space over which cultural meanings move as effortlessly as does capital. Style is personal, but the market is a public space over which culture and capital (both conceived as private property) can freely pass.

After 1900, the pictures of the market sketched in applied arts circles no longer show a timeless mechanism, like Adam Smith's "invisible hand," mediating between supply and demand, but describe instead a specific historical development; and rather than a transparent market in a state of equilibrium, they show one that is opaque and in crisis. Instead of efficiently relaying impulses of both culture and capital, the various economic functions between production and consumption are seen to be damming, hindering and deflecting them. In Gurlitt's account of the aesthetics of economic individualism and liberalism, the consumer went to market, made his choice, and had done his part in creating Style. Speaking at the founding of the Werkbund, Fritz Schumacher describes the exact same process, but he reaches a very different conclusion: "The path which leads from art to life has become much more complicated. It goes from inventor to executor, from executor to the mediating merchant, and only from him to the public."[47] In a speech before the Berlin Volkswirtschaftliche Gesellschaft (Economics Society), Muthesius spoke of this same opacity: "Through mass production, a complete estrangement between producer and consumer has developed. . . . [B]etween them stands a whole line of instances (wholesaler, agent, salesman) which makes any connection impossible."[48]

The problem was not just mass production but the way the economic forms of modern capitalism *as a whole* led to a state of estrangement which I earlier identified as alienated consumption. In the article on "Aesthetik und Wirtschaftslehre" (Aesthetics and Economics) quoted above, Helmuth Wolff describes the historical development of alienated consumption using the terms of a contemporary economic model, Karl Bücher's theory of economic stages. Bücher, professor of political economy in Leipzig, was with Brentano one of the mentors of the younger members of the Verein für Sozialpolitik, and his theory of stages represents one of the first major non-Marxist attempts to describe the development of capitalism.[49] Briefly, Bücher distinguishes three evolutionary stages: first, the household economy (*Hauswirtschaft*), in which all significant needs are met by production within the household; second, the city economy (*Stadtwirtschaft*), characterized by the division of labor and trade primarily among members of a closed community; and third, the national economy (*Volkswirtschaft*, often described after 1900 as the world economy or *Weltwirtschaft*), which Bücher considers capitalist. To economists Bücher's theory was not gospel, but it was an important landmark of historical economics, and it was also the account of capitalism most frequently

invoked by both economists and laymen at the time.

Wolff writes of "the close relationship between client and producer which still obtains in the age of the city economy," but which has disappeared "in the most recent economic stage, the national and world economy. In place of commissioned work there is now work for the market, the large world market, in which the producer is not familiar and the consumer of the goods quite unknown."[50] Now it is not surprising that Wolff, an economist, sought to assimilate the cultural discussion of aesthetics and alienation to his own professional concepts; what is however notable is that art critics could and quite often did take recourse to the terms of political economy. One example appears in the introduction to the influential critic Karl Scheffler's most important book of the pre-World War I period, *Die Architektur der Grossstadt* (The Architecture of the Metropolis). Here Scheffler traces the development of architecture and design in terms of economic evolution, which he characterizes using Bücher's stages. Transposing the concept of alienation which pervaded the discourse of Culture into the terms of the Historical School, he describes economic activity as culturally constitutive, the market as a fundamental social sphere, and the specifically capitalist market as a fallen realm. To Scheffler true Culture was represented by the city economy:

> If the family economy made something of an individual out of every family, so the city economy makes the entire city appear as an individual. That means that the city, as it developed up to the nineteenth century, had the character of something complete in itself, existing in and for itself. The city was surrounded not only externally, by moats and walls; it was also a unity in a spiritual sense.[51]

Culture, however, was not achieved as the result of a privileged relationship to work. Scheffler follows Bücher closely and emphasizes that the division of labor was already prevalent at this economic level, but that this did not intrude on the traditional horizon of experience: "The city economy . . . was in the lucky situation of being able to enjoy the advantages of the division of labor without losing the feeling . . . of familial origins."[52] This Culture arose due to the nature of the economic connections that developed, and not in spite of them. The economy, in other words, was identical with the cultural totality. In a striking passage, Scheffler draws the logical conclusion of his mix of discourses and lets the movement of goods and services in Bücher's city economy trace a hermeneutic circle: "One worked in the city and for the city; life moved in a circle. . . . That made the city a center of interests that could be clearly surveyed. Everyone could perceive the totality, and therefore everyone took part in the prosperity of the whole."[53] In the city economy, production and trade dealt with objects that functioned as carriers of the common spirit, and that spirit too constituted "prosperity." In the capitalist world economy, however, the sense of economic connection or *Zusammenhang* characteristic of earlier forms has been lost: "The industrial workers who fill the new quarters [of the city] work to satisfy needs that arise somewhere far distant in the country, or even beyond its borders; they work essentially for distant markets, for unknown customers, and not as city dweller for city dweller. They cannot perceive the effects of their activity within the city economy."[54] Totality, when it existed, was mediated by a market that brought producers and consumers together, but modern economic activity no longer led to a sense of wholeness and to the connections of community. The hermeneutic circle had been stretched beyond its breaking point by the ever wider distribution of the objects of labor.

Thus the aesthetic problems of capitalism were located not in production but rather in distribution and exchange, or, in the vocabulary of the period, in *Handel* (commerce or trade). The distinction between these two roughly defined sectors of the capitalist economy – which were considered to be entirely different in character and interest – was a leitmotif of the economic discussions of the time. As perfectly reasonable and even obvious as it may be, this distinction, exaggerated and absolutized, was central to the thinking of the Werkbund circle; there was there no loose, unnuanced equation of "industry" or "mass production" and capitalism such as we are inclined to attribute to them (or to use ourselves); industry or production was understood as but one component of the economic system of the modern age.[55] In Bücher's work, in fact, changes in modes of distribution and exchange are sometimes presented as more fundamental in describing the move from precapitalist to capitalist economies, for the technology of production led only to a quantitative increase in mass production and the division of labor, both of which were present in the precapitalist age, whereas the development of production almost exclusively for anonymous markets represented a more radical change. In essence, Bücher describes the development of capitalism chiefly as the development of modern commerce and thus of the increasing distance between the production and consumption of commodities.[56]

The distinction between production and commerce plays an even more important role in the work of Sombart (and Bücher and Sombart are without doubt the two most widely read economists of the period). If Bücher studies the developments in these two sectors separately, he still explores how they worked hand in hand. When he describes less the empirical facts of capitalism than its "spirit," however, Sombart sees a more fundamental cleft between the two spheres; he describes in fact a bifurcation of the "spirit of capitalism" into a spirit of production and a spirit of trade. Not only that: in dividing the spirit of capitalism into two constituent parts, he proceeds to judge them, relating one to the energy and progress of modernity and the other to the social pathology of capitalism that was seen to be gaining the upper hand at the beginning of the twentieth century.

Sombart calls the force behind technology and production (which he equates) *Unternehmergeist* (entrepreneurial spirit); it is the motor of organization, discovery and conquest, the heroism of the modern economy. Behind modern commerce he sees a parallel force which he calls variously *Händlergeist* (merchant spirit) or *Bürgergeist* (burgher spirit) and which he attributes to the English and with Jews.[57] Merchant spirit is said to pervade the sphere of commodity circulation (though it could be found in the production sphere as well) and produce the drive to calculation, speculation and the flattening of all values into quantitative terms. The *Unternehmer* is interested in his project per se, while the *Händler* sees economic activity only as a path to money and is thus indifferent to what he produces or trades. For Sombart, trade (or its spirit) is the parasite of the capitalist economy, its exploitative component. Commenting on *Der Bourgeois*, Scheler writes of the commercial spirit as "economically unfruitful," the entrepreneurial spirit as the "intellectually, ethically and biologically positive" force.[58]

"Capitalism," writes Sombart, "means nothing other than the dissolution of economic processes into two constituent elements: technology and commerce, and the primacy of commerce over technology."[59] Sombart here shifts – wholesale, we could say – the problems of modern capitalism into the realm of trade; his account is one economist's version of the market as a fallen realm.

Sombart's terms are, in themselves, not strikingly original. He simply reduces the Historical School's often nuanced division of the economy into sectors to a simple formula; he pairs run-of-the-mill anti-Semitism, which attributed to Jews not only control of trade and finance but also the ills of modernity, with a more attractive Nietzschean opposite, the energy and will of an heroic, profit-scorning man of technology.[60] No great claims will be made here for the direct influence of Sombart on the Werkbund in this respect, despite his involvement in and close contact with the group, though it is important that Sombart gave academic credence to the contemporary tendency to equate capitalism and its problems with the market, and his value-laden bifurcation of the modern economy does appear to be central to the group in the Werkbund most intent on a theoretical exploration of the cultural nature of the modern mass market. This division figured centrally in both Sombart's search for an economic explanation of an estranged and disenchanted modernity, and in the Werkbund's search for an explanation to, and a way out of, the dystopia of Fashion.

* * *

In Gurlitt's account of the movement of form on, or rather through, the market, Fashion was not a problem; in good liberal manner, change was equated with progress. By 1900, we know, Fashion was no longer viewed with such a benign eye. As the analysis of modern culture moved from *Kulturkritik* to political economy, the questions raised by this phenomenon became more pointed. In the words of the economist Walter Troeltsch, "the question as to the origin of Fashion centers on . . . whether fashions are made by producers [*Produzenten*] or merchants [*Händler*]."[61] In the Werkbund, the verdicts came down most often against trade. The issue is raised often and at great length, but perhaps it would be most useful here to look at the way commerce was treated by the two most vocal members of the Werkbund when it came to economic matters, Naumann and Muthesius.

Writing in the 1913 *Jahrbuch*, Naumann tries to spell out the role of commerce in the production and distribution of everyday goods. When he writes that "the merchant is the true carrier of the *theory of the free play of forces*,"[62] he identifies trade and not production with liberal capitalism, echoing others who saw the age of laissez-faire as dominated by this sector. He spreads the blame for the decline of quality evenly across the chain of commodity distribution, from wholesaler to retailer:

> In a hundred and more cases, the [commercial] businessman forces the quality of goods below the level that suits the manufacturer. The merchant demands good looks at a lower price. The whole fateful trend toward sham goods emerges to a large extent out of the purchasing offices of the wholesalers and agents. One can hear pained remarks from manufacturers about the tricks they are pushed to by the wholesalers. In many cases they would much prefer to make something solid, but they are dependent on the merchant, on the man to whom quality is utterly irrelevant.[63]

Like Sombart's Jew, Naumann's merchant is not interested in his objects, but only economic gain; his soul belongs not to creation but to competition, not to Style but to speculation. This creates the distorted physiognomy of modern trade – "the prices in the shopwindows, the baiting, the change of fashion and the stylelessness of all things."[64] The producer, Naumann writes, understands that making high-quality goods is in his own interest, and he understands this

interest as ideal: "Their own lives and their joy in work are elevated."[65] The merchant's interests are instead monetary and selfish. The high rate of wear and breakage of low-quality goods increases turnover; his motto is "'He who pays fast, pays twice!' When he has sold an article of passing fashion, he says 'Good-bye!' with a light heart."[66] Naumann replaces Sombart's hero with Ruskin's pious craftsman, but the villain, who has the speaking part in this drama, remains the same.

Muthesius examines the issue in his 1908 address to the Berlin Volkswirt-schaftliche Gesellschaft (and he repeats these points in a 1910 speech to the Deutscher Volkswirtschaftlicher Verband [German Union for Political Economy]).[67] His discussions are similarly lacking in detail and nuance, but he makes his point clearly. He considers Ruskin's and Morris's efforts to recreate precapitalist modes of production a case of "throwing out the baby with the bathwater"; clearly, for Muthesius the problem of the decline of the applied arts is not only with production itself, not with "industry" as a whole. This is worth noting. And the alienation of consumption is not presented in terms of an unavoidable historical development but as the hostile tendency of those involved with commodity circulation: "The interruption . . . took place due to the more or less long line of *intermediaries who thrust themselves between producers and consumers*, due to what we call the intermediary trade."[68] This alienation dissolves the bonds of Style, but the mere existence of middlemen alone does not create Fashion. That is instead the active exploitation of this parasitic economic sector: "The public has no desire to see a new wallpaper pattern every season. The desire arises on the path between producer and consumer, i.e. through trade."[69]

Referring to the utterly banal but obviously distasteful fact that commodities have to get from those who make them to those who use them, Sombart once said that "trade is a necessary evil."[70] It was perhaps the nicest thing he ever said about this state of affairs. Desperation had gotten the better of Muthesius by 1917, when he asked, "Can the world not defend itself against the evil influences of trade?"[71]

* * *

The issue here – the crime of commerce, the sin of the salesman – is the insta-bility of the representations surrounding the modern commodity. One might wonder at the vehemence with which guilt was laid at the feet of trade. The reason is no doubt the rapid spread of a type of sign that in fact thrived on a certain kind of instability. This new phenomenon was the overwhelming visual presence of advertising – in newspapers, on billboards, on delivery trucks, on the sides of buildings or even mountains, pressed into the hand at street-corners, arriving unwanted in the mail, or slyly stamped onto the blank field of the German banknotes of the period. It determined the look of the cities (figs. 33–5) and was increasingly visible in the countryside. Since advertising was directed at the consumer, it was, a bit uncritically, associated exclusively with trade and its "spirit": the Jew, writes Sombart, "is a virtuoso in advertis-ing."[72] To follow the metaphors, advertisements were the pox of the latest social disease imported by merchants. It is difficult to grasp the controversy which surrounded this phenomenon at a time when it was not really an accepted fact of life, but could, conceivably, be warded off.[73] The issue was debated passionately and with every imaginable amount of rancor.

In the cultural press, diatribes against the "advertising plague" were legion.

33. Peterstrasse, Leipzig, cover of *Seidels Reklame*, March 1913

34. Blind wall, Wallstrasse, Berlin, 1907 (Landesbildstelle Berlin)

Their flavor can be sampled in one account of a hapless city dweller's attempt to get away from it all, only to be followed by billboards wherever he goes. After "long weeks in the big city . . . after the thousand nerve-shattering impressions of the metropolis," the urbanite sits in his "favorite window-seat in the train." But instead of a soothing view of the countryside, he feels "slapped in the face" by the advertising signs placed there and imagines with trepidation the "unbroken chain of billboards" that is soon to come. He fears that "if this development is not energetically opposed, we will no longer move through our Fatherland, but rather in a giant plantation of advertising."[74] Sombart too joined the fray. He did so in the journal *Der Morgen* (and later, when there was talk of litigation and things got too hot for *Der Morgen*, in *Die Zukunft*); and he wrote expressly as a critic, not as an economist (though it is clear that he felt his credentials entitled him to considerable authority). He contrasts pre-capitalist exchange with the uncontrolled competition of high capitalism:

> It is a characteristic of the pre-capitalist . . . economy that the relations between producer, merchant and consumer are stable and traditionally fixed, that merchant and producer are never put in the position of having to concern themselves very much about marketing their goods, let alone having to coerce the consumer into buying them. . . . We know that capitalism has destroyed this idyll of peace and tranquility and replaced it with restlessness, feverish activity and nervousness. . . . We also know how it has come to this, we know how it is based on the essence of capitalist production, which rushes ahead of demand with its supply of commodities. Because more goods are produced and must therefore be sold, competition (which was unknown to earlier times) develops between the producers and merchants.[75]

35. Loreley butter shop, Neukölln, Berlin, ca. 1913 (Landesbildstelle Berlin)

36. North and south sides of the Neumarkt in Cologne, illustrated in *JDW* 1 (1912)

The free play of forces was taking over the visual aspect of public life: since

> advertising arose with high capitalism. . . it might seem as if it were an internal matter among businessmen [*Händler*]. . . . But the advertisement has a Janus-face: with one head it looks into business, with the other into the street. That is its essence: it seeks out the broad public to trap the fool. . . . Never for a moment letting us out of its clutches, advertising drags us against our will into the most unpleasant machinery of our economic life.[76]

Such discomfort with advertising was well represented in the Werkbund, though usually in milder form and sometimes not even put into words. In the Werkbund *Jahrbuch* of 1913, for example, Max Creutz shows pictures of facing sides of the Neumarkt in Cologne, illustrating, in effect, Style versus stylelessness in architecture (fig. 36). His positive example is Otto Schulze-Kolbitz's new building for the Cords Company, a clothing retailer, his "counter-example" the older buildings opposite. The Cords store is a good example of the advanced architectural taste of the time: the building spans and unites an entire block with a single facade and an unbroken roofline; the facade is marked only by the most restrained ornament and is free from arbitrary interruptions of the rhythm created by rows of regularly spaced windows between widely spaced pilasters. The counterexample shows a block divided up into separate

NORDSEITE DES NEUMARKTES IN KÖLN

GESCHÄFTSHAUS VON GUSTAV CORDS

ARCHITEKT: OTTO SCHULZE-KOLBITZ BERLIN

GEGENBEISPIEL: SÜDSEITE DES NEUMARKTES IN KÖLN

buildings; the roofline is uneven and irregularly broken and the facades are ornamented by a mix of historical styles. This is however not necessarily the most noticeable aspect of the comparison. More striking perhaps is the complete lack of advertising on the Cords building, where even the row of shopwindows at the base is demurely covered by a single line of awnings stretching from one end to the other in the photograph Creutz uses. By contrast, the buildings of the counterexample are checkered with the names of businesses, not all of which are housed in the buildings carrying their advertisement. One building bears a line of text between every row of windows and one atop its roof, a blind gable on the side of another building is painted with a business message, and three of the remaining roofs are topped by scaffolding to hold signs. This was not of course the issue Creutz was addressing in his article, but it is significant that he thought he could stack the deck in this way. Advertising was clearly incompatible with Style.

When the antipathy toward advertising was put into words, it was invariably done so by those who ultimately stood behind Muthesius and his drive toward *Typisierung*. Ferdinand Avenarius, whose journal *Der Kunstwart* was classified by the advertising expert Hans Weidenmüller among the "anti-advertisers,"[77] wrote an article on "Reklame und Kultur" (Advertising and Culture) which rehearsed Sombart's argument though in a more level-headed manner. Again explicitly equating advertising with nineteenth-century liberal capitalism, he writes that advertising's need to disturb exacerbates the problems of the metropolis, and its disruption of "tranquility" (*Ruhe*) is described as a threat to "spiritual hygiene."[78] Avenarius points out that advertising exists less for the good of the consumer than for the good of capital, and that advertised goods are not necessarily superior. His distaste is clear, but he raises some interesting possibilities when he writes that "the loathesome advertisement is only *one* factor of many in our modern civilization which only the fool or the idiot can 'despise' or 'hate,' but whose qualities have spilled out too quickly for a higher power to bring it everywhere into line."[79] Advertising could perhaps be subsumed by Culture, but clearly, as far as Avernarius was concerned, that had not yet happened.

One of the most stubborn of the Werkbund's anti-advertisers may well have been Muthesius himself. While living in England from 1896 to 1903, he had established contacts with the "National Society for Checking the Abuses of Public Advertising," and in 1899 he wrote an article in the Prussian government's architectural journal in an attempt to encourage a similar movement in Germany. Here Muthesius rehearses a litany of shock and disgust that would soon become familiar; it is a fine example of a period genre.

> Among the most striking impressions to which the foreigner is subjected in London is probably that of the unprecedented spread of public advertising. The train station at which he arrives is literally littered with broadsides of the most various kinds; should he walk onto the street, he sees entire building facades covered with giant inscriptions; in the evening, mighty letters assembled out of light-bulbs, alternately illuminated in red and white, announce in the public squares the name of some meat extract or the pills of a quack doctor. The omnibuses are covered from top to bottom with screaming endorsements for cacao and child's-milk, and in the Underground, the eye searches in vain for the name of the station among the flood of senseless billboards. . . .

There is no doubt that London and other English cities owe a good

deal of their repulsiveness to this advertising. The business instinct of the people has overrun all other impulses. . . . The advertising is not confined to the cities. Along the great railroad stretches, in the open country, scaffolds are erected to which broadsides endorsing laxatives, whisky and boot-wax have been attached. . . .

It is not a matter of what is advertised, but how it is advertised. That is what is so reprehensible. . . . Whoever has the money for the most frequent display of an advertisement, and whoever is thus able, quite superficially, to produce the most lasting impression in the human cerebral cortex, sells his goods best.[80]

Letters reveal Muthesius's continued contact with the English organization after his return to Germany.[81] If there are no published statements on the subject from his Werkbund period, that is not surprising: Sombart had provoked considerable controversy by publishing personal opinions about advertising – a subject on which he was required to lecture at the Berlin Handelshochschule – and he extracted himself from the rather ticklish situation only by invoking his right to academic freedom. In his attacks on certain applied arts firms as a lecturer at the same institution, Muthesius was similarly attacked and also defended himself on the basis of his academic freedom. But Muthesius was not only a teacher: he also served in the Prussian Ministry of Trade, where he enjoyed no such liberties. His ministry did back him, but it silenced him too by preventing his official involvement in the founding of the Werkbund. The limits of Muthesius's academic freedom were clearly drawn; after Sombart, advertising would have been too touchy a topic for Muthesius to broach in public.[82] Nonetheless, there are clear indications that his earlier aversion to advertising continued, fully in line with his belief in the culturally destabilizing influence of certain kinds of trade. In 1912 Muthesius led an effort to suppress the publication of an article on "advertising art" in the *Jahrbuch*, and he did so behind the back of the article's chief sponsor, Karl Ernst Osthaus. Osthaus responded quickly to the intrigue, and prevailed.[83] By this time the museum Osthaus had founded with the support of the Werkbund, the Deutsches Museum für Kunst in Handel and Gewerbe (German Museum for Art in Trade and Production), had emerged as essentially a museum of advertising designed by artists, encouraging such activity as the most important way for artists to gain entry into the consumer goods economy. The slow but steady polarization between Muthesius and the supporters of *Typisierung* on the one hand and Osthaus and those demanding the freedom of the artist on the other parallels this development.[84] And within a year of leaving the Werkbund, in 1917, Muthesius wrote again about advertising, which, in his words, had "taken on such frightening proportions that the [following] principle is spoken of as self-evident: one can sell any product, even the worst, if one has a quarter-million to spend on advertising."[85] For Muthesius, advertising had clearly not been assimilated to Culture, and the road to Culture would have to be sought outside of, and in opposition to, the realm of commerce.

* * *

In his 1911 address to the Werkbund entitled "Wo stehen wir?" (Where Do We Stand?) Muthesius describes the state of contemporary architecture and the dangers to Style:

A cabaret atmosphere prevails. One fears boring others by steadfastly advocating what is good. The trend toward restlessness, nervousness, fleeting

changes of mood which is peculiar to modern life has its impact on art as well. The question is whether our applied arts and architecture movement becomes infected or not. The ephemeral is certainly incompatible with the inner essence of architecture, whose inherent qualities are steadiness, tranquility and permanence. . . . The Impressionist attitude which prevails today in the other arts is therefore in a certain sense unfavorable to architecture. . . . The thought of an Impressionist architecture is simply horrifying – let us not even think it through! Individualist essays have already been made in architecture, and they have unnerved us; what then would Impressionist attempts do?[86]

"Impressionism" is the term Muthesius uses to describe a particular modern condition, and the imagery of contagion shows that he considers it a pathological one. Muthesius is clearly not referring only to a current of French art but to a social condition and the way art responds to it. The word was in fact one of the ways the relation between art and the market was thematized at the time.

In Germany, Impressionism was the term used to describe the attempt by painters to capture fleeting, subjective images of modern life, but it was also used – with the emphasis on the aspect of subjectivity – to denote currents we would now classify as Post-Impressionist, Symbolist and Aestheticist. And the range of reference of this word was even wider than that; it was an "attitude," a "trend" of the modern. The term achieved widespread popularity in Germany when Karl Lamprecht adopted it to describe the entire culture of the present in the last volumes of his *Deutsche Geschichte*, and his translation of the word multiplied its meanings into an entire constellation.[87] Lamprecht called the turn of the century the age of *Reizsamkeit*. The German word *Reiz* means "impulse" or "impression," more precisely "stimulation," but also on the one hand "charm," on the other "irritant." This latter interpretation is the one Lamprecht gave to the term: *Reizsamkeit* came to mean "irritability" or "nervousness."

Irritability as a cultural condition was related from the start to the economy: Lamprecht himself saw it as a sort of decadent denouement to the age of "individualism" and economic laissez-faire. But it was art critics more than historians who used the term "Impressionism" to describe the overlap between economy and culture. One of the most important studies of the subject was published in 1907 by the critic and art historian Richard Hamann, a member of the Werkbund. In *Der Impressionismus in Leben und Kunst* (Impressionism in Life and Art), Hamann describes as Impressionist phenomena we recognize from the more in-depth discussions of historical economics and its inflection of cultural criticism.

Impressionism, for Hamann, is the world-view corresponding to the liberal economics of the nineteenth century. He packs all the relevant concepts into a short series of sentences:

The basis of political Impressionism . . . is the modern liberal political conception, the demand of individual liberty, of the elimination of state regimentation, of free competition, free trade and freedom of movement. *Laissez aller, laissez faire*. [Liberalism] demands the atomism of actions as the leading ethos. If each looks after his own interests, competition will insure that both the powers of people and objective achievement will increase, and the sum of public welfare and prosperity will reach a maximum.[88]

This generalized Impressionism breeds in the social sphere of commerce:

> If we ask in which *class* Impressionism can most easily develop, we will have to refer to the *merchant class* [*Händlertum*]. It is a well-known fact . . . that liberalism is the basis of all trade. It is inherent in the role of the mediator that the merchant plays that he is not bound to a particular group, indeed that he stands equally close to and equally distant from both producer and consumer, and that, tied neither to the site of production nor that of consumption, he has greater opportunity for profit the freer the competition . . . and the farther the consumer lives from the site of production.[89]

Hamann identifies the distance opened up between producers and consumers – the locus of the Werkbund's critique of the decadence of modern form – as the space in which Impressionism develops. Like Fashion, Impressionism is the subservience of all values to the flow of capital; it is the indifference to the object produced, the inclination to mere speculation:

> The merchant . . . does not produce, and that is extremely important for the resulting ethos. . . . For him, everything is mere commodity, means without a history, and he is himself only an ephemeral station of this real possession. His true possession is capital, itself indifferent, shifting, valuable only as means. . . . Where capital enters production without the involvement of the owner, there enters most easily the complete indifference to the well-being of those who produce with the capital and to what they produce, which mirrors to a certain extent the pleasure of aestheticism.[90]

And the Impressionist is, of course, the Jew, who is most at home in the metropolis, in commerce, and in the money economy.[91]

Hamann was a respected critic and seems never to have been tainted by suspicions of anti-Semitism;[92] but this is a extraordinary series of statements, though a bit too concentrated to be easily grasped. It certainly does much to illuminate, but does not yet fully explain, Muthesius's remarks. Obviously, Impressionism is no mere stylistic matter, but a way of discussing form under liberal capitalism; yet precisely how is not yet clear.

Some clues appear in Muthesius's mention of the aesthetic criteria of "individualism" and "fleeting atmosphere" as opposed to the classical qualities of constancy, permanence and tranquility. This is how the architectural experiments of Jugendstil were regularly characterized; and in his discussion of "superficiality" and the "excess of the decorative," Hamann takes Peter Behrens's own house in Darmstadt, one of the best-known Jugendstil buildings, as his example (fig. 37).[93] Behrens's house was considered by contemporaries in Muthesius's terms: a caricature of the period "thinks through" the possible results of "nervousness" and "restlessness" and exaggerates the feared anticlassical qualities. The result of this "individualist essay" is a building whose flowing ornament subverts the self-stated aim placed above the door: "Stand firm, my house/ In the turmoil of the world" (fig. 38).[94]

Further, like Impressionism in Hamann's text, Jugendstil was implicated in the phenomenon of Fashion, which was also considered under the category of the anticlassical. In Muthesius's discussion, Fashion was clearly an element of Impressionism: the terms "restlessness" and "fleeting . . . change" are clear signals. In the Werkbund *Jahrbuch*, Richard Schulz connects these concepts by writing of Fashion as the need to have products "which surpass the previous ones in impressions [*Reizen*]."[95]

But Impressionism was more than just Fashion; the economy crept in with

37. Peter Behrens, architect's own house, Darmstadt, 1901 (*Deutsche Kunst und Dekoration* 9 [1901/2])

38. Artist unknown, caricature of fig. 37 from *Künstlerkolonie Darmstadt: Ein Überdokument*

other nuances. When Muthesius wrote of "steadiness, tranquility and permanence" versus "restlessness, nervousness and fleeting changes," he was repeating the characterization of advertising from Sombart's famous article in *Der Morgen*, where the economist discussed how capitalism "destroyed [the] idyll of peace and tranquility" and replaced it with "restlessness, feverish activity and nervousness." Along these same lines, consider the following description of an exhibition of Impressionist pictures written by the aesthetician and critic Broder Christiansen, in which some of the same terms resonate:

> One might blame the general stylelessness of the times on the fact that so many of the best painters today have succumbed to Impressionism. . . . This is [to a certain extent] a repercussion of our exhibitions. The large, quickly changing picture markets necessarily pervert the character of the works of art in that they obscure their goal – to enter a tranquil interior as something permanent. The picture is never at home in an exhibition; as a vagrant passenger it offers itself to the viewers rushing by. It must make its effect quickly, for one gives it but very little time. And it must make an effect, for it does not want to be overlooked and wants to beat the others to it. The artist must adapt his work to these premises of the exhibition. It is adjusted to the moment and makes no resistance to Impressionism. And forgets its original purpose in the petty exigencies of the market.[96]

Christiansen describes painting the way Sombart describes modern advertising: as having a Janus-face. The painting should look into the "tranquil interior" of the home, but must at the same time look into the gallery, which is discussed in the same way Muthesius spoke of the city street: the painting has to sell itself to hurried passers-by who might well not notice it for all the clutter and din. The modern painting and the advertisement each face the same rest-

less, nervous, over-stimulated viewer. In relating modern aesthetics to commodity exchange, critics describe Impressionism as form that – to its detriment – adjusts to the fleeting, indifferent glance of the urban consumer. To Muthesius's eye, as to Hamann's, Impressionism reproduces the urban glance that advertising addressed; to Christiansen's, painting responds to the conditions of the market by itself becoming advertisement. In either case, Impressionism is an "evil effect of Commerce."

3. PRODUCTION AND VISUAL FORM

> It wouldn't hurt you . . . at all to visit . . . a workshop. I find that
> one cannot understand a commodity if one has no conception of
> its origin.
>
> Friedrich Naumann[97]

In the orbit of the Historical School of Political Economy, the romantic anti-
capitalist sense of alienation as the loss of access to a common spirit was
refined and restated as the loss of access to the totality of an economic system.
In the Werkbund, this alienation from a spiritualized economy was located at
the point of the (bourgeois) consumer's confrontation with the mass market
commodity; in this the organization was undivided. And among the members
of the Werkbund who stood behind the theoretical and practical projects of
Typisierung – and it is they who set the tone of the discussions and who devel-
oped the corpus of ideas that is usually recognized as the legacy of the
Werkbund – the problem lay in the cultural repercussions of the commercial
sector of the capitalist economy. The attempts at reform which led to the pro-
posals of *Typisierung* as a way of de-alienating a cultural economy are the
subject of the rest of this chapter.[98] For the sake of clarity, we can draw a
rough distinction between on the one hand formal or visual measures, and on
the other economic or business measures to address the fallen state of capital-
ist visual culture. I will addressed the former category first, though it should be
borne in mind that the two categories are inseparable.

The question is the visual form Style would take, how it would look. It is
one of the questions begged by Simmel, for one, in his essay on Style. A possi-
ble answer, however, emerged from the consideration of the problem of alien-
ation as alienated consumption. Though Scheffler's sensitive account of econo-
my and totality showed that there were other possibilities, these discussions
were marked by a strangely self-conscious tendency to fetishize – by the will-
ingness, indeed the open desire, to let the subject's relation to commodities
replace the acknowledged problem of the relations between people or classes
and therefore a tendency to let a matter of vision and the senses replace an
analysis of society. Thus we find that consumers are discussed less as estranged
from *producers as subjects* as from an abstract, reified notion of *production as
a process*.

This becomes evident when we compare Scheffler's account with one very
similar, in this case by Adolf Vetter, a member of the Werkbund from the
Austrian government. Like Scheffler's, Vetter's economy is the one divided
into neat stages by Bücher. "Let me cast a glance at the history of the human
economy," said Vetter at the 1911 Werkbund meeting, and then narrowed his
focus: "a glance at the history of the commodity." What he meant was the his-
tory of the subjective relation to goods consumed. The household economy is
characterized by an intimate relation to these objects: "Raw materials are
processed at home, the product created at home and the consumption com-
pleted within the house. Widespread labor skills, multifaceted capabilities and
understanding result as a matter of course."[99] Under such circumstances, "all
work is, and can only be, quality work."[100] Here "Quality" (*Qualität*) is the
result of the consumer's awareness of or involvement in the making of things,
her or his physical closeness to production.

The making of one's own goods in the household economy is replaced by
the production for clients in the city economy: "The goods produced in a city
are sold by the producer himself. . . . As much as possible, things are bought

publicly and first-hand."[101] Later,

> Out of the city economy, the national economy, even the world economy develops. . . . [Q]uality work must lose its power. . . . The new era, with its large-scale enterprises [*Grossbetriebe*] resulting from the joining of capital and machines, with its separation of the producer from the consumer, must see one safeguard of quality work after another disappear. . . . The necessary use of surrogates is . . . encouraged by the dwindling technological knowledge of the buyers. The new era has brought us many new raw materials and an even greater number of new ways of processing [them]. What the competent woman could once understand and judge – the nature and origin of a commodity – is today a science of such scope that the individual can no longer master it.[102]

The city economy was for Vetter the last social configuration in which well-made goods were produced for informed consumers, in which Culture centered on production to which the consumer had sensuous access through the product itself.

At an earlier Werkbund meeting, the architect Theodor Fischer spoke of the same issue, though in isolation from the historical matrix otherwise so central to the discussions:

> Is not aesthetic enjoyment inseparably linked to a certain empathic experience of labor [*ein gewisses Mitarbeiten, Miterleben*]? Do we not distinguish connoisseurship from philistinism through the [connoisseur's] conception of how the object is made and [his ability to] reexperience its making? And is not the nadir of taste [today] to be explained precisely by the fact that our nation . . . has become incapable of empathically experiencing the production of that which is beautiful?[103]

Fischer's retreat from the economic context to the creative act was rare; more common were analyses like Vetter's, which attempted an interpretation of the physical interaction with everyday commodities using the terms developed in the Historical School. In either case, however, one thing was clear: any solution to the problem of alienated consumption would have to overcome the distance from production and the resulting estranged relation to the physical form of the commodity. In other words, the ground had to be laid for the reemergence of "quality work." J.A. Lux wrote in 1908 that "the so-called artistic problem of industry is at the same time the problem of Quality. This word has assumed a hypnotising power these days. It seems to contain the program of the future."[104] But was Quality possible on the industrial scale sought by the Werkbund? Lux thought not. As soon as one realizes what technical quality, strictly considered, really involved, he wrote, one sees the impossibility of its large-scale profitability. One example:

> The obligation to deliver quickly, imposed both by buyers and by competition, renders it impossible in the furniture business . . . to allow the production time necessary to achieve Quality. Whoever knows that the varnish on veneered furniture (presupposing [the use of] wood that has been dried for years) must stand for months in order to be firm will hardly expect much Quality with a delivery time of four to six weeks. A little skepticism is in order with respect to the usual assurances of Quality.[105]

Industry had only one potential, and that was to change the *appearance*, not the quality, of objects: "But in the main, the development of Culture does in fact depend on industry. It alone has the power, when it comes to form, to

spread good taste with decisive success, to change in one sweep the physiognomy of everyday life."[106] Lux strikes an ambivalent note. "Taste" was possible, but "Quality" at an industrial scale was out of the question. Only formal, not technical, issues could be addressed.

Lux knew what he was talking about; as far as he went, he was certainly right. But there are indications that Lux was being too literal-minded in dismissing the possibility of Quality out of hand. Like many terms the Werkbund used to describe its project, this one had other resonances and other potentials, and could slide from one pole of meaning to another. For in fact most members of the Werkbund did not distinguish between formal and technical concerns when speaking of Quality – a distinction which might seem implicit in the word itself. In his Werkbund address, Fischer gave the following definition: "Usually the word is an expression of a positive, good characteristic of an artistic or industrial object, good in the sense of the materials used and the technical execution, and good in the sense of form and color."[107] Similarly, Muthesius wrote that Quality "could not be exhausted with material solidity, least of all in those areas where beauty is of importance."[108] Quality could be a matter of form, and thus no different from Taste, which could "change . . . the physiognomy of everyday life." Both terms were synonyms or inflections of Style, the loss of which Osthaus had traced to the increasing distance from the "becoming" of objects.[109] In other words, Quality, defined as the overcoming of the estrangement between consumption and production, could be achieved, like Style, through signs or representations.

Quality as a sign pointing the way out of Fashion and through the crooked path of trade is the context in which "truth to materials" was most often discussed in the Werkbund. One of the group's earliest projects was to initiate the publication of handbooks on the nature and use of materials in production, the so-called *Gewerbliche Materialkunde* volumes (Industrial Material Primers). For the editor, Paul Krais, the books represented one way of addressing "issues which do not depend on Fashion."[110] Vetter waxed eloquent on the issue of material, seeing it as the basis of Style:

> To have Style . . . means: to express what one is in a visible, understandable and honest way. . . . The forms of expression that we seek are often modest and not infrequently more valuable the simpler they are. In their truth, authenticity, solidity – in other words in the correspondence of appearance to reality – we see their most important element, bringing and raising the level of Culture. We demand what I once called "the three truths": the truth and honesty of the creator to himself; then honesty with us . . .; finally truth to the material, authenticity not only to costly material, but truth in the sense that every material is given the form that corresponds to its qualities, so that it is recognizable as what it is: gold as gold, but also brass as brass, iron, stone, cement, leather, paper as that which they really are.[111]

Yet it would be misleading to stop here, for truth to materials was not an end in itself. Material was often discussed not as a matter of substance but of signification, of the use of form as sign to bridge an absence (which it simultaneously betrays). In this case, the absence – no secret – was that of production in the experience of everyday objects. The "truth" of materials, that is, was not simply a physical fact to be revealed; it was a complex meaning that had to be constructed. Fischer says as much in the address just quoted. He begins by warning against allowing material (as well as function) too large a role in determining the form of an object:

We have long been caught in the error that the three fathers of form [function, material, tools] must retreat behind the decorative idea. But for the most part today we have progressed so far in other directions that we are in danger of falling into *another* kind of one-sidedness. In our creations we give nearly unlimited license to *function* and *material*. That the *tool* also determines form is remarked much less often.[112]

Fischer proceeds to point beyond truth in materials to a truth in production as a process: "I do not want to speak of form which emerges from the material . . . but of form in light of what I just said about the tool, form [which emerges] from the manner of production and which can be explained in light of the tool used."[113] Fischer's distinction is not in itself curious (it follows from Semper's categories), but his insistence on assigning relative value to "truths" certainly is, unless one bears in mind the contemporary equation of production with cultural totality and of its absence with alienation. Fischer insists here on the need to advance beyond materials to a larger truth.

It is Muthesius who spells out most clearly the cultural role of production as sign and of such signs as Style. Addressing the Volkswirtschaftliche Gesellschaft (though he said and wrote these same things elsewhere), Muthesius states his starting point: the contemporary truism that "the essence of handcraft is individualization, that of machine work is schematization . . . [and] exact reproduction."[114] There are already echoes here of Simmel's extended discussion of Style which was discussed in the previous chapter, and it is worth summarizing Simmel's argument to see how Muthesius builds on similar ideas only to arrive at different conclusions. Simmel equates Style with industrial mass production by taking reproduction to be its essence and simplification to be its corollary. But while reproduction was a technical matter, simplification was not: the schematization of form served not to streamline production but rather consumption – to facilitate the use of objects by the largest possible number of individual users. And by the purchase and display of identical forms, subjects in a society could be united by sharing references to the same model, and thus (here is the weak link) signs of the same spirit. This is the utopian flip side of industry's ability to reproduce any form and the business need to appeal to as large a market as possible. Style as Simmel describes it is the industrial generation of the "with-many-shared," of forms suited to distribution; it is a sort of collective ownership of symbols.

Thus far, Muthesius would have little to argue over with Simmel. But Simmel balks and goes no further when it comes to an issue close to Muthesius's heart, the issue of industrial production. Production figures in Simmel's thinking only as *re*-production – it simply multiplies a model, and nowhere is that model defined or are its properties explored; it is a common denominator, but, as in a mathematical equation, it is simply factored out. The model disappears, becoming an abstract "Idea" whose appearance is ultimately arbitrary as long as it can function to generate the signified "Style" by the distribution of identical signifiers.

In a late text – *Handarbeit und Massenerzeugnis* (Handcraft and Mass Production) of 1917 – Muthesius seeks to refine the views he represented in the Werkbund and makes clear the central role of production in Style. At the same time he (finally) provides the positive moment of his protofunctionalist aesthetic of *Sachlichkeit*, the first and negative moment of which was the neutralization of Fashion by the neutralization of signification. Muthesius begins, like Simmel, with reproduction:

> The machine has enabled us to repeat the same object hundred- or thou-
> sandfold, to make exact mechanical copies in countless numbers. . . . The
> fundamental result of the introduction of the machine in production and
> thus the true difference from earlier times is the mass production of fully
> identical commodities in place of the earlier individual production.
> Through mass production, an entirely new kind of commodity enters com-
> merce, a species which did not exist before.[115]

Muthesius then takes a step back from the market and restores to production
formal criteria. The model is not considered in terms of an abstract "Idea"
(which in Simmel's hands is algebraically eliminated) but is given very real
properties – density, texture, hardness, malleability:

> Since the goal with all techniques is the multiplication of a model
> [*Grundform*], everything is dependent on the nature of this model; it is the
> mother of the hundreds of thousands of offspring hurled out by the
> machine. The model, however, must as ever be made by hand. For example
> all cast metal parts that are to be manufactured demand the prior manufac-
> ture of a model in a workable material (wax, clay, wood) according to
> which the matrix or the mold is made. . . .
>
> While earlier crafts worked according to the criteria of the object
> itself, other factors come into play with mother-forms for mass production.
> They must be formed in such a way that multiplication can be achieved on
> the basis of them. This is necessary because machines have certain limita-
> tions. Certain bevels, certain curves and edges cannot be punched or
> pressed. Or they cannot be cast, if the mold is not to be destroyed.[116]

From reproduction, Muthesius moves back to production, restoring sensuous
presence to the model – which regains its authority as an artifact, an original –
and to the nature of its interaction with the mechanical means of reproduc-
tion.

At first, machine form is described in terms of technical contingency;
Muthesius implies that machine-produced form *must* look a certain way: "The
necessity of the machine, the movement of its parts in predetermined direc-
tions . . . leads to a clearly recognizable limitation in the forms of machine
products. Thus the recourse to basic mathematical forms such as the cylinder
and rectangle which we observe in mechanically produced machine parts."[117]
But that "must" turns quickly into a "should" or an "ought," for no one ever
disputed that mass-produced items could imitate, indeed effectively, handmade
work. At issue was its "untruth." We are back to "truth," which Muthesius
constructs as follows:

> The manufacturing machine is . . . limited only in a certain direction; in
> another it is superior to the human hand. Precisely this necessity, the
> unshakeable uniformity and precision of its movements, creates a mathe-
> matical rigor which was inconceivable before. . . . Accordingly, machine
> work embodies in opposition to handcraft the smooth, spare, unornament-
> ed form with the utmost clarity and precision in manufacture.
>
> If such essential differences are present, then it follows that the goal of
> manufacture should be to grasp the special characteristic of the mass prod-
> uct and to elaborate it to perfection. That is a principle that is self-evident
> in every human endeavor.[118]

Muthesius writes not of technical necessity but of the representation of the

"essence" of technique, the definition of visual *references* to mass production and their refinement into a formal idiom. He describes the refinement and foregrounding of signs of the production process itself as an alternative to the formal effects of commerce (which demanded the imitation of hand labor). The result is Style: the signs of production are transcendent, because

> It is not handcraft, but rather machine work which prevails in our life today, which surrounds us at every step, which is economically decisive. . . . [I]t has become a primary promoter of Culture, has made available means of creation, has given freedom to those without means; and since all rely on the same objects it has prepared the way for the levelling of classes. Through its scientifically clarified, everywhere identical and thus everywhere appropriate form, it helps direct thoughts in the same direction, to unify forms of life and thus gradually to bridge over the existent contradictions.[119]

As for Simmel, Style is the unity of shared signs, but for Muthesius the vectors of signification do not move peripherally from owner to owner but centripetally to the literal model and to the indexical signs – abstracted and intensified – of the very making of the commodity. Muthesius seeks to ground Style, to rescue form from its semantic vagabondage through the paths of commerce, to give form a single, concrete referent. In the process, the transcendence usually attributed to the model is transferred to production itself.

For Muthesius, the signs of industry are Style. Industrial production is taken to be a transcendent totality which materially unifies all aspects of modern life and is capable of doing the same thing spiritually by the generation of its own set of representations. In line with other discussions of Style, the alienation from production is overcome by the surface form of the commodity. Production – or rather, its depersonified, declassed signs – could thus be perceived on the market, which had earlier obscured it; it could be brought into the home, which thus regains its visual connection to an economic totality. Since trade, it was felt, failed to mediate a sense of wholeness, production would have to reinvoke Culture. But since production did not figure in its human form – as labor – in this realm, it had to be distilled into a sign; it had to be recouped through Culture in order to redeem Culture.

* * *

Generating signs of production was one thing; making sure that they were distributed and read as such was quite another. Since forms, like the objects that bore them, had to move through the institutions of trade, Quality could only too easily turn into Fashion. Even the word Quality entered the market as another mere advertising phrase.[120] But the problems were deeper, structural. For the commercial institutions of capitalism were not only obscuring the traces of production, they were becoming completely independent of manufacture, putting products in a new and alienated context. Sombart noted this aspect of the visible development of commodity exchange. The "grouping of commodities in the store" had earlier been arranged "according to the origin of the goods." The "new store," however, is "grouped according to function. . . . In other words, there develops an arrangement of commodities according to their determined end, *according to their function in consumption [nach dem Gebrauchszwecke, nach dem Bedarf]*." The result is "a certain indifference with respect to origin."[121]

One way the members of the Werkbund sought to address the problem of commerce was by turning the retail institution, which had direct contact with

the final consumer, back into a realm that would be transparent to signs of production. Muthesius described the problem in this way:

> How is it possible to mold these many intermediary instances between producer and consumer in such a way that they instruct the buyer, as once the producer did? Is it possible and advisable, for example, to eliminate the intermediary instances? I do not believe we can count on that. I believe that these intermediaries will remain, and that we can only educate and instruct them in such a way that thay are technically schooled and that they consist, in every single branch, of people who understand most intimately the branch and the technical production of its products.[122]

Muthesius identified the first of two points at which reform of the retail trade was to be addressed: the salesman. The strategy was to turn the salesman from a mere mediator of capital – fashion for money – into a bearer of the symbols of production, the symbols of redemption. For Naumann, "the salesman represents production in the public," a role, however, in which he had failed:

> Buyers know only in the most seldom cases whence the goods come; often when they ask, they are purposely not told. The buyers have never seen how things today are woven or dyed or pressed or smoothed. How can they judge if something is properly made? They put themselves in the hands of the store's buyer. But even here . . . they deal only with the young man or lady behind the counter. All questions are directed to them and answered there. But – how are they answered?
>
> Earlier, in the handicraft workshop, each side learned from another when an item was ordered. For most things now these times are over, and the resulting gap has not yet been filled.[123]

While identifying the commercial businessman as the cause of Fashion, the Werkbund seemed nonetheless willing to proselytize, to try to bring the errant merchant into the fold: "The businessman . . . has a task for Culture, whether he will serve it or not. He distributes good or bad things for [everyday] life. He is the educator of the buyer. Without him, no spiritual movement can succeed, not even the German Werkbund."[124] To teach the salesman how to teach the consumer, the Werkbund organized lecture series on the "taste education of the businessman" in cooperation with local chambers of commerce and a national association for the education of commercial employees. They sought, in short, to instruct sales personnel in the recognition and transmission of signs of production. Carl Schaefer of the Werkbund, who had earlier arranged a lecture series of his own in Bremen, stressed the need to address the issues of the "evaluation of workmanship and material, the distinction between factory work on the one hand and handcraft on the other, each presupposing a different [kind of] beauty as the result of its activity."[125] Werkbund members toured the country in 1909, speaking on "The Necessity of Taste Education for the German Businessman" (Muthesius), "Dwelling and Household Goods" (Erich Haenel), "Useful and Luxury Objects" (Schaefer), "Fashion and Taste" (Else Oppler-Legband), "Textiles" (Krais) and "Shopwindow and Interior Decoration" (Osthaus).[126]

The second point of attack was the shopwindow, which Osthaus had identified as a locus of alienation in that it "shows us the commodity, and not [its] production," robbing the consumer of the "indispensable feeling for Style."[127] In his primer *Der Geschmack im Alltag* (Taste for Every Day), Lux discussed how the display of commodities was rendering their (production) nature

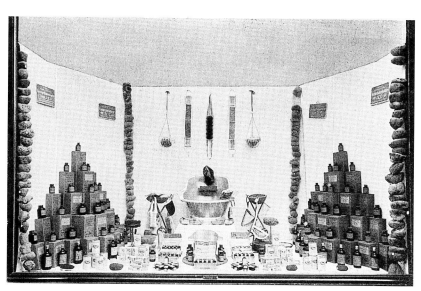

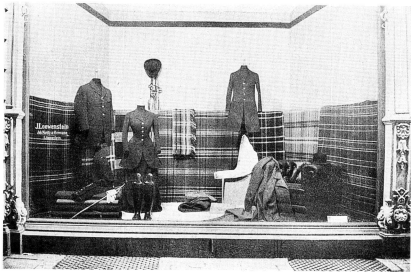

39. Shopwindow decorated by students of the Höhere Fachschule für Dekorationskunst for the Parfümeriefabrik Kopp & Joseph, Berlin, illustrated in *JDW* 2 (1913)

40. Shopwindow decorated by Julius Klinger, Berlin, for J. Loewenstein, Hagen, illustrated in *JDW* 2 (1913)

41. Shopwindow decorated with Bahlsen *Tet* packages, illustrated in *JDW* 2 (1913)

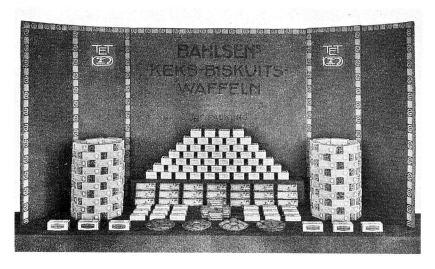

opaque: the shopwindow decorator "wants to offer the passers-by variety and entertainment, to enhance the advertising function of the shopwindow. Under his hands it quickly becomes a small stage on which he exercises his pictorial fantasy. Silk is then no longer silk, boots no longer boots."[128] Lux is echoed in the *Kunstgewerbeblatt* by Paul Westheim:

> A sugar loaf can certainly not look like a sugar loaf. It is given a few strings and hung as a carnival balloon. What is a bath sponge? As beautiful . . . as it may be, it becomes "stylish" only when dismembered and made into a clown or some other monster. In Leipzig I recently saw silk slips pour out of a drawer in a display case, and costly petticoats were hung as if by a washerwoman on a line. This way of turning a shopwindow into a panopticon spectacle is ideological. Ideological because they are based on a superficial, preconceived and alien notion that stands in no relation at all to the commodity. The saleable object is violated and corrupted.[129]

Of course, without creating another "scene," the shopwindow could not show production; that could be done only by the commodity. But contemporary displays were failing to let the object speak for itself. As in the Historicist or Fashion object, the truth of the material was being ignored in the shopwindow in the attempt to achieve a theatrical effect and thereby to attract the attention of the urban subject. To recreate the basis for Style, it was felt, the Werkbund needed to reform the principles of commodity display. In addition to lectures on the subject, they sponsored shopwindow competitions in several cities, placing their members on the juries, and in 1910 they founded a school, the Höhere Fachschule für Dekorationskunst, to teach "tasteful," "*sachlich*" shopwindow arrangement.[130] Their activity was not without success: they instituted a new look in shopwindow design which apparently caught on, no doubt because its formal principles were so easy to imitate. The Werkbund shopwindow was non-narrative: attempts to show the commodity in a scene, real-life or fantasy, were shunned. There were no elaborate props for the goods, and the goods themselves were not props for a plot. Close to Westheim's heart would have been the no-nonsense treatment of sponges, simply stacked and revelling in their natural irregularity, in the school's display for Kopp and Joseph perfumery in Berlin (fig. 39). To combat the deployment of commodities as signs of Fashion, the human figure – or, in the case of clothing stores, its head – was banned from the shopwindow: the buyer was offered no mirror in which to recognize him- or herself in the consumer imaginary, or to misapprehend a similar-looking member of the next higher class (fig. 40).[131] Robbed of narrative, the decorators resorted to geometry, and usually symmetry (fig. 41). Yet while the arrangements sought to short-circuit the semantic overload of Fashion, of gimmick and advertising, they found in most cases no signs that would speak clearly in their stead. The windows are, for the most part, not only controlled but also mute; the goods show themselves – their form and their material, perhaps, should the viewer care to look – and say no more.

One will not be able to shake the sense that these measures – among the most publicized of the Werkbund's activities – are both too tame and too pious. Commerce – the parasite, the necessary evil – was not going to be cured or converted by evening lectures on aesthetics and business ethics. As for the shopwindow: perhaps it could function as a frame for the commodity as a sign of production, but even the sympathetic critic Paul Westheim could hardly stifle a yawn: "A decorating principle . . . that is entirely based on *Sachlichkeit*,

that shuns any accessory in order to allow the commodity alone its effect, must necessarily refer in a more emphatic way to the object for sale. [But] it seems that things have already gone a bit too far, that a certain uniformity, not to say boredom, has become unavoidable."[132] For Westheim, the semantic control of commerce had crossed the line to semantic absence in general. No matter how one looked at it, that wouldn't sell. Fortunately there were other ways of letting production speak and of bringing trade to its knees.

4. Production and Economic Form

> At all times it has been custom to *force* dissenters to accept conventions and *to dominate by means of conventions*. But what convention is there today whose power we acknowledge? What convention do we allow to dominate us "spiritually"? . . . Is it the people? Is it the bourgeoisie? Capitalism? Do they have in them the style-forming power that we so, oh so deeply long for?
>
> Fritz Hellwag[133]

> Are there connections between the characteristics of an economic system and accomplishments in the applied arts? Yes, I think so.
>
> Werner Sombart[134]

The Werkbund was fighting for visual control of the marketplace. And while they fought over the market, the market itself was a battleground. Precapitalist and capitalist forms of production were struggling to maintain their existence or to achieve the critical mass of return on investment; at the same time the picture was complicated by the presence of all kinds of hybrids between traditional and modern enterprises as well as the emergence of new, some thought postcapitalist economic forms. Muthesius, Naumann and those who followed them in the Werkbund conceived of the struggle as being between production and trade, and in this they were certainly not alone. For Victor Mataja, who wrote the book on *Handel*, the conflict between these sectors of the economy was "the domestic war of capital."[135] He also wrote that "whoever has the market in his hand has the vital nerve of industry in his hand," and it is clear that these members of the Werkbund, like Sombart, thought that trade had gained the upper hand in the civil war and controlled the all-important consumer front.[136] They sought therefore to put their full energy behind the quickest possible development of the capacities and power of industry, which they saw as an opponent to commerce.

For Muthesius, the relation between industrial production and visual form led to the heart of the development of the machine aesthetic, but, as I have tried to show, not out of technical romanticism or even out of a sense of technical necessity. Instead, this aesthetic sought to redress the contradictions of the cultural economy. But a more ambitious goal of the Werkbund, it will be argued here, involved a consideration not of *technical* form but of *economic* form. The relation between art and industry did not have to be simply a matter of the forms machines could make; rather, industry was conceived as an economic force which could fundamentally change cultural conditions and could thus radically alter the way visual form operated. This was a more complex and mediated sense of the relation of form to industrial production, one called for by Sombart when he wrote that "the attempts to treat the problem of the applied arts from an artistic or technical point of view are numerous, while to my knowledge no serious attempt has been undertaken to do justice to the economic problem of the applied arts."[137] It is the Werkbund's attempt to consider the relation of aesthetic form to industry as an economic problem, and not a technical one, that must be traced.

If the technological form of "industry" was mechanized mass production, its economic form was that of the *Grossbetrieb*. The term means something on the order of "large-scale enterprise" and was understood as a capitalist form

with some specific characteristics: a large number of employees (a firm with one hundred employees was a *Grossbetrieb* by the standards of the day; so too was the AEG with tens of thousands); division of labor and mass production; the separation of management from production, and often of ownership from management; and the goal not merely of sustaining those involved but of the accumulation of capital. Though the objects at issue in the Werkbund did not necessarily have to be produced by *Grossbetriebe*, this was of course the essence of their project: the integration of the artist into the capitalist economy, the mass production and distribution of Style. In the words of Robert Breuer, who took over Muthesius's column on the applied arts for the yearbook *Die Weltwirtschaft*, "The applied art of the future will be nothing but the best and therefore economically most profitable commodity of the *Grossbetrieb*," while the *Kleinbetrieb* will "exercise no appreciable influence on actual production. Decisive will be only the achievements of big capital [*Grosskapital*]."[138] The issue of what the *Grossbetrieb* could do was the issue of what capital could do. The term moved beyond its economic origins with a book of 1892 by the economist Schulze-Gaevernitz titled *Der Grossbetrieb* (and subtitled "An Economic and Social Advance").[139] Schulze-Gaevernitz's point is predictable: the book is a liberal argument in the Naumann vein for the stabilizing influence of economic growth coupled with progressive social policy. In 1907 Schulze-Gaevernitz himself brought the concept to the doorstep of the reform movement. In full awareness of the developments leading to the founding of the Werkbund (which he would join) he invoked the aesthetic power of large-scale industry in a speech on "Culture and Economy" before Naumann's Evangelisch-Sozialer Kongress (Evangelical-Social Congress): "May the machine bring a beautiful life deep into the broad middle class and, beyond that, into the world of the worker! And may the modern applied arts *Grossbetrieb* thus become the bearer of a popular longing for beauty!"[140]

Others in the Werkbund were more specific about the relation between the economic form of the *Grossbetrieb* and modern design aesthetics. Scheffler saw the economic power of the *Grossbetrieb* as central to the unity of Style in architecture:

> The large blocks between four streets can no longer be built by speculators and small-scale entrepreneurs, but only by the highly capitalized *Grossbetrieb*. The conception that strives toward uniformity requires, in the end, the large building company that would build uniform blocks where today individual houses are built. In this way the building speculator – who builds in so infinitely cultureless a manner – disappears, . . . and the aesthetic will profit from this centralization of economic power.[141]

And in his 1915 study of the furniture industry, Alexander Schwab looks at the economic implications of the new desire that "all objects that are brought together in a room harmonize. . . . [that] the current concept of Quality implies unity.[142] He looks, in other words, at the business form best corresponding to Style. Two factors, he finds, make the traditional economic unit of the individual workshop incompatible with Style and make the *Grossbetrieb* necessary. First, only the *Grossbetrieb* can achieve the degree of production diversity necessary to lend a common visual denominator to a large variety of products:

> The matter becomes . . . difficult for the craftsman in that not only carpen-

try but a large number of other things that belong to the furnishing of a
'Culture-apartment' (as it is called in Berlin) must be subordinated to this
requirement of unity: heaters, curtains, vases, quilts, light fixtures, carpets,
clocks. The manufacture of all these different objects requires the coopera-
tion of various craftsmen.[143]

Visual *Zusammenhänge* require the common control of production. Second,
"the unified, total character can only arise through the unifying achievement
of the designing artist," of "expensive artistic personnel" whose services
required an investment beyond the capability of the traditional craftsman.[144]

That the *Grossbetrieb* was the business prerequisite of the Werkbund's
goals was clear, but some members of the organization went further. For the
Grossbetrieb itself was not a static economic form: contemporaries noted that
the move to this organizational form, seen as an inevitability of capitalism,
had gathered its own momentum. Firms were getting bigger, swallowing
smaller firms, merging with other concerns, or dividing up markets by forming
cartels, syndicates, fusions and trusts. An ever smaller number of companies
was controlling ever larger markets, sometimes establishing monopolies. Some
at the time reacted with alarm, but others were entranced by the concentration
of the power of capital. And many members of the Werkbund saw the move-
ment toward concentration as leading to a complete and long overdue reorder-
ing of the economy in ways that, to them, represented the rebirth of economic
conditions conducive to visual order, Quality and Style.

The attraction of cartels, trusts, and related economic forms becomes clear
with even the most cursory glance at a contemporary account of the phenome-
non; here I have taken a brief introduction to the subject by an associate of
Naumann, Richard Calwer. For Calwer, the essence of the various forms of
concentration is the voluntary surrender of a certain amount of business free-
dom in exchange for the absence of competition from other firms, a guaranteed
and constant rate of production, and a secure and protected market share. For
the price of the submission to a controlled market, a business's existence was
secure. Various forms of cooperation were possible: a cartel might agree to
adhere to common conditions in order to even out competition; it might fix
prices or production levels, or both; it might divide a market and allocate
shares to its members; and it could use its combined power to undercut those
firms that refuse to submit to its dictates. A syndicate or ring represents a closer
combination: the individuality of the members disappears as a single apparatus
is established for the purchase of raw materials and the distribution and sales of
the product. And a trust represents the fusion of formerly competing firms into
a single large, collective enterprise. The trust, if successful, becomes a monopoly
with absolute control of the market for certain commodities.

The move toward combination represents to Calwer the rejection of the
principle of laissez-faire capitalism and of the competition of individuals:

> As certain as it is that industry requires complete freedom for its expansion,
> it is also certain that at a particular level of development the free play of
> forces must fail; and that the way to economic progress lies not in competi-
> tion, but in the fusion of rivals. . . . The talk is no longer of "free competi-
> tion" and "full autonomy of the individual," but rather of the "fusion of
> former rivals in the pursuit of common business interests."[145]

In the areas of economic fusion, "large industry has ruthlessly, and in general to
the advancement of the German economy, broken with economic freedom"; in

doing so, they are reversing the logic of liberal capitalism, moving "from the so-called absolute freedom to a new connectedness."[146] The cartel is "the only possible and correct form for the progressive development of economic life" because it overcomes the problem of laissez-faire and the roller-coaster rides of business cycles: fixing prices "leads out of the anarchic conditions that existed in the era before cartels, into a period of regulated production in which the existence of industrial firms is no longer threatened by the free play of wild competition."[147] The cartel represents the reemergence of economic activity as a perceptible part of a totality and the transcendence of the private profit of the capitalist for the good of this (vaguely conceived) larger whole:

> The individual factory owner who is not in a cartel must rely on more or less subjective impressions in the planning of his manufacture. The cartel, however, is grounded in a detailed knowledge of the total market for a particular commodity. For the cartel, the interests of the individual company are no longer decisive, rather the collected interest of an entire branch or industry. It is a *factor which regulates production*, taking it out of the narrow frame of private business, and it becomes an economic factor that . . . no longer thinks in the short-sighted, self-serving way of the middle-sized or large isolated factory owner who only considers his own interests, though the important interests of the competition may be hurt or unheeded.[148]

Concentration replaces an ethic of speculation and private interest with one of efficient and organized production.

The terms with which the move toward concentration was discussed both echo and address the Werkbund's critique of capitalist production. It is therefore not surprising that the issue was raised there regularly and in depth. When the word "organization" appears, this is what they were referring to. In the *Kunstwart*, Johannes Buschmann wrote that

> If "individualism" was [once] the slogan for all intellectual endeavors, the slogan for economic aspirations is now "organization."
>
> The word "organization" covers the most various phenomena. It designates the essence of modern business, which unifies production that has been atomized by the division of labor, and it is also the philosophy of the economic unions which extend over the individual business: the rings, cartels, trusts.[149]

The word "organization" made it possible to speak vaguely, as Muthesius preferred to do: note how the cartel sneaked into his 1911 speech "Wo stehen wir?" under this guise. "A severe trend," he said, "is present in modern social and economic organization, a trend toward the subordination under leading principles, the strict ordering of every individual element, the suppression of the inessential in favor of the essential. This social and economic tendency toward organization has a spiritual affinity with the formal tendency toward organization in our artistic movement."[150] Muthesius presents "organization" as an ally of the applied arts movement: tying art to the *new* economy would be the antidote to Impressionism (which reflected an outdated laissez-faire). Karl Scheffler elaborated on the issue in a way Muthesius never did, moving without a hitch from the necessity of the *Grossbetrieb* to the desirability of the trust. He saw "organization" as the solution in architecture to the complex of problems we could call Fashion, individuality, Historicism or even capitalism itself:

> Capital is the cause of the decline, of all the sins and inadequacies of modern architecture; but it appears that the transitional period of capitalist confusion is drawing slowly to a close, as if the higher, organizing Idea of capitalism is slowly revealing itself. At first, the only thing that mattered in the new Germany was to amass riches; now power appears beside riches, and with power, responsibility. For power can only be maintained when it has the best interests of the whole in mind. Till now, capitalist power has changed masters from day to day, and thus it served only the ego; now, however, this power has begun to become concentrated, and thus aristocratic. As an example, we can refer first and foremost to the formation of trusts. These trusts unify ever greater capitalistic power, attracting the most competent people, and thus put an end to the profligate individualism that is the most serious obstacle to new conditions of Culture.[151]

Economic fusions became both the road to and the figure for the spiritual unity of Culture or Style.

The cartel or trust was seen to bring back in modern guise an economic form that had generated Quality in the city economy: the guild. For Scheffler, a "modern guild spirit [*Zunftgedanke*]" was "heralded by the formation of rings and trusts."[152] Both the pre- and postcapitalist forms, he wrote, have the potential to suppress competition by placing limits on self-interest and thus to impose an ethical economy. But this was in no way an automatic result of economic concentration. In the modern organizations, "the talk is only of prices and trade profits, . . . never of professional ethics." It would be a separate step to "introduce the morals of the old guild spirit into these modern cartels, to bind each member not only to 'business,' but also to ethics."[153]

What bound the concentrated forms of the capitalist *Grossbetrieb* with the medieval guild was the power to impose an order on the market. If the guild could simply legislate quality by instituting rules, the cartel could recreate the conditions conducive to Quality by using the power of production to prevail over the machinations of trade. Thus the new forms of economic concentration were evoked as the wrath of industry on an errant *Handel*. When the economist Walter Troeltsch suggested that Fashion could exercise an "educational influence" on the consumer, Bruno Rauecker, speaking for the Werkbund, vented his fury in the *Kunstgewerbeblatt*. He railed against this "Manchestrian doctrine" in the academy, but saw the signs of its supercession in the *real* economy: "On the horizon, we see the belief in German quality work take on ever firmer, clearer lines; on an *economic foundation*, we see the *ethic of production* (for products and producers) growing ever stronger; we see a time in which our *Volk* will gather its spiritual and technical weapons around an Idea which has its best title in the 'spiritualization of German work [*Arbeit*].' That is *our* creed."[154] Rauecker identifies public interest with production interests, and a business ethic with a production ethic. The power of fusions would give industry – i.e., the production sector – the power not only to control the market but also to change it, to impose its will on the way goods are made. Peter Bruckmann asked,

> Is it really in our economic interest that fashions and other such mass commodities arise from the expansion of industry and its technical capabilities, goods which bring their producers little material profit and no ideal gain and which bring their buyers no lasting joy? Is it not preferable that industry exploit its economically powerful position to give the entire mode of production a healthier foundation?[155]

The power wielded by these new economic forms, it was thought, could reverse the liberal capitalist trend which saw the commercial control of markets; industry could determine the look of things. Muthesius sketched this scenario as one in which "Production no longer needs to follow nervously the moods of Fashion; it can dictate taste."[156]

These notions of the guild or the production cartel as an antidote to *Handel* were not without a certain basis in reality. In the 1914 *Jahrbuch*, John Hambrook characterized the medieval guild by its "decided animosity to every form of capitalism." Hambrook was identifying capitalism with the market: the guild "had the sharpest eye out for the suppression of all intermediary trade and the narrowest possible limitation of wholesaling."[157] It is certainly not incidental that Hambrook echoes a particular aspect of contemporary discussions of economic concentration: Calwer wrote that "the effect of cartellization on *trade* is . . . decisive. It cannot be denied that the further the development of cartels has progressed, the more the intermediary commerce between producer and consumer is eliminated."[158] The effect of economic concentration on commerce was one no contemporary commentator failed to note.

The most gripping account of fusions as a stage in the battle between production and commerce appears in Rudolf Hilferding's *Das Finanzkapital* of 1910, perhaps the best-known analysis of the economic trends at issue here. Hilferding traces the process of the concentration of capital, and, probably due to the peculiarities of Central European economies, argues that power ultimately accrued to the hands of banks and bank capital.[159] This aspect of his analysis does not enjoy wide acceptance today, but Hilferding, with a Marxist's sharp eye for conflict in the economy, is ideally suited to describe the "domestic war" of capital in which the Werkbund felt it had such an important stake. "As long as free competition prevailed," he writes,

> trade could exploit competition between industrialists to its advantage. . . . It is the time in which the complaints of industrialists about the dictatorship of the merchants became ever louder. The actions of the *Händler* served the industrialists later as one of the justifications for the formation of cartels. . . . Thus the monopolistic associations will pursue the tendency to break the independence of trade.[160]

Industrial cartels can set the terms of production and prices, which were previously set by trade. Merchants and the market are brought under control:

> The fragmented *Händler* face a unified industry. The power of capital is now on the side of the industrialists. But not only that. The *Händler* now emerges as what he is: a dispensable auxiliary as opposed to indispensable production. At the same time the superiority and natural necessity of production over the capitalist necessity of distribution through trade is revealed. The syndicate reduces trade to its "legitimate borders."[161]

Production is presented as a transcendent given, trade as a dependent variable. The very function of traditional trade institutions could be changed. In describing this process, Hilferding does not speak in euphemisms such as "production ethics," but rather in terms of bitter, epic struggle:

> Thus [for example] the paper dealer [*Papierhändler*] becomes an agent of the syndicate, working for a fixed commission. His freedom is taken away, and his complaints about unfair treatment ring loud; he tells longingly of

the good old days of "doux commerce." The exploitation of competition between producers is forbidden him, and he becomes merely a tool to strengthen the syndicate, to eternalize the very monopoly that strangles him. He must relinquish all hope, for over the door that leads to the syndicate's buying office stand letters which are as terrifying to him as Dante's words over the Gates of Hell were to the sinner: Buy only from the firms of the syndicate and sell only at prices fixed by the syndicate! It is the end of the capitalist merchant.[162]

The subordination of the *Händler* to industry interests brings to an end the speculation carried out in the space opened up between producers and consumers and results in "the increase in direct contact between producer and consumer and with the transformation of the *Händler* into an agent of the syndicates and trusts."[163] And the effects of this process are described by Hilferding in terms that bear directly on the visual realm. He echoes the commonplaces of the spiritual economy when he relates advertising to liberal capitalism: "Bitter competition for markets prevails, and large sums are used in fighting this competition. . . . Large advertising campaigns are launched, . . . ten salesmen fight for every client."[164] Under the dominance of cartels and trusts, what others called the "advertising plague" is lifted: by eliminating traditional trade, monopolistic associations effect "a reduction in those circulation costs that are used to win the consumer for the product of a particular company at the cost of other companies. Expenditures . . . for advertising serve this purpose. . . . The formation of cartels reduces these costs enormously, limiting advertising to mere notification [*Bekanntmachung*]."[165] With the elimination of the economic entropy of laissez-faire trade and speculation, the visual entropy of advertising could also be brought into check.

The establishment of the "legitimate boundaries of trade," the "end of the capitalist merchant," the recreation of the "direct contact between producer and consumer," the reduction of advertising to "mere notification": this is an extraordinary group of changes to the conditions Werkbund members described and lamented as the economic status quo. In their affirmation of the cultural potential of the cartel, there can be no doubt at all that Werkbund members such as Muthesius and Scheffler had in mind its effect on trade. They need not have read Hilferding to be aware of the different weapons and tactics available in the civil war of capital. When, in the next section, some of the Werkbund's practical interventions in the capitalist economy are explored, their efforts to control or bypass commercial functions will be very clear. But since Hilferding's words could be seen as fighting words, the Werkbund had to be careful when using the rhetoric of concentration in specific ways; they hoped, after all, to *reform* trade. Or so they said. In his speech to the Volkswirtschaftliche Gesellschaft, Muthesius raised the other, more ominous possibility. "Two ways," he said, "are conceivable to reestablish actual contact" between producers and consumers. One was the program that was examined in the last section: "the reform of trade in such a way that it [can communicate] the same professional and the same technical knowledge as the producers themselves." The second possibility was created by the development of monopolistic associations: "the elimination of trade."[166] We saw that Muthesius stepped back when speaking to the economists and seemed to accept the existence of trade institutions. For Rauecker, however, there was no doubt about what to do with merchants who preferred Fashion to Quality: "Here the *obligation on the part of the producer to approach the consumer*

directly through the elimination of the commercial middleman is a moral act."[167] Such ideas are no less clear for being implicit when Scheffler sees his utopian Berlin of the future as "a city without the scream of advertisements, without the indecencies of present business life, because it belongs to the *Grossbetrieb* and [its] unifying organization."[168] Like Rauecker's, those *were* fighting words.

Although close attention was paid to economic form in the Werkbund, there was still some confusion about what the organization *itself* represented. Looking back after World War I, Walter Curt Behrendt described the Werkbund as a guild, or at least as manifesting its spirit: "The establishment of an ideal of Quality as the Werkbund has proclaimed is nothing other than the renewal of the old guild spirit which . . . measures the dignity of work according to its ideal value, not its superficial success." Behrendt's guild, however, sounds more like a trust: "The core of the Werkbund program, the striving for the union and fusion of all energies . . . is thoroughly symptomatic for the development of social life in the present. After a period of unreined individualism, the economic and social conditions are pushing towards strict order and organic bonds."[169] And there is no doubt that other members saw the Werkbund as supporting the cause of the cartels, or perhaps even being a cartel itself. Helmuth Wolff described one of the economic goals of the Werkbund as the establishment of "organizations that unite quality workshops in production cartels for Quality, in *Quality cartels*."[170] Gustav Gericke also admitted his interest in exploring these new economic forms, musing aloud that "it would be very interesting to look into whether the influence of new formations of economic life – the trusts, cartels and price combines – could be put to use for the advancement of Quality."[171] Robert Breuer described the union of firms in the interest of Quality – read "Werkbund" – as involving the renunciation of business freedom in the pursuit of common goals. The goal of quality "is the result of the ever more determined efforts toward a fusion of those who produce with this idea. Such unions are only possible when the allies renounce a part of their freedom and subordinate themselves to conditions consciously and in concert."[172] Breuer was describing the first step in the process of cartellization. And Gericke considered the efficacy of turning the Werkbund, in effect, into a cartel by mentioning the second step in this process – the exclusion of other, non-member firms: "It must be considered whether or not the decision should be taken that members of the group may not enter into contracts with persons or firms which are not members of the Werkbund."[173] Perhaps to allay fears, Naumann described the Werkbund using another term implying the rejection of liberal capitalism: "The Werkbund is a trade union [*Gewerkschaft*] of art creators against the market spoilers [*Marktverderber*]." In the same text Naumann also tried a different image, straddling commerce by embracing industrial capital and labor: "One could . . . compare the Werkbund with a trade union on the one hand and with an industrial syndicate on the other."[174] Though they were either unwilling or unable to specify a precise economic role and institutional form, the Werkbund represented to some of its members a way of exploring and using new forms of the power of capital.

<p align="center">❄ ❄ ❄</p>

The economic forms that arose in Germany before the turn of the century – the *Grossbetrieb*, the cartel, the trust – were still too new to be fully understood in the period of the early Werkbund. It was obvious that they represent-

ed tremendous economic power, and that this power would be felt beyond the economy in the realms of culture and politics; but precisely who would wield this power and how it could or would be brought to bear was not at all clear. As a result, many different hopes could be attached to these new phenomena, and in the process, the terms became somewhat multivalent.

Romantic anticapitalists, or those who availed themselves of this rhetoric, could see the reemergence of the spirit of production in the cartel and related it to the medieval guild. Breuer rejected this idea by bringing in the modern proletariat to take part of its place: "The guild is dead, but the trust and the trade union live on."[175] In describing the Werkbund, Naumann had similarly sought to balance capital and the proletariat in invoking the new face of order. This was in fact a central plank of his political platform – that the development of capitalist forms would lead, and was in fact leading, directly to socialist forms. The trust looked back to the guild of the past and embodied already the socialism of the future.[176] This was also Schulze-Gaevernitz's position, and even Hilferding saw economic concentration as leading ultimately to a radical change in the relations of production.[177]

For most Werkbund members, however, economic power meant the power to summon or impose spirit, or it could even mean spirit itself. The Werkbund was born, one could say, out of this equation. It is worth looking again briefly at the founding of the organization in this light.[178] In 1906 Schumacher, Naumann, Karl Schmidt and Muthesius joined forces in the planning and organization of an applied arts exhibition in Dresden. Their goal was to improve the quality of the objects displayed by encouraging and promoting the role of the "artist" as designer; to this end, only artist-designed objects were exhibited, and the objects and ensembles displayed were identified primarily by the artist, not the manufacturer. Traditional firms – those working in the historical styles, neither employing nor commissioning big-name artists – objected. When Muthesius continued to attack traditional applied arts producers in his highly publicized inaugural address, a trade organization, the Fachverband für die wirtschaftlichen Interessen des Kunstgewerbes (Association for the Advancement of Art Industry Interests), called for his dismissal from the Berlin Handelshochschule and his censure by the Ministry of Trade. Their calls were not heeded; instead, several firms – the Dresdener Werkstätten, Karl Bertsch in Munich and the Royal Porcelain Manufactury in Nymphenburg – seceded from the Fachverband and, within three months, the Werkbund was formed.

As Schwab points out, the new criteria of the applied arts – artists' designs, unified style and the production of ensembles – were unthinkable without the substantial capital required to commission artists and to achieve the production diversity that could lead to a formal unity of different kinds of objects. Similarly, Fritz Schneider of the Bund der Industriellen (Industrialists' League) said at the 1909 Werkbund meeting that

> It is self-evident that it is first the *Grossbetriebe* which . . . can take freelance artists into their service. Just as, for example, the great chemical firms have spent millions to encourage their chemists to invent along certain lines, so are the amounts which must now be spent for an artistic reworking of production irrelevant. One does not know . . . what sums appear in the accounting of the AEG for Prof. Peter Behrens and his activity as artistic advisor. No matter how high these sums are – for a firm whose daily turnover amounts to more than a million marks, they cannot be significant.[179]

The conflict between the Fachverband and those involved in the formation of the Werkbund is usually reduced to a matter of aesthetics, "a conflict between progressive and traditionalist factions" in the applied arts.[180] But the reason the smaller firms protested was simply that they did not have the resources Schneider talks about – the money to achieve the new criteria the reformers sought to impose on them in Dresden. The new style, supported mainly by artists as well as a few large firms which either employed artists or involved them in management, was a very real threat to the existence of the smaller firms.

Reduced to its bare economic terms, the battle out of which the Werkbund emerged was one between big capital (*Grosskapital*) and little capital (*Kleinkapital*), between the *Grossbetrieb* and the *Kleinbetrieb*. But the battle sounds quite different in the accounts that appeared as part of the new organization's well-orchestrated publicity campaign; there we see a line of argument that was at once brilliant, cunning, and probably even sincere. In his inaugural address, Muthesius managed to put the threatened traditional firms in the position of self-interested capitalists and to portray modern, capitalized firms as selfless bearers of spirit: the Fachverband represented the "*material* representatives" of the industry whose protests "arose out of purely pecuniary motives" and are merely "the expression of discomfort over the fact that new ideas, which from year to year have won more power in the spiritual life of the *Volk*, have shaken up, one could say collided with business as usual in applied arts production."[181] The minutes of the Fachverband meetings show that when Peter Bruckmann addressed the enemy camp and announced the secessions, he provoked unwanted snickers by joining power and spirit in the image of the sun:

> You cannot fight an idea which strives toward independent, artistic work. . . . If you in the Fachverband want to drive Herr Muthesius from his position, the idea would nonetheless remain. It is like shooting arrows against the sun. (Much laughter.) I am not saying that Herr Muthesius is the sun. (Renewed laughter.) No, the sun is the young, modern industry that does not only serve Fashion but which wants to be a part of the work of Culture.[182]

Consider, finally, Robert Breuer's mixture of incisive analysis and an equation of spirit with economic power that can only be called bloodthirsty:

> The attacks of the traditional firms are only explicable in that they have been hurt by the competition of the moderns, and that they do not possess enough spiritual elasticity to find the necessary connection. . . . If despite the intellectual and economic impotence of the opponents, there have been heated and at times malicious battles, this has its background in the desperate attempts always made by disappearing forms of production. . . .
>
> These attacks . . . found their voice in the Fachverband. . . . an association of people who, for the most part, work with modest capital, and whose balance is shaken by any disturbance of the market. . . . The campaign ended predictably with the full defeat of the members of the Fachverband; they had merely proved once again that inadequate capital and inferior minds cannot survive in the modern production process.[183]

Breuer, it should be noted, was a loyal (albeit revisionist) social democrat.[184] This was not seen as a contradiction at the time.

In the spiritualized economy as it was explored in the Werkbund, the power

of the production sector was called upon to justify its existence by sweeping aside the fragmented forms of Civilization and imposing Culture on any dissenters. The AEG's membership in the Werkbund and its employment of Peter Behrens served as an example of this kind of cultural-economic intervention. The AEG was a near monopoly, Scheffler pointed out, and did not need to resort to form as a path to profits: their actions "are all the more notable in that it is a huge firm that dominates the world market which now loudly proclaims that the technical industry is also obliged to serve the tasks of Culture . . . ; that it has not done enough by delivering usable commodities and providing profits for stockholders, but only when it discerns higher obligations to the totality [*das Ganze*]."[185] Scheffler sought to avoid any equation of form and exchange value; the AEG was to be the pure case of production Culture. Charles-Edouard Jeanneret (later Le Corbusier) also noted the connection between power and culture at the core of the project. In his 1912 study of the German applied arts, he wrote perceptively of the goal of the Werkbund as the "realization of beautiful *industry*," and of the AEG's "authoritarian intervention" in the realm of art.[186] Writing in the Werkbund *Jahrbuch*, Franz Mannheimer did not begrudge the AEG its profits: he saw Culture as the ultimate winner, for "art could only be inwardly enriched by close contact with the fundamental powers of the times."[187] The AEG was pulling Germany out of "the stormy age of capitalism," out of "the era of machine work, merchant spirit and social chaos."[188] To the "merchant spirit," Mannheimer contrasts "the spirit of industry" whose importance was that it "was no longer satisfied with spatial expansion, that it became spiritually expansive and free and began to look beyond its own walls. A super-economic will [*überökonomischer Wille*] had to open the gates for art."[189]

"Super-economic will": Mannheimer self-consciously places the economy between Nietzsche's "Superman" and his "will to power." The disparaging remarks about "merchant spirit" reveal that Sombart's notion of "enterprising spirit," the energy of technique and production and the disdain for material gain, was reverberating here as well. Nietzsche, however, was not to everybody's taste, nor was Sombart; not everyone was willing to jettison morals for power. The spiritualized economy could accommodate that. Thus Fritz Schumacher speaking to the founding assembly: "Art is not only an *aesthetic* power, it is at the same time a *moral* power. But both together lead to the most important of powers: *economic* power."[190] Or, instead of affirming the moral but subordinating it to the economic, Hermann Hesse, a Werkbund member, simply equated them: "At issue is Taste as a moral matter, but morals here are synonymous with economics."[191] To shield the sun from stray arrows, the economy was given a moral glow as well.

※ ※ ※

It is tempting to say that what I have been describing is just the development of the ideology of monopoly capitalism, which was identified as such by Hilferding and described as follows: "This ideology is diametrically opposed to that of liberalism; finance capital wants not freedom, but domination; it has no sense for the independence of individual capitalists, but demands their bonding; it abhors the anarchy of competition and wants organization."[192] One might think he recognizes in the Werkbund the "cartel magnate," who, writes Hilferding, "thinks of himself as lord of production. . . . He feels himself to be the representative of social necessity against individual anarchy and considers his profit as due reward for his organizational activity."[193] But the

matter is not quite so simple. While this is not a study of the economics of the applied arts – I am trying mainly to trace the relation between design aesthetics and *theories* of the economy – a reality check is in order here. Such a check does not show a clear-sighted recognition of business realities on the part of the Werkbund spokesmen I have discussed; it shows instead that hardly a word they said about the potentials of the cartel, the trust, and the power of capital in architecture and the applied arts corresponded to the actual conditions of the time.

The example of "super-economic will" and of the fusion of spirit and capital in the Werkbund was of course the AEG; it was also Lenin's example of the capitalist monopoly in his 1916 essay *Imperialism*.[194] Yet what made the AEG so important to the Werkbund, what *made it a model*, was the very fact that it was an *exception*: it was the only firm among the hundreds in the organization that had the magnitude of capital and the kind of power that was invoked in these discussions. Fritz Schneider of the Bund der Industriellen said this straight out in his 1909 address to the Werkbund.

> A firm like the AEG can design its production without regard for consumers and can impose its purified taste upon them. In the finished goods industry, however, the AEG is an exception, for in general the industrial *Grossbetriebe* produce only raw materials or, in the best of cases, semi-finished goods. The manufacturing industry, on the other hand, consists primarily of middle-sized firms that can in no way force their taste on consumers with such sovereign will. They produce to a great degree for the world market, in which every experiment involves the danger of being destroyed by competitors who remain traditional.[195]

Furthermore, it is doubtful that even the AEG exercised the kind of influence talked about here when it came to most of the consumer goods designed by Behrens – electric tea-kettles and clocks, table fans, electric fires. Schwab says much the same thing as Schneider when he writes that the few *Grossbetriebe* in the furniture business "in no way form a core around which a capitalist concentration of the industry can crystallize."[196] And though there were *Grossbetriebe* in the Werkbund (the Deutsche Werkstätten, the Vereinigte Werkstätten, Bruckmann & Söhne) they too were exceptions. The firms of the Fachverband were not at all anachronistic: in terms of size, most of the firms producing furniture in Berlin had at least four but on the average only twenty workers.[197] Neither the market for nor the production of furniture in Germany could be described as "organized." The conditions dictated by classic high capitalism – competition, Fashion and all – continued unabated. "Changes in taste" continued to exist and work against the *Grossbetrieb*, writes Schwab, not the other way around: "The quick succession [and] fluctuations . . . often give the outsider the chance to adapt to the market more quickly than the sluggish apparatus of a large organization with expensive machinery; thus [the former] can compete successfully."[198] The cartels and syndicates apparently had no place at all in this field whose production "is based purely on the principle of competition."[199]

Schwab's conclusions concerning the furniture industry are pretty much on-target for the rest of the consumer goods sector of the German economy between 1890 and the Weimar period. This is a fundamental fact not only glossed over but obscured by Werkbund rhetoric. Breuer's dismissal of those working with "inadequate capital and inferior minds," for example, implies that capital was somehow monolithic, which it was not: capital had different

quantities, qualities, and interests depending on what sector or subsector of the economy it was working in. The cartels, syndicates and other economic forms which brought large amounts of capital to bear on markets in the attempt to control them were indeed the result of the tremendous growth in the German economy since the founding of the Reich, but that growth took place primarily in *heavy* industry, and it is in these areas that monopolistic forms developed. At the time of the unification, light industry and manufacturing occupied a more important position than heavy industry, but by the 1890s, the production of capital goods (coal, iron, steel, machinery and so on) achieved predominance over the consumer goods sector. This was a major shift in the structure of the German economy. And while by 1907, 82 percent of mineral coal, 48 percent of cement, 50 percent of raw steel and 90 percent of paper production in Germany was controlled by cartels, the consumer goods industry had hardly been touched by this trend.[200] Already in 1903, Sombart wrote that while the production of raw materials and occasionally of semi-finished goods could be cartellized, the further processing to finished goods could not be.[201] That market remained too differentiated to be controlled, a situation that did not change appreciably in the following decade. It is significant that Fritz Schneider was the syndicus of the Bund der Industriellen, an organization founded in 1895 to represent the political interests of *light* industry; the Werkbund steered clear of the powerful Centralverband Deutscher Industrieller (Central Union of German Industrialists), founded in 1876 as the interest group of traditional heavy industry and its huge combines.[202] The Werkbund did not represent the interests of organized capitalism for it hardly had anything to do with existing cartels, syndicates, fusions or monopolies at all.

The lack of correspondence between economic rhetoric and economic reality makes one thing clear: that we need to refine our terms when discussing the Werkbund as an effort to unite art and "industry," or when we take their own such descriptions at face value. "Industry" could mean very different things depending on what was being produced, and the interests of one industry were not always those of another.[203] What, then, to make of their rhetoric if it did not correspond to clear-cut business interests? What *were* these interests? And what were real economists (who should, and certainly did, know better) doing in the Werkbund if its economic talk was so out of line with economic conditions? In other words, what else was at stake?

The answers lie in the way statements about the economy were mediated by contemporary politics. The affirmation of contemporary economic concentration was, first of all, a political position put forward vehemently by Naumann, Schulze-Gaevernitz, and many of the younger memebers of the Verein für Sozialpolitik. They had no sympathy for the development of fusions and cartels as they witnessed them, for the sector where this had occurred – heavy industry – had political and economic interests allied with the large landowners, remnants of the feudal aristocracy. This "feudalization of the bourgeoisie" was the great compromise of German capital with the feudal past, the barrier to political reforms transferring control to the developing middle class, the renunciation of bourgeois power. But some members of the Verein supported the process of concentration for two reasons: first, because they felt the concentration of economic power could lead the way to its collective ownership, perhaps in the hands of a more benevolent state; and second, because they believed it to be an inevitable tendency any intervention in which would serve heavy industrial, *Mittelstand*, and agrarian interests – in other words non-bourgeois interests.[204]

A second answer to the question of why Verein members felt so close to the Werkbund is less a matter of the general thrust of the reformers' rhetoric than of the specific business interests of the Werkbund firms, interests which were diametrically opposed to those of the existing cartels and combines. The new applied arts organization spoke to the hearts of many Verein members when it came to a hotly debated political issue of the the time – that of the importance of exports. Both Naumann and Muthesius saw the nurturing of the export trade in consumer goods as an important goal of the Werkbund. Certainly there was an element of economic nationalism in this, but the domestic implications were much more important. And they had little to do with current scholarship's usual equation of the emphasis on exports with an "industrial capitalist" position, an equation which represents one of the most widespread and persistent misunderstandings of the Werkbund project. Again the label is misleading in that it is applied in isolation from the political tensions of the German economy of the day. The call for the development of the export industry was in effect inseparable from a call for free trade – and thus opposition to the stiff tariffs supported by heavy industry and agriculture. The issue of free trade versus tariffs was one of the most persistent and controversial points of political contention between the founding of the Reich and the First World War.[205] The attempt to encourage production for export was an attempt to jump-start the consumer goods industry, a relatively weak sector of the economy, and so to break the economic and political power of the reactionary alliance of "feudalized" heavy industry and the Junker landowning class, of "rye and iron." It was part of the bid for bourgeois power in Germany.[206] The Werkbund's alliance with the Bund der Industriellen, which represented light industry (and thus sought to keep tariffs low and to check the power of the cartels and trusts) must be seen in this light, as must the presence of organizations such as the Exportverband deutscher Qualitätsfabrikanten (Export Union of German Quality Manufacturers) on the membership lists and the lack of contact with heavy industry interest groups such as the Centralverband Deutscher Industrieller. The support of the export industry represents a very specific joining of political and business interests, interests which did not share in, but challenged, prevailing powers.[207]

But the call for economic concentration in the consumer goods industry does not represent merely an applied arts variant of political positions represented in the Verein für Sozialpolitik. And it was certainly not the attempt to brush up the image of some distasteful, exploitative actuality or to traffic in outright false consciousness: the large disjuncture between rhetoric and reality shows that they were not merely opposite sides of the same coin. As much as certain members would have liked it to be, the Werkbund was not the visible face of "capital," even if the Werkbund did borrow selectively from contemporary concepts of organized capitalism. The enthusiasm for cartels, "organization," and the "super-economic will" represents instead a view of the German economy as seen through the concept of Culture, and like Culture, this version of the spiritualized economy was nothing but a dream. Businessmen such as Fritz Schneider pointed out that there were structural reasons why the consumer goods sector was at the mercy of the market, and that this was why the commodity still spoke the language of Fashion. This was apparently too bitter a pill to swallow. To some, the cartel or trust offered too good an opportunity to pass up for the elimination of the mechanisms of the modern consumer market, a sphere with which they had not made their peace; these economic forms seemed to offer the chance to make good on the promise

42. Hans Weidenmüller/
Werkstatt für neue deutsche
Wortkunst, color lithograph
poster, ca. 1910 (Kaiser
Wilhelm Museum, Krefeld)

inherent in the notion of the spiritualized economy.

Thus Breuer's bloodthirsty comments on the tra-
ditional applied arts producers were not some
unvarnished truth; they were instead simply the
pose of a would-be bully. More common was
pathos, which I think is the best way to describe
Scheffler's prose (I would also call it Expressionist).
And one must look at the Werkbund's supposed
embrace of "industry" more in the spirit of wooing
than welcoming, a point which a poster by Hans
Weidenmüller makes touchingly clear (fig. 42). It
reads "Big Capital [*Grosskapital*] Sought For
Applied Arts Firm" – a strange sort of solicitation, a
lonely heart.

Appropriately, Scheffler's discussion of the archi-
tectural trust in his book *Berlin: Ein Stadtschicksal*
(Berlin: Destiny of a City) appears in the chapter
titled "Utopia." It does not make pleasant reading
today. He calls for

> A capital city no longer governed by parties, nor
> by city councillors who are burghers with a limit-
> ed horizon, nor by mayors who are like tame
> bureaucrats, but instead by extraordinary people
> of will with a great passion for deeds and for
> *Sachlichkeit*. . . . A community governed in this
> way would no longer leave the planning and
> building of suburbs and sections of the city to land speculators, but would
> become a builder itself; it would clear the way for the formation of great
> trusts in the city and would be something like the most powerful of these
> trusts. The old medieval guild spirit would be brought to life again, monu-
> mentalized. That would help to force together the individual professions
> into great unions, organizations and groups, and from the idea of such cen-
> tralized callings the new social idea of Culture would emerge in multifari-
> ous forms. One glimpses in the imagination a capital of German civic con-
> sciousness . . . composed in the center of great business buildings and on
> the periphery of monumentally fused apartment blocks, [a city] which no
> longer exhibits today's confusion of forms, but rather an architectonically
> tranquil, aesthetically rhythmic impression.[208]

Like National Socialism a quarter-century later, this aspect of Werkbund
thought stretches the gamut from procapitalist to anticapitalist thought to
points so contradictorily in-between that they render this scale meaningless.
One certainly recognizes the same lust for power and the simultaneous willing-
ness to submit to it. But there are crucial differences. The figures discussed
here remained true to their goal of theorizing the relation of visual form to the
capitalist market, and the conclusions they reached grew out of that attempt.
The ideas in the Werkbund were hardly politically neutral, but they were not
always primarily political. The theorists of the Werkbund considered the econ-
omy not merely in its capacity to produce wealth or political power, but main-
ly in its capacity to produce representations. Two decades later, Fascism
would realize the aestheticization of politics; the Werkbund represented
instead the aestheticization of the economy.

5. THE TYPE

> Consider the desire of certain idealists to make the commodity
> world uniform; they fancy that this is the way back to a "Style"
> which has been lost in the course of capitalist development. As if a
> Style, which can only emerge from a unified spirit, could be artifi-
> cially produced by some such superficial means as the standardiza-
> tion of everyday goods. Nonetheless the tendency toward the uni-
> formity of the commodity world is intensified by these bizarre
> Style-seekers. . . . [Thus] the famous "Type-Schmidt" in Hellerau
> dreamt of the single world-chair. . . .
>
> Werner Sombart[209]

In the consumer goods sector of the economy, big capital did not control the market. The syndicates and trusts had not brought their mixture of power and spirit to bear. Unlike many modern readers of the texts examined here, the members of the Werkbund knew that. Thus their writings were not an affir-mation of actual economic developments, nor even a reflection of them. They represented something much more active and ambitious: in outlining a sce-nario that bore no relation to the facts of the time, these texts are the attempt to influence and to shape the evolution of the German economy. Rather than making propaganda for the forces of capital that might be thought to have controlled the consumer market, the members of the Werkbund discussed here saw their task as that of organizing this chaotic economic space in the hopes that the new forms of concentrated capital could find a foothold there and use their power to carry out a radical program of cultural hygiene. The work of the Werkbund involved exploring the potential of these new economic forms – which had arisen in the heavy industry sector – for the consumer realm and determining how they could best operate there.

The Werkbund's efforts along these lines went by the name of *Typisierung*, or the development of "types." The concept was introduced into the official, public Werkbund discussions by Muthesius in his 1911 speech "Wo stehen wir?" where, we recall, he posited a symbiosis of Style and economic concen-tration. In the discussion after the speech, Cornelius Gurlitt summed up the issue in a way that became canonical in discussions of the Werkbund – "the question: type or individuality?"[210] But the concept was not Muthesius's alone: those who saw the Werkbund as the advance guard of a light industry export drive such as Naumann and his followers found that it expressed what they felt form in a capitalist economy should be, as did members who were exploring the relation between artists' designs and new production techniques – Karl Schmidt, Richard Riemerschmid, Bruno Paul.

To these members, the concept of the type had a very specific meaning or set of interrelated meanings (and these will be examined here). Yet, it must be pointed out, this was far from being the case at the Werkbund meeting of 1914 in Cologne, where Muthesius felt confident enough to present a series of theses that identified the development of types as the central task of the Werkbund. The ensuing debate, which marks to all intents and purposes the end of the unique collaboration of personalities and professions of the early Werkbund, revealed not only the resounding rejection of the concept by an important faction in the group, but also, paradoxically, confusion as to the meaning of the term. Speaking for the "individualists," August Endell situated his opposition to Muthesius's theses in his opposition to the word:

The very stylization of the theses is of such a peculiar nature that it presents great difficulties to grasp what is intended or expressed by the individual sentences. I am extremely suspicious of such stylization, for in this way one can say all sorts of things, and then defend oneself against any objection with the claim that *that* is not what was meant. . . . I have spoken with very learned people from all possible fields and found, to my astonishment, that those who did not have a precise knowledge of the state of the applied arts could not make heads or tails of the theses. That is a disturbing sign, the more so as we already have the unfortunate word "Quality" in the Werkbund program, a word that has led to the most dire misunderstandings. For "Quality" means in the end nothing more than to make something well, and that is simply self-evident. . . . And if to this unfortunate word "Quality" we added the even more dubious word "*Typisierung*," then the whole Werkbund program would be utterly botched, for this word, which did not even exist before, is the height of ambiguity.[211]

Endell points out in no uncertain terms that a standard Werkbund strategy, one I pointed out in the last chapter, had failed. Like the terms *Veredelung*, *Arbeit* and *Qualität*, *Typisierung* seems to have been chosen for its very discursive indeterminacy or, better, mobility: it could resonate back and forth between the realms of economics and culture. For those who thought these realms should be linked, the term accomplished precisely that; at the same time, it allowed users of the concept to locate its meaning at one pole or the other according to preference. And skeptics who saw a particular argument, a particular balance that not did suit them could be assured that "*that* is not what was meant." When the Werkbund came to argue over the issue, the result was confusion as different definitions emerged. One might be tempted to call this a mere "confusion effect," for the elasticity of the term allowed definitions to be strategically shifted as they were deployed in different arguments, for or against. Yet for many, I think, the confusion was real. Artists and architects, whose professional activity did not require a command of political economy, might not have grasped completely what was at issue, though they clearly understood enough to see that their interests were not being served. Though Endell's remarks imply that those who *did* have a "precise knowledge of the state of the applied arts" would indeed attach a firm meaning to the idea of the type, it is perhaps helpful to mention some of the different resonances the term had at the time.[212]

At its most general and harmless, the type was simply a synonym for an object with Style. This is certainly the thrust of the first of the ten theses with which Muthesius touched off the 1914 debate: "Architecture, and with it the whole area of the Werkbund's activities, is pushing toward *Typisierung*, and only through *Typisierung* can it recover that universal significance which was characteristic of it in times of harmonious culture."[213] But if the word "Style" tended toward the visual, the word "type" tended toward the philosophical. Defending Muthesius in the Cologne debate, Walter Riezler saw the type through the lens of Schopenhauer and the neo-Kantians:

I dispute that that which is called the "type" . . . means that solutions are found that are so good that they can be repeated in approximately this form and that out of such works a "Style" gradually results – I contest, I say, that this type belongs to the domain of the "concept." On the contrary, the "type" belongs to the realm of the "idea," and individual works approach more or less successfully this idea, which is never itself reached.[214]

At this level, however, the type was merely diluted philosophy: Riezler was saying little more than Scheffler, himself taking recourse to the clichés of the period when he wrote earlier of the search "not [for] the particular . . . but the typical, not the exceptional, but the generally applicable."[215] The type resonated more richly in architectural theory, where it had come in Germany to mean a standard, historically developed, modified and occasionally perfected formal solution; it was the living force of tradition, not its baggage, the synchronically relevant part of a diachronic development. In "Wo stehen wir?" Muthesius invokes Semper, and it was in Semper's work that contemporaries located the doctrine of the type. Semper wrote that "a cup, for example, is in its general form the same in all nations and at all times; it remains in principle unchanged, whether in wood, clay, glass or executed in any other material. The basic idea of an artwork which emerges from its use and function is independent of fashions of material, and of temporal and local conditions."[216] Certainly Muthesius was referring at some level to Semper's flexible and quite unthreatening notion of the type. But Semper's ideas emerge only subliminally, and except for such echoes, the traditional architectural concept of the type does not seem to figure importantly in the debate itself. And considering Muthesius's assurances, however lukewarm, that types were not to be fixed as a canon which would render artistic work, in theory, superfluous, the traditional concept of the type does not adequately illuminate the surprisingly controversial nature of the issue in 1914 or the confusion surrounding the word.[217]

More specific and potentially controversial definitions emerge in the context of contemporary ideas of industrial efficiency. Now it is consistent with the confusion effect that when it came to the debate, the Muthesius camp, which was thinking most intently about the capitalist economy, gave an almost exclusively cultural interpretation of the term. This was not so much a reflection of their position as a strategy of argumentation. In Cologne, an economic or entrepreneurial definition of the type was presented only by those who needed to do so *in order to argue against it*. Osthaus prefaces his remarks by saying that "what is truly to be understood under this word 'type' has not yet been made clear," and then proceeds to define it in another, equally incomplete way:

> To my knowledge, the idea of types has emerged from workers' housing construction. It has emerged that workers' colonies are considerably cheaper [to build] when certain construction parts – windows, doors, radiators, etc. – are typified, i.e. reduced to a few basic forms. . . . It is obvious that in such large constructions, the reduction to unified forms results in considerable savings, and therein, ladies and gentlemen, lies the justification of the idea of types. Now it has not been left at the construction of workers' housing: the attempt has been made to transpose the idea of types to the manufacture of furniture. To my knowledge this tendency has been pursued with the greatest enthusiasm by the Deutsche Werkstätten in Dresden. Here too, furniture of different kinds and functions has been reduced to uniform units [*Einheitsmasse*], to frame pieces, panels, etc. In particular quite ingenious combinations have been invented by Herr Riemerschmid, in which furniture of completely different kinds (beds, commodes, cabinets, tables, etc.) has been made by the assembly of different standardized forms. In this case too the development of types is based on cost considerations, for it is clear that furniture produced in this way can be sold more profitably than others.[218]

43. Richard Riemerschmid, "Maschinenmöbel" for the Dresdener Werkstätten, living and dining room set no. 1, pine, painted red or blue, 1905, illustrated in the catalogue *Dresdener Hausgerät: Preisbuch 1906*

Osthaus equates *Typisierung* with the rationalization methods of mass production, in particular with the Deutsche Werkstätten's use of standardized modules in the construction of *Maschinenmöbel*, their line of furniture developed by Riemerschmid in 1905 that sought to take advantage of the economies of machine production.[219] Indeed the *DeWe* catalogue of 1912 seeks to encourage the equation of the *Maschinenmöbel* and the type in at least two ways. First, the catalogue invokes a Semperian sense of the anonymously traditional or vernacular in its very title – *Das deutsche Hausgerät* or "German Household Furnishings." The furniture itself, with its unadorned, pared-down forms referring to no specific period style, reinforces this implication (fig. 43). Second, the term "type" is used: "The individual parts of these items of furniture," we read, "are interchangeable in their type-forms [*Typenformen*]."[220] When in 1908 the Vereinigte Werkstätten of Munich introduced a competing line of machine-made furniture designed by Bruno Paul, they simply appropriated the term, calling their products *Typenmöbel*.[221]

Did *Typisierung* in a business context simply mean the use of standardized parts in machine production? When looking for clues in contemporary texts from outside the Werkbund, a significant fact emerges: serious discussions of *Typisierung* by economists or business writers for the most part *post*-date the Werkbund debate. Though the word "type" had a tradition, Endell was not exaggerating in 1914 when he referred to *Typisierung* as a word "which did not even exist before." The Werkbund had in fact introduced the concept into the economic discourse of the period. It entered into widespread discussions only with the outbreak of the world war, which brought about the pressing need to explore new approaches to both production efficiency and product compatibility and which led to the establishment of a large number of norms, many of which are still with us today. When this issue became acute, economists looked, among other places, to the Werkbund for ideas. But while considerations of the concept by economic or business professionals represent later responses to the Werkbund's agitation and not sources of them, they are not useless for that. Let us briefly consider two of them.

In 1916, a certain Bruno Czolbe wrote on standardization in machine production in the journal *Thünen-Archiv*, an article Karl Schmidt, director of the Deutsche Werkstätten, considered "superb" (he attributes this to the fact that it was written after the Werkbund discussion).[222] Amidst case studies and comparative analyses, Czolbe makes some helpful distinctions and definitions. He defines standardization by opposition to individual production: the use of norms represents the attempt to eliminate the need to tailor the production process to an individual order. The reduction can take place at various levels: a normalization or standardization of individual parts (the same part can be used in a wide variety of finished goods); a standardization of groups of parts (entire groups can be normalized and used together in different products); or a

standardization of finished products (a reduction in the number of different finished goods produced). Only this last category, Czolbe tells his readers, represents *Typisierung*: "Standardized finished goods are called types."[223] The type represents the reduction of the variety of models of a given commodity; it is standardization not at the level of the part but at the level of the finished product. The difference is significant, and Czolbe defines it as follows: "Elements and element groups are almost without exception designated for the manufacture of finished goods and thus are used *within* the [producing] firm itself. . . . It is a quite different case with finished goods. It is their purpose, of course, to find their function *outside* the [producing] firm."[224] It is clearly this latter kind of standardization that was meant in the Werkbund by the term "type": standardization within the producing firm would be a purely internal matter; only standardization of the kind visible outside the factory could have a cultural impact.

A firm, it should be pointed out, can rationalize in these ways without necessarily enhancing its profitability or performance. Czolbe sees the first two kinds of standardization as for the most part improving a firm's ability to handle a variety of orders at minimal cost. He sees *Typisierung*, however, as likely to *reduce* a manufacturer's flexibility and to create a handicap in the ability to meet customers' needs: "With *Typisierung*, the positive moment of the . . . previous experience [with standardization] was reduced even more than in the case of the standardization of element groups."[225] In other words, the establishment of types is not a necessary or even advisable rationalization measure.[226] With this in mind, and using Czolbe's inside/outside distinction, one could characterize *Typisierung* as the extension of the concept of standardization outside the factory – an extrapolation of the logic of norms beyond the circumscribed sphere of production and into the market. The establishment of types was no longer a matter of production technique (or even production efficiency); it was a matter of the way products were to meet the consumer and his or her demands – a matter of the market.

Clearly there was a certain economic logic to types: assuming constant supplies and production conditions, it is no doubt cheaper to produce the smallest possible variety of a certain kind of good. Cheaper, but not necessarily more profitable, for a firm offering only types would not be able to compete in certain sectors of the market or adapt to a changing one. This is Czolbe's argument, and it is based on a competitive capitalist situation. However, in the rare instances in which the word "type" was used in the economic literature before the Werkbund debate, it appeared in discussions of heavy industry and its *controlled* market. In *Das Finanzkapital*, Hilferding quotes J. Grunzel's *Über Kartelle* of 1902: "The cartel wants mass-goods showing no substantial difference in quality, form, material etc. . . . Cartels achieve this . . . either by selecting only certain standard articles on which the branch routinely depends, or by specifying types according to which all producers are to manufacture their products so that differences in quality are factored out."[227] The cartel began to control a market by controlling, limiting, and dictating the goods that appeared there.

There is much to indicate that the supporters of *Typisierung* in the Werkbund were not thinking in terms of a competitive market, in fact that the idea of the type was part and parcel of their vision of a controlled market created by concentrated capital (though imported into the consumer sector). Muthesius's second thesis, for example, reads as follows: "*Typisierung*, to be understood as the result of a *beneficial concentration*, will alone make possible

the development of a universally valid, unfailing good taste."[228] With the word "concentration," he situates *Typisierung* in the context of the move toward cartels and syndicates. Similarly, Karl Schmidt wrote: "We know that . . . in all areas today, organization is the most important and most essential thing; that types are sought, syndicates, files, universal formats – order and compatibility in the place of anarchy and lack of discipline. If artists used to believe that the introduction of certain norms represented violence done to them, today we see in such attitudes vestiges from the time of narrow individualism."[229] Here Schmidt is more expansive than Muthesius. The type and the syndicate are explicitly equated as forces of order over a state of chaos defined as cultural laissez-faire.

No less an economist than Karl Bücher sums up the description of the production type that has begun to emerge here – its definition, its utopia, its economy. In a 1921 addition to a 1910 article on "Das Gesetz der Massenproduktion" (The Law of Mass Production) he explores a set of terms which, he writes, had arrived on the scene in the years following his original publication (and thus during the early years of the Werkbund and, of course, the war). "Specialization," "normalization," and "*Typisierung*," he says, are "measures that can be united under a slogan that is no less forbidding: standardization."[230] Defining the terms in a way thoroughly consistent with Czolbe's discussion, Bücher writes that "under 'specialization' should be understood the separation of industrial production process into its simplest components; under 'normalization' the making uniform of construction forms and units; under *Typisierung* the formation of *a limited number of constant products*."[231] On the standardized world, Bücher sums up what is clearly the Werkbund dream as a technocratic cliché: "A streak of uniformity would go through all of human life; it would dominate the production of goods as well as commerce and consumption; every deviation, every disturbance through individual inclination would be banned."[232] Significantly, he adds that standards are part of the vision of the "organized" economy: "Everywhere huge firms with monopolistic control of the market would have production under their thumb; commerce and consumption would have to adapt to them."[233] *Typisierung* would be important in this economy in that it "seeks to bind consumption to specific product forms, to types."[234]

Bücher's tone – clear, harsh, slightly ironic – is helpful, for it clears the issue of the polemics and hedging on one hand and the mountains of microeconomic detail on the other which tended, even at the time, to render the matter quite opaque. He shows that *Typisierung* represents the production sector's attempt to control the product form (and thus visual appearance) of commodities on the market, in effect the attempt to organize consumption according to the criteria of productive efficiency. In limiting at the level of manufacture the number of different forms a specific commodity could take, the supporters of types sought to eliminate the role of trade as a mediator of forms between producer and consumer; the standardized economy had no room for an independent *Handel*. Like the consumer, Bücher writes, trade would have to adapt to the dictates of production. *Typisierung* is a corollary of an economy organized in cartels and trusts, its product policy: it describes the way commodities in that economy would appear. Types were the formal means by which the unruly consumer market could be disciplined by the production sector.

Czolbe and Bücher, I would argue, correctly identify a significant and overlooked aspect of the Werkbund's idea of *Typisierung*, one which corresponds completely to the sense of the economy that lay behind discussions of design

aesthetics there. The theme of discipline certainly runs through the discussion of types in the Werkbund. In "Wo stehen wir?" where the call for the type was raised in the context of economic organization, Muthesius defines the Werkbund's quest as "bringing back into our expressions of life that order and discipline whose external characteristic is good form."[235] J.A. Lux was arguing along the lines of such an authoritarian intervention in the consumer market when he wrote that "the masses can only be made bearable when bad products are withheld from them and only good ones are offered. They can not be asked, for they have no judgement." The only option was, from above, "to *determine the market* . . . in favor of Culture."[236] In a series of letters on the issue written after the Cologne debate, Karl Schmidt wrote to a young economist, Else Meissner, that "for me the matter of types means nothing other than replacing disorder and lack of discipline with order and discipline." Understanding precisely what was at stake, his correspondent pointedly asked if this did not represent "the violation [*Vergewaltigung*] of the consumer by the producer," a charge Schmidt denies just as Lux did – by explaining that the consuming public "lacks judgement."[237] Fritz Hellwag takes Peter Behrens's products for the AEG as his example of types, and also locates their importance not on the side of production but at the nexus of supply and demand:

> The AEG has been the first to use its capitalist power . . . to simplify its product line [*Angebot*] and thus its means of production – in other words to create standing types that represent the most perfect, simple expression of their function not only technically but also artistically. On the one side they seek a simplification of the aesthetic demand, and on the other side a simplification of the corresponding supply; both tendencies function simultaneously with and upon the other.[238]

Even if Hellwag transforms compulsion into reciprocity – seeing a docile consumer reacting to what is offered and not the disciplinary nature of its imposition by "capitalist power" – he describes *Typisierung* as creating the situation in which demand corresponds to and adapts to a supply whose formal abundance is radically curtailed.

Hellwag also equates by analogy the type's enforced simplification of the market with the formal simplification of the commodity. The type was, in the end, the Werkbund's concrete alternative to the Fashion object, the carrier of commodified ornament, the seductive signs of class, the visible trace of the merchant spirit. Like Style, the type was regularly placed in opposition to Fashion. Muthesius, for example, writes that the Werkstätten had achieved their success "not with the help of changes in Fashion, but with ever-improved, artistically good types."[239] In neutralizing the vicious cycles of Fashion, types pointed the way out of the dystopia of an Impressionist, commercialized world. Writing that types, found by the "superior, architecturally disciplined intellect, . . . do not *disturb*," Lux invokes by negation the constellation of Fashion, Impressionism, and advertising.[240] Similarly borrowing vocabulary from the critique of Impressionism, Robert Breuer writes that the task of the applied arts is to "overcome . . . that condition of nervousness [*Unruhe*]" and to direct artistic development into the "tranquil wake of the typical." Through the type, capital suppresses Fashion: "The concept of the type becomes a force which impedes every form of arbitrariness . . . with inescapable severity."[241] The type was Style, or form as it emerged from the Werkbund's respiritualized economy.

⁎ ⁎ ⁎

44. Lucian Bernhard, trademark for the Deutsche Werkstätten, registered 1910 (Deutsches Patentamt, *Warenzeichenblatt*)

45. Bruno Paul, trademark for the Vereinigte Werkstätten, registered 1908 (Deutsches Patentamt, *Warenzeichenblatt*)

The idea of the type grew out of the project of finding an economic solution to a cultural problem; its name resulted from the attempt to translate the result back into the language of Culture. While those who thought about form only in terms of Culture were necessarily in the dark about the subtleties of the type, some economists took the concept seriously (though critically). But beyond the fallout of the Werkbund's 1914 debate, the idea of the type never caught on in a big way, probably because it already had a name in everyday language. Consider what Naumann wrote as early as 1906: "Everywhere the following system is becoming the new standard procedure in the applied arts: a business manufactures certain characteristic *types or brands*, advertises these types and seeks in this way to achieve a *centralization of taste and of the market* in a particular area."[242] In defining the type as the reduction of product variety, and its function as control of the market, Naumann finds he can call it a *brand*. Though the idea of the type may have had a broader resonance and wider possibilities, the trademark commodity or *Markenartikel* was, for the Werkbund, certainly one mundane example of it. Along the same lines, Alexander Schwab dispenses with the technical aura of the *Typenmöbel* and the *Maschinenmöbel* and discusses them simply as *Markenmöbel*, brand-name furniture.[243] In doing so, he was pointing out something that was probably quite clear to contemporaries: that the *Maschinenmöbel* were sold under the well-known *DeWe* brand, and that the word *Typenmöbel* itself was a registered trademark (figs. 44, 45). That the Vereinigte Werkstätten could use this latter word as a trademark is in fact proof that the term *Typen* (types) did not yet have a generally accepted trade meaning at this time, and thus that its meaning was only in the process of being defined.[244] In a business context, this term was clearly new, and like Naumann, Schwab defined it simply as the everyday brand.

But perhaps the brand-name product was not so mundane after all. It was certainly something quite new, and, as the type sought to do, it rearranged the relation between the industrially produced consumer commodity and the market. Traditionally – and this is the scenario described in the Werkbund's critique of high capitalist commerce – objects were produced by manufacturers according to the wishes of the middlemen or merchants who ordered them. The *Händler* determined both the form of an object and its price, and he took over responsibility for advertising the merchandise, which appeared under his name. The actual manufacturer, neither named nor recognizable by obvious visible characteristics of an object, disappeared from view in the market. A two-page spread of alarm clocks from the 1912 catalogue of a mail-order retailer gives a sense of the way non-brand name commodities appeared on the market (fig. 46). These pages – from well over a dozen of clocks in general – show a bewildering variety of heterogeneous models and styles. Stukenbrok, a

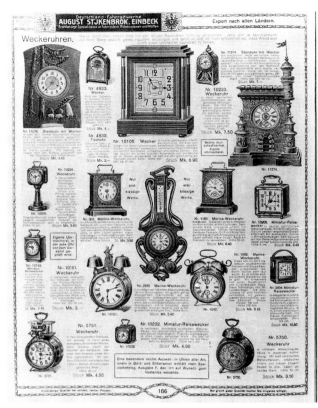
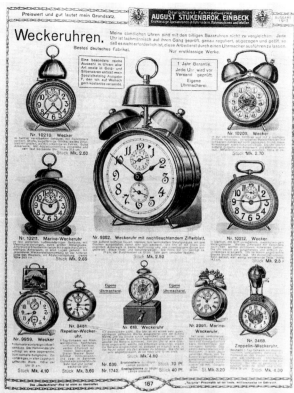

46. Alarm clocks in the A. Stukenbrok mail-order catalogue (August Stukenbrok, Einbeck, *Preisliste 1912*)

general goods merchandiser, sold alarm clocks in miniature, mounted on columns, in the shape of a Renaissance fortress or a Gothic arch, or set into a panel painting of an enchanted forest; there were clocks that were square, round, in Art Nouveau Yachting Style, or topped by a biplane with an alarm that sounded like a propeller. All were assembled into the assortment of a single retailer. Some were probably designed according to Stukenbrok's specifications, others ordered from stock, some perhaps low-priced surplus. Though the firm's "own clock workshop" was to vouch for quality, no indication is given of the different manufacturers (and there were without doubt many). This was the semantic overload and so-called stylelessness of liberal capitalist commerce, in which a theoretically unlimited number of different models was poured by manufacturers into a market given its form by middlemen and retailers.

Merchandising commodities by brands, a practice that became widespread in the late nineteenth century and which prevails today, represents two major innovations. First, as in *Typisierung*, the manufacturer reduces the variety of models or lines of a specific product; and second, the commodity and its packaging (in the case of foodstuffs only the packaging) are given a trademark – a word, symbol, firm name or combination of these elements which identifies the producer.[245] At the same time, the producer takes over the task of advertising its products as well as the responsibility for guaranteeing their quality; it could also fix retail prices, choose wholesale and retail outlets, and expand into markets far from the factory. Four pages of electric tea kettles designed by Peter Behrens from an AEG catalogue of 1912 show the different way the trademark commodity appeared on the market (fig. 47). The number of differ-

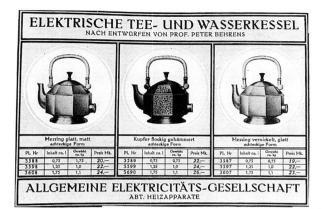 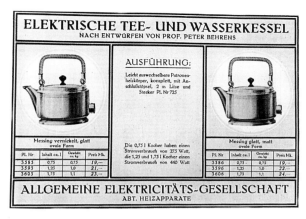

47. Peter Behrens, four pages from an AEG price list for electric kettles, 1912 (from T. Buddensieg, ed., *Industriekultur*, courtesy Gebr. Mann Verlag, Berlin)

ent models is curtailed to variations on three basic designs (a squat teardrop form with a rounded woven handle; and an octagon and cylinder, both with square handles) sold in three different sizes (0.75, 1.25 and 1.75 liters) and standard finishes (brass, copper, or nickel plate; smooth or striated). The advertising literature is meant for distribution in the entire German-speaking market and is published by the AEG, not by a local retailer. And the AEG materials exhibit another tendency of trademark commodities. Through their packaging and advertising, and often on the very surface of the goods, these objects are all given a common visual denominator: often a certain house style – here the reduction to basic geometric forms without excess ornament – and, of course, the trademark itself.

As a commodity form, the brand-name product seemed to address some central points of the Werkbund's critique of the mass-produced object. In the words of Victor Mataja, author of the most detailed account of advertising in the period, the purpose of the trademark was "to direct the attention of the buyer principally or exclusively to the producing firm, or to the designation through which the origin of the commodity in a particular company is shown."[246] The rationale for this reestablishment or recreation of direct contact between producers and consumers is precisely the modern state of alienated consumption. Here Mataja quotes a contemporary on the relation of the merchant to the commodity, but he could as well be talking about the consumer's relation:

> Knowledge of brands has replaced a knowledge of goods. . . . The knowledge of goods can only be empirically learned. Petroleum, lard, margarine, coffee, cocao, tea . . . and hundreds of other articles from all areas of economic life are no longer bought and sold after an inspection of their quality, but rather simply according to the brand.[247]

For Alexander Schwab, the *Marke* or brand, by providing a guarantee of quality or invoking a reputation for it, similarly circumvents the problems of the distance between production and purchase for the buyer of furniture. In buying a brand, "the customer is spared the difficult and in many respects impossible inspection of technical and artistic quality; he relies on the reputation of the manufacturer and, in most cases, the designing artist.[248] The result is a situation which in Mataja's words begins to sound like the achievement of the long-sought transparency in the capitalist distribution of goods: "The characteristics of the brand system are only evident where the commodity enters intermediary trade. An article may pass through a dozen hands: as soon as it bears the mark of its site of origin, connections are created between this site

and the consumer which are lacking in the absence of the mark."[249]

But like the type, the trademark commodity was not quite so benign. It too was a weapon in the battle over the market; it was the consumer goods industry's way of trying to organize and control the market by bringing traditional forms of commerce into check. The producer, wrote Bücher after the war, "enters into a sort of personal relationship with the consumer of his products behind the back of the commercial dealer and thus becomes independent of him."[250] Already in 1910, Mataja had written that

> the degree to which the manufacturer binds the consumer to his product, his brand, is at the same time the degree of his emancipation from dependence on intermediary trade. . . . [T]he public that is educated and stimulated by advertising . . . does not follow the advice of the retailer as much as it demands familiar brands from him. . . . [T]he merchant must order and carry these, even when it suits him better to carry other articles.[251]

The manufacturer's independence did not only concern product form, but also price, which the producer set at both the wholesale and retail level. The retailer received a fixed (and usually quite modest) commission. The result of a successful brand was the producer's control of the market for his goods, the "compelling [of] the dealer," the "limitation of free trade."[252]

The successful brand could create a monopoly, but for the most part it simply freed producers from the dictates and expense of middlemen and allowed them to expand their market for identical goods. The system did, however, tend to limit the freedom of the commercial sector that had developed over the course of the nineteenth century. The trademark economy was the consumer goods sector's equivalent of the organizing tendencies of concentrated capital, though at a somewhat reduced level. But despite this qualification – which is significant – Bücher's description of the role of commerce in the brand market coincides, point for point, with Hilferding's account of the taming of trade by cartels and syndicates. The introduction of trademark goods, writes Bücher, forces the commercial businessman into the position of a "mere distributor":

> Choice, the search for the best sources, the weighing and measurement of quantities, the determination of prices are denied him; his activity is reduced to a minimum. He cannot compete with other firms over a brand-name good; everyone can buy it for the same price, and the consumer does not care who carries it. The profits of increased turnover go primarily to the object's producer, whose name and mark gain exposure with every package

48. Peter Behrens, AEG retail
showroom, Potsdamer
Strasse, Berlin, 1910
(Bildarchiv Foto Marburg)

49. Lucian Bernhard, shop-
window for Stiller shoe store,
Berlin, illustrated in *JDW* 2
(1913)

bought. . . . [With] brand-name articles, the merchant [is reduced] to a mere servant of the producing firm.[253]

The activity of the commercial middleman was not eliminated, but he was reduced to the role of an agent. Producing firms did not eliminate *Handel* but sought instead to take over existing structures to their own ends. In the writings of the time, the effects of the trademark and of the cartel on commerce were treated as essentially identical, a point that was clearly not lost on the members of the Werkbund thinking about *Typisierung*. Like the trust and the cartel, the trademark object offered producers a way to "reduce trade to its legitimate borders"; it was another version of "the end of the capitalist merchant" which Hilferding described.[254]

The trademark led to the introduction of a completely new trade institution, one which figured prominently in the pages of the Werkbund *Jahrbücher*: the retail affiliate or subsidiary store. With such stores producers sought to further limit their dependence on trade, taking over all commercial functions down to the level of the individual retail sale. After the war, Bücher described these efforts as another "attempt to completely eliminate" trade: with "the establishment of retail affiliates . . . the producer sets up numerous shops in the most prominent areas of its market in order to maintain control of its products down to the final consumer. The firm can thus keep the commercial profit and gains again an unmediated relation to its consumers. . . . Numerous retail affiliates also serve as constant advertising for the company."[255] Hoeber seems to allude to this in his discussion of Peter Behrens's showrooms for the AEG (fig. 48), which he calls "the logical conclusion of their cultural policy." He describes this "cultural policy" in terms which also had a purely economic import – the bypassing of the traditional wholesale trade, for in Behren's stores the firm could "enter into direct contact with the broad buying public."[256] The Werkstätten also sought to exploit fully the commercial potential of their trademarks, one of which figures prominently in the ironwork in front of the *DeWe* retail affiliate in Dresden.[257] All the shopwindows illustrated in the *Jahrbücher* represent either the new, laconic shopwindow design of the Höhere Fachschule für Dekorationskunst or the displays of retail affiliates; and the large number of such projects that appeared in the *Jahrbücher* indicates the Werkbund's tacit endorsement of this kind of highly capitalized commerce controlled by production interests (fig. 49). Such projects were the architectural moment of the attempt to bring commerce into check; they pointed to one more way that concentrated capital could operate in the consumer sphere. As such they were not neutral in the battle over the market or its cultural front, a battle the Werkbund fought in the streets, using its shopwindows to give the mute commodity the powerful voice of the trademark.

What, then, was this "voice" (to take a bad metaphor, but one used at the time)? The brand-name commodity moved through the economy in a way different from the anonymous consumer object of the nineteenth century, and as it did so, it gave its visual attributes different functions and raised the possibility of a new kind of commodity visibility. Here I would like to pursue *one* interpretation of the commodity visibility governed by the trademark, an interpretation suggested by the clear sympathy the trademark found in this circle of the group.

The products Peter Behrens designed for the AEG were commonly called "types," and it is worth comparing another one of these types with an anonymous mass-market counterpart. In contrast to the selection in the Stukenbrok

14-Tage-Geh- und Schlagwerk.

Nr. 11290.

50. Peter Behrens, mantle-piece clock for the AEG, ca. 1910 (*Deutsche Kunst und Dekoration* 26 [1910])

51. Peter Behrens, trademark for the AEG, registered 1908 (courtesy AEG Firmenarchiv, Frankfurt/M.)

52. Mantlepiece clock in the A. Stukenbrok mail-order catalogue (August Stuken-brok, Einbeck, *Preisliste 1912*)

catalogue, Behrens's domestic clocks of approximately 1910 appear in a limit-ed number of models, and their ornament is at the same time reduced to a bare minimum. The mantle clock, for example, consists of a single vertical rec-tangular slab mounted atop a simple base (fig. 50). The vertical body of the clock is not treated as a surface for ornament or for sculptural articulation; the lower half, housing the pendulum works, is left as a flat field while the upper half is filled by the nearly unadorned circle of the clock face with simple arabic numbers (even the customary arrowheads on the pointers are absent). The severe geometry of body and base is softened only by a simple molding sur-rounding the clock, an extra molding on the sides which forms thin setbacks near the top, and a set of circular knobs at the juncture of body and base. Only the distinctive hexagonal trademark, designed by Behrens and registered by the AEG in 1908, completes the design at the center of the clockface's lower half (fig. 51). The difference between this and the Stukenbrok clock dis-guised as a fortress, complete with tower, banner, and crenelated upper wall, is clear enough. But one need not go all the way to kitsch. The simple and restrained oak clock offered in the same catalogue for a price probably more in line with the AEG models differs from these in essentially the same way (fig. 52). The body of the clock is flanked by two literally rendered columns, and the panel covering the pendulum is decorated by a finely detailed intarsia urn, both literal references to the classical tradition.

The radical reduction exhibited by the brand-name object could be consid-ered simply an aesthetic decision reflecting the taste of the designer and the responsible executives. On the business side, one could also point to the mod-ishness of pared-down geometric forms at the time (something not unrelated to the Werkbund's efforts). But there are other business differences behind the visual difference, and they have to do with the different economic function of form in the trademark commodity. In the Stukenbrok clocks, the columns, intarsia inlays and crenelations are the forms that bear exchange value; such

1893

1896

1954

1963

53. Development of the *Odol* bottle and label, 1893–1963 (from Väth-Hinz, *Odol: Reklame-Kunst um 1900*, courtesy Anabas-Verlag, Giessen)

clocks were sold to a large extent either by an appeal to novelty or an appeal to signs that could serve the owner by reflecting taste, education, politics, or other qualities that could be read in class terms. In the case of the brand-name object, the form that is the carrier of exchange value (and of course not only form does so) is instead primarily the trademark. It would be to overstate the case to claim that the rest of the design functions as a neutral backdrop to the trademark (which with some, less representative goods is indeed the case – see the example of the coal briquette below), but it must at the very least highlight and reinforce the form which has been made known to the public at considerable expense, and which represents either an image or a reputation that presumably serves as the catalyst to the purchase.

Werkbund observers noted, in other words, a certain tendency toward neutrality (Behrens and Simmel called it "impersonality") in some of these objects, or at least the absence of the excessive and accumulated representations which served to mirror self-conceptions or to make the proclamations of class or chic that went in the Werkbund by the name of Fashion. The brand was to serve as a guarantee of the constant quality of a product, but in order for it to do that work, the very forms of the product had to remain constant too. They tended, in any case, to be less volatile than those of the anonymous mass-market goods, less subject to change: the famous bottle for *Odol*, for example, one of Germany's first major successful trademark products, has changed only four or five times in the century since its introduction (fig. 53). Every aspect of the brand-name product's appearance was sensitive because of its association with the product line; changes could jeopardize product visibility, which had to be bought through advertising. It was the need to exploit a trademark effectively, and not any *technical* considerations of productive efficiency, that often functioned as a sort of brake on the velocity of change in the appearance of the commodity. This made the trademark commodity look like the antithesis of Fashion and made it a candidate for the label of Style. Calling such goods "types" said as much.

The potential for semantic restraint was also seen to apply to the advertising of the brand-name article. We may wonder why: brand advertising was every bit as intrusive as traditional endorsements were. In Richard Seewald's woodcut *Revolution* of 1913, for example, the brand names splayed across a blind

54. Richard Seewald, *Revolution*, woodcut (*Revolution* 1 [1913])

55. Lucian Bernhard, color lithograph poster for Manoli cigarettes (Josef Feinhals, Cologne), 1910 (*JDW* 2 [1913])

wall in a nameless city scream every bit as loudly as the proletariat's political demands; they are all part of the very same urban jumble of representations and impressions, from business as usual to class warfare (fig. 54). Dyed-in-the-wool anti-advertisers certainly did not curb their wrath when confronted with the brand. Consider the following diatribe:

> On every cliff, in every bathroom, in every magazine, on every treetop . . .we see the short phrase, unproven and unprovable: "Odol is the best for your teeth." But how has it come to pass that this simple fact has turned that revolting fluid, with its relatively trivial material worth, into the national stench of the Germans? The toothglasses of every hotel in Germany . . . stink of Odol, and there are people who perfume themselves with it. . . . No one considers that he himself has to pay for this unprecedented advertising that stops at nothing and must cost millions. . . . Does printer's ink still have so much power? On every corner in Berlin, sekt bottles shine into the heavens, soon a glass follows, then the glowing liquid flows in. . . . Only the connoisseur who notices the brand . . . is sickened.[258]

And the famous international trademarks of the period – the little Michelin man of 1891, and the mustachioed portrait of K.C. Gilette of 1895 – were hardly tactful in their relentless ubiquity.

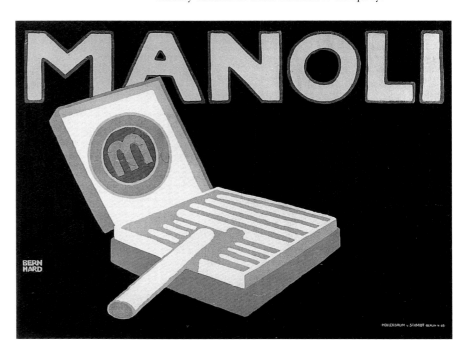

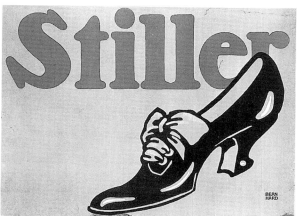

Yet the supporters of the type in the Werkbund were looking less at the reality of the brand than at a certain potential; and they had a very particular kind of advertising in mind, one which presupposed the trademark. Brand advertising was represented in the Werkbund *Jahrbücher* by many examples of a new trend: the so-called *Sachplakat* – "object poster," or, echoing *Sachlichkeit*, "objective poster" – and its smaller printed equivalents.[259] These advertisements, whose chief innovator was the Berlin graphic artist and Werkbund member Lucian Bernhard, exhibit an extreme reduction of means: dispensing with all but the most essential text, they tend to show a highly schematized image, usually the product, and indicate the manufacturer. In Bernhard's famous *Manoli* poster of 1910 (fig. 55), for example, the rendering of the product – here cigarettes in a box – is flat and devoid of distinguishing marks, anonymous and unspecific. The product is differentiated from others of its kind only by the name and the trademark crest of the manufacturer. The representation of the commodity is stripped of ornament, abstracted to what contemporaries called a "type,"[260] and the commercial signs are limited to a single mark of origin. The advertisement is reduced to a type and a trademark.

Such an analysis of this classic *Sachplakat* does not do justice to the subtleties of the design – the perpendicular counterpoint of the single, tobacco-edged cigarette and the white and grey stripes of those in the box; the cigarette's foreshortening and its precarious balance which activates the flat black ground and turns it into a deep space. But it is a reduction and absence of obvious conceit or gimmick which allows for easy reinforcement, for example by the Manoli car illustrated in the Werkbund *Jahrbuch* exhibiting the name and the Manoli crest (fig. 56). The reduction of the product in the advertisement to the suggestion of a shared, vernacular type was striven for; what was sought was the precarious situation in which plagiarism was practically unavoidable, as in Bernhard's *Stiller* poster of 1908,

56. "Manoli" delivery car, illustrated in *JDW* 3 (1914)

57. Lucian Bernhard, color lithograph poster for Stiller shoes, 1908 (Deutsches Historisches Museum, Berlin)

58. Lucian Bernhard, signet for Stiller shoes, ca. 1908 (*Seidels Reklame* 2 [1914])

59. Anonymous signet for Petzon shoe store, Magdeburg (*Seidels Reklame* 2 [1914])

60. Julius Gipkens, color
lithograph poster for Kaiser
coal briquettes, 1913 (Kaiser
Wilhelm Museum, Krefeld)

61. Newspaper advertise-
ments for light bulbs (*Seidels
Reklame* 2 [1914])

62. Three bookmark adver-
tisements for lightbulbs
(*Seidels Reklame* 2 [1914])

which shows only a schematic shoe "type" and the quite interchangeable
brand name (figs. 57–9). Even the completely cartellized, standardized com-
modity, hardly a mass-market consumer product in the usual sense, appeared
quite at home in the *Sachplakat*. In Julius Gipkens's *Kaiser* poster of 1913 (fig.
60), the coal briquette – the standardized commodity par excellence,
unchanged in form to this day – appears bearing only its trademark name,
diagonally splayed across a ground of red and orange stripes suggesting heat
and flames.

Like the shopwindow, the advertisement for the trademark product had
only to display, in the most schematic way, the commodity itself, and then one
more thing: the trademark or manufacturer's name. In many cases the trade-
mark became more effective as the rendering of its carrier became less specific.
The advertisements promoted by the Werkbund approached (but stopped just
short of) a state in which there was only one variable in the advertising of a
specific article: after the representation of the type, only the trademark marked
the distinction between products. Such was clearly the case in advertisements
for light bulbs, in which the type was reduced to often identical line drawings
of the same screw base, filament and pointed glass housing (figs. 61, 62). The
trademark name across the filament or field is the only significant variation.
Here too the overwhelming visual and business importance of the trademark,
the chief visual bearer of exchange value, could be seen to function as an effec-
tive semantic brake.

The posters in particular are not quite as neutral as I have implied: the con-
siderable fantasy of accomplished practitioners found plenty of room to
maneuver in the space opened up between the trademark and the schematic
rendering of the naked commodity, not to mention in the design of the trade-
mark itself. With its frontal formality and symmetry, its rhythmic repetition of
the trademark letters and its insistent perpendicularity, Behrens's prospectus
design of about 1910 for AEG light bulbs, for example, creates a stable, classi-
cizing rendering of the object; its only playful note is the analogy of the fila-
ments and the lines of the honeycomb signet (fig. 63). This was far removed
from Bernhard's later (ca. 1920) rendition of the formula: the diagonal place-
ment of the bulb gives the poster its dynamic note, and the bright colors of the

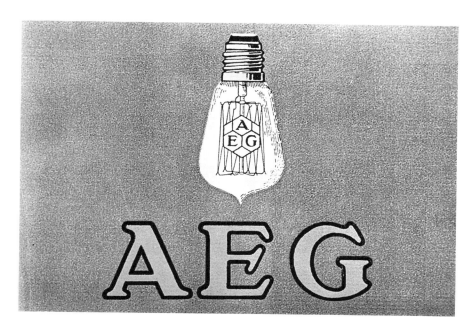

63. Peter Behrens, cover for
an AEG prospectus, after
1908 (from T. Buddensieg,
ed., *Industriekultur*, courtesy
Gebr. Mann Verlag, Berlin)

64. Lucian Bernhard, color
lithograph poster for Osram
light bulbs, ca. 1920
(Deutsches Historisches
Museum, Berlin)

trademark and the ground as well as the reflection and shadow in the glass all
allude to qualities of energy, illumination and optical transmission (fig. 64).

This space between type and trademark represented, it seems, the "legiti-
mate boundaries" of the visual production for the commodity market; it was
interpreted, in a way, as something approaching the "limiting [of] advertising
to mere notification." The members of the Werkbund need not have looked at
it this way; there was abundant evidence that their analysis of the trademark
advertisement was wrong; but the trademark was clearly seen to have the
potential to solve certain problems. Consider Sombart's follow-up to his
famous tirade on advertising, where he wrote that the advertisement "is loud;
it speaks in superlatives, contains value judgements, is not content with the

65. Newspaper advertisement for Santo vacuum cleaners compared with a color lithograph poster for AEG speedometers by Peter Behrens, 1912 (*Seidels Reklame* 1 [1913]).

mere statement of facts."[261] Fritz Hellwag writes similarly about the semantics of laissez-faire: "Word and object have not coincided for a long time. Corresponding to the flashy objects of the last quarter of the previous century, a false appearance and exaggeration have taken root in linguistic matters as well; it is beginning to sicken us. The most forced and meaningless superlatives are used."[262] The superlative was pointed to as evidence of the explosion and inflation of representations in the commercial sphere that not even Henry van de Velde managed to avoid in his famous *Tropon* poster of 1897 (fig. 7), with its immodest statement that "Tropon is the most concentrated nourishment." The trademark offered a way out of this pattern of strained diction. In 1913, the advertising journal *Seidels Reklame* contrasted the verbal explosion (in six different typefaces) resulting from free-for-all competition with a Behrens newspaper ad in the *Sachplakat* style, putting exhortations to "Request 2000 references at no cost! 100 testimonials!" next to the restraint of the brand-name object, the corporate giant which needed only to say its name (fig. 65). "We place the nervousness [*Unruhe*] of the Santo advertisement across from the refined tranquility of the AEG advertisement, which shows nothing but the object, the name, and the firm, and otherwise lets the reputation of the house speak for itself."[263] The message was that the sphere of commodity exchange no longer needed to display its nineteenth-century haste and nervousness; the pathology of Impressionism could give way to the salutary reemergence of classical order on the market.

The way the concepts of the type and the brand overlap suggests the belief that, by tracing its straight and narrow path through the economy, the new commodity bearing the mark of its maker would carry out the work of cultural hygiene that the Muthesius faction in the Werkbund had called for. They seemed to believe that the brand could function as a type and would represent a kind of Style acceptable to big capital, whose support they were soliciting in changing the face of the market. Following the clues of contemporary accounts of the brand system, they interpreted the trademark as a semantically centripetal force that would subsume both the commodity and advertising to

big capital and Culture simultaneously. Karl Scheffler said as much in an article on Behrens titled – pointedly and polemically, I would argue – "Kunst und Industrie" (Art and Industry). Over an illustration of a Behrens trademark for the AEG (fig. 66), he writes, "We have a new sign [*Zeichen*] that the bourgeois *Unternehmungsgeist*, which till now has only been concerned with the accumulation of material gain, is beginning to idealize; that it – finally! – is beginning to feel the need to make its necessary and monumental lust for work moral by considering its duty to beauty; and that only in this way is it becoming truly aware of its modernity."[264]

66. Peter Behrens, trademark for the AEG, registered 1908 (courtesy AEG Firmenarchiv, Frankfurt/M.)

Here Scheffler plays on the German word for trademark, the mark identifying the brand: *Warenzeichen*. The word *Zeichen* allows a somewhat broader range of meaning than the English words "mark" or "sign," one which encourages Scheffler to inscribe within it yet another shift of the kind so characteristic of Werkbund theory. The word allows him to move from the brand's obvious economic work to a kind of cultural work; it allows him to move from a conception of the sign as a simple graphic mark to one which sees there something transcendent, a symbol of the kind the Romantics theorized.[265] The single word allows Scheffler to give the trademark a cultural interpretation: it was the symbol of a new economic spirit, and at the same time a symbol of the commodity's redemption.

The Werkbund experimented a number of times with making its own *Marke*. The third annual report of 1910/11 noted the desire of member firms to turn their membership into a tangible market value by using it to achieve the sort of market visibility associated with the trademark: "The wish has been expressed . . . several times that firms be enabled to emphasize externally their membership in the Werkbund by the use of a characteristic sign on their publicity materials, stationery, etc."[266] On 2 October 1911 the Werkbund board of directors responded with the following decision: "Every member is permitted to use the letters 'DWB' on letterheads, business cards and similar printed material as a sign of its membership in the German Werkbund."[267] At the same time they published a group of suggested signets designed by four of the more prominent graphic artists of the group.[268]

This was a very tentative step. Any of the signets could easily have been taken for a trademark, and that is no doubt what the firms, whose own trademarks could not have had the Werkbund's nationwide prestige, had in mind. Yet the Werkbund went out of its way to dispel any such notions. First, nineteen signets were published as suggestions – far too many to create the sort of immediate and unequivocal identification with a single firm that a trademark was supposed to achieve. And second, the decision included an important stipulation, one that represents a partial refusal of the member firms' request: "The use of such a sign is . . . not permitted in advertisements, catalogues, or on the commodity itself."[269] The signet could not be used precisely where the trademark was most prominent. It was clearly meant to stay behind the scenes on business correspondence; it would not make it all the way to the market, the only place where it could do the kind of work the trademark did best. The Werkbund clearly wanted to avoid any confusion about its own status and that of its mark.

Within a few years, in its second attempt to make its mark on the market,

67. Peter Behrens (?), tea
service, nickel and nickel
plate, in the *Deutsches
Warenbuch*, 1915
(Werkbund-Archiv, Berlin)

68. Richard Riemerschmid,
hot water pot, warmers and
kettle with heater, polished
brass, in the *Deutsches
Warenbuch*, 1915
(Werkbund-Archiv, Berlin)

69. Trademark for the
Dürerbund-Werkbund
Genossenschaft, registered
1916 (Deutsches Patentamt,
Warenzeichenblatt)

the Werkbund created just such a confusion; it sought this time to go a bit beyond its legal bounds (it was a non-profit organization[270]) and to use its mark to act a bit like a cartel or syndicate. In 1913 the Werkbund, Ferdinand Avenarius's Dürerbund and four retail merchants' associations formed the Dürerbund-Werkbund Genossenschaft with the aim of publishing a catalogue – the *Deutsches Warenbuch* – that would "offer exemplary mass-produced goods for household use and thus exert a significant influence on culture in general."[271] The Werkbund's sixth annual report describes the goal of the group as the "purchase, manufacture and sale of high-quality work [*Wertarbeit*] for the German home; the catalogue *Das Deutsche Warenbuch* will gather the best mass-produced goods and label these goods with an insignia [*Wertmarke*] – the *Dürerbund-Werkbund-Marke*."[272] The ideas surrounding the project are familiar. The items were referred to as types, and they were described as an attempt to offer an alternative to Fashion.[273] Photographs were taken which resemble the most *sachlich* of shopwindows: objects are displayed in a deadpan way, in pictures whose even spacing and neutral, textless background were clearly meant to be a stern contrast to the carnival of display customary in contemporary catalogues (figs 67, 68, 46). And the attempt to stress the themes of the traditional and the universal implicit in the notion of the type reached a new level: critics did not fail to notice the forced way in which the title of the catalogue – literally "Book of Commodities" – sought to echo the Gospels.[274] What was quite new, however, was the way the goods pictured in the catalogue and sold by member merchants sought to look and act like brand-name com-

modities through the use of a trademark: "The members of the Dürerbund-Werkbund Genossenschaft agree to designate the goods gathered here with a mark and to display them prominently."[275] The mark, a trademark, was duly registered with the German patent office (fig. 69).

In light of the association that was developing between types and monopolistic forms of control over the market, and the way the use of trademarks could create or simulate such a process in the consumer sphere, it is not surprising that the *Warenbuch* was surrounded by controversy. When it finally appeared in late 1915 (a year behind schedule due to the outbreak of the war) the most strident attacks came from an unnamed critic in the *Münchener Post* who no doubt took his cue from the Werkbund's own writings. He described the Dürerbund-Werkbund Genossenschaft as "a trust working by means of the most flagrant boycotts" and seeking to create a "monopolistic tyranny"; its mark was a "medieval-guild designation" used to distinguish the organization's own goods from those of "non-Werkbund origin." The *Warenbuch* represented nothing more than an "advertisement for Werkbund articles" and was termed "an act of violence against the German economy."[276]

The anonymous author's claims were certainly overstated, but not nearly so much as the Werkbund and its allies sought to make them appear. The first protests were raised already in 1912, when the plans were in an embryonic state, and they came from the group that was traditionally most, and most immediately, hurt by both trusts and trademarks: the wholesale trade. The situation was complicated by the fact that it was not necessarily in the interests of storeowners to go behind the back of their wholesalers as they were in fact still quite dependent on traditional trade institutions. In the wake of protests on the one side and hesitation on the other, the Dürerbund entered into intense negotiations. Publicly, Avenarius wrote that

> at the top of these organizations stood wise and farsighted men who recognized the correctness of our intentions. And it was precisely cooperation with culturally conscious merchants which was the ultimate goal of our plans, as we had [from the beginning] . . . declared. Thus the discussions between the authorized men of the trade and the directors of the Dürerbund led to a fundamental agreement: to pursue together our common goals.[277]

Since the commercial organizations which ultimately joined the Genossenschaft were primarily retail associations, the *Händler* Avenarius wrote of here were clearly retail storeowners.[278] A private letter from Avenarius to Riemerschmid suggests the same scenario and gives insight into the nature of the negotiations that took place. That Avenarius was talking to retailers is implied by his reference to their desire for the use of a *Marke* as well as his comment that "if the *Händler* understand their interests, they have to go with us."[279] Avenarius could not have been writing of wholesalers here; his words make sense only as part of a line of argument that sought to divide the storeowners from their traditional suppliers. Indeed, when the *Warenbuch* was finally published, it contained the by then standard account of the deleterious effects of commercial intermediaries.[280] The middlemen had been shut out, a familiar phenomenon in turn-of-the-century Germany.

The retail merchants struck their bargain with the Werkbund and the Dürerbund. At issue was the right to carry what they must have thought would be a prestigious and profitable line of what Avenarius described as "elite merchandise."[281] If convinced of the feasibility of the enterprise, they

would not have wanted to be left out. It might even have been an exclusive franchise merchants bought into, or so went the accusation in the *Münchener Neueste Nachrichten*:

> Through the weight of their name and the verdict of their experts, the Dürerbund and the Werkbund give to [only] a fraction of similar and equal stores the right – through the *Warenbuch*, confirmed with an insignia – to identify their goods as selected, exemplary . . . and the most beautiful of the time. . . . This is a procedure that has figured in numerous cases of illegal business practices and which does not become better or more legal through the ceremonious shrouding in the name of artistic and ethical goals.[282]

The Genossenschaft's defence against the charges is not terribly convincing, reiterating the usual arguments used to counter antitrust actions. Avenarius stresses the supposedly voluntary nature of agreements that limited free trade and is silent on the limitations on members' freedom and the anxieties that compel them to join: "Membership in the Dürerbund-Werkbund Genossenschaft was open to *all* owners of reliable business enterprises. . . . [W]hoever did not join *did not want* to join."[283] And he tried to play down the importance of the all-important trademark: "The designation of the Dürerbund-Werkbund Genossenschaft says to the buyer, on the object itself, that it has passed the inspection of our examining committee, nothing more. Whoever's taste leads elsewhere will find other goods in the same store and furthermore in the surrounding stores. No one contests that there is excellence [to be found] even in the goods that have not been examined by us."[284]

These were evasive answers. But though there was enough to the charges to make them hard to counter effectively, the *Warenbuch* was not the front for a classic producer's syndicate seeking to bring the institutions of distribution and exchange under its control. In fact, the organization bears some resemblance to another, related economic form of the time, a sort of trade cartel or counter-cartel in which a large retailer such as a department store or a group of commercial firms sought to exploit a position of power over weak, unorganized manufacturers or, as in this case, middlemen. This is what the writer in the *Münchener Neueste Nachrichten* was implying when he wrote that "the fact that merchants have united in the place of producers strikes us as a case of driving out the devil with Beelzebub."[285] Significant in this regard is the high price the member retailers managed to charge for their goods, something noted by both supporters and critics alike.[286] In light of the extended negotiations, it can only be assumed that a good chunk of these prices remained the storeowners' share.

Yet the Dürerbund-Werkbund Genossenschaft was not really a commercial cartel either. It was, if one must define it, a limited corporation composed of non-profit organizations, some of whose members were in turn corporations; one which sought to select goods from producers and to assist their distribution through the use of a trademark and a network of existing institutions which became the corporation's agents. It is an economic form which is hard to pin down and was certainly unique. But then, syndicates and cartels too were hard to pin down at the time. Hence the confusion on the part of critics, who recognized an anti-laissez-faire tendency in the attempt to control a market, as well as their agreement, in effect, with those supporters who themselves invoked the new economic forms by calling the project "an example of German organization."[287] In any case, the Genossenschaft was clearly an attempt to meddle in the economy, to put something like types on the market

and to assist in their sale. Perhaps the *Warenbuch* even represented the attempt to separate the type from the brand as it existed then (and still does now) – in other words the attempt to separate the brand from capital. I think, in fact, that this is precisely what it was. That is mere conjecture, but it would correspond to the line of thought Muthesius, Naumann and others supporters of *Typisierung* had developed by reading economic forms in terms of their ability to nurture spirit.

In any case, Avenarius writes that the *Warenbuch* reflected a "decidedly anticapitalist tendency."[288] There is a significant element of truth in this claim. The project was part of the Werkbund's arrogant and naive attempt to use capital in the struggle for Culture, to manipulate capital to its own, occasionally anticapitalist, ends.

<div align="center">* * *</div>

Karl Schmidt, "Type-Schmidt," thought the world of the economist Karl Bücher. The director of the Deutsche Werkstätten read Bücher's works, invited him to give lectures, and taught his ideas to shop-floor apprentices at the firm.[289] It even seems that Schmidt sought Bücher's blessing for the program of *Typisierung* to be raised at the 1914 Cologne meeting.[290] It took a while – until 1921 – but Bücher, it seems, finally obliged; at any rate he wrote an article on the subject, the one I have already quoted from above. But it was not the sort of article Schmidt had solicited. It was instead perhaps the strongest and most convincing argument against *Typisierung* to appear in print.

Bücher had a good sense of the utopian spirit behind the idea, that "streak of uniformity [that] would run through all of human life," but he did not find the idea of a market organized according to productive efficiency, as he extrapolated it, to be any too pleasing. "A thoroughly specialized, typified, normalized world," he wrote, "would be a petrified world which would have to accept identical commodities and do without the stimulating drive to progress. It would presuppose consumers who cannot transcend the given. Are we far enough along in our industrial evolution to bring it to a close, . . . to fix for all time forms, dimensions, and sorts of commodities?"[291] True to the Historical School's doctrine of the economy as a human sphere, he dwells on the fate of the spirit: "One can hardly imagine the man of the future – who is typically dressed, lives, eats and drinks typically – as a free being."[292] But Bücher was not sounding the alarm; he saw little reason to believe in the imminent arrival of the world of the "specialization fanatics, the norm-givers and the friends of the type."[293] It would produce its own backlash, he says; trade, not production, would be the ultimate winner. Commercial institutions would have to take over the increasingly complex problems of distributing uniform products over wider, stretching markets. Business would flow to the *Händler* who could gather an interesting selection of goods *in spite of* the prevalence of these standardized types, for "the consumer demands variety."[294] The more restricted the product range, the less exciting it would be, the more necessary the commercial middleman. Commerce has its place. Not only does he wonder "if the results we can expect from such a standardization would be entirely positive," but also "whether we can seriously expect that industry would voluntarily submit to the plans for standardization." His ultimate question is most to the point, and most subversive in light of the line of thought we have examined in this chapter: do we, he asks, "really find ourselves in the alleged condition of economic anarchy?"[295]

The dream of Muthesius, Naumann, Schmidt and others would turn into a

nightmare; but not to worry, Bücher seems to say, they're wrong anyway, it will never come true. A system of production that would impose order did not exist, for the capitalist economy did not function like the mythical construct called Culture. There was spirit in the modern economy, and it had its own logic, but it defied control of the crude kind Muthesius and others suggested. Capitalism, Bücher suggests, produces signs that do not submit to the discipline of production, signs that gather in the space of commerce and can not simply bypass it. Bücher did not explore these signs; from the perspective of political economy, no one in the Werkbund did. But there were others in the group, especially artists, who had less the theoretical insight than the urgent professional need to develop some sense of how such signs worked. For the most part these artists straddled the fence or ended up on its other side in the 1914 debate on *Typisierung*, and they had a very different sense of the role of visual form in the modern economy.

Magical Signs:

Copyright, Trademarks and "Individuality"

1. COLOGNE 1914 AND THE RESPONSE OF THE INDIVIDUALISTS

> About Cologne: Do you really believe that the fight over the type
> was the true content of the meeting? It was only the veil of Maja,
> behind which lay the true disagreement.
>
> Karl Ernst Osthaus[1]

The acrimonious debate between Hermann Muthesius and Henry van de
Velde at the 1914 Werkbund Exhibition in Cologne is a *locus classicus* in the
history of modern architecture in the West, a point of reference for the devel-
opment of modern design theory. A week before the Cologne assembly, the
seventh annual meeting of the group, Muthesius distributed ten theses that
formed the core of his keynote address, theses which described what their
author saw as the ineluctable development of "types" in architecture and the
applied arts and which asserted the urgent aesthetic, political and economic
necessity of actively furthering this tendency. Muthesius had presented these
ideas before, often and publicly; but on seeing them presented as official
Werkbund policy (the theses were to be put to a vote and their author clearly
expected no opposition) a small group, mostly artists and architects, cried foul
and planned a response. They chose van de Velde to draft and present ten
"countertheses" representing opposition to the program of *Typisierung*.
Hearing of the opposition, Muthesius toned down his address in the hopes of
assuaging the offended faction. To no avail: Muthesius's last-minute qualifica-
tions were lost in the din. Van de Velde presented his response; the theses
stood against the countertheses, igniting a controversy from which the organi-
zation never recovered in its original form.

In his first thesis, Muthesius proposed that "architecture, and with it the
whole area of the Werkbund's activities, is pressing towards *Typisierung*."[2]
Van de Velde's response was presented not as that of an unspecified cultural
subject but as the response of the *artist*: "So long as there are still artists in the
Werkbund and so long as they exercise some influence on its destiny, they will
protest against every suggestion for the establishment of a canon and for

Typisierung." "By his innermost essence," he continued, "the artist is a glow-ing individualist, a free spontaneous creator" who "will never subordinate himself to a discipline that imposes a type upon him."[3] Van de Velde made clear that he did not mean to step outside the parameters of the discourse on Culture: to Muthesius's statement that "only through *Typisierung* can [archi-tecture] recover that universal significance which was characteristic of it in times of harmonious Culture," he replied that "the artist . . . has always recog-nized that currents which are stronger than his own will and thought demand of him that he should acknowledge what is in essential correspondence to the spirit of his age. . . . He willingly subordinates himself to them and is full of enthusiasm for the idea of a new style."[4] Muthesius saw the reduction of applied arts design to recognizable types as an integral component of the Werkbund's need to "concentrate its attention upon creating the preconditions for the export of its industrial arts"; van de Velde retorted that "the need to export . . . lies like a curse upon our industry" and that the efforts of the Werkbund should be directed instead toward cultivating "the gifts of inven-tion, of brilliant personal inspiration," even "individual skill which attends to joy and belief in the beauty of the most sophisticated execution."[5] He envi-sioned an age of *Typisierung* as a time when "individual strivings begin to slacken," when "an era of imitation will begin and forms and decorations will be used whose production no longer calls for any creative impulse."[6]

Van de Velde had drawn the battle line: the supporters of *Typisierung* and "beneficial concentration" – a phrase which we have seen represents a cultural reading of contemporary economic trends – stood in conflict with the cultiva-tors of "individual strivings" and "personal inspiration," the typifiers against the individualists. In the debate that followed, the factions quickly became clear. Among the speakers who echoed Muthesius's views were Ferdinand Avenarius, Peter Bruckmann, Karl Gross, Richard Riemerschmid, and, in his closing address to the meeting, Friedrich Naumann – precisely those who were involved in the practical project of the development of types and its theoretical formulation growing out of the discourse of political economy. And indeed it was primarily artists who spoke in support of their colleague and mentor van de Velde: Rudolf Bosselt, August Endell, Hermann Obrist and Bruno Taut. At the core of this group was their patron, publicist and confidant Karl Ernst Osthaus, who also spoke, and the young Walter Gropius, who worked behind the scenes.[7]

In light of the ambitious and self-conscious nature of the Werkbund's theo-retical project, it should be clear that it was no mere matter of aesthetics that was at issue in Cologne – whether Style was represented, say, by the undeni-ably vapid neoclassicism which was overwhelmingly in evidence in the exhibi-tion architecture (and which apparently pleased no one), or by the pared-down Jugendstil idiom practiced by some of the architects in the Osthaus cir-cle; or whether unity was preferable to variety. In recent scholarship, a consen-sus has emerged which seeks to take into account the breadth of the issues involved in the debate. Such a view sees in the advocacy of *Typisierung* an acceptance of the economic realities of mass production and the attempt to develop a properly industrial aesthetic; in the individualist position it sees a rejection of economic necessities and the retreat to a craft approach. A sober appraisal of modernity is contrasted with a burning defence of anachronistic artistic principles. This view valorizes the Muthesius position: it implicitly or explicitly labels his stance "correct" or "progressive" and places it in a privi-leged position behind the presumably "industrial aesthetics" of Le Corbusier

in France and the Neues Bauen in Germany. A related view tends to reverse this valorization (though the views are not mutually exclusive). Instead of positioning the groups on either side of an axis dividing the pre-industrial from the modern, it disposes them about an axis separating left from right. In this interpretation, Muthesius's position betrays an accommodation or compromise with capital, while van de Velde's represents a resistance to or rejection of the demands industrial capitalism imposes on the modern artist.[8]

These interpretations, however, still rely on a fairly literal reading of the 1914 debate and a teleological reading of earlier texts. The exploration of the emergence of the *Typisierung* project from the discourse of political economy that was presented in the preceding chapter has served, I hope, to problematize and call into question such views of Muthesius and his allies. We have seen that their relation to the capitalism of the time was decidedly ambivalent, and while they did affirm and support certain trends they discerned in the contemporary economy, they badly misjudged the relation of these developments to the applied arts. Needless to say, the utopia of the type and the spiritualized economy they sought to achieve did not come to pass. In this chapter, I would like to offer a reconsideration of the "individualist" position. It will be argued here that the stance articulated by van de Velde was not based on a retrospective craft model but was instead deeply rooted in the economic realities of the time; that it cannot be characterized in terms of artists' resistance to capitalist developments but rather in terms of their attempt to integrate themselves into this evolving modern economy; and finally, that this position was in no way "wrong" or "unrealistic" but was in fact the logical outcome of an astute appraisal of the cultural field created by modern capitalism.

Admittedly, this is not an easy case to make. For while the position put forward by Muthesius is a unified, consistent, at times compelling *argument*, the van de Velde or Osthaus position, though not unsophisticated, was not formulated as part of a systematic inquiry or reform project. It was instead part of a practical attempt to represent the interests of artists and architects working in a changing economy. When the agitation in the interests of this very specific group turned to discursive argument, the terms were defined defensively, in reaction to threats and opportunities, real or imagined. Put another way, the Osthaus group was not so deeply enmeshed in a discourse (beyond that of Culture) as was their opposition – a discourse that could provide them with a consistent kind of knowledge with which to analyze their problems as well as consistent meanings, objects and terms with which to represent their project. They found empirical answers to a very real problem – that of maintaining a viable role for the traditional producers of "art" in a modern economy – but when it came to defining their principles, they found themselves forced to take recourse to discourses which did not always refer to the phenomena they were concerned with. Specifically, they borrowed arguments quite uncritically from the tradition of bourgeois liberalism and from Romantic aesthetics. This made it hard for them to talk clearly about twentieth-century modernity, though I hope to make clear that it was precisely that which they were addressing.

It is thus difficult to sketch a discursive field in which to situate the texts and artistic productions of the Osthaus group. But another sort of context can be drawn, one which helps us map the modern economy, the site of their projects, and which also reflects the broad realignment between traditional sectors of manufacturing and trade discussed in the last chapter. This context is the law. The applied arts movement in Germany was precisely contemporary with a major overhaul of the laws governing the economic use of visual form. A

new trademark law was barely a decade old when Behrens designed his famous AEG logos, and a new copyright law for works of the visual arts was enacted in the very same year as the founding of the Werkbund. Together, these laws provide signposts that defined the economic field in which the Werkbund planned its cultural interventions, signposts discussed regularly in applied arts journals and thus well known to artists at the time.[9]

Although the developments in the Werkbund have never been considered in this context, the law provides coordinates that the artists and enthusiasts in the Osthaus group recognized, even if they did not always frame their arguments or understand their concerns in these terms (and sometimes they did). Unlike Culture and political economy, which occupied the foreground of Werkbund discussions, the law often retreated into the background. It gives us, however, a set of terms for describing the function of both form and the artist in a modern economy as well as delineating a single field on which to assemble the fragmentary statements made by the Werkbund "individualists."

2. I<small>NDIVIDUALITY</small>

> When the Reverend Naumann . . . declared in Dresden that a chair
> by Riemerschmid is just as much a cultural achievement as, for
> example, a poem by Goethe, this demonstrates no great apprecia-
> tion of Goethe on the Reverend's part, and proves nothing at all
> about Riemerschmid's universal chair.
>
> <div align="right">critic of the applied arts movement[10]</div>

> The laws that will govern the economic use of aesthetic, intellectu-
> al, moral and religious goods in the coming decades are of concern
> to *all* of us.
>
> <div align="right">Ferdinand Avenarius[11]</div>

If we consider the artists' or "individualist" position first at its most literal level, a fundamental but, in the literature on the Werkbund, completely over-looked fact emerges: that it was, at the time of the founding of the organiza-tion, Werkbund orthodoxy. Even the figures who seven years later were the most outspoken opponents of the loosely defined doctrine were at first unam-bivalent in their assertion of the importance of the artist's "individualism." We can take as our guideline here a fairly typical comment by Muthesius from the early Werkbund years. In 1908 he wrote that "every new development of Style can be traced back to the *personal* labor and the *individual creative power* of one or a group of artists."[12] He obviously saw no contradiction between the "personal work" of "individual creation" and collective nature of Style. In fact, as much as the achievement of Style and "harmonious Culture" were the ultimate and somewhat abstract goals of the reformers, the primacy of the artist and his right, indeed obligation, to cultivate his personality was the cen-tral concrete principle behind the founding of the Werkbund.

The beginning of the series of controversies leading to the formation of the group was of course the Dritte Deutsche Kunstgewerbeausstellung of 1906 in Dresden and its novel selection and exhibition policy.[13] Recall that only objects and ensembles executed after designs by a named artist were accepted, and that these entries were labelled with the designer's name first, followed by the name of the producing or executing firm. These were significant reversals of customary practice. J.A. Lux describes how the tables were turned:

> Already during the Dresden exhibition, a group from the art industry grum-
> bled loudly enough about being put at a disadvantage by the artists. The
> latter always used to sit quietly in the background, hardly named; the pro-
> ducer was the exhibitor, the commissioner of designs, the bread-giver. This
> time it was the other way round: the *artists* exhibited under their own
> names, and the producer figured only as executor. They were still named
> clearly enough, but not first, and that had economic repercussions.[14]

Lux writes only of grumbling, for the matter had not yet erupted into a full-blown "affair." But what should already be clear is that this simple change in the order of information on an exhibition label was not a mere matter of trade etiquette, an empty gesture or a marketing ploy. At issue instead was the understanding of the artist's contribution to the exhibited items, the economic and legal status of this kind of work.

Directly after the 1906 exhibition, Muthesius defined the opposing camps

not according to personnel or aesthetics but by a distinction in the type of labor they performed. The "grumbling firms" consisted of "applied arts producers, merchants and craftsmen, thus of the *material* producers in opposition to the *intellectual* producers." "The interests of both parties," he continues,

> must be fairly balanced; a mutual relationship must be created that guarantees the artist a certain share of the success of the objects of which he is the intellectual creator.
>
> Such relationships have long existed in another area which concerns the industrial distribution of intellectual products – in publishing. Here the writer is granted a certain share of the profits of his book. The contractual arrangements are most varied, but in any case the contract secures an appropriate recompense for the author. That the name of the intellectual author of a work is prominently displayed and not suppressed goes without saying. . . .
>
> The publishing contract could be a parallel for those for applied arts objects meant to be mass produced.[15]

In comparing the work of the applied artist with that of the literary author, Muthesius is seeking to position the designer as an author or *Urheber* – that is, as an artist in a specific and important legal sense. For the literary contracts to which Muthesius refers and which tended to remunerate intellectual labor in this way were governed by a special law – that of copyright (*Urheberrecht*). And in again raising the explosive issue of the display of the artist's name, Muthesius invokes a central point of copyright law: the right of the author to have his name appear on or next to his work (or, conversely, to withhold it), even when the work is executed and sold by another party. This was the true polemical gesture of the Dresden exhibition and the source of the controversy which led to the founding of the Werkbund: the central symbol of copyright – the right to sign one's work – was written into the rules of the exhibition. Even though applied artists and architects were not entitled to the privilege of copyright at the time of the exhibition, the organizers created a world in miniature in which the designer was presented as an artist in the legal and economic sense.

According to the German laws in effect in 1906, copyright was granted to those who exercised "individual creative activity" using the media of "the creative arts": literary (or academic) writing; music; painting, drawing, and engraving; and, in some cases, sculpture.[16] This is how the law defined the artist, to whom it gave a simple but economically important privilege: the exclusive right to reproduce or have reproduced, to distribute and to sign his work for the duration of his life (heirs inherited this privilege for a period of thirty years after the death of the artist). The artist retained these rights even after the sale of his work, and in many cases, the law ranked the author's right to his creation above the purchaser's right to his acquired property.[17] The rights could be transferred or sold, but this was not to be construed simply by the sale of such goods, and, as Muthesius's comments show, it was not customarily stipulated. Copyright law created, in effect, a special kind of commodity – the intellectual or cultural.[18] And it created for them a separate, protected economy within the larger regular economy.[19]

The law recognized applied arts designs as intellectual property, but it did not recognize their designers as authors. Registered design law (*Musterschutz*), which regulated these commodities, regarded the act of design as commodified, alienated labor: both the labor itself and its fruits belonged to the pur-

chaser. Unless otherwise stipulated in a contract, design work done in the
employ of or commissioned by an industrial producer was the property of the
producing firm, which was considered the author.[20] This was the arrangement
to which the firms which grumbled in Dresden were accustomed, even if Lux,
speaking for the artists, sees this as crass exploitation: "When they face the
lone, dependent artist, the producers use their economic power to conceal the
artistic employee and to present the 'firm' as the true author [*Urheberin*]."[21]
This exploitation, however, was not only in full accordance with the law but
also faithfully reflected its definition of the labor involved. Even if an artist
could negotiate a contract which granted him the authorship of his own
designs, the protection offered by design law was both weak and cumbersome:
Musterschutz was not automatic (as was copyright) but required the owner's
registration of his design, and it remained in effect for a period of only one to
three years. Upon application and payment of fees, this could be extended to a
maximum of fifteen years.[22]

In 1906, at the time of the Dresden exhibition, a review and revision of the
copyright law was in progress, one which many hoped would grant the
applied artist the same rights that were given those who worked the more
exalted media. In jumping the gun, the exhibition organizers were probably
seeking to create a reality (or the appearance of one) to which the members of
the legal advisory board would feel obliged to conform in the drafting of a
new law. The *Kunstgewerbebewegung* was quite aware that its fate was being
decided with the drafting of this legislation, and the large number of articles
on the matter which appeared in their journals between 1900 and 1907
reflects their concern. For the most part, these articles were written by legal or
business experts and simply explicated the issues involved or outlined poten-
tial changes, but there were partisan articles too. One expert on intellectual
property law, Albert Osterrieth, wrote a long essay in the *Kunstgewerbeblatt*
to defend his thesis that "works of the applied arts should be protected as
works of fine art."[23] There were dissenting voices as well, but the tenor of the
discussions was summed up by Ferdinand Avenarius, who told the general
audience of the popular cultural journal *Der Kunstwart* in no uncertain terms
that "copyright affects us all."[24]

On 9 January 1907, Wilhelm II signed the legislation for a new, broader
copyright law for works of the visual arts; it went into effect on 1 July of the
same year. It came to be referred to simply as the *Kunstschutzgesetz*, and it
granted the same *Urheberrecht* enjoyed by practitioners of the traditional art
media to architects and designers of applied arts objects (including advertise-
ments) as well as limited copyright to photographers (expiring ten years after
the author's death).

§1. The authors of works of the visual arts and of photography are
 protected under the terms of this law.

§2. Products of the applied arts are considered works of the visual arts.
 The same applies to buildings in which artistic aims are pursued.

 Designs for products of the applied arts are also considered works of
 the visual arts, as are those for buildings of the kind designated in ¶1.[25]

This was nothing less than the legislative validation of the aims of the applied
arts movement. "What we have long sought has now been achieved" was the
commentary that accompanied the news in the *Kunstgewerbeblatt*.[26] "With
respect to copyright, §2 ¶1 equates the products of the applied arts with

works of high art," wrote the annotator of an early published edition of the new law – the spare, juridical version of a statement made nine years earlier by van de Velde: "We cannot accept within art any separation which seeks one-sidedly to grant a higher status to *one* of art's many manifestations and expressive possibilities than to the others; a separation of the creative arts into high art and a second-class lower, industrial art, however, serves no other purpose."[27] It would seem that the new law had legally recognized a cultural space similar to that inscribed in the concept of Style, which saw the expression of spirit as much in the most mundane functional object as in the greatest masterpieces of the high arts. And it would seem that the conflict between the supporters of the applied artists and the traditional manufacturers had finally been decided, the former having prevailed.

But the polemics, in a way, had only just begun. It turned out that the law was much more ambiguous than the first two momentous paragraphs made it appear. For by extending the space of copyright across a broader field of production, the law had allowed in media in which some but by no means most products were entitled to *Urheberrecht*. This is clear in the qualification the law gave to the protection of architectural works – a town hall but not a storage shed, perhaps a factory if it represented the pursuit of "artistic aims." The same restriction applied to the lower arts and advertising but did not even need to be written, for to distinguish between ordinary production and "applied art" was to make the same judgement, one that could be upheld or overturned in court. The situation was relatively clear in the earlier law: barring the case of expired copyright, a newly made work of fine art was either entitled to copyright, or it was plagiarized. But now, a work of the applied arts such as a chair was not so clear-cut. Though products in this medium or combination of media – carpentry, upholstery, wood inlaying and so on – were theoretically entitled to *Urheberrecht*, the existence of convention or tradition threw the law a curve. A Chippendale chair, for example, perhaps not a copy of any existing chair but one made in roughly the same style, was neither a plagiary nor an original artwork. Medium could no longer serve as a reliable guide in defining the work of art. Though extending the scope of "art," the 1907 law still did not *define* it. This had to be decided in the courts, which needed criteria to make the distinction. And the criteria they would use were of paramount importance to applied artists.

Interpreters had little trouble filling in this hole in the law, at least in principle. The work of art in the case of the more questionable media was defined, tautologically, by the presence of an artist: "The indispensable prerequisite for claims of protection under this law is the presence of an individual creative [*formgebende*] activity, as in works of the high arts."[28] The status of art was a function of the presence of individual creativity. In his attempt to justify the granting of copyright to applied artists, Osterrieth works through this aspect of the work of art on the example of the old law. He asks after the common denominator of works traditionally entitled to copyright:

> What do they have in common? An idea of beauty, aesthetic value, aesthetic effect? Not at all! For we cannot bring all these things . . . under a single principle. Yet something speaks to us from all these things, something similar yet in each one so utterly different – namely the *creator* himself, the *person* who stands behind the work, and who speaks to us through the work. . . . All works of literature, art and music are only revelations of a person, revelations of the individuality of the author. . . . This applies both

for *aesthetics* and for the *law*. . . . In a work [of art], the law seeks the personality of the creator. For copyright the decisive characteristic of the intellectual product [*Geisteswerk*] is the *individuality* of the creator.[29]

In both legal and applied arts circles, "individualism" came to be shorthand for the de facto definition of the artist, legally considered. In *Innen-Dekoration* we read that "the [new] law says . . . that the non-subjective aspects of form are not entitled to protection. . . . The law protects forms only to the extent that they are individually created."[30] From 1907 on, the artist in the applied arts was defined as the individualist. It made good sense to claim this status, for the individualist enjoyed the privileges of copyright, which not only protected his artistic capital but allowed him to turn it into exchange value on advantageous terms.

In the Fachverband für die wirtschaftlichen Interessen des Kunstgewerbes – the organized opposition to the agitators of Dresden and the defender of the traditional practices of the applied arts – these issues were still being debated even after the new *Kunstschutzgesetz* had been signed into law, just as Muthesius continued his agitation. At the annual Fachverband meeting in June 1907, the discussion of how to organize opposition to Muthesius's inflammatory attack on the organization was only one point on the agenda, but other contributions also dealt with essentially the same question: what to do about the invasion of the applied arts by the new, legally defined artists.

It is ironic that the members of the Fachverband frame their argument in terms of Style and end up sounding rather like the Muthesius faction seven years later. Carl Behr of the firm A. Bembé in Mainz railed against the alleged chaos of the Dresden exhibition: "There are as many different modern styles as there are original artists. They have only one thing in common: what they create must be *different* from everything preceding them."[31] Yet he describes the problem not in terms of a culturally transcendent pathology but a legal one: artists "anxiously claim personal idiosyncrasies as *inalienable property* [*unantastbaren Privatbesitz*]."[32] Behr also uses juridical terms to describe Style, which he says can only develop "when artists are selfless enough to strive for and accept a common formal language. Perhaps [this can be accomplished] by making the best of what is achieved *common property* [*Gemeingut*]."[33]

But what the Fachverband criticized in the Dresden exhibition was precisely what Muthesius still celebrated in his inaugural address of 1907 at the Berlin Handelshochschule: "What every observer in Dresden must have noticed first was that everything exhibited, from the smallest work of embroidery to the furnished room, spoke *its own artistic language*."[34] Muthesius was defining works of the applied arts as works of art, and artists as individualists, as authors. And thus the artists of the Osthaus group, who from 1907 to 1914 did not really change their position, thought they recognized one of their own. Hermann Obrist, impassioned opponent of Muthesius in 1914, was equally impassioned in his support in 1907: "Men such as Muthesius are our most valuable allies; they can be sure of our gratitude as well as the respect of all cultivated people."[35]

If the conflict between the Fachverband and the Werkbund has since been written as that between reactionary and progressive aesthetics, it was clear to Carl Behr at the time that it was nothing of the sort. The conflict concerned the artist and the economics of individuality. While the traditional firms could accept "the new style, which is viewed everywhere as a refresh-

ing trend" (and we will soon see why), they objected to "the guiding role that is claimed by the 'artists' . . . the *power* that the artists seek."[36] The climax of the meeting came when Peter Bruckmann and J.A. Lux took the podium. In the last chapter, we heard how Bruckmann invoked the spiritualized economy and claimed that spirit stood on the side of capital. Lux used instead the terms we now recognize as juridical: "I am convinced beyond any doubt that your endeavor is to banish the artist from the applied arts. You imagine applied arts without art."[37] There were scoffs, but Lux was merely rehearsing the complaint made in the Fachverband's official protest about the exhibition, where they objected that it had become "not an *applied arts* exhibition but an *artists'* exhibition."[38] The very same distinction was made by both sides, and it was neither academic nor aesthetic; only as a legal distinction can we understand its fundamental importance. At issue was whether the applied arts were art and the designer an artist, and thus whether the designer or the manufacturer was to control the economic exploitation of form in the market.

Announcing the withdrawal of the two firms he represented from the Fachverband, Lux added: "We declare ourselves to be members of an organization that has been formed for the protection of artistic interests."[39] This too was Osthaus's interpretation of the event. "The Werkbund," he wrote, "was founded to support the art of its founders."[40] In uniting artists with businessmen, the founders sought to renegotiate the relationship between the parties and to put the artist in control. The Werkbund was to serve as a sort of pendant to the new copyright law, furthering in a practical way the legal gains achieved by the *Kunstgewerbebewegung*. Rather than developing any specific stylistic program, it was to serve Style by defending the designer's privilege of producing spiritual commodities according to the legal model of the artist. The protagonists of Dresden – Muthesius, Naumann, Schmidt and others – realized that this project hinged on the applied artists' claim to being what van de Velde would later call a "glowing individualist" – a phrase as laden with meaning in 1907 as it was in 1914. Though the individualists of 1914 came in time to interpret this position rather elastically and to explore other legal and economic functions of artistic work, they never fully abandoned the paradigm of copyright. Yet in 1911, when he had rejected the "individualist" position in favor of types, Muthesius changed his description of the heroic campaign for copyright that Dresden 1906 represented. In his address to the Werkbund entitled "Wo stehen wir?" – his first manifesto of the spiritualized economy of the type – he talks not in terms of individual languages but rather of "a clarity of expression, a newly unified national character showed by the applied arts in Dresden 1906."[41] Muthesius was rewriting history to obliterate traces of his earlier stance, streamlining theoretical positions of the past to lead them to the type. What, for Muthesius and his allies, had gone wrong with copyright, with the rights it gave artists and the individuality it demanded of them?

<center>✳ ✳ ✳</center>

The change in the legal status of the visual forms attached to certain everyday goods is part and parcel of a change in the way these goods were produced. With the spread of mass consumption, these commodities came increasingly to be industrially – and thus, in the eyes of the law, not culturally – manufactured. At the same time, objects produced by traditional craft

means became much more expensive and exclusive; they migrated to a market niche in which higher and more varied demands were made, demands we can loosely call cultural. At the turn of the century, this was the niche in which artist-designed goods appeared. Yet while the firms of the Fachverband still produced their wares using traditional craft technology, their equally traditional business structure did not allow them to make the jump from the non-cultural to the cultural market for consumer goods. They could not afford the artists, their rights, and their product – the new sort of visual sign that was a protected and expensive commodity. They were forced to produce within an older legal paradigm in which design was not cultural and designers were not artists.

This paradigm dictated specific labor practices. Draftsmen or modelers (*Musterzeichner*) trained in the historical styles were employed under the same terms as other workshop labor: the products of their work belonged to the employer, who was, in the eyes of the law, the author of all of these products. Indeed, the Fachverband's efforts to maintain the viability of this model led them to try to turn back the clocks by writing the old law into new contracts: employees of Fachverband firms and artists commissioned by them were required to cede their copyright privileges, and disputes among members had to be settled within the organization, without recourse to the courts.[42]

This legal paradigm also corresponded to a particular stylistic tendency: that of Historicism. For the forms of the historical styles had a particular and definable legal status, one which applied to the Greek and Roman orders, the pointed arch of the Gothic, the Rococo garlands of Louis XV, the spare curves of the *Directoire*, everything down to the smallest details of these traditional idioms. And their widespread use around the turn of the century was due, I would say, not only to the social dynamics of Fashion or the rampant philistinism of which early defenders of the modern wrote, but also to this status. According to the law, the visual signs drawn from and representing the Western tradition could not be owned or controlled; they had no legal authors. They were the common property Behr of the Fachverband demanded, a common visual currency available to all without charge or legal complication. The signs of this tradition were the raw material of everyday production which could be mined directly and which cost no more than the labor entailed in their drafting: "You copy the old furniture," wrote Karl Gross of the Werkbund, ". . . and spare the expensive designs."[43] This unauthored status was of fundamental importance to both the old and the new laws concerning the applied arts, for even if *Musterschutz* did not recognize the artist as author, it contained the same distinction between original and copied form, and the courts had determined that work in the historical styles was not original. Every commentary on the law pointed this out; it was basic business knowledge in the branch.[44] Osterrieth gives the legal rationale of this applied arts aesthetic:

> The [historical] style serves the artist as a [visual] law and as a store of set forms. Thus whoever works in a certain style is obliged to subordinate himself to the law of that style. . . . Familiar forms and non-individual motifs – everything dictated by the law of the [historical] style – do not comprise individual creation. . . . Only individual creation is the object of protection; everything else is free.[45]

Those who used these forms did not own them, but the historical styles

nonetheless had significant exchange value through their application to commodities produced and sold in the regular capitalist economy. In Osterrieth's well-chosen term, the forms of the Western tradition were "free" signs and could be attached to commodities at will.

The members of the *Kunstgewerbebewegung*, however, had another way of describing the traffic in free signs. They called it "theft." For "the 'industry-style of the nineteenth century,'" wrote Karl Gross, ". . . the legacy of our fathers, the ornamental treasures of the millenia, served perfectly for exploitation and to satisfy fashion fancies. These treasures were not 'acquired' – they were stolen."[46] Of course the artists were wrong to describe Historicism in this way, but they can be excused for the error in light of their own bitter experience with the pre-copyright model of visual form in the applied arts. For the weakly protected or even unprotected designs of the Jugendstil artists were simply drafted into traditional production's system of free signs. Listen to Obrist's jeremiad:

> O Pharisees! Are you doing anything different from what you have always done? Before, you diligently plundered *Hirths Formenschatz*; you rummaged in pattern books; you exploited the draftsmen from the much-maligned but (for you) indispensable art schools; you repeated the designs of the famous architects of the past watered-down one hundred times, always unable to create anything of your own out of the old styles. And now you subscribe to all the art magazines like pulp tabloids; you go to all the exhibitions; you have the catalogues of all the English, French and American firms; you catch wind of every new Fashion and, as ever, force your draftsmen to sketch Jugendstil today, Neo-English tomorrow, then Biedermeier, Neo-Viennese or Neo-Dresden. Are you "modern"? Do you have good "taste"? Are you "*sachlich*"? . . . A sight for the gods! And whence do you have these wonderful things, if not from us artists?[47]

Unlike the artists, applied arts producers did not distinguish between Jugendstil and the earlier styles, for the law before 1907 did not require them to. Both were considered the industrial product of their own employees. "A group of producers," wrote *Deutsche Kunst und Dekoration* in 1901,

> have decided to work in the new way, using artists' designs. But, encouraged by our present *Musterschutzgesetz*, many find it much easier not to take on the risk of producing such designs, but simply to take artists' designs already on the market and have their draftsmen alter them just enough so that they do not come into conflict with the law – then they throw these onto the market much cheaper than the original artist designs.[48]

The point of *Musterschutz* law that allowed such copying was the clause that distinguished copy from original. It was called, revealingly, the "free use" clause:

> §4. The free use [*freie Benutzung*] of individual motifs of a pattern or model for the production of a new pattern or model does not constitute unlawful copying.[49]

The results of this clause were twofold. First, designs could be copied, provided they were altered enough by the hired hands to allow the claim of "free use." And second, the appearance of an artist's work on the market

was likely to be in this corrupted state. To Karl Scheffler writing in 1903, this dual fate marked the death of Jugendstil:

> Industry has torn the new values of form and technique from the hands of the artists. . . . [A]fter a short struggle, industry has laughingly triumphed, and the best ideas are prostituted in the factories. There are optimists who are thrilled that the modern *Kunstgewerbe* has achieved such a broad influence, who see proof of the popularization of the good in the industrial exhibitions and the department stores. In truth, this mass success is the beginning of the end. . . . While industry finishes its plundering . . . Obrist is forgotten, van de Velde robbed and Behrens exploited.[50]

Furthermore, the lack of copyright protection allowed imitators to imply a particular artist's authorship of counterfeit designs. They were allowed, for example, to take over an artist's name as a generic description: "*Stil van de Velde*" was the most familiar case.[51] Before 1907, the artist's name, the inalienable accompaniment of author status, was also a sign available for free use in the applied arts.

The failure of Jugendstil is often described as the result of a non-synchronism between artistic production and the conditions of modernity. Technically, critics point to designs of objects for mass distribution that resisted contemporary techniques of mass production; stylistically, they point to the use of organic forms as a veil obscuring a technological urban world, or to the creation of rich, overgrown interiors as a last haven for the bourgeois cultural subject threatened by political and economic realities.[52] The contemporaries of Jugendstil also criticized this tendency as a problem of timing, but it was, I would say, a non-simultaneity of a legal kind that they were referring to. The creators of Jugendstil produced their work as art and as culture, but the law of the time allowed their designs to be handled as simple industrial commodities. If the historical styles supplied industry with forms that were free, Jugendstil taught industry means of liberating those that were not.

Like so many modernist tendencies, the history of the *Kunstgewerbbewegung* is the history of the attempt to resist the mass-market appropriation and the uncontrolled commodification of the visual signs of everyday life. In Germany, the first step was the development of a range of personal but loosely allied formal idioms that sought to break out of Historicism, interpreted as an industrialized cycle of authorless forms. This experiment, which went by the name of Jugendstil, ended in fiasco. In Scheffler's words, it produced a style characterized by a "frightening adaptability" which allowed it to be stolen from its authors and debased at will.[53]

The second step is one which has not been explored here but which I would characterize as the attempt to develop a specific business form for artistic production which would protect the artist and his artistic commodity. It was, in effect, the attempt to create a protected, quasi-self-sufficient system of production that would guarantee the rights of artists by putting them in charge of the execution of their own designs. Borrowing the idea of "banded workshops" from William Morris's utopian novel *News from Nowhere*, artists founded a series of "*Werkstätten*" all over Germany, of which the Vereinigte Werkstätten and the Dresdener Werkstätten are the most well known.[54] Writing in *Dekorative Kunst* in 1900, Scheffler described this as a response to the situation we recognize well in which "accumulated artistic material becomes a source of income for others": in

the workshops, artists "seek to create for themselves *a clearly circumscribed space* [*einen fest umgrenzten Spielraum*]" in order to avoid being "dependent on the cyclical tendencies of the market."[55] The founders of the *Werkstätten* were indeed responding to Morris's example, but even from the beginning, they did not really share their mentor's fundamental anticapitalism. Their objections to the modern economy's management of form were based on aesthetic grounds and financial self-interest. Their goals were thus more limited in scope, goals an anonymous writer in *Dekorative Kunst* a year later described as "to control their ideas during production and to exploit them economically in the interest of the artists."[56]

The leading figures of the *Werkstättenbewegung* – Schmidt, Riemerschmid, and their mentor, Naumann – were all involved in the planning of the 1906 Dresden exhibition and the founding of the Werkbund, both of which represent the flowering of the third attempt to circumvent the destabilizing influence of the mass market. This involved a shift of paradigms: from the literally closed production system of the *Werkstätten* to the legally protected realm of copyright. This was the step which I have tried to show represents both a major impetus behind the founding of the Werkbund as well as the original necessity of the "individualist" position. The model of this solution was the Deutsche Werkstätten, which Muthesius described in 1908 as an "advance in an economic sense in that artists were not shareholders of the enterprise. . . . Instead they were placed in a regulated relation to the manufacturer, one which corresponded to the usual agreement between author and publisher in the case of literary productions."[57] The "advance" of the copyright model was the opening of the protected economy of visual forms into the larger economy, allowing the workshops to capitalize and streamline their business operations and more effectively compete – with the traditional firms, which were, as ever, liberating artists' designs.

But sometime around 1910, the influential core of the Werkbund rejected this last experiment and embarked on the fourth and final attempt to find a way of bringing visual form in a capitalist economy under cultural control. This was the project of *Typisierung*, which I have tried to describe by situating it in the discourse of political economy. We are now in a position to understand why Muthesius and the group around the *Werkstätten* rejected the paradigm of copyright and embarked on a path in direct opposition to the policies which lay behind the founding of the Werkbund and to which many members maintained an allegiance.

The reason, I would say, is that the new copyright law which now applied to the Werkbund artists and their work still failed to protect the artist and to assert any order over the economy of visual forms. Already in 1908 Anton Jaumann asked,

> Have the important artists really enjoyed such significant benefits from the protection of their property rights? . . . The assumption that the laws protecting artistic property would force the business world to commission their designs directly from the leading artists has proven thus far to be false. Despite Dresden, many of our best artists are only poorly supplied with commissions, but the art industry is doing a brisk business indeed.[58]

And in 1911 Adolf Vogt summed up in the pages of *Innen-Dekoration*: "The new copyright law which took effect on 1 July 1907 and which granted to the applied arts the same protection as works of the visual arts has hitherto proven to be rather illusory."[59] High hopes had been disappointed.

Some members of the Werkbund, it seems, realized the inviability of copyright's protected market. They realized that the big, unprotected economy of nameless businesses and anonymous draftsmen would always surround the protected economy with its names and artistic designs, feeding off it, destabilizing it, and ultimately corrupting it.

The problem was that the motor of change, variation, and theft was, paradoxically, inscribed in the copyright law itself, in its definition of the artist as individualist. Though the new legislation, in theory, substantially increased the protection of intellectual work and even turned the industrialist's hired hand into a potential artist, it contained the same clause that appeared in the old *Musterschutz* law to distinguish the individualist from the plagiarist. It was the "free use" clause again, which defined authorship not by inspiration but by difference:

§16. The free use of a work is permitted if an individual creation [*eigentümliche Schöpfung*] is produced through its use.[60]

This legal criterion of "art" was the central point of Vogt's bitter obituary of the hopes for the new copyright bill:

The main problem [in the applied arts] about which the artists complained most continues unabated: the unscrupulous "interpretation" and variation of original works. The new law provides no basis for fighting this, for it forbids only "reproduction," direct copies. But exact copies were always rare, even before the new law. The strength of those "interpreters" was always the alteration of the often bizarre inventions of the artists to make them palatable for a larger public – or so they said. In any case, things were altered from the beginning.[61]

"Copying is the greatest sin in artistic things," wrote Jaumann, "but no law will prevent it, for the use of others' motifs in the creation of a new work is expressly permitted by the law."[62] Though the definition of "art" had changed, the status of the applied artist was not appreciably different under the new law. All a copyist had to do was to alter his model enough to claim that a new work of art had been created, that the change revealed the presence of a new individual. This was a point of law that the courts apparently interpreted fairly liberally. So the new law now worked both ways. The claim of being an "individualist" – a "free spontaneous creator" as van de Velde called him – not only turned the applied artist into an author, it turned the plagiarist into an author as well, provided he cover his tracks.

Gustav Gericke, representing the Anker Linoleum Works in the Werkbund, suspected this problem in the new law as early as 1908, when he told his audience at the first annual meeting: "To avoid being hurt by improper business practices, we must look into whether artists' designs delivered to industry are adequately protected by copyright law. Dishonest businesses must not be allowed to use a loophole in the law to rob artists and industries of the fruits of their cooperation. Unfortunately it is all too possible to copy designs through the use of seemingly insignificant alterations."[63] The free use clause was in fact more than a "loophole": it provided, one could say, an instruction sheet for the theft of intellectual property within the law itself. And it provided the recipe for Fashion as well. For the "insignificant alterations" Gericke mentions, the minimal deviations that signified "individuality" in the eyes of the law, were fully analogous and at times identical to the deviations that comprised the "new" as it had been

identified by critics of the mass market from the discourse on Culture. Vogt writes that the variations at issue were not always made "out of consideration of the law, but out of consideration of the market."[64] Under the new copyright law, even the Werkbund itself could be robbed of its achievements and at the same time implicated in the scenario of Fashion. Justifying his plan for types at the Cologne meeting, Muthesius drew attention to an alarming development: "Speculators think they have recognized a distinctive new speciality, the 'Werkbund speciality,' as they call it. In many cases it is clear that a purely superficial merchant spirit [*Geschäftsgeist*] and not deep conviction is the driving force, that they have spotted the 'Werkbund speciality' as a new Fashion and want to secure the profits."[65] It was the same scenario Scheffler had described, how the presence of borrowed designs in the department stores signalled both the success and the failure of Jugendstil. For the Werkbund was so successful that it had become a name to be borrowed: in the annual report from 1913/14 we read that "the German Werkbund no longer has to fight against indifference . . . but rather against the exploitation of its name as a Fashion [*gegen die Ausbeutung seiner Autorität zum Modewort*]."[66] On the example of the Werkbund itself – as a word, a group of recognizable formal tendencies, and as an authority – members began to recognize yet again how the legal definition of individuality produced a rhythm of change, a syncopation in time and form which robbed the author of his artistic capital and fed it into the market of changing fashions.

For art critic Franz Servaes writing in 1905, the "curtailment of the personality" was the "first commandment of Style." But he still saw the individual as the core of Style: "Only where its uncontrolled proliferation endangers the organic unity of the work of art should the personality subordinate itself. But when it is immersed in the idea of the work, when it suffuses the work with a fiery conviction of the necessity of the Style . . . there the personality should live in sovereign freedom."[67] This was the view around 1900 in the discourse on Culture. As late as 1908, one year after the legal affirmation of the equation of individuality and Culture, Muthesius still believed so. But after a decade of fighting to control form on the market, in practical experience with the legal apparatus that governed its activity there, certain leaders of the applied arts movement finally and completely changed their tactics. Karl Schmidt of the Deutsche Werkstätten was prepared to take the practical consequences of his decision. He no longer published one catalogue but instead two, dividing his production into two separate parts. He continued to manufacture artists' designs for the carriage trade, which was always willing to pay the premium for an original work of art; but for the mass market, presided over by the unruly industrial authors, he offered only that new species, the type:

> Important artists . . . have understood how to adapt to the modern mechanized mode of production. Whoever recalls the furniture of these artists from ten or twelve years ago knows that they bore not the least similarity to each other. The following pages contain designs of these very artists, but it will tax the viewer to distinguish one artist from another. That is how strong the feeling for the typical has become among them. In this accord of the most varied and most vigorous individualities, in this common understanding for the ways and ends of modern production which is the base of each of the individual designs, an unmistakable law, a style is revealed.[68]

This was a new definition of Style that no longer had room for the individual, part of the final stage of the movement's attempt to create Culture. This time, of course, they sought to combat Fashion by using economic muscle, not legal rights. Schmidt's "unmistakable law" was to operate outside the system of courts, statutes, paragraphs and clauses, for, as Jaumann wrote, "this curse cannot be fought by legal means."[69] Even with the help of the law, the artist – the individual – could not control the generation of signs in the consumer market.

3. Exchange and Utopia

> It is gratifying that such an influential organization as the Werkbund takes the topic of advertising seriously in its publications. This development is due no doubt to [the influence of] Herr Karl Ernst Osthaus. . . .
>
> *Seidels Reklame*[70]

> Deep inside a person wants to be completely free, but his surroundings do not allow it. He must say to himself: Yes, I am a free artist, but that does not help. I am at market, and if no one buys from me, I am lost; I have only one life, I need customers! What should I do?
>
> Friedrich Naumann[71]

Hermann Muthesius, Karl Schmidt and the "friends of the type" in the Werkbund ultimately understood the relationship between individuality and the instability of the forms and representations appearing in the capitalist marketplace, how the law sanctioned the syncopated beat of Fashion, how the artist, legally defined, failed to form the basis of Style as they conceived it. To them, the artist was compromised, so they sought answers beyond the law and beyond the artist in the new economic developments of the time. The "individualists," on the other hand, continued to see the work of the artist as central to Style. In defining their position, we must look to the group of artists who spoke up for van de Velde at the 1914 Cologne exhibition, to the members of what one commentator called the "*Kulturkomplex Osthaus*" after their patron.[72]

Out of conviction (in the case of Osthaus) or a sense of self-preservation (in the case of the others) this group stood firm in its support of the artist, and not surprisingly they continued to use the term that denoted the artist's rights – "individuality." At one level, then, the slogan "individualism" had nothing to do with aesthetics per se but meant in fact little more than an assertion of the continuing importance of the artist in modernity, a defence of the relevance of the traditional production – or rather, of the traditional *producers* – of "art" in a capitalist economy. The defence of artists' interests led this faction to a new battle, one that came to a head in 1914 and no longer concerned a point of law. For the solution to the problem of Culture that Muthesius was proposing directly impinged on the activities of the protesting artists in two ways. First, the program of *Typisierung* hinged on a curtailment of the number of models that would appear on the market and thus a limitation of design production. The production of types would henceforth be the domain of a few "superior, architecturally disciplined intellect[s]," to use J.A. Lux's phrase; and from the way the Werkbund's commissions for the Cologne exhibition were distributed, it is clear who the most prominent of these were to be: Muthesius himself, Peter Behrens, Bruno Paul.[73] And second, *Typisierung* stood at the center of an attempt to limit and legislate artistic production for the realm of commerce. This meant that the individualist was being shut out in yet another way, for commerce, I will be arguing, is the economic sector in which these artists were finding their future would lie.

Perhaps it was the leader of this group, Osthaus, who came to identify his work most completely with the realm of commerce, considered decadent by so

many. Osthaus's chief contribution to the Werkbund effort was the founding and operation of the Deutsches Museum für Kunst in Handel und Gewerbe (German Museum for Art in Commerce and Industry) in Hagen. Osthaus had already founded and funded the Folkwang Museum to further the cause of the avant-garde in painting and sculpture, and his second venture was a continuation of his patronage activities.[74] Like the Werkbund, the Deutsches Museum sought to integrate the artist into the modern economy, and like the Werkbund at its founding, it sought primarily to serve the interests of the artist. Osthaus and his museum pursued this latter goal quite unabashedly. Already in an article of 1904, Osthaus and the Folkwang had engaged in the fight to protect the legal rights of the artist and to convince industries to "get their designs from the source, that is from style-creating artists." While encouraging the industries to leave "the great transformation of Style of our age in the hands of the geniuses born for this task," Osthaus put in a good word for perhaps the most important of his protégés, Peter Behrens, then director of the Düsseldorf applied arts academy.[75] Announcing the founding of the Museum under the auspices of the Werkbund five years later, he cast his net a bit wider, but note his consistent emphasis of the figure of the particular artist:

> The German cultural movement of the last fifteen years, which is exemplified by names such as Behrens, Endell, Hoffmann, Olbrich, Paul, Riemerschmid and van de Velde and which has led to a reunification of art and trade [*Gewerbe*] after a period of deepest estrangement, recently found an organization embodying its will in the German Werkbund. Artists and industrialists who bitterly experienced the cultural nadir of our manufacturing, and who saw the best chances for the assertion of German work in the world market in its improvement, joined together to pursue the goals of the movement.[76]

For Osthaus the artist always preceded the organization. The collection of the new museum, he continues, would encompass "all the objects of commercial life – printed material, advertising articles and packaging; then a collection of the materials of the applied arts such as various kinds of wood, stone and leather, metals and their alloys in all varieties; and finally a collection of samples of artistically valuable products such as textiles, tiles, appliances."[77] The order here is significant, for in placing the paraphernalia of "commercial life" first, Osthaus reveals his priorities. In fact, of these three areas, the museum concentrated its collecting activity only on the first – the posters, catalogues, packaging. Of the travelling exhibitions organized by the museum, well over half concerned the visual accessories to modern trade: "Advertising Graphics," "Art in the Service of the Merchant," "Cigar Packages," "Modern Posters," "Advertising Art." The Deutsches Museum was in effect a museum of advertising. But one with a specific and characteristic criterion: "Almost all works" collected there, writes August Kuth, Osthaus's first assistant, were "signed with the artist's name."[78] When it sought to go beyond propaganda efforts and actively bring commissions from the business world to the artists, the museum established an "exchange" to advise small businesses on advertising and to recommend suitable artists.[79] Osthaus, in other words, founded a non-profit advertising bureau, or at least a referral service. There were also plans for the establishment of an "advertising academy."[80]

Whether by design or by necessity, Osthaus and his museum concentrated their efforts on the visual production serving the realm of exchange rather than seeking to involve the artist in the production process per se, determining

70. Posters at a travelling exhibition organized by the Deutsches Museum für Kunst in Handel und Gewerbe, Hagen (Hesse-Frielinghaus *et al.*, *Karl Ernst Osthaus*)

the forms of everyday household objects from this perspective only. The museum and its artists reveal an important aspect of the functional transformation taking place in the art world at the time, as traditionally trained artists sought a profitable field of activity – sought, in other words, a livelihood. Writing in the Werkbund *Jahrbuch*, Hans Weidenmüller, who ran his own advertising agency, pointed out that "the design and manufacture of publicity materials comprises a considerable portion of the applied arts and the art industries"[81] – not a statement we would expect to hear from the Muthesius camp, nor a situation they would want to acknowledge. But it was quite natural, Weidenmüller continues, that an artist would make a move into the area "most closely bordering on his own field of activity." Thus the painter took over "the poster, the newspaper advertisement, packaging and the signet; the architect created shopwindows and showrooms, department stores and factories; the graphic artist gave us an overwhelming abundance of printed materials useful in advertising."[82]

Osthaus and the artists whose work he commissioned, published or otherwise supported – van de Velde, Endell, Klinger, Ehmcke, Gropius, and others – were well aware that given the established production processes of the day, positions as "artistic adviser" (this is the job Behrens had been given at the AEG) were extremely scarce, whereas the number of advertising commissions was in principle unlimited. Whatever problems *Typisierung* might solve, they were not theirs. Nor would it have escaped the artists' attention that Behrens – "Mr. Werkbund" as Julius Posener has called him[83] – spent much of his time designing brochures, exhibition pavilions and shop counters. They realized, in other words, that the work of Behrens (who never made clear his allegiance at Cologne) could be given an interpretation different from the one which saw in it the development of types. Osthaus, along with his artists and protégés, knew quite well that the artist or architect could not ignore the realm of commerce. If they were to remain employed, Culture could not be limited to a sphere artificially defined as production. And they knew that *Typisierung*, if successful, would endanger their livelihood in ways more fundamental than the simple imposition of some formal canon.

Osthaus and his faction were destined for conflict with the Muthesius camp, with its often instinctual aversion to commercial fanfare and its painstakingly theorized marginalization of this sphere from Culture. Recall,

for example, the struggle between Osthaus and Muthesius over the presence of articles on advertising in the Werkbund *Jahrbücher*. This conflict, however, does not always seem to have been an open one, though it is, I think, fundamental. Perhaps out of a recognition of the differing interests represented in the Werkbund – on the side of business members as well as of artists – the Muthesius camp did not openly and explicitly attack advertising as a whole, though they never hid their vigilant suspicion. But it is clear that there were different views on the issue in the Werkbund. Compare a photograph of one of the Deutsches Museum's exhibitions which shows *Sachplakate* of the kind the "norm-givers" usually approved of (fig. 70), but now stacked, salon-style, from floor to ceiling, with Muthesius's splenetic critique of advertising excess, of "omnibuses covered from top to bottom with screaming endorsements," of "the flood of senseless billboards," the "broadsides endorsing laxatives, whisky and boot wax." Through its presentation, the Deutsches Museum undermined the entire interpretation of what could be considered the "acceptable advertisement" centering on the trademark or the brand. Or consider the following proposal for an exhibition that explicitly affirms the transformation of the fine artist into commercial servant:

> It shall be shown that commerce, industry and trade represent today important customers for decorative painting. Commissions which have hitherto gone to inferior workers should be given to artists. In this way, not only would the customers gain benefits of an economic and representative nature, but artists would also receive decorative commissions of a large scale that could be well paid because these works serve practical purposes. . . .

> The following areas would be considered in the exhibition:

> - artistic billboards and frescoes for large train stations with international tourism
> - artistic railroad advertisements along rail stretches
> - artistic advertisements on the sides of buildings
> - advertisements on theater curtains
> - streetfront advertisements
> - company signs, etc . . .
> - artistic advertising frescoes for hotels, department stores, arcades, etc. . .

> To a certain extent the exhibition represents the first truly modern art exhibition. The artworks serve a purpose. . . .[84]

Advertising covering facades, blind walls, theater curtains, railway stretches: the Deutsches Museum was proposing as art everything that was most despised by the anti-advertisers.

But such seemingly uncritical efforts bordering on the burlesque are not the rule. In general, the position developed in the Osthaus faction was neither simple nor unreflected nor naive, despite the fact that it was never clearly or programmatically formulated. Osthaus was fully conversant with the customary division of the economy into production and trade, but, going against the grain, he tried to present commerce as an area that was just as "cultural" as production. If he did not dispute that industry has provided "symbols of a new world culture," he wanted nonetheless to show that "all areas overlap and suffuse the second important sphere of modern economic life, commerce, with cultivated forms."[85]

In tracing this position, I propose to look briefly at the very different way Osthaus and his associates interpreted the work of Peter Behrens, work which was viewed by others as embodying the notion of the type. A cumulative view is necessary, for it was apparently not an easy thing to say that commerce was "cultural." At first Osthaus failed to find adequate metaphors and reference points, a familiar failing when it came to describing the new prominence of institutions of commodity exchange. Even before the precise nature of Behrens's duties at the AEG were clear, for example, Osthaus celebrated the new business arrangement in *Kunst und Künstler* as follows:

> Since a short time ago Peter Behrens has served as artistic adviser to the *Allgemeine Elektricitäts-Gesellschaft* in Berlin. . . . One can assume that this is not due to philanthropic desires, that instead the economic necessity of an alliance of industry with art made itself felt in the administration of this huge enterprise. And there lies a victory, so surprisingly great that it has surpassed the wildest hopes of the recent years. Art has regained its citizenship in Germany![86]

Osthaus here has chosen a very interesting word to describe the role of art: "citizenship." It was a word whose import is not very clear but one that was probably chosen with some care. *Bürgerrecht* – literally, the rights of the burgher – means not only access to the public sphere of political discourse; no less importantly it means the right to own, buy and sell commodities.[87] In Germany around 1900 this would not have been only a faint echo: there the guild organization of production was not so distant history, the capitalist organization of the economy was less than a century old, and the rule of the bourgeoisie was not yet a complete reality. Rather than characterizing the agreement between Behrens and the AEG as Scheffler saw it – as art gaining access to the brute means of production, to power – Osthaus talks about art having gained access to the market, a public forum. He seems to define Culture not as a privileged locus of meaning but as a space of exchange. Culture was not equated exclusively with production but with something like a public sphere in which products and ideas can change hands, with something like a market.

I do not bring up Osthaus's statement first because it is a particularly clear or convincing statement on the relationship between art and the market (it is not) but because it reveals a pattern in the way the individualists made their case. In their use of the words "individualism" and "citizenship," Osthaus and his allies were borrowing ideas from the discourse of bourgeois liberalism; apparently these were the first and best terms they could find to discuss both the importance of the individual and the space of commerce as something positive. Examples of such borrowing abound. In the same passage, Osthaus reverses the usual argumentation that the AEG, in Jaumann's words, "was not using Behrens as an advertising ploy,"[88] implying instead that it was fine if they were: he prefers to imply that self-interest and the free play of forces, laissez-faire in other words, was most beneficial to cultural development (in this case). Similarly, in his essay on the shopwindow, Osthaus asserts the importance of the shopkeeper leaving "the confines of his guild" and moving "into the spiritual life of the *Volk*" – overturning the otherwise usual valorization of controlled, precapitalist production and equating culture with a free, open market.[89] And certainly the notion of the genius is unthinkable outside of the context of bourgeois liberalism.[90]

But the use of the metaphorics of liberal capitalism is not really consistent

and does not, on its own, tell us much. The individualists had no real objection to the actual changes that were occurring in the consumer economy, nor did they have any objection to the declaration of a formal dictatorship, as long as it was in the hands of an artist.[91] I think instead that the use of the bourgeois discourse of political and economic freedom to describe the twentieth-century conditions of artistic production served a particular purpose. It allowed the artists and their supporters to borrow an argument, ready-made, to counter the threatening appearance of a disciplinary ideology that appeared in the opposing camp. Indeed, to a certain extent they simply lifted the vocabulary of the argument then raging between the supporters of free trade and those of organization.[92] And the fact that these positions tended in practice to overlap (witness Naumann's desire for *domestic* organization and *international* free trade) further indicates that the rhetoric was being removed from its original context and being put to different uses. As such it is evidence of the same difficulty in finding terms to describe the sudden social prominence of the sphere of exchange we witnessed in the first chapter. For this is where the artists hoped to work; this was the center of Osthaus's developing sense of culture under modernity.

Needless to say, discussions became more specific when they centered on Behrens's advertising oeuvre, which the Hagen group considered to be as significant as his designs for useful objects. A survey of Behrens's business graphics was included in the Deutsches Museum's series of *Monographien Deutscher Reklame-Künstler* (Monographs on German Advertising Artists), their first and only publishing venture, initiated in 1911. Fritz Meyer-Schönbrunn, Osthaus's second-in-command, opens his introduction to the picture survey with a direct attack on the position espoused explicitly by Sombart ("trade is a necessary evil") and shared by others in the Werkbund:

> Only a petty-bourgeois romanticism can look at advertising as a necessary evil and dismiss it indifferently. In our modern, complex economic system, in which producer, salesman and consumer move ever farther from each other, in which the functions of supply and demand are ever more entangled, in an age when it is an exception that an individual client appears in the place of the collective consumer for finished goods – [in such an age] farsighted industrialists and businessmen have recognized the necessity of practical, large-scale advertising and have understood how to make it a means of beauty and . . . of education.[93]

Here Meyer-Schönbrunn accepts the familiar terms of the alienation of consumption but gives them a twist characteristic of Hagen policy: the space between producer and consumer is not a void, an absence to be bridged over, a cultural rift. It is treated as a positive space to be filled, potentially a site where beauty can emerge. Meyer-Schönbrunn continues with a radically revised account of Behrens's redesign of the AEG products. "In their immense quantities," he writes, "these products become propaganda for a logical artistic will."[94] Yet he does not see the pared-down geometry of Behrens's designs as reflecting the logic of production, but rather as a reflection of the artist and at the same time as advertisement or "propaganda." For this autonomous logic and clarity is the same as that with which "Behrens reformed the organs of modern advertising": exhibition pavilions, shopwindows, stores as well as posters and printed material.[95] "This universality of artistic talent," Meyer-Schönbrunn concludes, "enables Behrens to introduce an enclosed complex of organic and logical beauty into the overwhelming disparateness and confusion

of production."[96] For Meyer-Schönbrunn, it is not production that provides cultural unity, and that unity can not be accessed through products alone. Unity – "organic and logical beauty" – is achieved in the forms by which these objects come to market, forms which do not refer vertically to production but horizontally, out in the sphere of exchange to other products and to advertising material. Production is the locus of modern chaos, unity is achieved in the space of commerce.

In his article "Das Schaufenster" in the 1913 Werkbund *Jahrbuch*, Osthaus develops this line of thought further. Despite its polemic clarity, this is a difficult text, so surprising are its deviations from the productivist Werkbund orthodoxy (whose terms and tone, moreover, are often used by the individualists). Like Meyer-Schönbrunn, however, Osthaus's starting point is the same one that appears in so many Werkbund accounts of modern estrangement: the inevitable description of alienated consumption, one I have quoted earlier. "The Orient" – Osthaus's figure for precapitalist society –

> knows no shopwindows. There the stalls of handcraftsmen and traders are lined up in roofed bazaars. . . . The whole store is, if you will, the shopwindow.
>
> But it is also the workshop. . . . The weaver, shoemaker, tinker, and innkeeper go about their work before everyone's eyes, and even the miller pours his corn into the trough which his harnessed donkey goes round and round. The fascination of the bazaar is the result of the interest we take in creation and production. By watching, we understand and learn, and herein lies the ultimate reason why the Orient, like earlier Antiquity, never lost Style in any of its crafts.[97]

Osthaus locates the loss of Style with the development of commodity exchange as an autonomous space, no longer adjacent to and transparent to production:

> The shopwindow of the North shows us the commodity, and not production. What is missing is the fascination of becoming, which makes the Oriental bazaar so attractive. One thinks only of the function of the commodity, not of the work it involved. Becoming is completed in a closed workshop, and only the privileged have the opportunity to observe it. In this way the most important source of the interest in work is lost to most, the most indispensable foundation of the feeling for Style is taken away.[98]

For Osthaus, as for Muthesius and Scheffler, production was historically the spiritual center of Culture and the source of Style. But from this point on, Osthaus veers off from the usual line of argumentation which describes the need to reestablish contact with production by the use of signs and which accepts the market as a cultural space only to the extent that it erases itself, transmitting exclusively signs referring to production. Instead Osthaus accepts the radical rupture in the traditional cultural totality that is imposed by the capitalist production and distribution of goods. Though he maintains the retrospective goal of Style, the visual access to a transcendent cultural totality, he will seek to use the means of the modern economy and the different kind of sign it could produce. And while Osthaus writes that "the new [shop]window will be *sachlich*,"[99] he does not propose to replace the "fascination of becoming" with *signs* of becoming, reestablishing absent production as nonetheless culturally transcendent. He proposes instead to evoke the feeling for Style with radically new means.

The new shopwindow will be *sachlich*: "Instead of *telling* a story, every commodity will itself *be* one."[100] Osthaus uses this common Werkbund word

but changes its meaning; it no longer means "objective" or "matter-of-fact" but something quite different. Like others, Osthaus does relate *Sachlichkeit* to the elimination of the usual tinsel flashiness of contemporary displays, though not in the interest of semiotic reduction – rather that of semiotic "concentration." The shopwindow must

> captivate, lure and stop [the passing crowd] in its tracks; the commodity must take on meaning for them, must enthrall them, make them forget the intoxicating glitter; it must be alone with Everyman. So alone that the magical suggestion spins its web and the entranced passer-by cannot escape the thought: "I must possess you."
>
> But the mystery of the marriage of the buyer with the commodity requires concentration. It must employ all means to isolate the commodity. Above all, the window needs a frame.[101]

In asserting that the commodity must be framed, isolated, indeed decontextualized, Osthaus suggests a logical and consequential acceptance of the changed character of the modern commodity as simultaneously alienated and alienating from its own production. Yet at the same time as the frame figures this isolation in this account, it invests the commodity with new qualities unknown to those for whom production was no secret: the qualities of the work of art as conceived in the late eighteenth and the nineteenth century, from the Romantics to the Symbolists. Located at a literal nexus of art and life, the frame was an important issue at the time of both the aestheticist and applied arts movements which sought to extend the scope of art, either by opening art to everyday objects or by replacing life with art. In 1902 Simmel devoted an article to the subject in which he wrote that the work of art

> closes itself off against everything external to it, as a world unto its own. Thus its borders . . . [are] an absolute end which enact a rejection of and defence against the external as well as an internal unifying concentration [*Zusammenschluss*] in *one* act. What the frame of the artwork accomplishes is that it symbolizes and strengthens this double function of the border. It closes off the artwork from the surroundings and thus also from the beholder, and thus helps to place it in the distance from which and only from which it can be aesthetically enjoyed.[102]

By virtue of a framing device, the commodity displayed is given an "internal unifying concentration" and is invested with "distance from which and only from which it can be *aesthetically* enjoyed"; both impose the reception of the object as a formal, self-contained unity, as a work of art. This move is not without a certain paradox, for it re-establishes the distinction between frame and art work, and thus between life and art, which runs counter to the *Kunstgewerbebewegung*'s postulate of, say, the frame itself being worthy of the artist's attention. But a frame was a commodity too, and could in theory be put in a shopwindow: the new distinction between art and life becomes a supple and shifting line, capable of enclosing and isolating any saleable commodity within its privileged space. In Osthaus's shopwindow, unlike Lux's, the signs borne by the commodity do not point back to a visually absent production process but provide instead access to a purely internal totality on the model of the Romantic work of art.

Osthaus's figure for this sort of market sign is the trademark, and, as modern a development as it is, it seems to allow him to discuss the power and potential of art in this quite traditional nineteenth-century way. Like Scheffler,

he invokes the trademark sign as symbol: "Trademarks shine forth, transformed into magical signs [*zu magischen Zeichen gewandelt*] The whole atmosphere is that which the child experiences before the curtain that shall, for the first time, reveal to him the world of dreams."[103] But rather than simply letting the word *Zeichen* elevate the economic work of the mark to the level of culture (or using it as an alibi for theories that made such claims), Osthaus here sees the matter much more literally, explicitly situating his discussion within a traditional aesthetic context. Yet as traditional a conception of art as this is, the product framed by the shopwindow is most certainly not, for Osthaus, Kant's object of disinterested contemplation:

> Whatever is offered in this magical cabinet is always something precious, even it is only boots in black leather. [August] Endell has made something out of them which is surrounded by a fascinating glow from the Thousand and One Nights. They stand on inclined racks, silk cloth from India is spread under their soles, the panelled walls are decorated with mother-of-pearl and costly woods. Whatever is placed there glitters like a king from whose crown jewels sparkle, around whom beautiful women dance and offer bowls of golden fruit. The passer-by is in a trance; the silk clothes intoxicate him; before him open the lips that he – in these boots – will kiss.[104]

Desire, anathematized by other critics of the mass market as a signifying force beyond cultural control, is welcomed into the shopwindow not only as a boost to sales but as a way of intensifying the interaction between the cultural subject – the consumer – and the visual forms of everyday objects, however banal.

What to make of this sudden irruption of aestheticist fantasy? Its tone taxes the reader; one does not know whether to read into the text the cynicism of the businessman or the reverie of the Symbolist. But the point Osthaus was trying to make did not require him to choose between the means-end rationality of business and the otherworldliness of the artist; he was trying to unite them. For the text represents an assertion of the practical necessity of the artist's work, of imaginative plenitude over formal containment: "Here is the secret of a good display: fantasy, the salesman's most faithful helper, is called for."[105] If production could make do with a few "disciplined architectural intellects," then commerce, Osthaus wants to show, still required the formal imagination of the artist.

In his sacerdotal mood and his conception of the magic and mystery of the work of art, Osthaus is not really straying much beyond the scope of the *Kunstgewerbebewegung*. These qualities recall the aestheticist tendency of certain projects of the Jugendstil, in particular the esoteric tone and solemn ceremonies of the Mathildenhöhe artists' colony in Darmstadt.[106] In 1900, Ernst Ludwig, Grand Duke of Hessen, invited a group of artists including Behrens, Joseph Maria Olbrich and Rudolf Bosselt to the Mathildenhöhe to realize a "Document of German Art," "the unity of art and life, artist and artisan, house and decor."[107] The Mathildenhöhe marks an important stage in the development from aestheticism to the applied arts movement, for the operative notion of the *Gesamtkunstwerk* in Darmstadt extended to architecture and the design of everyday objects (it is here Behrens built his Jugendstil home). But the daily life served by these objects was not that of the mass market; it remained isolated in an aesthetic space completely separated from the quotidian realities of the turn of the century. In adopting and reviving the tone and content of esoteric aestheticism, Osthaus asserts the continued relevance of the artist's

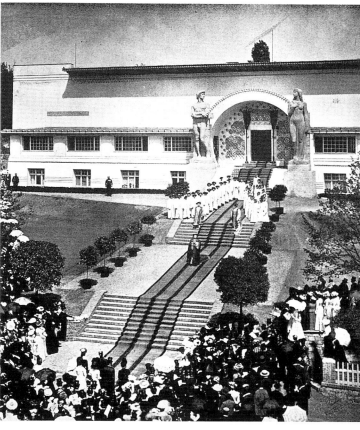

fantasy in the modern economy.

"Das Schaufenster" is also, I believe, yet another interpretation of the work of Peter Behrens, so prominent in Darmstadt. For although Osthaus refers in his article to many of the artists who enjoyed his support – Endell, van de Velde, Bernhard, Ehmcke, Gipkens – he not only mentions but alludes in several ways to Behrens, the artist with whom he worked most closely. When Osthaus writes of the erotic energies circulating in the marketplace, for example, of the magic web and the kissing lips, he might be borrowing almost literally from the erotic subject of Behrens's most famous early work, his woodcut *The Kiss*, published by *Pan* in 1898 (fig. 71). More significant, however, is the phrase "magical sign," for the magical sign as Osthaus describes it was a very important motif in Behrens's oeuvre, and one which made its appearance in Darmstadt. It was the focal point of Behrens's staging of the opening ceremony of the artists' colony (fig. 72), a short parable written by Georg Fuchs called "Das Zeichen" (The Sign) in which a prophet carries a covered object to the colony's patron, reciting:

> As dust, sealed by force
> Becomes diamond from a blind core,
> Firmly formed, reflecting the change,
> Light in light, star in star. . . .
> (He uncovers and raises the crystal gem.)
> The diamond, symbol of a new life,
> Under this sign is unveiled
> A new age of young souls,
> The time has come, you have not waited in vain.[108]

In Behrens's ceremony, the oracle presents Ernst Ludwig with a great crystal – a symbol of art and transcendence, representing the transformation of

71. Peter Behrens, *The Kiss*, color woodcut, 1898 (*Pan* [1898])

72. Peter Behrens's performance of Georg Fuchs's "Das Zeichen" at the opening ceremony of the exhibition "Ein Dokument Deutscher Kunst," Darmstadt, 1901 (A. Koch, ed., *Grossherzog Ernst Ludwig und die Ausstellung der Künstler-Kolonie in Darmstadt*)

73. Peter Behrens, fron-
tispiece to *Ein Dokument
Deutscher Kunst* (Munich,
1901)

74. Peter Behrens, the
artist's bookplate (*Deutsche
Kunst und Dekoration* 9
[1902])

dust to diamond, life to aesthetic perfection. It was quite precisely the *Zeichen* as Romantic symbol, simultaneously the internal totality of the work of art and the visual embodiment of nonsensuous transcendent truth. This "Sign" was the formal and thematic focal point of many of Behrens's works in this Jugendstil period, from his frontispiece to the Festschrift published with the opening ceremony (fig. 73), to his *Ex Libris* (fig. 74), to the title page of his book on the theater which he dedicated to the artists' colony (fig. 75).[109]

When, twelve years later, Osthaus writes that it is now the trademark which is the mystical "Sign," he can be taken at his word. Here Osthaus gives, I would suggest, nothing less than the iconography of Behrens's most impor-tant work of commercial graphics, his AEG logo. It is precisely the diamond crystal of the "Sign" that Behrens took as the inspiration for the trademark, doubling the border, regularizing the points into a perfect, radially symmetri-cal hexagon containing three large hexagonal facets to hold the initials of the company (fig. 76).[110] Certainly the honeycomb pattern alludes to the diligence and industry of the honeybee; by this metonymy Behrens has found the abstract equivalent of the traditional symbol of industry as we saw it in Sütterlin's poster for the 1896 Berlin Trade Exhibition (fig. 17). And perhaps Behrens was classicizing his "Sign" in line with Riegl's description of the clas-sical gem as "a crystalline form broken into clearly distinguished partial planes (usually by facets) . . . [with] a clear border."[111] Behrens might even have sought to use the regularization of the crystal and its facets into perfect hexa-gons to give the electric company's signet a technical aura by alluding to the benzene ring, a chemical model central to the development of Germany's chemical industry and one of the country's most fabled scientific successes (fig.

77).[112] In any case, Behrens was performing variations on a form that was already, in his oeuvre, a sign of the transformative magic of art, a symbol of transcendence.

Allusions continue. Behrens's "Sign" made its appearance in the hallowed atmosphere of the theater, the late nineteenth-century *Gesamtkunstwerk* combining stage, music, literature and the plastic arts. And the magic of the theater is a constant reference point for Osthaus, who saw the shopwindow as a stage. Osthaus also devotes considerable attention to the electric illumination of the shopwindow and its "mystical magic" as "legacy of the stage."[113] Having cooperated with Behrens on a stage production in Hagen, Osthaus was well aware of Behrens's extensive writings on the theater dating from his Darmstadt period and his more recent attention to the issue of electric stage illumination prompted by his cooperation with the AEG.[114]

The iconography of the magical sign lays bare the development from the diamond form of kissing lips to the literal diamond of the mystical "Sign" to the crystal AEG logo, regularized into a set of interlocking hexagon facets, its shine now shamelessly electric. It shows how a certain current of modern art in Germany moved from the hothouse atmosphere of aestheticism to modern

75. Peter Behrens, title page, *Feste des Lebens und der Kunst* (Leipzig, 1900)

76. Peter Behrens, trademark for the AEG, registered 1908 (courtesy AEG Firmenarchiv, Frankfurt/M.)

77. Benzene rings

commercial life, how artists moved from the theater as a "school of beauty,"[115] "the supreme cultural symbol,"[116] to the stage of the shopwindow that served as an "educator of the Volk."[117] In any case I would assert that this is how Osthaus interpreted the AEG trademark, as showing not a radical break between *l'art pour l'art* and the visual work of modern commerce but a transfer of artistic energy and utopian hopes.

What were, then, the utopian hopes Osthaus identified with the trademark? They are quite different from Scheffler's, and we might try to describe them as follows. They center on the commodity, considered in its modern, alienated, reified conditions of appearance. This lack of context, the breakdown of connections to a larger totality, Osthaus says, can be accepted and turned into the basis of an alternative sort of totality: an isolated object as a figure of unity, internal perfection and transcendence on the model of the Romantic work of art. Thus Osthaus sees in the sphere of commodity exchange the potential for the remobilization of desire, dream and magic, all of which had, according to contemporary critiques of capitalism, disappeared from the fallen capitalist present. His is a response to the dystopia of alienation or, to use Max Weber's phrase, a disenchanted or demagified (*entzauberte*) world. According to Osthaus, the magic of Culture, lost with the alienation from production, could be regained in the realm of exchange.

Osthaus's text comes, to put it mildly, out of the blue. As a discussion of form under capitalism, it is fragmentary, unmediated, full of undefined terms and unmarked leaps of logic. So too is my brief analysis of it here – necessarily, because none of the texts considered thus far provides adequate terms for understanding it. "The Shopwindow" also takes us a long way from more concrete ways of mapping culture by legal clauses and economic developments. I would like, then, to devote the rest of this final chapter to advancing my argument by working backwards, filling in some of the gaps and providing mediations to see what sense Osthaus's text can make not only on its own, free-floating terms but in the context of capitalist Germany before the First World War. There is, I think, a good reason for doing so. While Osthaus's understanding of market is hardly worthy of comment as an answer to the problem of alienation, it is bold, prescient, at times astute as a description of the cultural or signifying function of the commodity and visual form under capitalist conditions of modernity.

<center>* * *</center>

For the most part, the move from stage to shopwindow, from art to economy involved a considerable change in tone and rhetoric. Osthaus's essay shocks and resists interpretation because it combines the old rhetoric, one which was a source of discomfort to commentators in the Werkbund a decade later, with the new project.[118] The artists had already begun to dress and act more like businessmen than bohemians. But this conceals a basic continuity in their work and thought from Jugendstil and aestheticist roots through the Werkbund, a continuity that was also revealed in the anger and pathos of their outburst in 1914 when the traditional principles of fantasy and individuality were called into question. Thus in a certain way, the move from art to advertising was a natural one, for artists would find, Osthaus writes, that the market – by which I mean the set of representations involved in commodity exchange – welcomed the kind of magic they had learned to create: unique, individual signs, allusive yet resisting the simple, determinate signification proposed by the supporters of a more productivist *Sachlichkeit*. In providing this

78. Ernst Deutsch (later
Ernst Dryden), newspaper
advertisement for Manoli
cigarettes (Josef Feinhals,
Cologne), ca. 1912
Kunstgewerbeblatt, n.s. 24
[1912])

kind of sign to be used applied to or accompanying the commodity on its way
to the consumer, the artists, the "individualists," were answering to the
demands of modern business much more, I think, than the "norm-givers" and
"friends of the type" ever did.

For to turn a profit, producers of consumer commodities, the large-scale
producers that availed themselves of the trademark, needed not only to pro-
duce cheaply, but to sell dear. For the purposes of the former, *Typisierung* was
of only limited help; but concerning the latter, its opposite, individuality, could
be very important indeed. Companies needed to ensure their distinction from
other producers and the immediate recognizability of their merchandise. Firms
and products entered the consumer market as individuals: like the artist, each
arrived with a name. The Manoli cigarette factory (owned by Jos. Feinhals
and Company), for example, which employed the Werkbund artists Lucian
Bernhard and Ernst Deutsch, cultivated a well-known personality of worldly
elegance: "Who would take a box of Feinhals cigarettes from an unkempt
suit?" asked Osthaus rhetorically.[119] In a newspaper advertisement for
Manoli, Deutsch showed the right kind of suit, a dinner jacket (fig. 78). Both
Deutsch and Osthaus were referring to one name under which Manoli sold
cigarettes: *Dandy*. The trademark name gave an image, the publicity backed it
up. Deutsch created an anecdote around the cigarette. The commodity was
sachlich in Osthaus's terms: it did not tell a story, it was one. Bernhard's
poster showed the package he had designed for Manoli: the simple *M* crest
which turned the box into a monogrammed cigarette holder (fig. 55). Word of

79. "Gregor," newspaper
advertisement for "Moslem
Problem" cigarettes, 1913/14
(*Seidels Reklame* 2 [1914])

80. Emil Nolde, *Prophet*,
woodcut, 1912, 32.4 x 22
cm., Schiefler-Mosel 110
(British Museum, London,
© Nolde-Stiftung, Seebüll)

mouth showed showed that the fictional character – that of a simple cigarette
– had become a fact on the market.

Other cigarettes were different stories. The *Moslem Problem* cigarette bor-
rowed its personality from the (presumably) exotic origin of the raw materials
instead of the (allegedly) sophisticated act of their consumption. To reinforce
the distinctive name, an artist named Gregor resorted to an old trick. He liber-
ated Emil Nolde's *Prophet*, a woodcut of 1912, shuttling him from a German
Urwald to the Casbah and putting a cigarette in his mouth (figs. 79, 80). The
eyes glazed over; both Gregor's problem and the Moslem's problem were
solved. (Only Nolde's remained.)

Even types were individuals. As paradoxical as it sounds, and despite the
bitter fight-to-the-end that raged in the Werkbund, this was the daily reality
businesses faced. Take the light bulb. The AEG sent theirs to market in the
pared-down classical dress that characterized everything emerging from the
firm since Behrens's arrival. That was part of its character (fig. 63). The rest
was commonly provided by the well-known company name and their picture
trademark, which combined the scientific aura of the benzene ring with the
sharp edges and piercing light of the clear crystal gem. This was a particularly
well-defined and well-rounded personality. Rival Siemens used a more dated
method: they registered the word *Wotan*, tapping into the power of the
German god of myth for their much more modern product. The
Auergesellschaft m.b.H. made its light bulb a perfect individual, identifying it
with a proper name: they registered the invented word *Osram*, which means
nothing beside the object it was chosen to designate (fig. 61).

The signs which appeared on the market – the forms of the product and its advertising material, the name of the firm or the particular items, the trademark (word or picture) – asserted individuality and distinction from the competition. They encouraged the consumer to develop a sense that one product was superior to another, suited him better, would please him more or reflect better upon him. The artist was a natural place to look for this individuality. A firm could acquire personality by identifying itself with a well-known artist: the makers of *Tropon* food products, for example, commissioned van de Velde to design packaging and posters in the style inimitably his own (fig. 7); his monogram signet appeared prominently on the poster. Along these lines Anton Jaumann writes that "'Behrens-style' and 'AEG-style' coincide perfectly."[120] Usually, however, the firms relied on an artist not to assert his own personality but to create a new, perhaps fictitious one, that of the firm. That was in fact the case at the AEG, and Jaumann admits that "Behrens's name is in fact hardly, or only discreetly, mentioned in the company's announcements."[121] In trademark advertising, the individuality of the artist had to be sacrificed to the identity of the firm. In the words of Hans Weidenmüller, who not only wrote about advertising as culture but also ran an advertising agency, "It is not the individuality [*Eigenart*] of the single advertising artist . . . but rather the individuality of the enterprise and its merchandise that is to be represented in convincing, memorable form; the practical task dominates, the applied artist serves!"[122] And distinction from other firms had as its corollary the greatest possible identity within a firm, the products and all publicity material that formed their visual market context. Recall Meyer-Schönbrunn's account of Behrens's use of the same "formal logic" when designing both objects and publicity material; recall also that it was the unified appearance on the market and not the reflection of production which supplied this logic. Weidenmüller also commented on the issue, borrowing the clichés of Style:

> Enduring success in advertising is never the result of single publicity items . . . but of the planned use of various kinds of advertising. The advertiser can no longer tolerate his designers producing publicity items in individually realized artistic form, for with this achievement of individuality, the strong, unified, total impression of a firm's advertising is never attained; and it is this which is the true task of advertising. . . . In advertising exhibitions of the future, the advertising material of single enterprises will be placed side by side in as large numbers as possible to show the powerful, even thoroughness of each individual piece and thus the complete spiritualization of advertising as a total group achievement.[123]

As in the Utopian scenario of Style, formal unity is evidence of spiritualization, but here it is reduced to the scale of the product line. This unity functions somewhat like a frame: on the outside, it distinguishes products from those of other firms, asserting difference, closing them out; on the inside it implies identity and consistency. In locating the frame around a firm, Weidenmüller describes a middle position that, in its realistic scope, must have made considerable sense to many at the time who had to translate cultural theory into practical work that paid. His *Gesamtkunstwerk* is neither an isolated work of art nor an entire culture "from sofa cushion to city planning," but an advertising campaign.

A look at the practical work of advertising allows us to correct some of the flaws that became apparent in the utopian, productivist account of the type that nearly became Werkbund orthodoxy. While highly capitalized manufac-

turers of consumer products may well have bypassed certain traditional *institutions* of commerce by such means as the trademark, they did not bypass commerce as a field of representations accompanying commodity exchange. They did rather the opposite: they invaded this field. Sombart noted this development and called it the "commercialization of industry." His chief example was none other than the AEG; he described its prowess not only in technique but in marketing – its remarkable ability to create products first, and then to create demand.[124] Rather than flooding the market with signs of a distant sphere of production, manufacturers of consumer goods surrounded their products with signs functioning according to the logic of the marketplace.

Not even production was immune from signifying according to the logic of commerce. Indeed the remarkable fact is that the factory itself soon bore the mark of the commercial logic of the brand. It is Walter Gropius who puts this development into words in a series of well-known statements on the question of industrial architecture. These are worth looking at here, first of all to lay to rest the widespread notion that Gropius was somehow out of place in the Osthaus camp, and second to show how some of the ideas contained in "The Shopwindow" could be expressed in more conventional form.[125]

When Gropius speaks of Style in 1914, he uses the standard terms of the necessary deferral of the individual to a transcendent spirit: "As long as the spiritual conception of the time hesitates and falters in the absence of a single, firm goal, art will not have the opportunity to develop Style, i.e. the unification of the creative will into a single conception. In our day such common conceptions of world-moving importance are beginning to emerge from the chaos of individualist perceptions."[126] For years, however, he had written that it is the sovereign will of the individual genius alone which can express this spirit:

> The realm of art, the monumental art of the genius . . . is the representation of higher, transcendental ideas by material means that belong to the sensuous world of space and time. . . . Thus the will orders chaos, renders the arbitrary necessary, the unordered rhythmic. . . . The creation of the work of art requires therefore personality, the power of genius. Only the genius possesses the power of infusing the worldly with something otherworldly. He captures the spirit of the totality and captures it in physical form. Only the genius creates truly monumental works of art which have the power of influencing all other artistic manifestations, down into daily life.[127]

The creation of Style is the task of the individual artist. Yet when writing of the practical issues of industrial architecture, Gropius moves unproblematically from a discussion of the effect of architecture on the worker (Style dealienates labor by granting symbols, not power) to a discussion of the factory as publicity: "While the artist has long been recognized as indispensable for posters, the work of the architect from the perspective of advertising has not yet been appreciated."[128] He developed this theme in the Werkbund *Jahrbuch*:

> The fully new character of industrial buildings must stimulate the lively fantasy of the artist, for no traditional form restricts it. And the less the originality of the formal language is limited in its development, the greater the advertising power the structure will have for its owner. . . . A dignified exterior rightfully reflects on the character of the entire firm. And the attention of the public will certainly be more intensively captured by the artistic beauty of a factory, by the original, impressive silhouette than through advertising and company signs.[129]

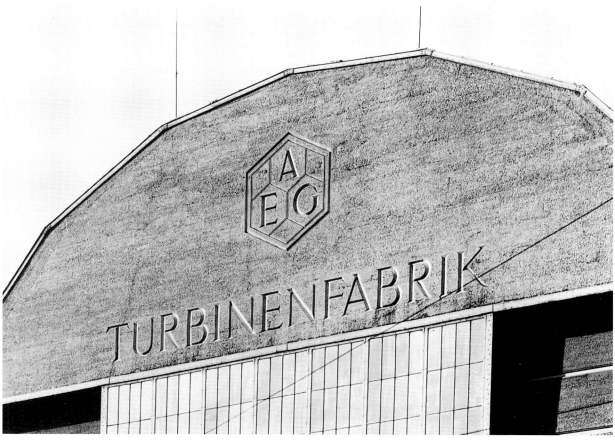

81. Peter Behrens (with Karl Bernhard), facade detail, AEG Turbine Factory, Huttenstrasse, Berlin, 1909 (Landesbildstelle Berlin)

Nor did Gropius have anything against traditional advertising in the context of architecture; he was just trying to do one better. Letters to Osthaus reveal his cheerful willingness to devote an external wall of the Model Factory and Office Building he and Adolf Meyer built at the 1914 Werkbund Exhibition to billboards.[130]

In Gropius's writings there is no evidence of the tension between production and trade that was the central theme of the battle for Style in the Muthesius camp. Gropius clearly saw the task of the architect as the ennobling of production through shared symbols of spirit, but while the artist had to transcend production, he is not described as representing it or making *it* transcendent. Gropius does not ask the artist to derive form from function or the production process. Form was, however, to lead over and out of production and represent the producer. Transcendent signs were delivered to the market without being grounded in labor.

When Gropius wrote and spoke of industrial architecture, he usually invoked the example of Behrens, his teacher, and he often used photographs of the AEG Turbine Factory of 1909 (fig. 21) to illustrate his ideas. It is clear why. Behrens applied the hexagon trademark not only to mantle clocks and newspaper advertisements but also to just such factories: placed here like a rose window above the curtain wall of his "cathedral of labor," the crystal facets mimic the window panes and the six sides echo the sexpartite vaulting of the monumental gable (fig. 81).[131] Along with the word *Turbinenfabrik*, it is the only applied ornament on the building. Gropius and Behrens would

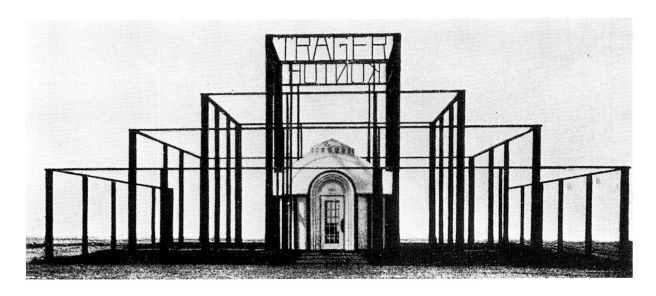

82. Bruno Taut (with Franz
Hoffmann), exhibition
pavilion for the Träger-
Verkaufs-Kontor Berlin
G.m.b.H. at the Ton-
Zement-Kalk-Industrieaus-
stellung, Berlin, 1910
(*Berliner Architekturwelt*
13 [1911/12])

83. Bruno Taut (with Franz
Hoffmann), Monument to
Steel at the Internationale
Baufach-Ausstellung,
Leipzig, 1913 (*JDW* 3
[1914])

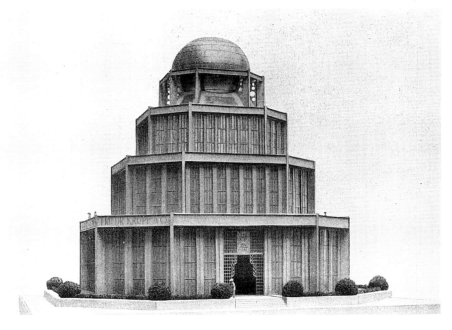

have been glad to believe Wolf Dohrn's far-fetched claim that "the fact that
the new, Behrens-designed trademark is used with great enthusiasm in the
workshops . . . is a significant indication of the prevailing working spirit. The
workers want nothing to do with the old, conventional trademark, for they
regard the new one as the true symbol of their labor."[132] But Gropius and
Behrens knew that the magical sign was also, and primarily, at market. Fritz
Hoeber, Behrens's Boswell, wrote that

> For the broad public, the aesthetic value [of Behrens's work] is revealed
> most visibly in the publicity material that a huge enterprise such as the AEG
> must publish every day, in the flyers and brochures . . . [and] in the various
> factory marks of the firm which Behrens understood to abbreviate so preg-
> nantly into a lively cursive monogram or as a supremely typical, three-

celled octagon [*sic*] that are already so widely known as to be the true symbol of the AEG.[133]

The interplay between graphic trademark and factory architecture shows Behrens trying to create the kind of form Gropius described, functioning in the realms of *both* production and exchange.

This dual presence of form that Gropius describes was a fundamental force behind the development of modern industrial architecture in Germany, and one which did not go unnoticed by architects. Consider, for example, the structure Bruno Taut built for the Trägerkontor company in 1910 (fig. 82), a simple domed chamber in masonry with a Romanesque portal surrounded by the empty geometry of a building frame, rectangularly set back from a raised center, astonishing in the graphic monumentality of the voided structure. At one level it is quite matter-of-fact, a mere demonstration of the company's product, the iron frame. But its emphatic symmetry is probably more than that: its form evokes Wilhelm Worringer's description of abstraction as the will's imposition of order over chaos, a notion that would have been well known to Taut, who moved in Expressionist circles. In its structural separation from the closed core, the scaffolding seems nonetheless gratuitous for an industrial client, were it not for the crucial fact that the work is architecture precisely as Gropius described it, as advertising: it was an exhibition pavilion designed to give an image to a product rather than to serve any technical function.[134] The product was eminently practical; its use in the pavilion, however, more representative than *sachlich*.

Taut's other major works of the pre-war period were also advertising structures. His Monument to Steel of 1913 (fig. 83) was commissioned by an association of steel producers for a trade exhibition in Leipzig. Taut places a gold sphere atop a monumental stepped pyramid whose blue-painted steel frame contrasts clearly to the glass and dark brick with which it is filled out. Here, as one commentator writes, "the steel industry no longer sought a practical presentation of its products and their technical potential, but rather to represent itself."[135] And the famous Glass House (fig. 84) served as a showcase for the products of the glass industry, in particular those of the German Luxfer-Prismen Syndikat.[136]

It is the imaginative use of modern building materials and their connection to the building industry which gives the coordinates by which Taut's early projects are usually interpreted. And the exploration of the new potentials of steel, glass and reinforced concrete does perhaps qualify these projects as examples of pre-war *Sachlichkeit* or, in Banham's words, the "factory aesthetic."[137] Yet I want to suggest here that such technical rationales are not the only, or even the most important, aspects of these projects, even less than they were for Behrens. For *sachlich* is the last word one can use to describe these buildings. And in the case of the Glass House, Taut's violations of practicality leave the six-sided gable and heavy piers covering the steel frame of Behrens's Turbine Factory miles behind. The interior of the glass pavilion, especially the famous "cascade room," was an explosion of color and sensuous delight (fig. 85). It was filled not only with sober displays of information about the various sponsors' products (these were housed in a colorful "cupola room" above, under the dome) but with stained-glass windows by Expressionist artists, illuminated from behind, walls of silvered glass, ceilings of brilliant glass panels, floors of colored glass mosaic, and a waterfall leading over a glowing base down to a "kaleidoscope room" at the base, illuminated with patterns of color

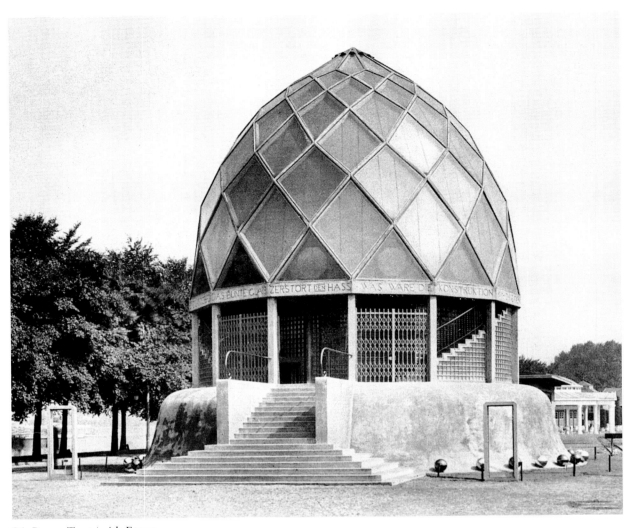

84. Bruno Taut (with Franz Hoffmann), Glass House, Werkbund Exhibition, Cologne, 1914 (*JDW* 4 [1915])

changing every twenty seconds. The building, as is well known, emerged from a close exchange of ideas between Taut and the visionary poet Paul Scheerbart, and their fantasy of a glowing, crystalline glass architecture was primarily a poetic utopia, not a technical one.[138] The design of the building led visitors on a carefully conceived ceremonial path, up stairs around the side of the base that offered a last view of the real world, into the glowing realm of technique above, then down into the revelatory world of color and light in the cascade room below, and finally down broad stairs flanking the waterfall and outside the building. The Glass House was nothing less than another pageant of the glowing crystal; it was in fact a glowing crystal itself. It was a replay of the cult of beauty's ritual of the magical "Sign," a last brilliant flowering of the spirit of Darmstadt.

And, of course, it was also an advertising pavilion (fig. 86). Thus the coordinates shift from the technical to the most transcendent aesthetic and land, finally and obviously, at the commercial. The ritual, it seems, is simply that of the commodity, and Scheerbart's visionary verses inscribed around the base of the dome just doggerel of an advertising copy-writer.[139] Yet the importance of the Glass House lies less in the use to which it was put (which could, though I

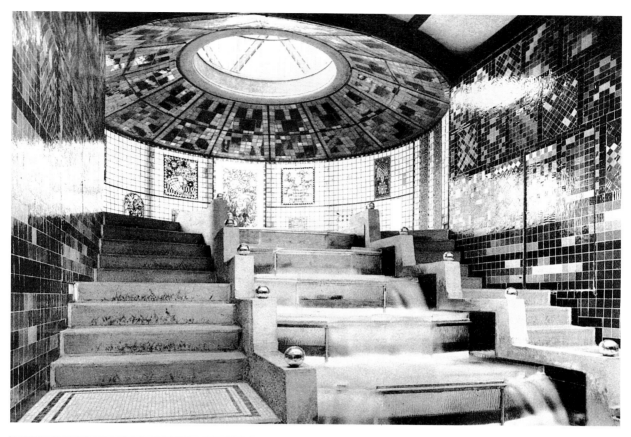

85. Bruno Taut (with Franz Hoffmann), cascade room in the Glass House, Werkbund Exhibition, Cologne, 1914 (*JDW* 4 [1915])

86. Advertisement for the Glass House placed by the Luxfer-Prismen-Syndikat in the official catalogue to the 1914 Werkbund Exhibition

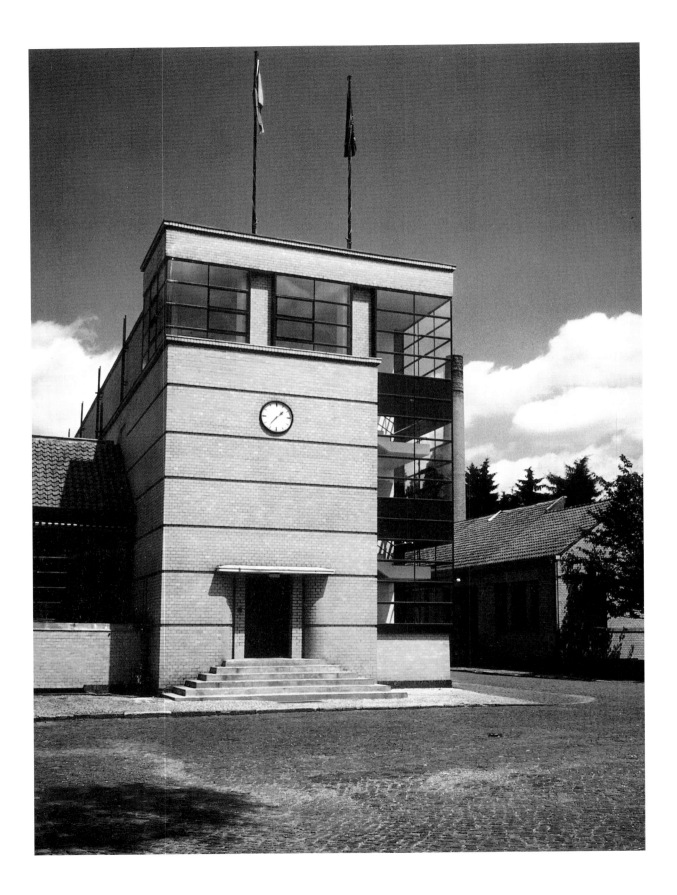

think wrongly, be described as cynical) than in the relation between the very different purposes it managed to serve simultaneously. A look at the history of the project shows that Taut probably did not conceive it as primarily commercial in nature, but rather found that to do so ultimately served his own ends. For the Glass House, it seems, was not really commissioned by the glass industries at all; instead, Taut conceived the project together with Scheerbart and *then* went about seeking funding from firms which could benefit from the exposure their products would receive. In the end his expenses were not even covered.[140] No businessman sought out the artist to give his goods the aura of art; rather, Taut realized that he could only find funding for his architectural utopia to the extent that it could serve particular business needs, and that these needs were neither aesthetic nor technical but commercial. This may well have been distasteful to Taut – he certainly never showed Gropius's enthusiasm for advertising – but he was obviously aware that commercial function was one of the bases of architectural innovation and that advertising was one of art's routes of access to the market, one ground for its "citizenship." The ultimate question is not which interest – the technical, the commercial, or the aesthetic – represents the true force behind the Glass House, but rather the way they had to combine to allow the work to be built at all.

The tension between Scheerbart's lyrics and the jingles they seem to mimic, between the shimmering waterfall and the no doubt bemused response of the businessmen asked to pay for it, shows that although Taut knew what purposes art needed to serve, he was not quite ready to alter his conception of the work he did to take this knowledge into account. And the clumsiness of the financing scheme needed to build the pavilion shows that the Glass House was, in fact, no model for the relation of art and economy. The most complete symbiosis of these forces might better be glimpsed in the industrial architecture of Gropius, an architect considerably more self-conscious about the nature of the cultural field in which he worked.

This self-conciousness is shown in the writings we have looked at. What Gropius wrote was, however, not just theory. As a practitioner he knew first-hand about the interplay between the client's commercial needs and the architect's ambition to give artistic expression to the forces of the age; it was probably made quite clear to him by one of those "subtle factory owners" he wrote of – in this case, Carl Benscheidt of Alfeld an der Leine, founder of the Fagus G.m.b.H., who commissioned Gropius and Meyer to build his factory in several campaigns beginning in 1911 (figs. 3, 87).[141]

The artistic innovations of this extraordinary work are well-known, and their analysis forms a cornerstone of the historiography of modern architecture in Germany. The main building's exaggerated stereonometry is reminiscent of, and perhaps indebted to, Taut's Trägerkontor pavilion with its Worringerian clarity asserting the sovereign order of the artist's will. The dramatic glazing of its sheer glass walls recalls the metaphors of crystalline transcendence that appeared not only in Darmstadt but in works from Nietzsche to the Expressionists. In the Fagus-Werk Gropius also develops certain aspects of his teacher Behrens's industrial architecture, specifically the Turbine Factory: we recognize the vertical articulation of the glazed wall with tilted piers, though the piers here are brick-faced, not steel, and they are inclined behind the plane of the glass panes instead of emerging in front of it. Familiar too are the horizontal striations of the main entryway on the south-west side, completed in 1914; they recall the green bands put into the monumental (but hollow) concrete piers flanking the facade of the AEG factory.[142] Yet Gropius

87. Walter Gropius and Adolf Meyer, Fagus-Werk, Alfeld an der Leine, main building viewed from the southwest showing additions completed by 1914, present state (Frederic J. Schwartz)

is clearly working towards another view of technique than that which motivat-
ed Behrens, one less reliant on classical precedents and conventions of repre-
sentative architecture. The glazed sides still have a classicizing regularity and
proportion in the placement of the piers, but the overt references to a pedi-
ment are rejected, as is the symmetry of the entrance facade. The building
seems reduced to its bare elements – brick, steel and glass – disposed in a logi-
cal, consistent, minimal way.

But such a conception of technique is not in any way a clear reflection of it.
The unsupported glass corners of the main building and the thinness of the
recessed and reclining piers have long convinced many critics that the building has
a steel frame; yet the piers are of brick, and the whole structure is, for all its aes-
thetic radicality, quite traditional in construction.[143] And the dramatic main
building – the most commonly, and often exclusively, illustrated part of the com-
plex – is not, strictly speaking, a factory at all: it houses primarily the administra-
tive rooms of the firm. The more narrowly defined "industrial" work is per-
formed in an adjacent one-story building (fig. 20 and visible to the left of the
main building in figs. 3 and 87) that is rarely shown and considerably less con-
spicuous.

Form, in the Fagus-Werk, represents production, but does not reflect it.
This state of affairs is the direct result of the nature of the commission. Carl
Benscheidt, who founded the Fagus-Werk, a shoe-last factory, was until 1910
the technical director of Carl Behrens G.m.b.H., another firm manufacturing
the same product in Alfeld. After a falling out, he founded his own firm in
direct competition with his old employer, gambling on winning an advantage
through the use of new American techniques of manufacture (and with
American capital). The design of the new factory was another gamble that
must be understood in this business context. The first (north-east) glass corner
of Gropius's new Fagus-Werk faced the factory of Carl Behrens opposite the
railway tracks, only a few hundred yards away. In contrast to the older firm's
factory, built in the traditional historicizing red-brick factory architecture of
the period, the deep, glowing yellow of the brick chosen by Gropius would
have made the structure seem an apparition. Benscheidt wanted to give his fac-
tory a distinctive appearance, an image of up-to-date technical perfection as
part of his bid to secure a market position; he was clearly trying to cultivate a
visual contrast between the old firm's traditional building and his new one, a
contrast that would give visual form to the new firm's committment to techni-
cal innovation. The nature of his concern can be read clearly out of the con-
tract he made with Gropius. The latter was to build according to the basic
plan of an architect originally given the commission – Eduard Werner, a local
professional with considerable experience with factories of this type. Gropius,
on the other hand, was merely "to give the complex a tasteful appearance."[144]
And the depth of Benscheidt's concern is made clear by the extraordinary
patience he exhibited in written correspondence with the young, inexperienced
architect who did not always follow instructions and who, with arrogance
only thinly disguised by conventions of politeness, regularly tried (and usually
failed) to extort major changes on the client's part.[145]

Gropius was to give the new factory (whose foundations were already
being laid according to Werner's plan) a *facade*, for it was precisely an *image*
that Benscheidt wanted from Gropius. Benscheidt was well aware of the
importance of merchandising and knew how to exploit advertising to start up
a business.[146] He knew to use a young architect sincerely intent on creating a
"representation of higher, transcendent ideas" to give his firm its own visual

Fabrikmarke. M. Hertwig.

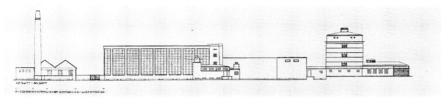

88. Max Hertwig, trademark for Fagus G.m.b.H., ca. 1911 (*Der Industriebau* 4 [1913])

89. Walter Gropius and Adolf Meyer, Fagus-Werk, Alfeld an der Leine, elevation of the north side of the complex showing the first stage of construction, 1911 (*Der Industriebau* 4 [1913])

90. Max Hertwig, ink drawing of Gropius and Meyer's Fagus-Werk, Alfeld an der Leine, ca. 1911 (*Der Industriebau* 4 [1913])

personality, and Gropius knew what else he had to achieve in the pursuit of his own goals. The Fagus-Werk may well have epitomized what many critics thought the industrial type in architecture should be, the exemplar of the factory, the very image of modern production; yet the technique represented here was as much a matter of the firm's personality as it was of the building's construction – more so, in fact. This was in no way dishonest. For even if Gropius was trying to create, through his use of his building materials, a sort of "factory type," a cultural representation of industrial technique, he knew what Behrens knew, that the reality architectural practice was more complex. He knew that the architectural type too had to be an individual, and that this was the only justification for monumental architecture in a modern economy.

Carl Benscheidt knew more tricks of the trade. He did not let the visual capital represented by the facade of his new factory sit still; as a commodity on the market, the architectural signs of individuality had to circulate. He commissioned a Werkbund artist, Max Hertwig, to design his new company's logo (fig. 88), and also to produce a picture of his new factory for use in printed advertising. A comparison of Hertwig's rendering with the elevation by Gropius and Meyer on which it was clearly based is revealing about the forces to which visual forms in the economy were being subjected (figs. 89, 90).[147] In the technical drawing the mass of the building is dissolved into thin lines, accentuating the dematerialized quality stressed by critics who see the building as the expression of structural concerns. Hertwig's version shows roughly the same view – the north side of the first phase of construction as seen from the railway tracks (and from the factory of Carl Behrens) – but with the building now glowing in a dark, abstracted industrial landscape, monumental in its presence. The reduction to the broad, flat forms of the Jugendstil and the increased density the building is given do violence to the technical rendering on which it was based; the technical information of the elevation is sacrificedfor the immediate impact of advertising, making clear the representative component of the factory's function. The building of the elevation is twisted to show adjacent sides or more impressive facades; it is distorted, flattened and monumentalized in its transformation into a commercial sign, from a sign bound to production to one circulating far from the factory.

In his writings on the aesthetics of the factory, Gropius describes a larger cultural process that came to be deeply embedded in the most advanced industrial architecture of the period: the way visual forms did not revolve around the production process but were being drawn to the other pole of the economy as it was discussed by contemporaries. Instead of the market pointing to production, the realm of production was being assimilated, or was assimilating itself, to commerce's field of forms. If production was to signify, it would have to do so on the market, and on the terms which obtained there. In pointing this out, Gropius was doing two things: he was making a pitch for the artist, asserting the modern necessity of his work; and he was telling the artist that his job was not to change production, but instead to relocate it in the realm of commerce, to move signs from one site to another. The artist in industry had to reconfigure production from a signified to a signifier to be circulated on the market. Even the industrial architect was working in *Handel*, and the genius, if he was to be heard and seen, had to advertise, both for himself and for others.

<center>* * *</center>

Let us pull together the fragmented clues offered by metaphors, allusions and rhetoric and try to turn a group of statements made to protect a vested interest – the right of the artist to continue, more or less, the kind of work he was doing – into something like an argument about the way the visual forms of and around both architecture and everyday goods function in a modern economy.

The first point central to the statements made by Meyer-Schönbrunn, Osthaus, Weidenmüller and Gropius is that form under capitalism – form that accepted its commodified status and the economy as its context – responds to trade, not production. If in the productivist cultural utopia of the type, advertising refers only to a product which itself refers to production as an ultimate signified, the vector is now reversed: both the product and production itself are, considered as signs, advertising. The form of an object serves a commercial function, that of furthering the exchange of goods for money, and it does so by asserting identity and difference in varying proportions according to a commercial logic that differed from that of a mythical culture of shared signs. That, they realized, was how commodities were sold: by magical signs moving people to buy, signs that had individuality, signs that were auratic and perhaps erotic.

The second point concerns trade considered not in terms of economic functions but as a signifying space. These writers claimed that commerce was not and would not be a transparent realm that would relay signs of unity originating elsewhere. They described this field as an opaque one that does not deny its own semantic presence but creates its own kind of sign, concentrated and abundant. Since production was receding from unmediated visibility in the part of the economy that bourgeois consumers encountered, a different kind of sign was in order, one perhaps without a single cultural referent or a signified of Culture. In moving beyond the typifiers' grudging acceptance of the space of exchange as a space of representations (if only one to be bridged over), the individualists represent exchange as a preeminent modern signifying space. Thus they represent Culture not as a content but as a locus, a site coinciding with that of commodity exchange. Cultural "citizenship" required access to this space of magical signs.

The third point is signalled by the insistent conflation of commerce and culture in the comparison of the unified form of brand visibility with the work of art. Gropius, using the most recognizable terms of romantic anticapitalism, speaks of advertising in terms of transcendent symbols of Style, formal princi-

ples that were also spiritual; Weidenmüller describes a Wagnerian publicity *Gesamtkunstwerk*, additive but creating a unified effect; and, perhaps most strikingly, Osthaus describes advertising in terms of aura and aesthetic distance, of self-contained perfection and of allusive, at times intransitive metaphors, of the non-mimetic creation of a world instead of its mere reflection. I do not think that these writers were suggesting that one should go to the market to find "art." I think that they were saying something else, and that their equation should be read as just a simile. They were pointing instead to a fundamental relation between the visual forms they saw developing on the market and the non-mimetic fantasy realm of art as it developed in Germany around 1900. It was a kinship that perhaps had something to do with the very state of alienation itself, a state that had as its obverse a constant drive to utopia.

No doubt some of these claims are postulates and all overshoot their mark, but they have a certain internal consistency, one that continues to see the artist as relevant, indeed necessary, even after the rude awakenings from the earlier dream of a protected sphere of artistic labor and of the imposition of Culture from this privileged space. It is a position that could maintain an aging notion of artistic work while understanding the modernity of the site in which it would, willy-nilly, operate, understanding this much better than those who rejected the artist for anonymous production types. The "individualist" position of van de Velde, Osthaus, Gropius and the others who spoke against Muthesius is, when one pieces it together, compelling enough for us to want to test – perhaps not to see if the claims were true or not but to see how they could be made at all. Fortunately there was yet another interpretation of the trademark, the sign central both to Osthaus's sense of modern magic and to Muthesius's dream of the type, one which both had to refer to, implicitly or explicitly. For this we must return to the law.

4. COMMODITY SIGNS

> The colossal apparatus created by modern commerce in order to
> bring its goods to the buying public is in truth just as characteristic
> of our age as the pyramids were for the Egyptians. Whereas earlier
> an entire people stood in the service of these great edifices, today
> we all are in the service of the new, all-embracing spirit of supply
> and demand. This spirit gives our age its "Style."
>
> *Seidels Reklame*[148]

For the members of the Werkbund, the long-awaited copyright law of 1907
failed to negotiate a culturally and economically stable relationship between
visual form and the modern economy. It failed to establish a distinction
between spiritual and non-spiritual commodities or to provide a legally secure
position for the artist. This was perhaps the central problem that faced the
Werkbund soon after its founding, wreaking havoc with the original members'
plan to unite art, industry and commerce by subordinating production to the
rule of the artist as they had done in Dresden in 1906. We have seen how posi-
tions developed which sought to compromise, to retreat from the assertion of
the artist as dictator of culture and to integrate him more fully into the econo-
my on terms that were not necessarily his own. Since the artist was not to rule
by fiat, these attempts involved the search for other principles that would con-
trol culture, principles more powerful than the artist but which he could
nonetheless accept. One group found this principle in the alliance with a force
which did, they hoped, have the power to impose Culture: organized capital,
which was equated with the control of production. The other group sought
instead an economic space in which the artist could reign, exercising the sover-
eignty of imagination: the seemingly chaotic realm of commodity exchange.

Paradoxically, however, both these positions – or attempts, or theories –
chose the trademark as emblem and exemplar of the kind of cultural work
they hoped to accomplish. What was it, then, about the trademark that
allowed it to be the "sign of a new enterprising spirit" for Karl Scheffler and
the supporters of a spiritualized economy ruled by concentrated capital at the
same time as it was the "magical sign" of Osthaus's vision of a commercial
world ruled by individualist artists? Why did their very different interpreta-
tions of the problems of culture under capitalism and their solutions to them
intersect here? And how could the trademark provide such disparate views
with understandings of how form acted, or could act, in a capitalist economy?

A look at the German trademark law, I have already suggested, can orient
us. In its essence it is simple, and as a way of understanding the relation
between form and the market it provides powerful terms and a compelling
model. The first law in Germany to define and regulate the identification of a
wide range of commodities by trademarks was enacted in 1874. It was not
merely the result of the need to unify the legal code of the newly united state:
nothing truly comparable had existed there earlier.[149] Widely regarded as
inadequate and technically flawed, this first law was replaced with new legisla-
tion in 1894. In the words of one legal commentator, trademark law is a
"child of modern times."[150] Specifically, it grew out of two related develop-
ments of the second half of the nineteenth century. The first was a function of
the broadening of markets. As customers lost contact with producers, the door
was opened for imitations, surrogates and frauds. Even if one had a notion of
the "genuine," it was becoming increasingly difficult to identify it by labels,

marks or other signs of origin. The second development was the drafting of all possible words, pictures and symbols into the campaign to sell goods – the superlatives, the claims, the hype of advertising. Everything was "original," everything was the "best," and not only objects but the signs identifying them were subject to relentless copying. From the look of things, nothing was sacred: the entire realm of signs was grist for the mill.

The complaint that commodification was absorbing an alarming proportion of the linguistic and visual realm was not merely a polemical stance but a very real fact (figs. 33-5). It was of deep concern not only to cultural critics (who called it "Fashion") but to businessmen, lawyers and statesmen. As the role of words and images in social production changed and broadened, it became clear that some sort of legal administration of the realm of signs was necessary to maintain the economic and semiotic stability of society. As it was applied to the very specific problem posed by the identification of consumer commodities, this control was bureaucratic but not tyrannical; it sought to cooperate with capital while allowing basic functions of communication to operate unhindered, functions which were threatened when capital was left to its own devices and untamed energies. Here the law did not seek to maintain an uncommodified realm of culture (or, like copyright law, a quasi-cultural space in which the circulation of commodities was placed under tight limits), for it was an economic and not a cultural chaos it sought to avoid. So to help honest businesses sell their goods and to keep open the lines of social communication, the law made, within the limited scope of the problem it addressed, a bold distinction. It distinguished between signs – verbal or visual – that could be owned and those that could not. Those that could be owned were called, simply and logically, "commodity signs" (the literal translation of *Warenzeichen*, the German word for trademark). Signs that could not be owned were called "free."

Trademarks were of course words or visual symbols that a business could use to identify and distinguish its goods on the market. In the words of the law:

§1. Whoever wishes to make use of a trademark in his business operations to distinguish his commodities from the commodities of another can apply for registration of this sign in the trademark registry.[151]

Despite the common use of words as trademarks, the law considered the commodity sign to be visual in its essence, even as it transcended the visual: "Every trademark must be perceptible by the eye. It produces an impression, however, not only on the sense of sight, but on the entire range of the senses and memory. In the case of individual signs, sight, hearing or imagination can be involved to varying degrees."[152] Only the visual form of a word could be registered, though the sound it represented was protected. A business could choose or create its trademark and register it for use on or accompanying its products (the law divided commodities into forty classes and innumerable subclasses; the signs could be registered for any or all of them). For this very particular but nonetheless important use, the trademark law allowed a firm to control completely the business use of a certain sign in specific market sectors:

§12. The registration of a trademark has the effect that the registering party enjoys the exclusive right to affix the trademark to goods of the classes applied for, their wrappers or covering; to introduce the goods marked in this way into commerce; and to affix the sign to prospectuses, price lists, business correspondence, advertisements, bills and the like.[153]

The trademark guaranteed the origin of goods for the customer by allowing a business to prevent the use of its sign by its competitors. To this end, firms could buy up entire linguistic blocks to prevent encroachment.[154] A trademark helped a business achieve a visual or aural market presence; it was "the most secure means for the businessman to thwart incursions into his market and to retain the customers he has acquired."[155] For a fee of thirty marks per sign and an infinitely renewable period of ten years, companies could own words or symbols in their capacity to be used in commodity exchange; as a commodity, the rights to these signs could be bought, sold, stockpiled, hoarded, even inherited.

The law puts the definition of the commodity sign into sharper relief by its discussion of free signs, the counterpoint to which trademarks assume their meaning. The legislation of a realm of free signs was a response to the need to decommodify certain signs, to remove them from circulation as commodities; such signs could not be owned because of their "necessity for the public" and their "necessity for trade."[156] They were "signs which . . . may not be removed from common use, even to a limited degree, for the gain of individual enterprises."[157] The logic of the non-commodified sign is clear. On the one hand, it equalized competition by allowing no one firm the exclusive rights to signs traditionally used in a branch: the words "extra dry" for makers of sparkling wine or the snake and staff for pharmaceutical companies. On the other hand, it forbade the use of signs that were necessary for the continued and unhindered production and circulation of commodities, signs to which all needed access to keep the wheels of social life turning. For example, the presence of "Butter" brand dairy products would leave others without an unequivocal designation; the market would be fragmented into a sea of self-referential proper nouns. The word "Kilo" as a trademark for weighable goods could cast weights and measures into question, just as registering the letters "T" or "I" would send others scurrying to avoid the letter in the name, labelling or description of the commodity and to avoid the geometry in its form. Similarly the use of a red cross would render meaningless the necessary symbol of Geneva Convention neutrality. And the rights to the familiar, schematically rendered light bulb as a trademark (or an important part of one) would imply the exclusivity of a widespread, standard, perhaps even technically determined commodity form. Even if the production form itself was not patented, its exclusive use as a market sign would give an unfair advantage to a single firm, create confusion among consumers, and lead in practice to a curtailment of the use of non-patented techniques. The result would be destabilized market and production conditions. In general, renderings of common commodity forms, even in outline, as well as basic geometric figures without distinctive coloring or typographical accents were for these reasons frowned upon by the patent office, which made these decisions. When it came to the market visibility of consumer commodities, their appearance and labelling, these forms had to be available to all without cost or legal snags. They had to be part of a generally accessible, non-commodified set of visual signs, a common currency.

The legal definition of the commodity sign was both non-linguistic and non-cultural. The law construed the system in which signs signify neither as a language nor as a space of spirit or sociation, but rather as the system in which goods and services circulate. This definition was horribly mundane, understanding *Zeichen* as mere "mark"; it was a matter of property, pure, crude

and simple. But trademark law's radical distinction between free and commodity signs allows us to see how the mark could be raised to a *Zeichen* of a loftier sort; and it also provides important terms for describing the difference between the type and the individualist positions in the Werkbund, indeed the key which explains why each sought to deploy the trademark to its own very different ends.

The types position, for example, is implicit in the legal terms with which Paul Schultze-Naumburg, owner of the Saalecker Werkstätten, frames his discussion of Style already in 1906. Schultze-Naumburg did not speak in Cologne, but he was certainly no friend of the individualists, and his early rejection of the 1907 *Kunstschutzgesetz* (not yet signed into law when he wrote these lines) prefigures Muthesius's later position. Here he is talking about copyright, but his discussion strays into the realm of the patent. In any case, the issue is the ownership of form: "Imagine such legislation in a time of truly healthy artistic development. Think for example of the twelfth century when the first Gothic cathedrals were built. If they had been immediately placed under copyright, and the authors had patented them so that they alone would have the rights to build further Gothic cathedrals, then the development of the Gothic style would have looked pretty silly."[158] The forms of everyday life, he writes, should be "clean and pure; and this can only happen if each copies the other['s work] and makes it a little bit better. . . . This is only possible with the *entire* store of human knowledge, and when [the artist] has created something from this store, he can not think that it is his *private* property."[159] In describing the incompatibility of Style and copyright, Schultze-Naumburg draws a distinction between forms with a certain exclusive kind of exchange value and those available to all. For Schultze-Naumburg, Style presupposes the presence of shared forms.

By getting rid of authors, relocating the development of form from commerce to production, and the use of trademarks, the supporters of *Typisierung* hoped to achieve precisely this widespread use of shared forms. They hoped to limit individual signs – copyright forms or trademarks, which are also signs of distinction – and to clear the way for the use of the common visual vocabulary as laid out in the law. For the "type" was precisely the free sign. In the words of Dr. jur. W. Rhenius, a commentator on the law,

> Not suitable for the distinction [of one's goods from those of another] are *representations of the commodity* to which the trademark will be applied; nor of technically significant parts or their names, even when they are registered; nor schematic representations and outlines of the commodity. . . . The picture of a commodity is also unsuitable for *related* commodities, for example the picture of an umbrella for canes, of a boot for shoes.[160]

Rhenius describes here the point of law we have already considered on the example of the light bulb: the general, customary appearance of a commodity could not be registered as an exclusive commodity sign, for this would, in practice, force other manufacturers to change the look of their own products to achieve a distinctive appearance and market individuality. Indeed, the law provided no recourse to prevent the obvious sort of copying we witnessed in the case of Lucian Bernhard's *Stiller* shoe type (figs. 58, 59); only the combination of the company name with the abstracted image of the shoe could be protected. As far as trademark law was concerned, the standard, traditional or technically determined form – described in the Werkbund as the type – was available to all in that no one was allowed exclusive rights to it. Recall the

light bulb advertisements, how the infinite variability of the trademark encouraged commerce to leave the look of the item intact (or allowed them to compensate for its untouchable status) (figs. 61–3). The way the law described the interplay between free and commodity signs encouraged certain Werkbund members to believe that the signs of distinction that entered the representational field of the market could be limited to this single mark. The commodity need not be new or original, writes Seligsohn: "One can apply a trademark to a good that is in no way different from others."[161] The supporters of types, and of the brand-name product interpreted as the type, clearly believed that the appearance of everyday objects could be limited to standard, traditional or technically defined forms, that, by fiat or by technical necessity, these forms could be limited at the level of production and shared as free signs. The trademark would allow production to speak by limiting the voice of commerce to single commodity signs. Culture would once again be a visual world of non-commodified forms: the "world chair," the round clock, the unadorned factory, in Muthesius's words "the whole area of the Werkbund's activities" from sofa cushion to the city, could share the forms of Style; the trademark would limit the culturally destabilizing tendencies of modern trade by factoring out market conditions and leaving a single, minimal coefficient, a minimal mark. Capital had the power to speak in the free signs that remained.

"There is thus a pronounced distinction between the individual signs of §1-4 of the law – the trademarks in the sense of the law – and the general sign, the free sign of §4," wrote one commentator, a judge.[162] The "friends of the type" sought to borrow this latter, non-commodified realm of signs from the economy and to call it Style. The law also provided a description of the modest, nameless role of the artist and how the steady improvements Schultze-Naumburg invokes could become part of a shared vocabulary, creating a steady development of formal solutions instead of the "style-hunt" of Fashion: "Individual signs can turn into free signs if they lose their quality of individuality in commerce."[163] This was a utopia of free signs in which the commodification of form was confined to a single mark.

Needless to say, this scenario looked quite different when it was sketched by supporters of Osthaus and van de Velde. Paul Westheim reviewed Schultze-Naumburg's own contributions to the 1914 Cologne exhibition as follows: "Schultze-Naumburg has prevailed. Like an antique store, he delivers palaces and furnishings in Empire, Biedermeier or some other Fashion style."[164] For the individualists, the free signs of tradition were still stolen forms with an illicit exchange value, that of Fashion and its unlimited potential for unauthorized exploitation. For the artist to create Style, market signs would have to be individual, and for signs to be individual, they had to be *owned*. The trademark fulfilled this requirement. It did not matter to the artists that it was no longer they who would own the forms they created. By offering his crystal "Sign" to the AEG as a trademark, for example, Peter Behrens gave up his rights to it; he was well paid for his work, but the trademark henceforth belonged to the AEG. Trademark law replaced the spiritual act that lay behind the legal definition of copyright with a bureaucratic one: signs were not created, they were registered, and whoever registered a sign first was its owner.[165] So when the crystal "Sign" moved from the stage to the shopwindow via the trademark registry (fig. 91), it was no longer introduced with the elevated verse of the prophet, but with the dry prose of the lawyer sending an application to the patent office:

The trademark hereby presented, which shall be used for the goods stipulated in the enclosed list, consists in its essence in a hexagon which contains in turn three small hexagons containing the letters A E G. The sign shall be used alone or in combination with numbers, letters, words, typographical symbols, ornaments, borders or other accessories in all colors and sizes, reproduced by hand or by mechanical means, on the goods, business papers, wrappers and the like.[166]

This was the kind of concession artists had to make in order for art to gain its "citizenship," to embed artists' form in the economy and to allow them to continue producing the kind of work that was their specialty: the signs of individuality. For in their function of distinguishing one business's goods from those of another, trademarks were precisely signs of individuality of a kind that were needed by the capitalist economy of Germany around 1900. Section one of the law defines the purpose of the trademark as the distinction of the goods of one business from those of another; they served as the replacement for the name of the producer, a stand-in for the proper noun. Indeed, Arnold Seligsohn, author of one of the more substantial pre-war commentaries on the law, derives the justification for trademark law from the modern legal status of the individual:

> The legal basis of trademark law is the right to privacy [*das Recht der Persönlichkeit*]. This right stipulates above all the recognition of a person in his individuality, in his uniqueness. The need to distinguish [subjects] is met in civil law by right to and requirement of a name, in commercial law by the regulations concerning businesses. Beside these rights, trademark law appears as an equal, similarly aimed at the individualizing of a person, namely the producer or distributor of a commodity.[167]

The definition of the trademark was one way the modern bourgeois subject was written into the law (and it is significant in this regard that trademark law did not derive from Roman law). The appeal to the trademark as a sign of distinction is a symptom of the modernity of the individualists in contrast to the ideology of the "norm-givers" which skirted the present, wavering shakily between pre- and postcapitalist tendencies.

Like the individualist forms of Jugendstil, the trademark could be deployed as ornament; Rhenius interprets the law as allowing its use as "decoration" on the commodities for which it was to do the business work of distinction.[168] Occasionally the trademark was used in this way. The AEG hexagon was the only applied ornament on the Turbine Factory (of course no consumer commodity), which dispensed even with the classical orders; Behrens's clock faces also bore only the logo beyond the necessary marks and pointers. But there were times when the trademark went beyond its polite differentiation of types and took over the appearance of a commodity or its publicity material.

91. Behrens's hexagon trademark for the AEG as it appears in the *Warenzeichenblatt*, the monthly listing of all new entries into the trademark registry, showing the classes of products which the trademark could be used to advertise

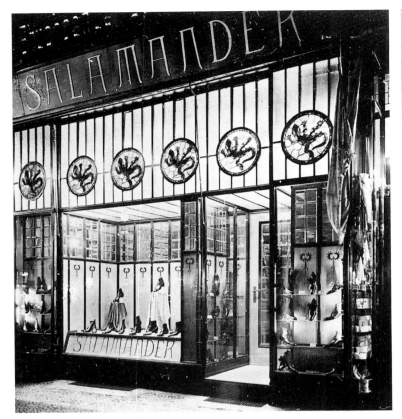

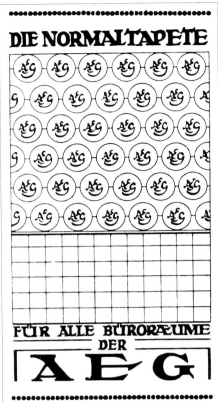

92. August Endell, storefront and retail showroom for the Salamander shoe store, Potsdamer Strasse, Berlin, ca. 1910 (Bildarchiv Foto Marburg)

93. From the *Bierzeitung*, published by the Verein der Beamten der AEG und BEW, 1907

Bernhard's M-trademark for Manoli cigarettes is the only decoration on the package; the Salamander trademark in stained glass took over the frieze above the shopwindow in August Endell's shoe store on the Potsdamer Strasse (fig. 92); this was certainly another glowing magical sign Osthaus would have had in mind. Even if this was not all that widespread a phenomenon at the time, it was common enough to joke about. One anonymous prankster at the AEG turned an early Behrens trademark into a wallpaper pattern (fig. 93); and Joe Loe let Salamander's trademark mascot mimic the swinging curves of the Jugendstil as it climbed society curtains (fig. 94). And if the trademark was not legally a work of art, works of art could nonetheless be trademarks. When the plans for the *Deutsches Warenbuch* were being developed by the Dürerbund, Ferdinand Avenarius took the precaution of registering Dürer's self-portrait, placing it in a circular frame and reducing it to a graphic, black-and-white image resembling a woodcut (fig. 95). Similarly, the AEG incorporated a dramatic corner perspective of one of its factories (not by Behrens) in a registered mark for electric clocks and measuring instruments (fig. 96).

The trademark was clearly becoming a valuable sort of ornament around the turn of the century. If visual form was to be owned and exploited, one of the most effective strategies was to turn it into a trademark. We should not overemphasize the revealing overlap of the trademark with both ornament and the work of art, but it is clear that ornament was adapting to new conditions under which form could enhance the exchange value of commodities. These conditions were perhaps better articulated by trademark law and its definition of commodity signs than they were by copyright law, which directed

Hallo Bob!
Jch kann heute nicht zum Tango Tee kommen
ich muß um **4 Uhr** nach der
Tauentzienstr. Ecke Marburgerstr. Das

Salamander

Schuhgeschäft wird nach vollendetem
Erweiterungsbau wiedereröffnet
Das muß man sehen!
Es soll ja ganz großartig sein.

94. Joe Loe, newspaper
advertisement for the
Salamander shoe store,
1913/14 (*Seidels Reklame 2*
[1914])

95. Trademark registered in
1913 by the Gemeinnützige
Betriebsstelle deutscher
Qualitätsarbeit, founded by
the Dürerbund, after a self-
portrait by Albrecht Dürer
(Deutsches Patentamt,
Warenzeichenblatt)

96. Trademark registered in
1909 by the AEG (Deutsches
Patentamt, *Warenzeichen-
blatt*)

producers to the free signs of the Western tradition. Occasionally borrowing
works of art or taking on the role of ornament, the trademark responded to an
economy in which the exchange value of many commodities was closely tied
to their ability to assert difference by their visual form, conditions under which
form had to look out to the market and not back to production.

This last matter was not only the core of the individualist position but was
also the very heart of the law's definition of the trademark. To avoid
encroaching on the legislated realm of free, non-commodity signs, the trade-
mark had to avoid all references to common denominators. The law forbade
not only the use of general, at times traditional or typical forms of commodi-
ties, but also all references to the "method, time or place of manufacture; to
the characteristics of the commodity; to the function [*Bestimmung*] of the

97. Bruno Paul, trademark
for the Vereinigte Werk-
stätten, ca. 1908, based on
a color lithograph poster
of 1904 by Paul for the
Vereinigte Werkstätten
(F.H. Ehmcke, *Wahrzeichen,
Warenzeichen*, 1921)

98. Peter Behrens, trademark
for the Insel-Verlag, ca. 1903
(F.H. Ehmcke, *Wahrzeichen,
Warenzeichen*, 1921)

commodity; to price, quantity and weight of the commodity."[169] The result
was described by Finger as the "tendency to designate goods . . . [by] single
words which are either freely invented (fantasy words in the narrow sense) or
which, even while belonging to the common vocabulary, *stand in no relation
to the commodity or its particularity through the meaning of the word*."[170]
The model of the trademark was the previously meaningless pictorial sign or
the nonsense word, the likes of *Maggi, Kodak, Lysol, Rolex, Aspirin*, or *Odol*.
Now these words need not be entirely meaningless: *Maggi* has a certain unde-
niable magic, *Rolex* a Latinate and regal ring. Similarly, Bruno Paul's trade-
mark for the Vereinigte Werkstätten is a parable of quasi-socialist teamwork
(fig. 97), while Behrens's mark for the publisher Insel-Verlag is an allegory of
the autonomy and insularity of the literary art (fig. 98). And many trademarks
were mythical references, and thus words or pictures with meanings – mean-
ings, however, that said precious little about the products they adorned. So
when it came to the actual way trademarks were being used, friends of the
type such as Hugo Hillig, writing in Werkbund member Johannes
Buschmann's *Welt des Kaufmanns*, had their problems with the presence of so
many individuals on the market:

> Imagine a farmer's wife comes to town to buy herself a washing machine.
> She finds nothing that is simply called a washing machine, but she will sure-
> ly be shown a *Heureka*, a *Schonia*, a *Weltwunder*, a *Hausfrauenstolz*. If she
> buys a sewing machine, she'll make the acquaintance of a *Viktoria*, a
> *Saxonia*, a *Germania* and a few other personalities of this kind – and all she
> wanted to buy was a good sewing machine. . . . In no other country is the
> trademark situation so bad as it is in Germany and Austria, and the for-
> eigner who observes this will come to the conclusion that the name must
> inflate the quality here, that *quality is replaced by the name*.[171]

As far as the patent office was concerned, the criteria of the trademark was
that it be "arbitrarily chosen and formed," and that it make an "immediate,
individual impression."[172] The commodity sign was, ideally, a "fantasy sign"
with as little real-life reference as possible to the commodity it named.

Put another way, the commodity sign could not be *sachlich*. Not, in any case, in the sense in which Muthesius used the term, the usage that has become authoritative. A sign that could be owned could not refer to quality, production, or to traditional or technical form in any but the most mediated way. Since the indexical signs that Muthesius defines in terms of reference to production were not unique, they were limited in their exchange value in the eyes of the trademark law, off-limits as individual market signs. Function too was off-limits. Listen to the way one critic responded to the actual market appearance of light bulbs, cheap and unglamorous but a product of the latest technology, perhaps the perfect modern type: "There have been so very many newspaper advertisements for electric light bulbs recently (such as the AEG bulbs, *Osram* bulbs, *Wolfram* bulbs, *Tantal* bulbs, etc.). But to my knowledge . . . in none of these cases is even the slightest attempt made to explain the advantages of the bulb in question."[173] Since signs that could be owned depended on fantasy, there developed a tendency for quality and function to drop out of the signifying circuit of commodity exchange as it was developing in Germany around 1900.

In creating the realm of commodity signs, the law dictated an arbitrary relation between the production or function of the commodity on the one side and its market designation on the other. The law created a new class of signs seemingly separate from those of the actual, material functioning of the economy. But while this class of signs was separate from production in terms of reference, it was inextricably linked to it, drawing a new and totally unrelated picture of the world of commodities for the consumer and then exerting its influence back upon it. Isolated from the actual semantic functioning of the infrastructure but tied to it, supporting it, and feeding energies into it, these commodity signs were in no way a set of signs without referents, but they were a set of signs without reference *in production*. In defining a semantic distance from production, the law separated – deceptively – references into base and superstructure. Trademark law gave a certain fallacious legal necessity to the phantasmagoria of commodities in the marketplace; it was one more way commodity fetishization was written into the law. And in terms of the Werkbund debate, the law sundered production signs from commercial signs, the crux of the battle raging there about the way form functioned in a capitalist economy. At this level, Osthaus and the individualists were certainly right about the trademark: as much as it could bring the consumer closer to production in terms of economic functions, it drove a final semantic wedge between them. The law isolated the commodity sign from production, put a frame around it that lent it its aura and magic; it displaced the signs accompanying commodities into a semantically distinct and seemingly autonomous market that could look, to some, like Culture.

But let us take two steps backwards. First, the trademark with its metaphysical subtleties is only one – and not necessarily the most fundamental – principle of the way commodities signify under conditions of modernity. And second, the individualists did not spend all of their time designing trademarks and their accessories, let alone in a systematic or programmatic way. But there is no doubt that the artists knew, in a rough way, the terms of the law and the way it defined the function of form on the market.[174] This puts their talk of individuality, magical signs and mystical atmosphere in a context that lets us see it as both sensible and even sophisticated (if a bit disingenuous). I think it is safe to say that the trademark law provided them with a model, at the very least with a sense, of the way visual form now functioned. By providing one

extremely up-to-date example of the way the relation between form and the commodity *could* be negotiated, it gave insight into the way that relation was in fact developing.

Specifically, trademark law placed the economic use of visual form firmly and finally in the realm of advertising; it sketched a picture in which it was the moment of sales and not production or use (defined in the simplest way as function) that would be decisive in terms of commodity form. It pushed the use of form into the space of commerce while leaving production, narrowly considered, unartistic and even invisible. It defined the space of commodity exchange as an autonomous field of representations. And by stipulating that signs doing commercial work not be rooted by references to production, the trademark law confirmed that the radical rupture Werkbund members had identified in modern culture – that between the production and consumption of goods – could not be bridged over. It affirmed Osthaus's view that this rupture would have to be accepted, and that Culture would have to be remade or redefined, not merely reconnected.

The trademark had other capers too, perhaps not so theological but probably just as important to the artists. For trademark law defined the modern subject and the modern conditions of visuality in ways that precisely echoed the individualists' own understanding of these matters. First, the law was to regulate the way signs function as marks of distinction "*im Verkehr*" – in commerce:

> §20. The application of the terms of this law is not diminished by alterations made to other names, firms, signs, coats of arms and other commodity designations to the extent that there is, despite this alteration, a risk of confusion in commerce.[175]

At issue was not only whether a sign encroached into the non-commodified realm of free signs but whether it impinged on the legal rights of another business by coming close to its sign, whether it could confuse or mislead a consumer as to the origin of a certain product. These legal grounds for turning down a sign were termed "*Verwechselungsgefahr*," the risk of confusion. This led the courts to all manner of formal analysis worthy of the art or literary critic (and usually far more concise). And when it came to testing a sign against the risk of confusion "in commerce," the subject interpellated by the law was the *consumer*:

> Commerce is divided into circles whose interpretations can differ: manufacturers, distributors, wholesalers, retailers, consumers. Manufacturers . . . are removed from the use of signs. . . . Distributors and wholesalers buy from specific manufacturers and attach little value to the mark as a sign of origin. . . . It is the *retailer and consumer* whose understanding is of concern, for in these circles the mark has a value as a sign of origin.[176]

In defining the visual subject as the consumer, the law mirrors the cultural subject as defined in the discourse on Culture.

The law further echoed the terms of cultural criticism by specifying the visual subject as the *alienated* consumer:

> To be considered are chiefly the *retail consumers* who customarily buy according to the brand. Whoever uses other criteria or who inspects the commodity itself is not to be taken into account. A less educated *average buyer* is to be assumed, that is to say one who is not especially knowledgeable or attentive but who is nonetheless – concerning the effect of the sign on the

eye, ear, and imagination – neither near-sighted, nor hard of hearing, nor simple-minded, and who approaches the commodity with the care typical of the usual buyers of the commodity and with the awareness that he is facing a distinguishing mark.[177]

The law assumed a subject whose understanding of commodities develops in isolation from their production.

And finally, the law defined the visual subject as rushed, probably urban and suffering from sensory overload, precisely as critics discussed the subject suffering from *Reizsamkeit*, the chaos of the visual field of commerce, the conditions of Impressionism. When determining the legality of a trademark, the courts bore in mind that the subject of trademark law could no longer see details: "It is certainly appropriate – and the courts have recognized this in practice – that the consumer does not inspect a label closely *in the haste of commerce* [*bei der Eile des Verkehrs*], that the pictures or words do not make a sharp impression on his memory."[178] Therefore the trademark had to adapt not to traditional aesthetic principles but to this modern mode of vision: "Whether the joining of the parts [of a trademark] create a unified image is immaterial. But the entire composite sign must be *visible at one glance*."[179] Aside from the uncontrolled commodification of signs, the quick vision of the consumer was the preeminent fact of the visual field over which the law sought to assert control. Commodity signs had to be "figural or verbal signs that are freely chosen, in their entire extent immediately perceptible and visible at one glance."[180] In the words of another commentator, "As a rule, a fleeting glance is enough to apprehend and recognize" a trademark.[181] According to Richard Hamann, Werkbund member and author of a widely-read study of Impressionism, art under modern conditions of visuality responded in precisely the same way as the trademark at the same time as it recreated, in permanent form, this hasty vision:

> Modern ornament is planar ornament. . . . It consists of planar patterns that can only be perceived when the whole is seen at a single glance. . . . This vision with *one* glance is also brought to bear on paintings. To capture the first impression in all its fleetingness and unrecognizability, to bring to canvas indirect vision's lack of clarity . . . is an Impressionist ambition. Again the name is justified: the mere impression; the subjective picture existing as a sensory perception shall also exist in the objective picture instead of being corrected by memory to correspond to what we call reality or the objectively perceptible. The eye shall, if possible from a distance, not focus on a specific object [but rather] survey the entire picture. . . . Careful inspection does not offer new perceptions, as in nature. . . . To catch with a single glance, but not to question.[182]

Hamann describes Impressionist vision the way the law defined commercial or consumer vision. Here he could well be discussing the visual conditions of the trademark, and in a way, of course, he was.

※ ※ ※

The importance of the Impressionist viewer in the discussions of the Werkbund can not be overestimated: he is the alienated visual subject who, bombarded by the excesses of modern urban life, sees moving fashions instead of a stable Style. He was the threatened cultural subject as defined by an educated male bourgeoisie at the beginning of the century. From time to time he

came to the surface of these discussions, and when he did, he would race through the city like a Futurist, in a speeding car. For example in Behrens's 1910 speech on "Kunst und Technik" (Art and Technics), which we have looked at before for its definition of Style:

> Our age has been seized by a haste that leaves no time for absorption in details. When we race at high speed through the metropolis, we can no longer see the details of the buildings. Just as the images of the city seen from an express train passing by at high speed can only have an impact through their silhouettes. Individual buildings no longer speak for themselves. Such a way of seeing our environment has already become a habit for us, and the only architecture that corresponds to it is one that is as closed as possible, with tranquil, flush planes offering no obstacles. When any particular feature is to be emphasized, it should be placed as a goal of the direction in which we are moving. An articulation of large planes, a surveyable contrast of prominent features and expansive planes or an even sequence of necessary details creating unity – these are necessary.[183]

By the time Behrens gave his talk, the Impressionist viewer was a well-known figure in cultural criticism, and for advertisers too he was a standard, a known quantity, a regular customer. Advertisers referred regularly to more mundane urban versions of Marinetti's debauch of gasoline, dust and sweat: the cover of one professional journal (fig. 100) shows the consumer hurtling through Berlin on an omnibus, the skewed perspective making the front wheels seem to bear down on the viewer, texts and landmarks blurred (only the name of the journal remains clear in this over-didactic example). Yet Behrens's response to modern haste in 1913 was still to intervene and preserve the equilibrium of the threatened senses. We recognize in his lecture the key terms employed by norm-givers in their attempt to bring the modern visual environment under control: tranquility, surveyability, unity. Impressionism – the chaos of commerce, capitalism and Fashion – was to be counteracted. So it is not surprising that when he turned in his discussion from architecture to the design of everyday goods, Behrens suggested the type:

> The same approach that has just been described as decisive for architecture applies also to smaller objects produced by industry. . . . [This will be achieved] when all imitation of craft forms and of the historical styles is avoided, and when their opposite – the exact execution of machine manufacture – is used and artistically expressed. Thus genuineness will be emphasized in every way; above all those forms will be artistically used and developed which emerge as it were directly from the machine and mass production and which are appropriate to it. Thus it is a matter of achieving types for particular products, cleanly constructed and true to materials.[184]

Behrens defines the type precisely as we have in the last chapter: it would be stripped of excess ornament, made impersonal, and bear only the signs of its production. Production Style would replace Fashion; free signs emerging from the technical process would replace the kind of commodity signs the norm-givers most abhorred.

The trademark, we know, could be and was interpreted along these lines – as a visual force bringing chaos under control – and it was precisely Behrens's AEG logo that was most often invoked. Now this was most definitely *not* what Osthaus meant when he alluded to it as a "magical sign," but it was magic nonetheless. Listen to the way Worringer described "primitive" abstrac-

tion – a concept he often paired with the epithet "crystalline" – at the first Kongress für Ästhetik und allgemeine Kunstwissenschaft, held in Berlin in 1913. We can borrow it not only as a revealing analogue to Behrens's architectural aesthetic but as a description of the hexagonal signet:

> *In the form* of this early geometric ornament, not only in its symbolic content . . . lies that secret power for which I choose the perhaps too pronounced expression "magic." The simplest aboriginal signs with their sensuously neutral character, projected onto an equally neutral plane, isolated from every immediate life context, in their linear rigidity full of the feeling of tranquility and necessity: they are simultaneously linear conjuring formulae with which the primitive exorcises . . . his fears; conjuring formulae with which he protects himself and that which he holds dear from the arbitrariness of the demons. These forms have for him the appearance of the absolute in a world of relatives; they belong in their form, not only their content, to the sphere of protective magic.[185]

Behrens, we saw in chapter one, was thinking about impersonality and transcendence on the market, and he was using Worringer's terms to do so (though perhaps mediated by Simmel). And as it turns out Worringer was writing about Behrens – in particular, his Turbine Factory crowned by the trademark – as a representative of the *Stilkunst* which expresses the conflict of *modern* man who, like the "primitive," is "tired of his individualism" but who lacks "the power to achieve again transcendence [*Allgemeingültigkeit*]."[186] This is no surprise: Style versus Fashion, abstraction versus empathy, and transcendence versus chaos were the mainstays of the discussions on art in Germany around 1910, encompassing the areas of both Expressionist and design aesthetics.

We are thus left again with two interpretations of the trademark, two kinds of magic. This is symptomatic, for Behrens, then as now the model of the Werkbund artist, incorporates in his work the issues, tensions, uncertainties and debates of the organization.[187] This made him, even at the time, exemplary but also vulnerable. Behrens himself found this out at the same conference at which Worringer spoke. There he presented his by then standard (not to say canned) speech on Style, on Riegl, on impersonality and technical form. It is a pity we do not know who was in the audience, but the registration list for the conference includes not only many familiar Werkbund figures but also the likes of Karl Lamprecht, Aby Warburg, the young Erwin Panofsky and Georg Simmel. His audience was intellectually agile and they put him on the spot, identifying precisely a major tension in orthodox Werkbund aesthetics.

The problems raced in with the Impressionist viewer in the speeding car and crashed straight into the stable surfaces Behrens had prepared for him. Professor Oskar Wulff of Berlin opened the question session:

> I wouldn't see any truly significant impulse for architectural form in the haste of modern life, so strongly emphasized by the speaker and based on the reference to automobile traffic. . . . But concerning the [architectural] exterior I would like to ask where Herr Behrens would stand with regard to the demand that it should express the interior and its function. There is an ambiguity with regard to this point which I find disturbs the aesthetic enjoyment of one of the most beautiful new buildings in Berlin. The west wing of the Wertheim [department store] building on Leipziger Platz, completely medieval in style, hardly lets us assume the busyness and nervousness [*Unruhe*] of a department store behind its stern, ceremonious architec-

99. Peter Behrens, unrealized project for Tietz department store, Düsseldorf, 1906 (Fritz Hoeber, *Peter Behrens*)

ture. Even if this dissonance only depends on the associative factor of an aesthetic judgement, it still seems to me that the demand that function be expressed in architecture cannot be completely dismissed.[188]

Wulff took haste to be less the velocity of the automobile than the feverish activity of modern commerce, and he pointed to the site of exchange as an example of this "nervousness." Did the harmony of a static, unified Style misrepresent the energies of modern life? Was it not this discrepancy that clashed, undermining the unity of spirit and form?

Victor Basch, eminent professor of aesthetics at the Sorbonne, kept the heat on Behrens. His question is so subversive that it too should be savored in nearly its full length.

What struck me particularly in [Behrens's] address is the following: he says that every art which fulfills its function should embody the prevailing tendencies of the age in which it lives and works. Now Professor Behrens quite rightly points to feverish haste as the signature of our age, the excessively fast life which is documented by electric streetcars, automobiles and sailing ships. *It follows naturally that architecture should incarnate this fever, this haste through some appropriate technical means.*

When we race through the streets of our metropolis at high speed, we can no longer see the details of the buildings. Thus it seems to me that the most modern architecture should be adapted to the cinematographic character of our age. Now I ask Professor Behrens how it follows that precisely the most modern architecture in Germany should scorn this desire? The character of this architecture contradicts the demands made by Professor Behrens; [it expresses] the heavy and not the light, the massive and not the gracious, the eternal and not the fleeting, the monumental and not the silhouette. I have viewed the new buildings in Berlin with the greatest astonishment, but in Cologne I was truly dismayed when I saw department stores in the strict, somber style of Egyptian mausoleums, crowned with archaic statues, towering eternally in the sky, alien to our world and age. *Department stores which should embody the speed of commerce, of exchange, the pouring in of materials from all the countries of the world, and above all the rapid changes of Fashion – and mausoleums!*[189]

100. H. Skala, cover of
Seidels Reklame, April 1913

Basch was calling the entire basis of Behrens's design aesthetic into question, pointing to a fallacy in the definition of Style as simultaneously a reflection of the spirit of the day and a force that would create a cosy Culture for an alienated modern man. Basch's question would have been all the more embarrassing for Behrens in terms of his architectural practice: he too had submitted designs for a major department store (for Tietz in Düsseldorf), and the word "mausoleum" describes its classical orders and reliefs and its heavy, horizontal symmetry only too well (fig. 99). Behrens must have gathered what remained of what Scheffler called his "senatorial" dignity and replied shortly that "haste must be understood as only one part of our environment."[190] Two days later he led congress participants on a tour of his factory buildings; we do not know who followed or what transpired.

Much to his credit, Behrens, it seems, reconsidered the problem of Impres-

sionism, economy and culture soon after the collision of views at the 1913 congress. In an article published in the 1914 *Jahrbuch*, he takes on these views directly and recognizes the possibility of a different kind of cultural intervention as well as suggesting an interpretation of his own work that diverges from his 1910 call for types (and we have seen that Behrens's work supports differing interpretations). Thematizing the issue of modern urban visuality, he called his article "Einfluss von Zeit- und Raumausnutzung auf moderne Formentwicklung" (The Influence of Time and Space Use on the Development of Modern Form). Here he lets form partake of movement instead of counteracting it: "The use of space and time can be construed in their effect as the rhythmic principle in design [*Formgestaltung*]," he writes. "Rhythm is actually a measure of time, a measure of movement. But it seems justified to borrow this term for the visual arts if one is inclined to understand them not as rigid but as something living, organic."[191] The issue of haste comes up in a different way, as a matter of spirit not to be reduced to a material pathology:

> "Nothing is more common than haste." And yet we all hurry. The reason for this can not be explained materially. . . . Haste is determined by the rhythm of our age and is psychic in origin. It is the foundation of our creative work, but it has not yet been mastered by art as a cultural form. It is still immature like the parvenu, and we are not yet finished with it: we have not yet found the refined form of life for the necessary way we live.[192]

Haste appears as a potentially positive force, if one not yet mastered. Behrens then proceeds explicitly to turn his back on the widespread desire to tame modern energies in the name of Style: "Such an elemental and general quality of our age can not be fought by romantic considerations that preach tranquility."[193] He follows this logic, which leads him to the heart of the issue, to the decadent but pulsating realm of commodity exchange:

> It is futile to find fault with glaring posters, but a cultural advance to order the screaming colors and bizarre lines harmoniously. It is philistine to scorn the swift changes in Fashion, but wise to recognize and enjoy the economic utility of the joy in change. The new age, which has swept away the charm and atmosphere of dreamy cosiness, presents new tasks for art which will find a great, unified fulfillment when we recognize the rhythmic beauty of our time.[194]

Thus Behrens concludes his article. Quite suddenly, market energies are accepted as a motor for Style, and the chaos of the commercial realm is to be harnessed as a progressive power. Behrens put an end to the disciplinary rhetoric with which he had surrounded his own work. The biggest change: there is room for Fashion in Culture. Behrens had become, or become again, an Impressionist.

There were other Impressionists in the Werkbund, and they led a meager, second-class existence; they were the friends of Osthaus, and every public role they were given in the organization had to be fought for bitterly. Former Impressionists and Jugendstil artists flocked to Hagen: van de Velde, Bosselt, Endell, Behrens, Lauweriks. There many found customers for their architectural services as well as work in commercial ventures. The attacks on Impressionism and Jugendstil that were regularly issued from some quarters of the Werkbund were not directed entirely against a common external enemy, as was so politely implied; and they foreshadow, in reverse, the counterattack of the individualists in Cologne. The individualists too believed in the spiritual

transcendence and unity of Culture, but their Culture was not the disciplinary visual regime advocated by the supporters of *Typisierung*.

August Endell, for one, made no bones about his frustration with certain strains of romantic anticapitalism which he saw as a total negation of modernity. At the beginning of his book *Die Schönheit der grossen Stadt* (The Beauty of the Metropolis) of 1908, he took on, from within, the standard varieties of *Kulturkritik*: the complaints against the age, the retreat from the present, the return to nature, the flight into art, the flight into the past, and the rejection of haste too: "It is considered self-evident to disparage the present: our age is painted as degenerate, nervous, over-hurried; the speed of the automobile is naively equated with the speed of life."[195] For Endell had found other forms of unity in modernity, hidden but fundamental, forms that were, like trademarks, often abstract but which channeled modern economic life in closed circular paths that encompassed all:

> Perhaps . . . technical constructions are not the most magnificent creations contained within the economic life [*Arbeitsleben*] of a city. Since so many people live together, thousands of ordering organizations are necessarily created. Just as bees, between the thick swarm of their hot bodies, unintentionally produce the miracle of the six-sided cell, so all these remarkable structures arise within the tightly-packed population of a city, forms that order commerce, social life, mutual dependence. It would be a tempting task to portray how necessity compels man to order his relationships, and what beauty lies in this order. Even the organization of larger businesses, their structure, construction, working process, accounting, control systems are remarkable enough. One could compare them to crystal forms, so pure and clean, so consistent and transparent is their form.[196]

Endell raises movement from a pathological condition of perception to a principle of urban life, and its most visible manifestation, Fashion, to an affirmation of modernity. Fashion, he writes, is almost the only creation of the age that lives and moves. "The pedants who consider Fashion folly, who consider it meaningless precisely because of its transience, are guilty of a sin against life. For Fashion is only a symbol for life itself – life which is fleeting, changing, lavish, which always spreads its gifts without anxiously calculating whether the expenditure is proportionate to the result."[197] The references to Fashion are an unmistakable invocation of the semiotic energies of capitalism, which was after all inscribed in the notion of Style not only negatively, as a foil, but also positively, as the carrier of a Style to come. Few in the Werkbund could bring themselves to utter the word in this way: Endell and Behrens are, to my knowledge, the only members of the Werkbund to put the changes of fashion in a positive light. But their pictures of change and movement on the model of modern commerce are fully in line with the Osthaus group's unequivocal location of Culture there. For Endell, this is the realm of a "hidden beauty which does not speak to the senses, which is only accessible to those who use their imagination and intellectual fantasy to follow empathically these economic structures [*Arbeitsgebilden*]."[198] The rapid circulation of goods, services, money and people describes a new hermeneutic circle, a bit hazy and atmospheric but one which traces circular paths that are, in the end, Culture, their elements Style. Understanding this would "give our culture unity, connection in labor, enthusiasm and inspiration for common achievement."[199]

The individualists – former Impressionists, the core of the Osthaus-van de

Velde opposition in Cologne – defined form under capitalism as a moving target; they conceived of it in circulation. The energy carrying it, which they equated with that of the market and the sphere of commodity exchange, was the motor of Style. They looked at form the way the law looked at the trademark: as a sign that circulated on the market; as a sign that evoked and created realms of modern imagination no longer grounded in production; as an individual sign that could, as such, borrow the energy of the commodity; as a sign that was abstract, pared-down, perhaps minimal not in order to tame the modern economy but rather to be able to function effectively within the visual conditions it presented. The individualists sought not to stop the flow of representations but to articulate it and use it as an artist's medium. Anything else, Behrens realized, would be philistine.

* * *

When in July of 1914 the issues we have examined here came to a head, Walter Benjamin was about to celebrate his twenty-second birthday. He was a university student and well versed in the intricacies of the discourse on Culture and the reform movement in the arts. How else to explain the following paragraph, which he later wrote to appear in a book on Baudelaire?

> Taste develops with the definite preponderance of commodity production over any other kind of production. As a consequence of the manufacture of products as commodities for the market, people become less and less aware of the conditions of their production – not only of the social conditions in the form of exploitation, but of the technical conditions as well. The consumer, who is more or less expert when he gives an order to an artisan . . . is not usually knowledgeable when he appears as a buyer. Added to this is the fact that mass production, which aims at turning out inexpensive commodities, must be bent upon disguising bad quality. In most cases it is actually in its interest that the buyer have little expertise. The more industry progresses, the more perfect are the imitations which it throws on the market. . . . In a speech about trademarks Chaptal said on 17 July 1824: "Do not tell me that in the final analysis a shopper will know about the different qualities of a material. No, gentlemen, a consumer is no judge of them; he will go only by the appearance of the commodity. . . ." In the same measure as the expertness of a customer declines, the importance of his taste increases – both for him and for the manufacturer. For the consumer it has the value of a more or less elaborate masking of his lack of expertness. Its value to the manufacturer is a fresh stimulus to consumption.[200]

Benjamin takes up here the same elements of modernity the members of the Werkbund found crucial: commodity production, alienated consumption, surrogates, Fashion, trademarks. Benjamin did not write this, however, with the intention of making a point about the trademark commodity. Rather the reverse: he wanted to make a point about high art. With its lack of reference to the reality of production and its free-floating address to the consumer, the commodity created the conditions for an autonomous, modernist art: "In *l'art pour l'art* the poet for the first time faces language the way the buyer faces the commodity on the open market. He has lost his familiarity with the process of its production to a particularly high degree."[201] Unlike the allies of Osthaus, Benjamin probably did not know the law, yet his analysis of Baudelaire and Mallarmé led him to a similar equation of the work of art and the commodity that needs a trademark. Osthaus took the work of art as a given and sought to

let the alienated commodity borrow it magic. Benjamin describes instead the work of art itself as alienated under capitalism, and bearing the scars of commodification. The modern constellation they sketched, however, was the very same one.

But following Osthaus and calling the commodity "art" does not say much, though the isolated, even alienated origin of form points to a fundamental relation that developed under capitalist modernity. Conflating the visible realm of the commodity more or less as they found it with that of Culture and calling its appearance Style says a bit more. The individualists were not alone in finding the congruence of commodity circulation and culture a compelling fact. Georg Simmel, another "Impressionist" in the eyes of many, said something similar in his 1900 *Philosophy of Money* (which he revised in 1907):

> The exchange of the products of labour, or of any other possessions, is obviously one of the purest and most primitive forms of human socialization; not in the sense that "society" already existed and then brought about acts of exchange but, on the contrary, that exchange is one of the functions that creates an inner bond between men – a society, in place of a mere collection of individuals. . . . It is, therefore, almost a tautology to say that exchange brings about socialization: for exchange is a form of socialization. It is one of those relations through which a number of individuals becomes a social group, and "society" is identical with the sum total of these relations.[202]

Simmel accepts the modern money economy as a given and identifies it as the preeminent space of social intercourse under the conditions he describes. It is an alienating field that nonetheless binds subjects together; paradoxically, commodity exchange is a mediating force which simultaneously separates and unites. This ambivalence runs through all of Simmel's writings on culture; it allowed him to assert the possibility of Culture as well as to diagnose its tragedy; it made him at the same time a critic and an apologist. Despite his intricate philosophical prose, Simmel was the poet of laissez-faire.

A trifle less concerned with the fate of the subject under modernity, a bit more interested in their livelihood and that of their friends, the artists around van de Velde and Osthaus were inclined to be a bit more optimistic. They had made some important discoveries. They realized that form under capitalism could not be disciplined, and that any attempt to do so would fail – and hurt them, the artists, in the process. But they also knew that form was not out of control, even if they would choose to make some strategic interventions by artistic, economic and legal means. By rejecting a productivist perspective which did not serve their interests, they came to the conclusion that visual form in modernity did indeed have a logic; and even if this logic dictated an attenuated, essentially abstract relation to a social totality, it was not free-floating. The visible forms of everyday life participated in and followed the circulation of commodities, and therefore Style would be found at the site where this circulation assumed visible form for the bourgeois cultural subject, the consumer. In their hands, Style came to be more a locus than a specific formal prescription (though there were occasional elements of this as well). To the desire for unified form that had become implicated in a disciplinary notion of culture that threatened the artist, they responded with a functional notion of Style as a visual space that already existed and was created by the circulation of commodities. Style was, for better or worse, form in its function as a commodity; it tended, irreversibly, toward the individuation of form and the era-

sure of production. These were the insights of the individualists, and they are not insignificant.

With the trademark, the cultural distance between production and consumption was recognized, accepted, and written into law. The law showed how form in the economy – working in concert with the commodity, to a certain extent *as* a commodity – could function on the basis of this lack or rift, building another world of representations that hovered above the economy, pouring energy into the daily grind of production, distribution, exchange and consumption while rendering it invisible. The trademark fetishized. As such it partook of the same shift of registers from production to consumption that represents the key strategy producing Culture as a discursive fact and as a notion of totality. The farewell the individualists bid to production as a source of totality was not without a sense of loss, and they knew full well that the products of labor were being fetishized. In fact they not only understood and analyzed this state of affairs but sought to carry it one step further. For if through the idea of Culture the relations of production could be transcended, the view into the shopwindow allowed the individualists to find such a space within the economy itself. It did not bother them that this was just a trick done with mirrors and lights, for it suited their purposes. Others at the time were thinking about the very same issues: Georg Lukács, for example, emerging from seminars with the sociologists, also focused on commodity fetishization as a central cultural fact of modernity, ultimately extrapolating it into the scenario of reification. In the Werkbund opposition, the same state of affairs was simply given a different interpretation. The frame that excluded production created works of art. The realm of fetishized signs could look like Culture, and with a little work, reification could once again be called transcendence.

Epilogue

A decade after the Cologne debate, two younger members of the first Werk-bund generation – Walter Gropius and Bruno Taut – were the leading lights of the organization. Two decades after the founding, Mies van der Rohe, Gropius's fellow student in the office of Peter Behrens, opened the Weissenhof Siedlung, an extraordinary exhibition of experimental housing near Stuttgart which he had organized and which represents perhaps the height of the Werkbund's post-war influence. No one argued any more over *Typisierung* in this influential core of the architectural avant-garde: by general consent, the mass-produced type was considered the goal of design activity. And with the strategic placement of members of this avant-garde in academies and local governments, the heirs of the *Kunstgewerbebewegung*, despite the opposition they faced, seemed well positioned to pursue the Werkbund's original goal of putting artists in charge of the economic machinery producing the objects and environments of everyday life.

Yet though we can trace a linear history with relative ease in terms of per-sonnel and morphology, a huge gulf separates the theory and practice of 1927 from that of 1907. Even when the words remained the same, the battles in which they served as weapons were different, and the kinds of knowledge expressed through these words before the First World War were no longer found to be useful after it.

Take Style. It was, we know, what was supposed to unite "architecture, and with it the whole area of the Werkbund's activities," as Muthesius said in his first thesis in the 1914 debate; "from the sofa cushion to city planning," as the phrase went. And in his "Principles of Bauhaus Production" of 1926, Gropius describes, it seems, the very same cultural sphere: "The Bauhaus wants to serve in the development of present-day housing, from the simplest household appliances to the finished dwelling."[1] But Gropius no longer used the concept of Style to describe the common principle that would give these objects their form. The everyday commodity no longer served as a carrier of spirit, but would instead "fulfill its function usefully, be durable, economical, and 'beautiful.'"[2] "Beauty" is as close as Gropius got to spirit or style, and he distances himself from it with his inverted commas.

Lip service was still paid to style, however. In *Der moderne Zweckbau* of 1923, Adolf Behne, a Werkbund member from before the war, quotes a con-temporary artist saying that "Style is the expression of the communal will of many, ideally of all, [it is] democracy of the creative will."[3] But why is the artist Behne chooses to quote Kurt Schwitters, the "*Merz*-artist" who traf-

ficked in the discarded, the out-of-date, the used-up emotions of yesteryear? Was he the only person not embarrassed to tell us what Style was, once something so true it was never too tedious to repeat? Certainly not. But Behne was, I think, trying to tell us something more than the old cliché. Maybe it had something to do with the the title of the article from which Behne quotes: it was called, in warning, "Watch Your Step!"[4] Style was still spoken about, but without the pathos, without the "utopian, desperate" cry Scheffler wrote of. Spirit was no longer a common currency that could circulate like a commodity. Its stock was low after the Great War with its final showdown between Culture and Civilization. As a word it was like ready money: here today, gone tomorrow, in the end worth nothing more than the paper on which it was printed.

What was lost in the afterlife of Style as a discursive remnant was the complex and mediated (if ultimately inadequate) way in which it allowed the relation between economy and culture to be grasped. And while the cycles of fashion did not slow during the 1920s, Fashion as a category, as a way of talking about the cultural voice of capital, was no longer placed in counterpoint to the language of spirit. Gropius still wrote about architecture as having "forfeited its status as a unifying art" and reflecting "an uprooted world which has lost the common will necessary for correlated effort."[5] But, breaking the old mold, he does not point to capital as the cause of the problem. Instead, he chooses a flimsier opponent, one he could more safely take on: the academy. And when an article on Fashion – "The 'Modern' as a Commercial Commodity" – appeared in the Werkbund's new journal, *Die Form*, it too is characterized by a strange distancing maneuver: it was a translation of an essay by an American critic, Lewis Mumford.[6]

Even the bright side of the economy, the trademark, lost its luster. Johannes Molzahn, artist and friend of the Bauhaus, wrote in *Die Form* as follows, using a completely new set of criteria and metaphors to describe an old object of concern:

> The trade-mark is . . . the link between *production* and *consumption*. No organisation can exist and expand for long unless it uses such a device as a token to represent it. If that is the purpose of the emblem, then it must do it without a lot of written backing, building exclusively on optical means, i.e. those means which in the briefest period of time produce the best and most profound impression . . . [on] the psyche. The significance of the emblem is absolute, its shape is determined purely according to optical mechanical laws; the function determines the form just as it does in the machine, is only the result of perfect construction in the sense of the greatest possible efficiency.[7]

Instead of serving as a "magical sign" of a "new bourgeois enterprising spirit," the commodity sign is now discussed as an "advertising mechanism" in the disenchanted terms of the physical sciences.

And perhaps most surprising, more surprising even than the fact that former "individualists" were now leading the quest for types, is that there was no longer any confusion over the meaning of the word. It could now be contained within a simple definition: "*Typisierung* means agreeing on certain forms for doors, windows, hardware, room sizes, installations, plans, and finally entire buildings; 'norms' mean quantifying these types. [Types and norms] are a self-evident result of machine production."[8] This definition, like scores of others like it, sparked no debate. Now this new clarity did not develop because mistakes had been corrected or misunderstandings cleared up, but because the

meaning of this word, or the set of meanings within which it was used, had changed. The confusion that erupted in 1914 was an important part of the debate, and for the term to settle into a simple meaning, it had to do so within a different set of parameters; it had to stop reverberating between shifting registers; it had to stop being a term by which very different and occasionally conflicting positions were to be negotiated and resolved. In other words, it was no longer a word that could refer to a spiritualized economy, for such an economy had ceased to exist.

It is not hard to understand why the economy did not seem cultural in a lofty, transcendent way in the 1920s, for it no longer functioned with the material steadiness usually necessary for spiritual meditation. The economy was in a shambles. In the midst of war, revolution, and inflation, the bringing together of machinery, raw materials, capital and labor was often an insurmountable task. Cultural corollaries had less importance than the problem of making the economy work at all. As revolution reared its ugly head, the brute forces of production that earlier seemed so desperately in need of aestheticization now seemed to many to be the only ones strong enough to give society a working foundation. With the exception of a small revolutionary minority, soon routed, Germany capitulated to capitalism as offering the best chances for order and the closest approximation to the pre-war status quo that they could find. Whatever the artists and architects of the 1920s thought of this, by 1923 it was a *fait accompli*.

So there was a mood change: the *"Neue" Sachlichkeit* wanted nothing to do with the piety and pathos of the old one, and the economy no longer had its deeply moral glow. But there is another reason for the difference in meanings, valences and functions attached to certain words, one that mediated and is related to the great historical events of the time but which must be grasped separately: that the system of institutions and discourses within which these concepts assumed their pivotal functions in both theory and practice was no longer intact. Before the war, cultural initiatives and reformist projects emerged from a set of voluntary organizations of which the Werkbund is a good example; they were usually bourgeois and addressed the concerns of this wealthy but politically ambiguous class. Culture served them as a field of operations as well as a way of representing the world they experienced and over which they hoped to achieve hegemony. Businesses were attracted by the commitment of their owners, by political interests and by market opportunities. Artists were attracted by their simultaneous search for higher meaning and gainful employment. And bodies of knowledge such as sociology and political economy were put to use or called into being to mediate between these concerns. Outside of such a system, the outpouring of confusion and alarm, scholarly analyses and reform programs of which the Werkbund was a part would be unthinkable, as would its project to explain and influence the development of culture under modernity.

Thus the peculiarly pre-war alliance, for example, of Walter Gropius, whose deeply felt cultural concerns and no less deeply felt professional needs led him to the Werkbund, and his patron Carl Benscheidt, a self-made man whose calculus must have been different but who found that Werkbund artists could help him. By 1919, however, Gropius was no longer a free agent in the field of Culture. He was a bureaucrat. He may have had the same ambitions, but his field of practice was very different. As head of an art academy, his interests were, first of all, pedagogical. And since the academy was publicly funded, his requests, arguments and justifications were often pitched to a par-

liamentary audience and concerned matters of budgets and accountability; and these were politicized in a very different and considerably less polite way. In his architectural work for the trade unions, Bruno Taut too became somewhat of a bureaucrat; and with the huge scale of the housing estates he built for Berlin in the 1920s, he became something of the "artistic dictator" he had called for in the 1914 debate. The term fits his Frankfurt colleague Ernst May even better. As director of all municipal construction, he was able to give entire suburbs their radically *Neues Bauen* stamp. In this context the economy ceased to be construed as a sphere of conflicting cultural energies, of utopias and dystopias; as the exposed underbelly of a nearly bankrupt society, it was looked at in terms of efficiency and means-ends rationality, of poverty and property. Even the objects of the artists' attention – homes, furniture, and the like – were now subject to different forces. Many of the commodities they were dealing with no longer had to sell themselves in quite the same way: especially in the area of housing, the economy was one characterized by scarcity, and in such a market the shopwindow no longer needed quite the same subtleties and charms.

Certainly some sectors of the artists' former markets lived on and spoke the same language as before, that of Culture; and the consumer market, the one that feigned abundance, grew dramatically in economic and visual importance. These are, however, not the tendencies that set the tone for the discourse that grew up around the objects of everyday use and their form after World War I. I do not mean to imply that the discourse of architecture and design was any poorer in Weimar than in Wilhelmine Germany: in many ways it was in fact more active, vital, and engaged. But what I want to suggest is, first, that rather than seeing the 1907–14 period as a prelude to the 1920s, we must recognize the deep ruptures that separate pre- and post-war theory; and second, that this deep cleft was due to the fact that the professionals of culture, economics and art who came together in the first Werkbund generation did not meet in the same way, inflecting each other's debates, either in the post-war Werkbund or in any other organization or forum.[9] Bodies of knowledge were coming together in new configurations. So while we see theories of art and design, of the city, of new modes of subjectivity, and of the specificities and potentials of new media, we no longer see particularly well developed theories of the nature of form under capitalism, of the relation of culture and economy. For those we must look elsewhere.

My argument in this book has been that the aesthetic discussions of the Werkbund, which included and commanded the attention of figures far beyond the architectural community, were an important part of the first sustained and often sophisticated discussions of the nature of culture in a consumer-oriented capitalist economy – in other words, the first discussions of mass culture. Here too we are accustomed to dating the origins of mass culture theory in Germany to the 1920s and 1930s, to the work of figures such as Walter Benjamin, Bertolt Brecht, Siegfried Kracauer and Theodor Adorno. To be sure, the increased tempo of the economic and political instrumentalization of the leisure industries altered the scope of the problem and increased the urgency of its analysis.[10] But when the Weimar and post-Weimar thinkers about mass culture searched for analytical tools with which to approach the problem, many reached directly back to concepts developed in the pre-war discourse on Culture, concepts developed during their own youth to address the phenomena they had themselves experienced. They did not accept these concepts uncritically or leave them unchanged. Yet neither the consumer culture

of the twenties and thirties nor the theories which sought to account for it grew out of thin air. The economic and the intellectual ground for both developments was fertile. Thus we find many points of contact with the pre-war applied arts movement in the work of Ernst Bloch and Georg Lukács – no surprise in light of their intellectual apprenticeships under Georg Simmel and Max Weber, publishing connections with the likes of Karl Scheffler and even social encounters with Friedrich Naumann.[11] But here I would like to look briefly at just a few of the arguments and themes addressed by Adorno and Benjamin to suggest how fundamental the pre-World War I discussions occurring in and around the Werkbund were to the influential body of thought on the problem of mass culture which is loosely termed the Frankfurt School.

It is in particular Adorno and Horkheimer's notion of the "culture industry" as developed in the chapter of that name in *Dialectic of Enlightenment* that represents to this day one of the most important statements of the problem. The chapter is subtitled "Enlightenment as Mass Deception." Using examples culled mainly from the film, radio and magazines of the thirties, Horkheimer and Adorno discuss the social effects as well as stylistic characteristics of the standardized products of the entertainment industry, cultural items manufactured and distributed as commodities, solely on the basis of exchange value. Through the entertainment industry, they write, taste is manipulated in ways that reveal the totalitarian tendencies of all capitalist systems.

The culture industry thesis is well known. What is interesting here is not the thesis itself but rather the way the discussion remains framed in the romantic anticapitalist terms of the earlier, pre-war discussions of culture under capitalism. The familiar dichotomous categories of chaos versus unity, Culture versus Civilization, and most important Style versus Fashion are the coordinates within which Adorno and Horkheimer construct their argument. Even as the very first line of the chapter states their rejection of the fundamental assumption of *Kulturkritik*, it signals that the terms of this discourse will be central to their argument. Their starting point is the cultural despair we recognize well, but now Adorno and Horkheimer have a response to it: "The sociological conviction that the loss of the support of objective religion, the dissolution of the last precapitalist residues, technical and social differentiation and specialization have led to cultural chaos is disproved every day. Culture today stamps everything with the same mark."[12] If the "unity of all production" is the criterion, Adorno and Horkheimer assert, Culture is overwhelmingly in evidence under advanced capitalism.[13]

A few pages into the chapter Adorno and Horkheimer narrow their focus to the categories of the pre-war applied arts reformers and reply similarly that the despair is misguided: "The complaints of the art historians and the advocates of Culture over the extinction of a Style-creating force in the West are horribly unfounded."[14] One thinks here of the likes of Wölfflin, who wrote in a spirit of resignation that "this uprooting of style dates only from our own century and we have really no longer any right to talk of styles, but only of fashions"; one recalls the tacit agreement but the optimistic turn of Gropius, writing in the Werkbund *Jahrbuch* of the "Style-forming value of industrial building forms."[15] But the concerns were unwarranted: the lack of Style was a myth, for the forms of the cultural goods which were being produced for the mass market in fact "surpass the rigor and authority of true Style, the concept with which the educated idealize the precapitalist past as 'organic.'"[16] Adorno and Horkheimer present a paradox: they find the "new Style" precisely in the kitsch of the culture industry usually considered "Fashion," for despite the

"permanent pressure to produce new effects," these goods nonetheless "remain bound to old patterns."[17] Rehearsing the clichés of the critique of Fashion, they describe the realm of the mass market as one characterized by rapid change; but rather than revealing any inconstancy of spirit, Fashion merely veils the iron consistency of the social system it serves: "What is new in the phase of mass culture compared to late liberalism is the elimination of the new. The machine rotates on the same spot. . . . [Novelty] is served by tempo and change. Nothing can remain as it was; everything must be in perpetual motion. For only the universal triumph of the rhythm of mechanical production and reproduction ensures that nothing changes, that nothing emerges that does not fit in."[18] Change serves only "the reproduction of the always-the-same."[19] It is this constancy of change and its paradoxical complicity with the absolute permanence of the relations of production that Adorno and Horkheimer seek to demonstrate, and which they choose, revealingly, to characterize as Style. But while the "new Style" of the culture industry is only a "caricature" of the Style longed for by cultural critics, it nonetheless reveals an historical truth of styles in general: "The concept of true Style is transparently revealed by the culture industry as the aesthetic equivalent of domination. The conception of Style as mere aesthetic consistency is a romantic fantasy projected on the past. In the unity of Style . . . various structures of social power are expressed, not the obscure experience of the dominated."[20] The totality of Culture is quite simply that of domination.

This is not the place to subject Adorno and Horkheimer's text to a more extensive analysis in light of pre-war debates, or to summon other texts, especially by Adorno (who examined these issues repeatedly, both before and after *Dialectic of Enlightenment*) on culture under capitalism.[21] Nor is it possible here to trace in detail other correspondences between the Werkbund discussion and the theory of the culture industry such as Adorno and Horkheimer's related economic analysis, their remarks on magic and the trademark, and their consideration of the artful creation of the aura under conditions of production and reception that would seem to render it obsolete. But it should nonetheless be clear that the culture industry chapter responds to the earlier theories of Fashion and represents, to a certain extent, an extension of them. In particular it echoes Sombart's discernment of the "unification of demand" behind the shifting surfaces of everyday commodities.[22] At the same time it presents a theory of Style defined dialectically in relation to Fashion. Style, write Adorno and Horkheimer, wears a changing face, while Fashion is timeless, hiding the always-the-same. Culture under capitalism reveals another side of the dialectic of Enlightenment in which the irrational is rationalized and the rational in turn takes the mask of the irrational as an alibi. Adorno and Horkheimer's text is perhaps the final attempt to define a modern Style, just as it is both a replay of and a final, ironic reply to the turn-of-the-century critiques of Fashion.

The culture industry chapter reveals one of Adorno's favorite modes of argumentation: the breaking down of a false opposition. The collapsed distinction between Style and Fashion is the fulcrum of Adorno and Horkheimer's argument, and the dialectical juxtaposition of the two provides the motor of what would otherwise be a somewhat static argument. In a way, the text represents as much the end of a debate originating at the beginning of the century as the beginning of the analysis of a more recent cultural phenomenon. A contemporary reading of the culture industry chapter depends, I think, on a recognition of the historical source of its core, not only of the phenemona it

describes. For to take the notion of the culture industry out of the context of the Style/Fashion dialectic is to miss the irony that makes of every seemingly uninflected, monolithic statement a minor explosion meant to overturn a very particular way of thinking, one still going strong when the book was published – that of *Kulturkritik*. Considered in isolation, the idea of the culture industry allows the old notion of Fashion to be removed from its intimate relation with a (finally bankrupt) notion of Style and to be hypostatized. The result is a "straight" reading of a text that must, however, like all of Adorno's and Horkheimer's, be read dialectically. (Perhaps its influence is due to the very fact that it *can* be [mis]read "straight," producing a seemingly static, closed, sometimes surprisingly simple argument.)

If Adorno and Horkheimer adopted the terms of the turn-of-the-century German debate and projected them forward to characterize later developments, I would like to suggest that Walter Benjamin was doing much the reverse in his Arcades Project: he projected these terms backwards in time to the manifestations of mid-nineteenth-century French *modernité*. His readings of Baudelaire and Grandville in particular rely heavily on the early German discussions of mass culture. Recall the fragment on "Taste" where Benjamin writes of the "social experiences reflected in [Baudelaire's] work" as precisely those defined in the post-1900 discussions of Impressionism: "the experiences of the neurasthenic, of the big-city dweller, and of the consumer."[23] We looked earlier at the way Benjamin raised, one by one, the themes of the applied arts movement in this text: the alienation of consumption, the changing function of form under commodity production (its reception as "taste," its production as Fashion), and the importance of the trademark. The concerns of the pre-war Werkbund were not peripheral to Benjamin's work. In the text on taste he discusses alienated consumption as the social background to the emergence of a hermetic modernism in poetry, and the trademark provides him, in fact, with the very model for his discussion of the cultural conditions of signification under modernity. "It is precisely this development," he writes, having outlined the way the consumer confronts the brand-name commodity, "which literature reflects in 'l'art pour l'art.'"[24]

For Benjamin, *l'art pour l'art* is the result, like alienated consumption, of an estranged relationship of signs and experiences to a totality, the breakdown of a unified field of meanings in the world. To translate into applied arts discourse: it is the loss of Style. The mode of signification in such a world is characterized by Benjamin as allegory, in which meaning can only be wrested from fragments, isolated splinters of a lost whole. In his dissertation on "The Origins of German Tragic Drama (*Trauerspiel*)" Benjamin writes that these fragments were once the residues of classical mythology; in modernity, however, they are nothing other than the banal products of the mass market: "The emblems" – in which the strained relation of pieces of the world to cosmic meaning is expressed in seventeenth-century *Trauerspiel* – "return as commodities."[25] In searching to express meaning in an age of commodity production, Baudelaire is an allegorist; and in defining him as such, Benjamin builds on the romantic anticapitalist analysis of the fallen state of signification under capitalism.

In asserting the radical disjuncture between the social *reality* of capitalist production and the social *appearance* of the commodity, Benjamin remains in the realm of Marxist orthodoxy, equating the estrangement of meaning with the commodity's alienation from production represented by exchange value. But his interests go beyond the Marxist critique and draw sustenance from the

discourse on Culture, with its analysis of the consumer's experience and his reception of the fetishized commodity. Indeed, in Benjamin's notes for the Arcades Project all the bases of the Werkbund discussion are covered: beyond the issues raised in the fragment on "Taste," one encounters the frame, the shopwindow, and the glow of the commodity. And for Benjamin too the category of Fashion – "the ritual by which the fetish Commodity wished to be worshipped" – is central.[26]

Like Adorno and Horkheimer (who adopt similar formulations), Benjamin describes Fashion as "the eternal recurrence of the new."[27] But in Historicism's repetition of archaic forms and in Fashion's "enthronement of the commodity" in the consumer market, Benjamin finds much more than manipulation; he shares what he describes as the caricaturist Grandville's "ambivalence between [the commodity's] utopian and its cynical element."[28] The utopian element he located in the commodity is very similar to the one inspiring the work of the Werkbund, whether one took it as Fashion (as did Benjamin) or tried instead to discipline it into Style. Yet for Benjamin the distinction was just as irrelevant as for Adorno. Consider the important passage on utopias in the 1935 exposé for the Arcades Project. This paragraph is fundamental to Benjamin's thought in many ways, but it is also, I would like to suggest, yet another repetition of and response to the terms of *Kulturkritik*, and it is one more statement of a dialectic between Style and Fashion. But the fulcrum on which this dialectic turns is not, as with Adorno and Horkheimer, the dystopia of Style as domination, but instead the utopia of Style as the image of an integrated social totality. Benjamin begins with a characterization of the contradiction of industrial Historicism, of the late nineteenth-century fashions: "To the form of the new means of production, which to begin with is still dominated by the old (Marx), there correspond images in the collective consciousness in which the new and the old are intermingled."[29] He proceeds, however, to describe Fashion as the attempt to transcend by visual means the contradictory relations of production, the attempt that went in the Werkbund by the name of Style: "These images are wish-images [*Wunschbilder*], and in them the collective seeks not only to transfigure, but also to transcend, the immaturity of the social product and the deficiencies of the social order of production."[30] In the passage that follows, the argument turns again twice, each time repeating the juxtaposition of the novelty of modern fashions with its counterpart in a retrospective longing for Style.

> In these wish-images there also emerges a vigorous aspiration to break with what is out-dated – which means, however, with the most recent past. These tendencies turn the fantasy, which gains its initial stimulus from the new, back upon the primal past. In the dream in which every epoch sees in images the epoch which is to succeed it, the latter appears coupled with elements of prehistory – that is to say of a classless society. The experiences of this society, which have their store-place in the collective unconscious, interact with the new to give birth to the utopias which leave their traces in a thousand configurations of life, from permanent buildings to ephemeral fashions.[31]

Benjamin's project was to release the utopian energies held captive in the commodity even as it served the interests of capital.

It is of course Baudelaire's fascination with fashions that is Benjamin's starting point, but it is revealing that the chief sources for his theoretical reflections are almost entirely German, and that he recognized how his interest put

him in the position of continuing a tradition.[32] And while Adorno and Horkheimer seem to echo the pre-war accounts that are best exemplified by Sombart and which saw Fashion as simple market manipulation, Benjamin draws instead on those accounts which stressed the way the forms of Fashion were put to use by consumers: the writings of F.T. Vischer and, especially, Georg Simmel.[33] In the latter's text on Fashion – which Benjamin read carefully and excerpted extensively in his notes for the Arcades Project – the earlier philosopher explored how the fashions which appeared on the market could serve the purposes of sociation in ways producers could not necessarily count on. While industry (to accept, advisedly, this generalization) produced signs of distinction, Simmel points out how these inevitably figure in systems of social identification.[34] Even if these forms of signification did not ultimately challenge the prevailing class structure (though they could occasionally blur the distinctions) Simmel's point can serve as the basis of an important critique of the usual notions of Fashion – and of Werkbund cultural theory as well. It is a critique Benjamin noted and made central to his argument. The point is this: that the signifying potential of the commodity does not end in the realm of commerce, with the manipulable dialogue between seller and buyer. In the Werkbund and in most theories of Fashion, the signifying potential of the commodity was attached to its exchange value. Even if cultural advantages could be found in this connection and reform projects predicated upon it, this subordinated signification to the capitalist production and exchange of goods. With his interest in "the 'outmoded,' in the first iron constructions, the first factory buildings, the earliest photos, the objects that have begun to become extinct, grand pianos, the dresses of five years ago,"[35] Benjamin points out how the connection between signification and exchange value breaks down beyond the sphere of commodity exchange, how signs could have a use value outside of the market, and perhaps a revolutionary one at that: as an explosive revelation of the changing face of eternal recurrence that could subvert the ongoing process of commodity fetishization. Benjamin points out a fundamental weakness not only in the notion of the culture industry but also in both understandings of form under capitalism that appeared in the Werkbund: the refusal to consider the function of representations, even commodified representations, in social praxis beyond the economic nexus of the market. For the signs sold on the market could have a long life after their first exchange; once bought, commodity signs could, at least in theory, be liberated. Perhaps it was Simmel's reflections on Fashion which prompted Benjamin's cryptic remark to Adorno, who had belittled the earlier philosopher: "You look askance at Simmel: might it not be time to respect him as one of the ancestors of cultural bolshevism?"[36]

Both Adorno and Benjamin collapsed the distinction between Style and Fashion, but in their differing analyses of mass culture (a central issue in the documents which have been collated and dubbed "the Benjamin-Adorno dispute") the issue that divided the Werkbund into standardizers and individualists was still very much alive. The debates were played out at very different levels, but both pinpointed the issue of identifying the primary force to which form under capitalism responds – whether to the dictates of production or to the complex field of signification that was the consumer market. Adorno and Horkheimer's equation of Style with domination was a point which Muthesius and Scheffler, for example, were fully aware of. The compromise with the economic powers that be was a price the friends of the type were willing to pay for Culture. The unmistakable authoritarian voice of production that Adorno

discerned in the din of the consumer market and which he critiqued as *Kulturindustrie* was seen to have a very different potential before World War I when it was called *Industriekultur*. Nor was this alliance with the forces of production inherently reactionary. Benjamin himself saw in it "the constructive, dictatorial side of the revolution"; the alliance had his sympathy.[37] In the 1920s the dream of production as the locus of Culture attracted many followers, who recognized it by various trademarks of the kind Le Corbusier was so fond of using: *Citrohan*, *Dom-ino*, *Voisin*.

But like the Werkbund individualists, Benjamin realized that the commodity would speak the languages of the market, of a semi-autonomous realm that left the signs of production (though not its relations) far behind. The artists around Karl Ernst Osthaus and Henry van de Velde identified the sphere of exchange as a uniquely modern cultural space, one that was entropic and centrifugal but one which could therefore (or so they thought) offer the artist a certain amount of creative freedom. The Werkbund opposition had a vested interest in this freedom, but not in the clutter and disorder they too often spotted in modern commerce. After the collapse of the precarious social balance of the pre-war period, a new group of artists explored the freedom offered by the consumer marketplace. But this group had a different agenda: they began systematically to cultivate the market's potential for chaos. They found another way of manipulating trademarks: "The poetry of the Surrealists," writes Benjamin, "treats words like company names, and their texts are in principle brochures for enterprises that are not yet established. Nestled in these company names are the fantasies once thought to be hoarded in the vocabulary of 'poetic' diction."[38] In Germany the brand names were *Dada* and *Merz*. As much as Le Corbusier and the Bauhaus, these artists too – the Dadaists and Surrealists – were the legitimate heirs of Cologne 1914.

Notes

NOTES TO THE INTRODUCTION

1. Max Scheler, "Die Zukunft des Kapitalismus" (1914), in *Vom Umsturz der Werte: Abhandlungen und Aufsätze, Gesammelte Werke*, vol. 3 (Bern: Francke, 1972), p. 382 (emphasis in original). Unless otherwise indicated, all translations are my own.

2. Quoted in E.H. Gombrich, *Aby Warburg: Eine intellektuelle Biographie*, trans. M. Fienbork (Frankfurt: Suhrkamp, 1984), p. 167.

3. The slogan derives from the title of a lecture given by Gropius during the "Bauhauswoche" in Weimar, August 1923.

4. One index of the weakness of the kind of theory exemplified by the Bauhaus is certainly the ferocity with which revenge has been taken in recent decades by – or rather in the name of – one excluded party: the consumer.

5. Nikolaus Pevsner, *Pioneers of Modern Design: From William Morris to Walter Gropius*, rev. ed. (Harmondsworth: Penguin, 1975); originally published as *Pioneers of the Modern Movement* in 1936.

6. Sigfried Giedion, *Space, Time and Architecture: The Growth of a New Tradition*, 5th ed. (Cambridge: Harvard University Press, 1967), p. 493.

7. Even the most scrupulous historians regularly conflate van de Velde's position in the Werkbund debate with his work and judge them both on the same terms. For example Reyner Banham: "Henry van de Velde's polemic against Muthesius at the 1914 Congress still left the question in the form 'Type or Individuality' and should be regarded, like his elegant theatre at the Werkbund exhibition in Cologne that year, as a spirited rearguard action by an outgoing type of designer." *Theory and Design in the First Machine Age*, 2nd ed. (Cambridge: MIT Press, 1981), p.78.

8. "The steel frame is clearly exhibited; wide, perfectly spaced glass panes replace the walls on the side and in the middle of the ends; and if the corners are still expressed by heavy stone [sic] with banded rustications and rounded at the angles, the metal frame projecting its sharp corners above these stone pylons redresses the balance boldly and effectively. . . . Here for the first time the imaginative possibilities of industrial architecture were visualized." Pevsner, *Pioneers of Modern Design*, pp.203–4.

9. Banham still considered the Glass House under the rubric of the "Factory Aesthetic"; *Theory and Design in the First Machine Age*, p.81. Only with the rehabilitation of architectural Expressionism could the Glass House begin to make sense in other contexts; see, for example, Wolfgang Pehnt, *Expressionist Architecture*, trans. J.A. Underwood and E. Küstner (London: Thames and Hudson, 1973), pp.75–6. The Glass House will be discussed in chap.III below.

10. Pevsner, *Pioneers of Modern Design*, p.38.

11. Steel beams are used in the floors of the main building, but the piers are made of brick. The building is, in Banham's words, "[b]y American standards of early 1914 . . . a rather old-fashioned brick-pier construction." *A Concrete Atlantis: U.S. Industrial Building and European Modern Architecture* (Cambridge: MIT Press, 1986), p.186. On the construction of the Fagus-Werk, see Helmut Weber, *Walter Gropius und das Faguswerk* (Munich: Callwey, 1961).

12. Georg Lukács, "Reification and the Consciousness of the Proletariat," in *History and Class Consciousness: Studies in Marxist Dialectics*, trans. R. Livingstone (Cambridge: MIT Press, 1983; original German 1923).

13. Ibid., p.83.

14. Both Riegl and Simmel were born in 1858. Though the work of Thorstein Veblen (born 1857) is beyond the space, though not the time, of this study, the reader may find profit in keeping the American sociologist's *Theory of the Leisure Class* (1899) in the back of his or her mind.

15. Guy Debord, *Society of the Spectacle* (Detroit: Black and Red, 1977; original French 1967).

16. *Le Système des objets* (Paris: Denoel-Gonthier, 1968); *La Société de consommation* (Paris: Gallimard, 1970); *For a Critique of the Political Economy of the Sign*, trans. C. Levin (St. Louis: Telos Press, 1981; original French 1972); *The Mirror of Production*, trans. M. Poster (St. Louis: Telos Press, 1975; original French 1973). See also the selections translated in Baudrillard, *Selected Writings*, ed. M. Poster (Stanford: Stanford University Press, 1988).

17. The work of historicizing the spectacle is more advanced in studies of Britain, France and the United States, where it appeared earlier than in Germany. See in particular T.J. Clark, *The Painting of Modern Life: Paris in the Art of Manet and his Followers* (New York: Knopf, 1984); Thomas Richards, *The Commodity Culture of Victorian England: Advertising and Spectacle, 1851–1914* (Standford: Stanford University Press, 1990); and Jonathan Crary, *Techniques of the Observer: On Vision and Modernity in the Nineteenth Century* (Cambridge: MIT Press, 1990), a convincing Foudauldian archaeology of the spectacle. On the issue of the dating of the spectacle, see Crary, "Spectacle, Attention, Counter-Memory," *October* 50 (Fall 1989): 97–107.

18. The standard history of the Werkbund is Joan Campbell, *The German Werkbund: The Politics of Reform in the*

Applied Arts (Princeton: Princeton University Press, 1978). For the early period in particular, see also Kurt Junghanns, *Der Deutsche Werkbund: Sein erstes Jahrzehnt* (Berlin: Henschel, 1982). The early history of the Werkbund is a central theme of Julius Posener's indispensable account of the architecture of the period, *Berlin auf dem Wege zu einer neuen Architektur: Das Zeitalter Wilhelms II.* (Munich: Prestel, 1979). John Heskett's survey *Design in Germany, 1870-1918* (London: Trefoil, 1986) provides an introduction to the subject in a larger historical context. Finally, Angelika Thiekötter has provided the most detailed and reliable reconstructions of the institutional history of the organization. See in particular her contributions to *Die Deutsche Werkbund-Ausstellung Cöln 1914* (Cologne: Kölnischer Kunstverein, 1984) and *Hermann Muthesius im Werkbund-Archiv*, exh. cat. (Berlin: Werkbund-Archiv, 1990).

19. I should add, however, that my intention is not to write social, economic or legal history, all of which would have to address very different matters. And furthermore, that theories of design were not the only products of the discourses examined here. Political projects – domestic antisocialism and imperialist expansion abroad – also availed themselves of the arguments and vocabulary I discuss. Such projects are not highlighted in the chapters that follow, though they occasionally come to the fore. They are also well documented in other accounts of the Werkbund that will be cited.

NOTES TO CHAPTER I

1. Fachverband für die wirtschaftlichen Interessen des Kunstgewerbes, *Der "Deutsche Werkbund" und seine Ausstellung Köln 1914: Eine Sammlung von Reden und Kritiken vor und nach der "Tat"* (Berlin: Fachverband, 1915), p.8.
2. Fritz Schumacher, "Die Wiedereroberung harmonischer Kultur," address at the founding meeting of the Werkbund, Munich, 5 October 1907, published in *Der Kunstwart* 21, no. 8 (1908): 135–8, here p.138.
3. The best account of this aspect of the *Geisteswissenschaften* is still Fritz K. Ringer, *The Decline of the German Mandarins: The German Academic Community, 1890–1933* (Cambridge: Harvard University Press, 1969); see also the more general typology of Romanticism in Robert Sayre and Michael Löwy, "Figures of Romantic Anti-Capitalism," *New German Critique*, no. 32 (Spring–Summer 1984): 42–92; and Georg Iggers, *The German Conception of History: The National Tradition of Historical Thought from Herder to the Present*, rev. ed. (Middletown, Conn.: Wesleyan University Press, 1983). On the Romantic artist, see Raymond Williams's classic study *Culture and Society: 1780–1950* (New York: Columbia University Press, 1983), pp.30–48.
4. Ferdinand Tönnies, *Gemeinschaft und Gesellschaft: Grundbegriffe der reinen Soziologie* (Leipzig, 1887), translated as *Community and Society*, trans. Charles P. Loomis (East Lansing: Michigan State University Press, 1957).
5. Georg Lukács, 1962 preface to *Theory of the Novel*, trans. Anna Bostock (Cambridge: MIT Press, 1971; original German 1920), p.19.
6. For general discussions, see Richard Hamann and Jost Hermand, *Stilkunst um 1900*, Epochen Deutscher Kultur von 1870 bis zur Gegenwart, vol. 4 (Frankfurt: Fischer, 1977), pp.102–20; and Hans-Joachim Lieber, *Kulturkritik und Lebensphilosophie: Studien zur Philosophie der Jahrhundertwende* (Darmstadt: Wissenschaftliche Buchgesellschaft, 1974). The classic studies in English are still important though problematic in their insistence on a

teleology from turn-of-the-century cultural criticism to National Socialist ideology; see Fritz Stern, *The Politics of Cultural Despair: A Study in the Rise of the Germanic Ideology* (Berkeley and Los Angeles: University of California Press, 1961); and George L. Mosse, *The Crisis of German Ideology: Intellectual Origins of the Third Reich* (New York: Grosset & Dunlap, 1964). Norbert Elias also discusses the distinction between *Kultur* and *Zivilisation* in *Über den Prozess der Zivilisation* (Basel: Haus zum Falken, 1939), 1:1–43.

7. Julius Posener writes that Muthesius "can be called the father of the Werkbund." *Berlin auf dem Wege zu einer neuen Architektur: Das Zeitalter Wilhelms II.* (Munich: Prestel, 1979), p.14. Muthesius did not, however, himself found the Werkbund, as Reyner Banham writes in *Theory and Design in the First Machine Age*, 2nd ed. (Cambridge: MIT Press, 1981), p.69.
8. From a manuscript in the Nachlass Muthesius, Werkbund-Archiv, Berlin, marked by Muthesius "Unbenutzter Werkbundaufruf" (Unused Werkbund Proclamation), now repr. in *Hermann Muthesius im Werkbund-Archiv*, exh. cat. (Berlin: Werkbund-Archiv, 1990), pp. 52–7, here p. 53.
 Muthesius was unable to attend the founding meeting of the Werkbund because of his position in the Prussian Ministry of Trade and his superiors' desire to avoid the Ministry's further implication in the controversy surrounding the founding. On this controversy, the so-called "Muthesius Affair," see Angelika Thiekötter's contribution to *Hermann Muthesius im Werkbund-Archiv*, pp. 38-44, as well as Joan Campbell, *The German Werkbund: The Politics of Reform in the Applied Arts* (Princeton: Princeton University Press, 1978), pp. 12-16.
9. *Völkisch* ideology sought historical explanations, cultural self-understanding and political policy based on a belief in the mystical essence of the German *Volk*. On *völkisch* thought in Germany, see Mosse, *The Crisis of German Ideology*. On Langbehn's popular audience, his stance toward the academy and academics' toward him, see Ringer, *Decline of the German Mandarins*, pp. 137–8, 258.
10. Hermann Muthesius, "Wo stehen wir?" *Jahrbuch des deutschen Werkbundes* 1 (1912): 11–12. (The Werkbund yearbooks are hereafter cited as *JDW*.) On the contemporary critique of the Enlightenment, see Ringer, *The Decline of the German Mandarins*, pp. 83-90.
11. In *Figures of Architecture and Thought: German Architecture Culture, 1880–1920*, trans. Stephen Sartarelli (New York: Rizzoli, 1990), esp. chaps. 1 and 3, Francesco Dal Co discusses in a very insightful way the relationship between the cultural philosophy of the time and what we could call "Werkbund thought," and many of the themes I raise in this chapter echo those discussed by Dal Co. That this occurs in the course of a very different sort of argument from Dal Co's in no way diminishes my debt to his work. The main points of Dal Co's book are also summarized in his "The Remoteness of *die Moderne*," *Oppositions*, no. 22 (Fall 1980): 75-95. Also relevant to my discussion has been the important work of Massimo Cacciari, in dialogue with which Dal Co's work should be understood. See "The Dialectics of the Negative and the Metropolis" (1973), in Cacciari, *Architecture and Nihilism: On the Philosophy of Modern Architecture*, trans. Stephen Sartarelli (New Haven: Yale University Press, 1993), pp. 3–96. And for an interesting discussion of the Werkbund in the context of the middle-class reform movement, see Mark Jarzombek, "The *Kunstgewerbe*, the *Werkbund*, and the Aesthetics of Culture in the Wilhelmine Period," *Journal of the Society of Architectural Historians* 53, no. 1 (1994): 7–19.
12. On the role of the sociologists in the tradition of the

Geisteswissenschaften, see Ringer, *Decline of the German Mandarins*, passim. Other helpful accounts include the extended discussions of Tönnies, Simmel, Weber and Lukács in Harry Liebersohn, *Fate and Utopia in German Sociology, 1870–1923* (Cambridge: MIT Press, 1988); on Simmel, the work of David Frisby, esp. *Sociological Impressionism: A Reassessment of Georg Simmel's Social Theory* (London: Heinemann, 1981), and chap. 2 of *Fragments of Modernity: Theories of Modernity in the Work of Simmel, Kracauer and Benjamin* (Cambridge: MIT Press, 1986); on Tönnies and Sombart, Arthur Mitzman, *Sociology and Estrangement: Three Sociologists of Imperial Germany* (New York: Knopf, 1973), parts 2 and 3; on Max Weber, Lawrence A. Scaff, *Fleeing the Iron Cage: Culture, Politics and Modernity in the Thought of Max Weber* (Berkeley and Los Angeles: University of California Press, 1989).

13. Werner Sombart, *Kunstgewerbe und Kultur* (Berlin: Marquardt, 1908). This book was published in a series titled, equally symptomatically, *Die Kultur*.

14. There is to date no complete Werkbund bibliography, and I think that it is fair to say that one cannot be compiled. Muthesius, for example, published in over one hundred different journals. The aesthetic writings alone of Friedrich Naumann, liberal politician and energetic Werkbund member, comprise an entire volume of his collected works. And by 1914, the Werkbund had over 1800 members, a high proportion of whom published actively. The organization included a large number of journalists, publishers and editors-in-chief (Ferdinand Avenarius of *Der Kunstwart*, Robert Breuer of *Das Werkblatt*, Johannes Buschmann of *Die Welt des Kaufmanns*, for example, not to mention the editors of the more standard applied arts periodicals – *Deutsche Kunst und Dekoration*, *Dekorative Kunst*, *Innen-Dekoration*, and *Kunstgewerbeblatt*); each of these addressed issues involving the Werkbund in separate articles and editorial contributions. The numerous Werkbund publications and projects were also extensively covered or reviewed in the daily press and wide-circulation periodicals.

15. Muthesius, "Wo stehen wir?" p.17 (emphasis added).

16. Karl Ernst Osthaus, *Grundzüge der Stilentwicklung* (Hagen: Hagener Verlagsanstalt, 1918), p.6.

17. Karl Scheffler, *Die Architektur der Grossstadt* (Berlin: Bruno Cassirer, 1913), p.68.

18. Peter Behrens, "Kunst und Technik," lecture given to the Verband Deutscher Elektrotechniker, 26 May 1910; repr. in Tilmann Buddensieg, ed., *Industriekultur: Peter Behrens und die AEG* (Berlin: Gebr. Mann, 1979), p.D282. (This book has been translated as *Industriekultur: Peter Behrens and the AEG*, trans. I.B. Whyte [Cambridge: MIT Press, 1984]; unless otherwise indicated, references are to the original and translations are my own.)

19. Behrens, "Kunst und Technik," p.D279. A very general but helpful discussion of contemporary ideas of style appears in Hamann and Hermand, *Stilkunst um 1900*, pp.212–20. Hans-Georg Gadamer has relevant comments in an excursus on the concept of style in the humanist tradition in *Truth and Method* (New York: Crossroad, 1986), pp.449–52. Another interesting discussion appears in Georg Bollenbeck, "Stilinflation und Einheitsstil: Zur Funktion des Stilbegriffs in den Bemühungen um eine industrielle Ästhetik," in H.U. Gumbrecht and K.L. Pfeiffer, eds., *Stil: Geschichte und Funktionen eines kulturwissenschaftlichen Diskurselements* (Frankfurt: Suhrkamp, 1986), pp. 215–29. Bollenbeck's conclusion, however ("In [these] theoretical discussions, 'Style' is not used as a clearly delineated central concept, but rather as a sign that relieves [its users] from the burden of further precision" [p. 226]), is diametrically

opposed to the point I seek to develop here.

As is now customary in English discussions of Culture and Civilization, I shall capitalize words (such as Style) whose meanings and associations assumed a particular density, making them discursive protagonists above and beyond the everyday usage of today.

20. Hermann Muthesius, "Architektur und Publikum," *Die neue Rundschau* 18 (1907): 207. This image was also used by Gottfried Semper, to whom Muthesius probably refers. See Semper, *Science, Industry, and Art* (1852), trans. in Semper, *The Four Elements of Architecture and other Writings*, trans. H.F. Mallgrave and W. Herrmann (Cambridge: Cambridge University Press, 1989), p. 130. Only around the turn of the century, however, were the implications of such imagery fully explored.

21. Hermann Muthesius, *Stilarchitektur und Baukunst: Wandlungen der Architektur im neunzehnten Jahrhundert und ihr heutiger Standpunkt* (1902; 2nd ed. Mülheim-Ruhr: K. Schimmelpfeng, 1903), p.49 (emphasis added).

22. Osthaus, *Grundzüge der Stilentwicklung*, p.69.

23. [Julius Langbehn,] *Rembrandt als Erzieher*, 24th ed. (Leipzig: Hirschfeld, 1890), p.27.

24. Georg Simmel, *Philosophie des Geldes* (1900; 2nd ed. Leipzig: Duncker & Humblot, 1907); translated as *The Philosophy of Money*, trans. Tom Bottomore and David Frisby (London: Routledge & Kegan Paul, 1978), p. 462; references are to the English translation, which I occasionally modify slightly.

25. Ibid., pp.462–3 (emphasis in original). Of course, like the related image of the Tower of Babel, the metaphor of (true) Style as the mother tongue is older than the turn-of-the-century debates and was not confined to Germany. It figures prominently, for example, in the discussion of Michelangelo in Sir Joshua Reynolds's last Discourse of 1790; see *Discourses on Art*, ed. Robert Wark (New Haven and London: Yale University Press, 1975), p. 278.

26. Simmel, *Philosophy of Money*, p.463.

27. Friedrich Naumann, *Deutsche Gewerbekunst: Eine Arbeit über die Organisation des deutschen Werkbundes* (Berlin, 1908); repr. in Naumann, *Ästhetische Schriften*, *Werke*, vol. 6 (Cologne/Opladen: Westdeutscher Verlag, 1964), p.256.

28. Ibid.

29. "Monumentale Kunst und Industriebau," lecture held on 10 April 1911 at the Folkwang Museum, Hagen, manuscript, Bauhaus-Archiv, Berlin, Gropius-Sammlung 20/3. Repr. in Hartmut Probst and Christian Schädlich, eds., *Ausgewählte Schriften*, *Walter Gropius*, vol. 3 (Berlin: Verlag für Bauwesen, 1987), p.29 (hereafter cited as Gropius, *Ausgewählte Schriften*).

30. Behrens, "Kunst und Technik," p.D280; compare Alois Riegl, *Spätrömische Kunstindustrie* (1901; 2nd ed. Vienna: Österreichische Staatsdruckerei, 1927); translated as *Late Roman Art Industry*, trans. Rolf Winkes (Rome: Giorgio Brentschneider, 1985), p.9; Winkes's translation, as here, is cited by the English title.

31. Behrens, "Kunst und Technik," pp.D280–1; Riegl, *Late Roman Art Industry*, p.9. Tilmann Buddensieg has pointed out Behrens's citations from Riegl; see his "Riegl, Behrens, Rathenau," *Kunstchronik*, no. 23 (1970): 282–3; see also Stanford Anderson, "Behrens's Changing Concept," *Architectural Design* 39 (Feb. 1969): 77. Riegl was most likely brought to Behrens's attention by Wilhelm Niemeyer, an art historian brought by Behrens (on Muthesius's recommendation) in 1904 to the Düsseldorf *Kunstgewerbeschule*, of which Behrens was then director; and also by Fritz Hoeber, professor at the University of Strasbourg; see the latter's *Peter Behrens* (Munich: Müller & Rentsch, 1913),

pp.53, 114, 219.

On invocations of Riegl by Gropius, see Karin Wilhelm, *Walter Gropius, Industriearchitekt* (Braunschweig: Vieweg, 1983), pp.30–3; and Horst Claussen, *Walter Gropius: Grundzüge seines Denkens* (Hildesheim: Olms, 1986), pp.26–30.

32. Muthesius, "Die nationale Bedeutung der kunstgewerbliche Bewegung," in *Kunstgewerbe und Architektur* (Jena: Eugen Diederichs, 1907), p.125.
33. Riegl, *Late Roman Art Industry*, p.231.
34. Muthesius, *Stilarchitektur und Baukunst*, p.62. The title page of the first edition carries the date 1902, but the publisher's cover is imprinted with the date 1901, the same year in which Riegl's work appeared.
35. Riegl, *Late Roman Art Industry*, p.15.
36. The design reformers could have found the same point in the work of Heinrich Wölfflin. They apparently did not, but perhaps Riegl did; compare this passage from Wölfflin's "Prolegomena zu einer Psychologie der Architektur" (1886):

"That style-forms are not created arbitrarily by individuals, but out of the feeling of the *Volk* – that the individual can only achieve success in creative activity when he is submerged in the general, when he fully represents the character of the *Volk* – is too generally accepted to require further elaboration. But though the quality of the feeling for form may be unchanged, one cannot overlook variations of its intensity. There have been few ages which have understood form in its purity . . . [only] the periods that have created their own style.

"Since, however, the large forms of architecture cannot respond to each subtle change of the temperament of the *Volk*, a gradual estrangement [*Entfremdung*] develops. . . .

"The heartbeat of the age must [then] be discerned in other areas: in the small decorative arts, in the lines of ornament, in lettering [*Schriftzeichen*]. Here, the feeling for form satisfies itself in the purest way, and it is here that the birthplace of a new style must be sought."

Wölfflin, *Kleine Schriften*, ed. J. Gantner (Basel: Schwabe, 1946), p.46.
37. Riegl, *Late Roman Art Industry*, pp.6, 17.
38. Wölfflin, "Prolegomena zu einer Psychologie der Architektur," pp.43–4.
39. Muthesius, *Stilarchitektur und Baukunst*, p.40; Idem, "Wo stehen wir?" p.16.
40. This has led to three fundamental but very different interpretations of Riegl that can be identified in the reception of his work. The first is a hermeneutic-phenomenological reading, which considers Riegl in the tradition of the *Geisteswissenschaften*, as discussed below; the basic text is Karl Mannheim, "On the Interpretation of 'Weltanschauung,'" (1921/2), translated in *Essays on the Sociology of Knowledge*, ed. and trans. Paul Kecskemeti (Oxford and New York: Oxford University Press, 1952), pp.35–7, 57–9, 76–82. Second, a neo-Kantian interpretation, as laid out by Erwin Panofsky in "The Concept of Artistic Volition" (1920), tr. Kenneth Northcott and Joel Snyder, *Critical Inquiry* 8, no. 1 (1981): 17–33. The third is an Hegelian interpretation, discussed by Ernst Gombrich, *Art and Illusion: A Study in the Psychology of Pictorial Representation* (New York: Pantheon, 1960), pp.17–21; and, combined with elements of Gestalt psychology, presented in Hans Sedlmayr, "Die Quintessenz der Lehren Riegls," introduction to Riegl, *Gesammelte Aufsätze*, ed. K.M. Swoboda (Augsburg: Filser, 1929), pp.xii–xxxiv.

On Riegl in general, see Otto Pächt, "Alois Riegl," in *Methodisches zur kunsthistorischer Praxis* (Munich:

Prestel, 1977), 141–52; Henri Zerner, "Alois Riegl: Art, Value, and Historicism," *Daedalus* 105, no. 1 (1976): 177–88; Wolfgang Kemp, "Alois Riegl," in *Altmeister moderner Kunstgeschichte*, ed. H. Dilly (Berlin: Reimer, 1990), pp.37–60; and most recently Margaret Iversen, *Alois Riegl: Art History and Theory* (Cambridge: MIT Press, 1993). On the different lessons later scholars could draw from Riegl's work, see Kemp's distinction between "monographic" and "stilgeschichtlichen" tendencies in Riegl's thought in "Walter Benjamin und die Kunstwissenschaft, Teil 1: Benjamins Beziehungen zur Wiener Schule," *Kritische Berichte* 1, no. 2 (1973): 30–50, here p.45.
41. One of Weber's relatively few discussions of artistic issues shows that the concept of the *Kunstwollen* went directly into his vocabulary as the appropriate way of conceptualizing visual form; see "Der Sinn der 'Wertfreiheit' der soziologischen und ökonomischen Wissenschaften," first presented at the 1914 meeting of the Verein für Sozialpolitik and repr. in Weber, *Gesammelte Aufsätze zur Wissenschaftslehre*, ed. J. Winckelmann, 3rd. ed. (Tübingen: J.C.B. Mohr, 1968), pp.519–21. Emil Utitz mentions Simmel's interest in Riegl in "Georg Simmel und die Philosophie der Kunst," *Zeitschrift für Ästhetik und allgemeine Kunstwissenschaft* 14 (1919): 9. The influence of *Spätrömische Kunstindustrie* can be clearly seen in Simmel's "Über die dritte Dimension in der Kunst," *Zeitschrift für Ästhetik und allgemeine Kunstwissenschaft* 1 (1906): 65–9; the Viennese art historian is not, however, mentioned by name.
42. Georg Lukács, *History and Class Consciousness: Studies in Marxist Dialectics*, trans. R. Livingstone (Cambridge: MIT Press, 1971; original German 1923), p.153 (emphasis in original). On Lukács as a student of Weber and Simmel, see Eva Karadi, "Ernst Bloch and Georg Lukács in Max Weber's Heidelberg," in W.J. Mommsen and J. Osterhammel, eds., *Max Weber and his Contemporaries* (London: Unwin Hyman, 1987), pp.499–514. Lukács's roots in this tradition are discussed in Michael Löwy, *Georg Lukács: From Romanticism to Bolshevism*, trans. P. Camiller (London: New Left Books, 1979). Lukács succinctly describes and trenchantly criticizes aspects of the "cultural sciences" circle around Simmel and Weber in his 1962 preface to *Theory of the Novel*, pp.11–23.

Riegl and his concepts are also mentioned in the work of another student of Simmel and Weber, Ernst Bloch, for whom the *Kunstwollen* figures as a central concept. See *Geist der Utopie* (1918), *Werkausgabe*, vol. 3 (Frankfurt: Suhrkamp, 1964), esp. pp.29–40, 125.
43. Mannheim, "On the Interpretation of 'Weltanschauung,'" pp.35–6, 58. Writing in 1921, Mannheim calls Riegl's work "methodologically still challenging today" (p. 76).
44. Friedrich Nietzsche, "Unzeitgemässe Betrachtung I: David Strauss der Bekenner und der Schriftsteller," *Kritische Studienausgabe*, 2nd ed. (Berlin: dtv/de Gruyter, 1988), p.163.
45. Friedrich Nietzsche, "On the Uses and Disadvantages of History for Life," *Untimely Meditations*, trans. R.J. Hollingdale (Cambridge: Cambridge University Press, 1983), pp.57–123. On the importance of Nietzsche to the *Kunstgewerbebewegung*, see Tilmann Buddensieg, "Das Wohnhaus als Kultbau: Zum Darmstädter Haus von Behrens," in *Peter Behrens und Nürnberg*, exh. cat. (Munich: Prestel, 1980), pp.37–47; Jürgen Krause, *"Märtyrer" und "Prophet": Studien zum Nietzsche-Kult in der bildenden Kunst der Jahrhundertwende* (Berlin: de Gruyter, 1984), esp. pp. 74–88; and Stanford Owen Anderson, "Peter Behrens and the Architecture of Germany, 1900–1917" (Ph.D. diss., Columbia University, 1968), chap. 3, passim.

46. Walter Gropius, "Der stilbildende Wert industrieller Bauformen," *JDW* 3 (1914): 29.

47. Wilhelm Worringer, *Abstraktion und Einfühlung: Ein Beitrag zur Stilpsychologie* (1908; repr. of 3rd ed. Munich: Piper, 1948), p.21. Gropius cites both Worringer and Riegl directly in "Monumentale Kunst und Industriebau," *Ausgewählte Schriften*, p.28.

48. Georg Lukács, *Estetikai Kultura* (Aesthetic Culture) (Budapest, 1913), quoted in György Markus, "The Soul and Life: The Young Lukács and the Problem of Culture," *Telos*, no. 32 (Summer 1977): 98.

49. Markus, "The Soul and Life," p.98.

50. On the example of the work of literature: "The whole of a work must be understood from individual words and their combination but full understanding of an individual part presupposes understanding of the whole. This circle is repeated in the relation of an individual work to the mentality and development of its author, and it recurs again in the relation of such an individual work to its literary genre." Wilhelm Dilthey, *Selected Writings*, ed. and trans. H.P. Rickman (Cambridge: Cambridge University Press, 1976), p.259.

51. Walter Erben, "Karl Ernst Osthaus, Lebensweg und Gedankengut," in Herta Hesse-Frielinghaus et al., *Karl Ernst Osthaus: Leben und Werk* (Recklinghausen: Bongers, 1971), p.35.

52. Dilthey, *Selected Writings*, p.203.

53. Karl Ernst Osthaus, "Die Gartenvorstadt an der Donnerkuhle," *JDW* 1 (1912): 93.

54. Max Weber, "Die 'Objektivität' sozialwissenschaftlicher und sozialpolitischer Erkenntnis" (1904), in *Gesammelte Aufsätze zur Wissenschaftslehre*, pp.190–2. For another discussion of Weber's remark with regard to notions of style, see Arnold Hauser, *The Philosophy of Art History* (Cleveland: Meridian, 1958), pp.212–15.

55. Walter Troeltsch, *Volkswirtschaftliche Betrachtungen über die Mode* (Marburg: G. Elwert, 1912), p.9 (emphasis in original).

56. Bruno Rauecker, "Der Krieg als Erzieher zur Type II," *Kunstgewerbeblatt*, n.s., 27, no. 2 (1915): 27.

57. These phrases were commonplaces of the reform movement that were taken from the first "Untimely Meditation."

58. Behrens, "Kunst und Technik," p.D282.

59. Walter Gropius, "Programm zur Gründung einer allgemeinen Hausbaugesellschaft auf künstlerisch einheitlicher Grundlage m.b.H." (1910), in *Ausgewählte Schriften*, p.19.

60. Fritz Hoeber, "Der kollektivistische Charakter der griechischen Kunst," *Sozialistische Monatshefte* 2 (1910): 705.

61. Walter Curt Behrendt, *Der Kampf um den Stil im Kunstgewerbe und in der Architektur* (Stuttgart: Deutsche Verlags–Anstalt, 1920), p.30.

62. Ibid., p.17.

63. The revisionists were an important element in Werkbund member Friedrich Naumann's attempt to unite German liberals and social democrats and to form a political bloc "from Bebel to Basserman." On the *Sozialistische Monatshefte* and revisionist socialism in general, see Roger Fletcher, *Revisionism and Empire: Socialist Imperialism in Germany, 1897-1914* (London: Allen & Unwin, 1984).

64. Heinrich Waentig, *Wirtschaft und Kunst: Eine Untersuchung über Geschichte und Theorie der modernen Kunstgewerbebewegung* (Jena: Fischer, 1909), p.4. Waentig was an economist, member of the Werkbund and a founding member of the German Sociological Society, formed in 1909 by Simmel, Tönnies, Sombart and the Webers.

65. These are more commonplaces of the Werkbund critique. "Billig und schlecht" was Franz Reuleaux's verdict on the state of the German applied arts in his report on the 1876 World Exposition in Philadelphia; see *Briefe aus Philadelphia* (Braunschweig: Vieweg, 1877), p.5.

66. Tönnies discusses Fashion at some length as well, without, however, devoting an entire work to the subject. See *Die Sitte* (Frankfurt: Rütten & Loening, 1909), pp.74–88. The best single source on German discussions of Fashion at the time is Silvia Bovenschen, ed., *Die Listen der Mode* (Frankfurt: Suhrkamp, 1986), in which several turn-of-the-century texts, including those of Sombart and Simmel, are reprinted.

67. Dal Co points out that Fashion was "the object of extensive study and continuous attention on the part of German culture at the turn of the century" and that "this question also held a prominent place in the architectural debate," discussing it briefly as "a variety of mere appearance" and (quoting Hermann Hesse) a "substitute for lost customs." *Figures of Architecture and Thought*, pp. 50-51, 60. And in works that only became available to me as this book was going to press, Mary McLeod and Mark Wigley explore from different angles the preoccupation of modern architects with Fashion which has also prompted my own discussion. For McLeod, the persistent references to women's fashions figure modern architecture's ambivalence toward certain aspects of modernity that were gendered feminine, while men's fashions served as a more positive model of cultural practice. Wigley presents an interesting deconstructivist argument that the obsession with fashions betrays an anxiety about the role of modern architecture in the very fashion cycles it seeks to halt, and that the theoretical obsession with structure hides the surface aspect of much of the work of the modern movement. While discussing earlier figures, Wigley's argument centers on the historiography of writers such as Pevsner and Giedion and the practice of Le Corbusier. Rather than taking a diachronic view parallel to the metanarrative Wigley challenges, I will be looking in depth at a synchronic matrix in which Fashion was discussed in Germany before the First World War. My argument will be that the discursive function of the concept of fashion that McLeod and Wigley focus on can only be understood through an exploration of the *material* economy implied by the term. Mary McLeod, "Undressing Architecture: Fashion, Gender, and Modernity," in Deborah Fausch *et al.*, *Architecture: In Fashion* (Princeton: Princeton Architectural Press, 1994), pp.38–123; Mark Wigley, "White Out: Fashioning the Modern," in *Architecture: In Fashion*, pp.148–268, and "White-Out: Fashioning the Modern |Part 2]," *Assemblage* 22 (1994): 7–49.

68. In my discussion of Fashion I will be drawing on the works of economists as well as cultural critics and applied arts reformers. The relation and overlap between the discourses of Culture and political economy are discussed in chap. II below.

69. "The first of the world's consumer societies," writes Neil McKendrick, "had unmistakably emerged |in England| by 1800." See Neil McKendrick, John Brewer and J.H. Plumb, *The Birth of a Consumer Society: The Commercialization of Eighteenth-Century England* (London: Europa Publications, 1982); on Fashion, see esp. the chapter "The Commercialization of Fashion," pp.34–99. On developments in France, see Michael B. Miller, *The Bon Marché: Bourgeois Culture and the Department Store* (Princeton: Princeton University Press, 1981) and Rosalind Williams, *Dream Worlds: Mass Consumption in Late Nineteenth-Century France* (Berkeley and Los Angeles: University of California Press, 1982). Studies of consumerism in Germany are rare. The emergence of a consumer culture in Germany has been dated to the last decade of the nine-

teenth century in Warren G. Breckman, "Disciplining Consumption: The Debate about Luxury in Wilhelmine Germany, 1890–1914," *Journal of Social History* 24, no. 3 (1991): 484–505. And Silvia Bovenschen, drawing mostly on German sources, writes of the "discursivization of the fashionable [*Diskursivierung des Modischen*] in the last hundred years"; see Bovenschen, ed., *Die Listen der Mode*, p.7.

My stress here (and elsewhere) on Germany's "lateness" should not be construed as adherence to the somewhat outmoded notion of a German *Sonderweg*, or special (and fateful) path to modernity that by-passed the social and political changes of a bourgeois revolution. This study has in fact developed in the context of a broad challenge to this view, and the material here should support that challenge. The basic reevaluation of the *Sonderweg* assumption is David Blackbourn and Geoff Eley, *The Peculiarities of German History: Bourgeois Society and Politics in Nineteenth-Century Germany* (Oxford: Oxford University Press, 1984).

70. On Semper and the theory of dressing see Heinz Quitzsch, *Die ästhetischen Anschauungen Gottfried Sempers* (Berlin: Akademie-Verlag, 1962, esp. pp.65–82; Heidrun Laudel, *Gottfried Semper: Architektur und Stil* (Dresden: Verlag der Kunst, 1991), esp. pp.101–50; Wolfgang Herrmann, *Gottfried Semper: In Search of Architecture* (Cambridge: MIT Press, 1984); and Mary McLeod, "Undressing Architecture," pp.46–9. Selections from Semper's works, including important excerpts from the section on "The Textile Art" and the theory of dressing from *Der Stil*, have recently been translated in Semper, *The Four Elements of Architecture and other Writings*.

71. For Semper's response to the Great Exhibition of 1851, see *Wissenschaft, Industrie und Kunst*, trans. in *The Four Elements of Architecture*, esp. pp.138–43. Semper also discusses the cultural effects of commercialization in *Der Stil*, trans. in ibid., pp.187–9, and in "A Critical Analysis and Prognosis of Present-Day Artistic Production" (ca. 1856/9), trans. in Hermann, *Gottfried Semper*, pp.251–3. Karl Friedrich Schinkel noted the effect of speculation on building in England a quarter-century earlier; see Schinkel, *"The English Journey": Journal of a Visit to France and Britain in 1826*, ed. David Bindman and Gottfried Riemann (New Haven and London: Yale University Press, 1993), pp. 15, 112, 180f. Even earlier observations can be found in J.W. von Archenholz, *A Picture of England* (1787, trans. 1891), quoted in McKendrick, Brewer and Plumb, *The Birth of a Consumer Society*, pp.55, 58, 94.

72. Fritz Schumacher, "Stil und Mode," in *Im Kampfe um die Kunst: Beiträge zu architektonischen Zeitfragen* (Strasbourg: Heitz, 1899), pp. 24–5.

73. Curt Glaser, "Stil oder Mode," *Neue Revue und Morgen*, no. 21 (1909): 733.

74. "Away from Fashion, to Style!" Quoted in Hamann and Hermand, *Stilkunst um 1900*, p.213.

75. Quoted in Troeltsch, *Volkswirtschaftliche Betrachtungen über die Mode*, p.10.

76. Werner Sombart, *Wirthschaft und Mode: Ein Beitrag zur Theorie der modernen Bedarfsgestaltung* (Wiesbaden: J.F. Bergmann, 1902), p. 14.

77. Johannes Gaulke, *Die ästhetische Kultur des Kapitalismus* (Berlin-Tempelhof: Freier Literarischer Verlag, 1909), p. 93.

78. Cl[emens] Heiss, contribution to a discussion in the Deutscher Volkswirtschaftlicher Verband, Berlin, on "Die Stellung der Kunst in der Volkswirtschaft," in *Volkswirtschaftliche Blätter* 9, no. 15/16 (1910): 264.

79. Sombart, *Wirthschaft und Mode*, p.23.

80. Robert Breuer, "Die Würde des Werkes," *Das Werkblatt* 1 (1908): 4.

81. Sombart, *Wirthschaft und Mode*, p.13.

82. Ibid. (emphasis in original).

83. Ibid., p.2.

84. Ibid., p.13.

85. Heinrich Pudor, "Praktische Vorschläge zur Erzielung von Qualitätswaren," *Volkswirtschaftliche Blätter* 9, no. 15/16 (1910): 283.

86. Gaulke, *Die ästhetische Kultur des Kapitalismus*, p.92.

87. Karl Lamprecht, *Zur jüngsten deutschen Vergangenheit*, *Deutsche Geschichte*, supplementary vols. 1 and 2 (Berlin: R. Gaertner, 1901 ff.); and Willy Hellpach, *Nervosität und Kultur* (Berlin, 1902).

88. From Simmel, "Die Grossstädte und das Geistesleben" (1903), trans. as "The Metropolis and Mental Life" in Kurt H. Wolff, ed., *The Sociology of Georg Simmel* (New York: Free Press, 1950), p.410.

89. Alexander Elster, "Wirtschaft und Mode," *Jahrbücher für Nationalökonomie und Statistik*, 3rd ser., 46 (1913): 193; idem, "Über die Bedeutung der Mode im Wirtschaftsleben," *Kunstgewerbeblatt*, n.s., 24, no. 11 (1913): 208; Troeltsch, *Volkswirtschaftliche Betrachtungen über die Mode*, pp.13–14.

90. Gaulke, *Die ästhetische Kultur des Kapitalismus*, p.92.

91. Muthesius, *Stilarchitektur und Baukunst*, p.37.

92. Ibid.

93. Karl Widmer, "Mode und Kunstgewerbe," *Deutsche Kunst und Dekoration* 8, no. 4 (1905): 254, 252.

94. Muthesius, *Stilarchitektur und Baukunst*, pp.60–1.

95. Waentig, *Wirtschaft und Kunst*, p.280.

96. Muthesius, *Stilarchitektur und Baukunst*, p.55.

97. A typically twisted and exhausting example: "The concepts of Style and Fashion overlap considerably and are not easy to separate from one another. In common linguistic usage, the word Fashion is synonymous with clothing fashions. Should, however, the quick alternation and inessential superficiality of clothing fashions be transferred to other realms, then one speaks derisively of a style as mere Fashion. And conversely, one would be equally justified in recognizing as Style a fashion in which the essential and general artistic feeling of the age is reflected. On the other hand, when one realizes that that which is called, in the broadest sense, the Style of an age must be expressed equally in each of its manifestations, there persist in Fashion (which generally changes its form quite quickly) slight surface variations which have no impact on the essence of Style. One will in fact have found that which is essential to Style only when one has reached this solid ground on which all such movement takes place. On the other hand, the stricter and more uniform the Style of an age is, the less room there is for such variations, and the more closely everything falls into line with the unified expression of s *single* Style-will, right down to clothing fashions." Glaser, "Stil oder Mode," p.731.

98. *Der Morgen* 2, no. 21 (1908): 675.

99. Joseph August Lux, *Der Geschmack im Alltag: Ein Buch zur Pflege des Schönen* (Dresden: Ges. Kühtmann, 1908), p.54.

100. Sombart, *Wirthschaft und Mode*, pp.19–20.

101. Alexander Schwab, *Möblekonsumtion und Möbelproduktion in Deutschland* (Berlin: Siemenroth, 1915), pp.2–3.

102. Troeltsch, *Volkswirtschaftliche Betrachtungen über die Mode*, p. 13.

103. Sombart, *Wirthschaft und Mode*, p.21 (emphasis added).

104. Troeltsch, *Volkswirtschaftliche Betrachtungen über die Mode*, p. 16.

105. Ibid., p.10 (emphasis added).

106. Johannes Gaulke, "Die Mode in sexueller und wirtschaftlicher Beleuchtung," *Das Blaubuch* 2, no. 45 (1907): 1364 (emphasis added).

107. Gaulke, *Die ästhetische Kultur des Kapitalismus*, p.107.

108. Walter Curt Behrendt, *Die einheitliche Blockfront als Raumelement im Städtebau: Ein Beitrag zur Stadtbaukunst der Gegenwart* (Berlin: Bruno Cassirer, 1912), pp.69, 68.

109. Ibid.

110. "Um das Handelsobjekt nach aussen zu empfehlen." Scheffler, *Die Architektur der Grossstadt*, p.30.

111. Ibid., p.34.

112. Sombart, *Kunstgewerbe und Kultur*, p.45.

113. ". . . die historische Mode mitzumachen und die alten Stilarten ins Kapitalistische zu übersetzen." Ibid., p.55.

114. Sombart, *Wirtschaft und Mode*, p.19.

115. Bruno Rauecker, review of *Volkswirtschaftliche Betrachtungen über die Mode* by Walter Troeltsch, *Kunstgewerbeblatt*, n.s., 24, no. 5 (1913): 138 (emphasis in original).

116. Georg Simmel, *Philosophy of Money*, p.56.

117. Georg Simmel, "Die Mode," in *Philosophische Kultur* (1911; repr. Berlin: Wagenbach, 1986), p.41. This essay first appeared as "Zur Psychologie der Mode," *Die Zeit* (Vienna), 12 October 1895; it was then published as *Philosophie der Mode* (Berlin: Pan Verlag, 1905), before being printed in its final form in 1911.

118. Simmel, "Die Mode," p.41 (emphasis added).

119. Ibid., pp.44, 41.

120. Ibid., p.40 (emphasis added).

121. Simmel, "Die Mode," p.43; here translated as "Fashion" in Donald Levine, ed., *Georg Simmel on Individuality and Social Forms* (Chicago: University of Chicago Press, 1971), p.299.

122. Bruno Rauecker, *Die wirtschaftlichen Grundlagen des modernen Kunstgewerbes in London* (Munich: M. Rieger, 1912), p.9. (This essay also appeared in the *Kunstgewerbeblatt*.)

123. Gaulke, *Die ästhetische Kultur des Kapitalismus*, pp.99–100.

124. Hermann Muthesius, "Die Bedeutung des Kunstgewerbes: Eröffnungsrede zu den Vorlesungen über modernes Kunstgewerbe an der Handelshochschule in Berlin," *Dekorative Kunst* 10, no. 5 (1907): 181.

125. Ibid., p.182.

126. Adolf Vetter, "Die staatsbürgerliche Bedeutung der Qualitätsarbeit," in *Die Durchgeistigung der deutschen Arbeit: Ein Bericht vom deutschen Werkbund* (Jena: Eugen Diederichs, 1911), p.16.

127. Muthesius, *Stilarchitektur und Baukunst*, p.23. On figure of the parvenu, see Jost Hermand, "Der gründerzeitliche Parvenü," in Hermand et al., *Aspekte der Gründerzeit* (Berlin: Akademie der Künste, 1974), pp.7–15; Dal Co, *Figures of Architecture and Thought*, p.50; and the extraordinary (if dated) study by Ernest K. Bramsted, *Aristocracy and the Middle-Classes in Germany: Social Types in German Literature, 1830–1900* (1937; rev. ed. Chicago: University of Chicago Press, 1964), passim.

The word "mandarin" is used here in a loose sense; that is, I do not mean to imply full endorsement of Fritz Ringer's somewhat problematic thesis that certain aspects of turn-of-the-century cultural criticism and philosophy are particularly characteristic of the once-privileged group of university professors. For instance, Muthesius, whom I quote here, was not a university graduate; he received his education at a *Technische Hochschule*, one of the embattled and democratizing institutions that challenged the educational hegemony of the universities. See Ringer, *The Decline of the German Mandarins*, esp. pp. 14-80.

128. Elster, "Über die Bedeutung der Mode im Wirtschaftsleben," p.210.

129. Lux, *Der Geschmack im Alltag*, p.51.

130. This key aspect of Werkbund ideology is best discussed and documented by Julius Posener in the chapter "Das Prinzip Wachstum: Friedrich Naumann," in *Berlin*, pp.49–80. It is also a central theme in two other studies of the Werkbund: Sebastian Müller, *Kunst und Industrie: Ideologie und Organisation des Funktionalismus in der Architektur* (Munich: Hanser, 1974); and Kurt Junghanns, *Der Deutsche Werkbund: Sein erstes Jahrzehnt* (East Berlin: Henschel, 1982).

131. Waentig, *Wirtschaft und Kunst*, p.414.

132. Elster, "Wirtschaft und Mode," pp.180–1 (emphasis in original). See also his "Über die Bedeutung der Mode im Wirtschaftsleben," p.208. Elster is consequent: "One could push these thoughts further, to the problem of whether there is a specific class erotics [*Klassenerotik*] which in its turn influences the transformations of Fashion and its efficacy" (p. 189); regrettably, he did not himself do so.

133. Gaulke, *Die ästhetische Kultur des Kapitalismus*, pp.98–9.

134. On the "savage" and Fashion, see Gaulke, "Die Mode in sexueller und wirtschaftlicher Beleuchtung," p.1361; on the search for the male, see F.T. Vischer, "Mode und Cynismus" (1859), in Bovenschen, ed., *Die Listen der Mode*, pp.37 and 45; on the "battle over the female," see Elster, "Wirtschaft und Mode," p.181.

135. "The battle of the Werkbund is in the first place a campaign to achieve a new masculine reason [*männlichen Vernunft*]; it is a battle against the inordinate foolishness of the times, an attempt to legitimize that which is, in a higher sense, self-evident and to bring that simple human quality back into everyday things, that quality which seems simply classic." Karl Scheffler, "Gute und schlechte Arbeiten im Schnellbahngewerbe," *JDW* 3 (1914): 42–3.

136. Sombart, *Luxus und Kapitalismus, Studien zur Entwicklungsgeschichte des modernen Kapitalismus*, vol. 1 (Munich: Dunker & Humblot, 19130. Just as Fashion was seen as French, Style as it was sought in the Werkbund was, for many of its members, to be a specifically German style. See Campbell, *The German Werkbund*, pp.60, 71–2; Müller, *Kunst und Industrie*, pp.77–84; and Dal Co, *Figures of Architecture and Thought*, pp.207–11.

137. Muthesius, *Stilarchitektur und Baukunst*, here cited from the first edition (Mülheim-Ruhr: K. Schimmelpfeng, 1902), pp.50–1.

138. Ibid., p.53.

139. Waentig, for example, points out the inadequacy of function as an aesthetic principle by reference to Riegl, who in his polemic against Semper saw function not as playing a "positive, creative" role, but rather a "restraining, negative" one. See Waentig, *Wirtschaft und Kunst*, pp. 316–17; and the discussion of Riegl above.

140. Muthesius, "Die Bedeutung des Kunstgewerbes," p.181.

141. Muthesius, *Kunstgewerbe und Architektur*, p.33.

142. Ibid., pp.134–5.

143. Max Scheler, "Der Bourgeois" (1914), in *Vom Umsturz der Werte: Abhandlungen und Aufsätze, Gesammelte Werke*, vol. 3 (Bern: Francke, 1972), p.242 (emphasis in original).

144. Theodor W. Adorno, "Cultural Criticism and Society," in *Prisms*, trans. S. and S. Weber (Cambridge: MIT Press, 1981), p.19.

145. Naumann's review "Berliner Gewerbe-Ausstellung 1896" appeared in his newspaper *Die Hilfe* and is reprinted in Naumann, *Ausstellungsbriefe* (Berlin-Schöneberg: Buchverlag der "Hilfe," 1909), pp.9–51. Simmel's review "Berliner Gewerbe-Ausstellung" was published in *Die Zeit* (Vienna), 25 July 1896, pp.59–60.

146. Walter Benjamin, "Paris, Capital of the Nineteenth Century," in *Reflections*, trans. E. Jephcott (New York: Schocken, 1986), p.151.

147. Naumann, "Berliner Gewerbe-Ausstellung," p.9.

148. Simmel, "Berliner Gewerbe-Ausstellung," p.50.

149. Ibid.

150. Ibid.

151. Ibid., p.60.

152. Naumann, "Berliner Gewerbe-Ausstellung," pp.45–7.

153. For another discussion of how traditional methods of signification were inadequate to new categories of experience in Germany at the time, see Tilmann Buddensieg's exemplary analysis of early AEG signets in Buddensieg, ed., *Industriekultur*, Eng. trans., pp.20ff.

154. For references to the large body of turn-of-the-century writings on Wertheim's, see Posener, *Berlin*, pp.453–74; and the bibliography in Peter Stürzebecher, *Das Berliner Warenhaus: Bautypus, Element der Stadtorganisation, Raumsphäre der Warenwelt* (Berlin: Archibook, 1979). A brief discussion in English can be found in Tilmann Buddensieg, "From Academy to Avant-Garde," in Buddensieg, ed., *Berlin 1900–1933: Architecture and Design*, exh. cat. (New York: Cooper-Hewitt Museum, 1987), pp. 125–31. An important article from the Werkbund *Jahrbücher* on the architecture of the department store is Alfred Wiener, "Das Warenhaus," *JDW* 2 (1913): 43–54.

155. Paul Göhre, *Das Warenhaus* (Frankfurt: Rütten & Loening, 1907), p.15.

156. Ibid., p.17.

157. Two other coordinates are important in understanding Göhre's work, to which we cannot do justice here: the Protestant Church (through his involvement in the Evangelisch-Sozialer Kongress) and the social democratic movement. On Göhre, see E. Pikart, "Paul Göhre," *Neue Deutsche Biographie*, 6:513–14.

158. Buber's monograph series included contributions by Werkbund members Karl Scheffler (*Der Architekt*) and Werner Sombart (*Das Proletariat*), as well by Simmel (*Die Religion*) and Richard Calwer, a close associate of Naumann (*Der Handel*). Letters reveal that Buber tried to recruit Muthesius as well, suggesting a study on *Die Wohnung*. Three years later, without having delivered a manuscript, Muthesius backed out of the project. Nachlass Muthesius, Werkbund-Archiv, Berlin, 2.1 (letters of 5 July 1906 and 16 February 1909); 2.4 (letter of 2 May 1908).

159. Paul Göhre, *Drei Monate Fabrikarbeiter und Handwerksbursche: Eine praktische Studie* (Leipzig: F.W. Grunow, 1891).

160. On Wertheim's clientele, see Göhre, *Das Warenhaus*, p.91; and Leo Colze, *Berliner Warenhäuser* (1908; repr. Berlin: Fannei & Walz, 1989), p.12.

161. Tönnies, *Community and Society*, pp.64–102 passim; Max Weber, *The Protestant Ethic and the Spirit of Capitalism*, trans. T. Parsons (New York: Scribner's, 1958; original German 1904–5), pp.180–1.

162. Peter Bruckmann, in *Die Veredelung der gewerblichen Arbeit im Zusammenwirken von Kunst, Industrie und Handwerk, Verhandlungen des Deutschen Werkbundes zu München am 11. und 12. Juli 1908* (Leipzig: Voigtländer, 1908), p.91.

163. Schumacher, "Die Wiedereroberung harmonischer Kultur," p.137.

164. John Ruskin, *The Stones of Venice*, vol. 2 (London: Smith, Elder and Co., 1874), pp. 165, 163.

165. Schumacher, "Die Wiedereroberung harmonischer Kultur," p. 136.

166. Ibid., pp.137–8.

167. Theodor Fischer, opening address, *Die Veredelung der gewerblichen Arbeit*, p.3 (emphasis added).

168. Ibid., p.17 (emphasis added).

169. John Ruskin, *The Stones of Venice*, vol. 2, pp. 165–7.

170. Walter Gropius, "Die Entwicklung moderner Industriebaukunst," *JDW* 2 (1913): 17 (emphasis added).

171. Bruno Rauecker, *Das Kunstgewerbe in München* (Stuttgart: J.G. Cotta, 1911), p.23.

172. Hermann Muthesius, *Wirtschaftsformen im Kunstgewerbe*, Volkswirtschaftliche Zeitfragen, no. 233 (Berlin: Simion, 1908), p. 11.

173. Karl Ernst Osthaus, "Das Schaufenster," *JDW* 2 (1913): 59. Osthaus's Orient was perhaps not *entirely* imaginary: see Fritz Meyer-Schönbrunn's account of a trip to North Africa by Osthaus in 1898 and his visit to the bazaar of Tunis in "Karl Ernst Osthaus und sein Werk," *Westermanns Monatshefte* 121, no. 726 (1917): 798.

174. Osthaus, "Das Schaufenster," p.59.

175. I will have much more to say about Osthaus and the shop-window in chapter III below.

176. Georg Simmel, "The Metropolis and Mental Life," p.411.

177. Simmel, *Philosophy of Money*, pp.453–4. David Frisby also discusses Simmel's account of the relation between changes in production and in consumption in *Philosophy of Money*; see *Fragments of Modernity*, pp. 90–3.

178. Simmel, *Philosophy of Money*, pp.454–5.

179. Ibid., p.456.

180. Ibid., p.454.

181. Ibid., p.457.

182. Ibid.

183. Muthesius, *Wirtschaftsformen im Kunstgewerbe*, p.11.

184. A point first made by Andrew Arato in "The Neo-Idealist Defense of Subjectivity," *Telos*, no. 21 (1974): 156–7.

185. Simmel, *Philosophy of Money*, p.455.

186. Ibid., p.456.

187. Ibid., p.458.

188. Ibid., p.455.

189. Walter Gropius, "Monumentale Kunst und Industriebau," lecture held at the Folkwang Museum, Hagen, 10 April 1911, manuscript, Gropius Sammlung 20/3, Bauhaus-Archiv, Berlin, repr. in *Ausgewählte Schriften*, p. 31.

190. Gropius, "Die Entwicklung moderner Industriebaukunst," p.20.

191. Karl Scheffler, *Die Architektur der Grossstadt*, p.157.

192. Adolf Vetter, "Die staatsbürgerliche Bedeutung der Qualitätsarbeit," in *Die Durchgeistigung der deutschen Arbeit*, p.18.

193. Ibid.

194. Bruno Rauecker, "Über einige Zusammenhänge zwischen Qualitätsarbeit und Sozialpolitik," *Kunstgewerbeblatt*, n.s., 24, no. 1 (1913): 5.

195. Ibid., p.8.

196. Ibid.

197. In recent literature on the Werkbund, much ink has been spilled in judging this aspect of the organization's program. Gropius's comments are discussed as part of an ideology critique in Sebastian Müller, *Kunst und Industrie*, pp.46–51; and in Chup Friemert, "Der 'Deutsche Werkbund' als Agentur der Warenästhetik in der Aufstiegsphase des deutschen Imperialismus," in W.F. Haug, ed., *Warenästhetik: Beiträge zur Diskussion, Weiterentwicklung und Vermittlung ihrer Kritik* (Frankfurt: Suhrkamp, 1975), pp.211–14. Karin Wilhelm seeks to counter these positions by emphasizing the "progressive" aspect of factory reform; see *Walter Gropius, Industriearchitekt*, pp.13, 16–17. From the passages quoted here as well as the abundant material published elsewhere, the reader should have no trouble forming his or her own

views on the social and political aspects of the Werkbund program and on the *Reformbewegung* in general. A particularly level-headed discussion of this matter appears in Posener, *Berlin*, pp.49–54.

198. Friedrich Naumann, *Der Geist im Hausgestühl: Ausstattungsbriefe*, supplement to *Dresdener Hausgerät: Preisbuch 1906* (Dresden: Dresdener Werkstätten, 1906), p.12; also quoted in Posener, *Berlin*, p.78. "Hausgestühl" is an archaizing neologism with certain ceremonial or ecclesiastical overtones.

199. Werkbund charter, section 2; see "Denkschrift des Ausschusses des Deutschen Werkbundes, 1907," repr. in *Zwischen Kunst und Industrie: Der Deutsche Werkbund*, exh. cat. (Munich: Neue Sammlung, 1975), p. 50.

200. This was the title given to the third annual meeting of the Werkbund in 1910 as well as to the first Werkbund yearbook.

201. This point is made by Posener, *Berlin*, p.529.

202. Quoted in Hoeber, *Peter Behrens*, p.83.

203. Karl Marx, "Die Revolution von 1848 und das Proletariat" (1856), in *Karl Marx als Denker, Mensch und Revolutionär*, ed. D. Rjazanov (Frankfurt: Makol Verlag, 1971), p.44.

204. Waentig, *Wirtschaft und Kunst*, p.297.

205. Helmuth Wolff, *Die Volkskunst als wirtschaftsästhetisches Problem* (Halle: Deutscher Kunstgewerbeverein, 1909), p.20 (emphasis in original).

206. Sombart, *Kunstgewerbe und Kultur*, p.53.

207. Ibid., pp.57–8.

208. Ibid., p.43.

209. That the sociologists' tragic pessimism, which is emphasized by most modern commentators, was always balanced by some notion of utopia is the thesis of Harry Liebersohn in *Fate and Utopia in German Sociology*. Liebersohn does not, however, discuss Sombart.

210. Robert Breuer, "Kunstgewerbe und Wirtschaft: Als Anmerkung zu dem kürzlich erschienenen Buch: Werner Sombart, 'Kunstgewerbe und Kultur,'" *Deutsche Kunst und Dekoration* 22 (1908): 305. The passage quoted by Breuer is from Sombart's book.

211. Georg Simmel, "Das Problem des Stiles," *Dekorative Kunst* 11, no. 7 (1908): 307–16.

212. *Kunstgewerbe und Kultur* was not, strictly speaking, a response to the establishment of the Werkbund; originally published in two parts in the *Die neue Rundschau* in 1907, it was prompted by the Dritte Deutsche Kunstgewerbeausstellung (Dresden, 1906), in which the figures who later formed the core of the Werkbund first came together to work in a concerted way for aesthetic and propaganda purposes. The 1908 reissue of these articles in book form can, however, be considered in light of the actual founding of the group.

213. Noted in the diaries of Siegfried Kracauer, who attended the lecture. In addition to summarizing the argument as it appears in *Dekorative Kunst*, Kracauer, at that time a student of Simmel, also writes of a "consideration of the laws of symmetry" which was apparently edited out of the printed version. Kracauer's diaries are preserved in the Siegfried-Kracauer-Nachlass, Deutsches Literaturarchiv, Marbach; relevant passages are reprinted in I. Belke and I. Renz, eds., *Siegfried Kracauer, 1889–1966* (*Marbacher Magazin* 47 [1988]), pp.11–12.

214. Simmel, "Das Problem des Stiles," p.314.

215. Ibid., p.307.

216. Ibid.

217. Karl Ernst Osthaus, "Material und Stil," in *Die Durchgeistigung der deutschen Arbeit*, p.25.

218. Lux, *Der Geschmack im Alltag*, p.246. In a similar vein,

Muthesius writes: "'Art' is on the whole somewhat too pretentious [a word] for many aspects of our work; it is often only a matter of taste, of good and suitable form, of decency. The custom of the last ten years of using catch phrases such as 'art in the house,' 'art on the street,' 'art of the shopwindow,' 'art of the student's room' (there is hardly a word left that has not been attached to the word 'art') is not without a comic aspect. In earlier times, when all manifestations of life bore the stamp of a tasteful unity, it would never occur to anyone to jump around in all corners of petty-bourgeois and business life with the word 'art'. . . . That from the second half of the nineteenth century the word 'art' is so often mentioned is only a sign of the sudden insecurity and a feeling of spiritual emptiness in all objects of good taste." Muthesius, "Die Werkbundarbeit der Zukunft," address to the Werkbund meeting, Cologne 1914, repr. in *Zwischen Kunst und Industrie*, p.88.

219. Along with *Stilarchitektur und Baukunst*, the fundamental text in this shift of consensus in Germany is Karl Scheffler, "Eine Bilanz," *Dekorative Kunst* 6, no. 7 (1903): 243–56.

220. Simmel, "Das Problem des Stiles," p.310.

221. Ibid. (emphasis in original).

222. Ibid., p.314.

223. Ibid., p.309.

224. Ibid., p.310.

225. Waentig, *Wirtschaft und Kunst*, p.386.

226. Ibid.

227. Simmel, "Das Problem des Stiles," p.314.

228. Ibid., p.313. In the original, the last sentence reads in its entirety as follows: "Von den Erregungspunkten der *Individualität*, an die das Kunstwerk so oft appelliert, steigt dem stilisierten Gebilde gegenüber das Leben in die befriedeteren Schichten, in denen man sich nicht mehr allein fühlt, und wo – so wenigstens werden sich diese unbewussten Vorgänge deuten lassen – die überindividuelle Gesetzlichkeit der objektiven Gestaltung vor uns ihr Gegenbild in dem Gefühl findet, dass wir auch unsererseits mit dem Überindividuellen, dem Allgemein-Gesetzlichen in uns selbst reagieren und uns damit von der absoluten Selbstverantwortlichkeit, dem Balancieren auf der Schmalheit der blossen Individualität erlösen."

229. Ibid., pp.314–16.

230. For a discussion of the Expressionist theme of *Erlösung*, see Roy Pascal, *From Naturalism to Expressionism: German Literature and Society, 1880–1918* (New York: Basic Books, 1973), pp.194–7.

231. Worringer's doctoral thesis was given to Simmel by their mutual friend, the Expressionist poet Paul Ernst. For Worringer's own account of his contact with Simmel in this period, see the introduction to the 1948 edition of *Abstraktion und Einfühlung*, pp.5–11. Beat Wyss discusses Simmel's use (and alteration) of Worringer's categories, though in a much later text; see his introduction to Simmel, *Rembrandt: Ein kunstphilosophischer Versuch* (1916; repr. Munich: Matthes & Seitz, 1985), pp.xii–xv.

232. Worringer, *Abstraktion und Einfühlung*, p.56.

233. "We want . . . to make the connection between the concept of Style . . . and the drive to abstraction." Ibid., p.46.

234. Ibid., pp.47–8.

235. Ibid., p.36.

236. Simmel, "Das Problem des Stiles," p.314 (emphasis added).

237. As was, no doubt, Simmel's own work such as the essay "The Metropolis and Mental Life." See Jill Lloyd, "Emil Nolde's Still Lifes, 1911–1912: Modernism, Myth, and Gesture," *RES: Anthropology and Aesthetics* 9 (1985): 41. It is interesting that Worringer seems to have prompted Simmel to apply his own ideas to the specific issue of visual form.

Riegl discusses the primitive fear before a threatening nature in terms of "fear of space" (*Raumscheu*) and sees the response to this in the use of inorganic, emphatically flat forms as a denial of the contingency of the individual position in space. See Riegl, *Late Roman Art Industry*, pp.21–3; and Worringer's extension of this to abstract form in general in *Abstraktion und Einfühlung*, pp.27ff.

238. Behrens's earlier use of models from Riegl in his typography and printed ornament is discussed by Gabriele Heidecker, who does not, however, explore the reasons for Behrens's reliance beyond repeating the fallacious argument that Riegl's examples were, for *technical* reasons, "particularly suitable for endless repetition." "Peter Behrens's Publicity Material for the AEG," in Buddensieg, ed. *Industriekultur*, Eng. trans., pp.183–5. See also, more recently, Gisela Moeller, *Peter Behrens in Düsseldorf: Die Jahre von 1903 bis 1907* (Weinheim: VCH, 1991), pp.287–9.

239. It should be pointed out that Riegl does not discuss the geometry of the items he illustrates in terms of the negation of individual contingency, which he ascribes to an earlier phase of antique art; that, however, is how Behrens himself spoke of his use of geometry, as discussed below.

240. "Prof. Peter Behrens über Aesthetik in der Industrie," *AEG-Zeitung* 11, no. 12 (1909): 5–6.

241. Ibid., p.6 (emphasis added).

242. Hoeber, *Peter Behrens*, p.104.

243. Hoeber, "Der kollektivistische Charakter der griechischen Kunst," p.707.

244. Simmel, "Die Mode," p.62.

245. Simmel does, however, write that material *can* function as a stylistic factor, though only in its potential to act as one of many qualities that can relate different objects to each other. "Das Problem des Stiles," p.309.

246. Georg Simmel, "Psychologie des Schmuckes," *Der Morgen* 2, no. 15 (1908): 454–9. This essay was reprinted, its comments on the applied arts abridged, as "Exkurs über den Schmuck" in Simmel, *Soziologie* (Leipzig: Duncker & Humblot, 1908), pp.365–72. The latter version of the text is translated in *The Sociology of Georg Simmel*, pp.338–44; however, *Schmuck* (decoration or ornament) is here too narrowly translated as "jewelry" and "adornment," rendering parts of the text senseless. On the overlapping meanings of the German words *Schmuck* and *Ornament* in this turn-of-the-century context, see Banham, *Theory and Design in the First Machine Age*, p.92.

247. Ibid., p.456.

248. Ibid.

249. Ibid., pp.456–7 (emphasis added).

250. Simmel, "Das Problem des Stiles," p.310.

251. Simmel, "Psychologie des Schmuckes," p.456.

252. Simmel, "Die Mode," p.39.

253. Ibid., p.45.

254. See for example his contribution to the wartime hysteria, *Der Krieg und die geistigen Entscheidungen* (Munich: Duncker & Humblot, 1917).

255. "For the modern man, the requirement of Style applies only for the individual objects of his environment, not for the environment as a whole. . . . Rooms which conform stringently to a particular historical style are for us oddly uncomfortable to live in, while those which are composed out of single pieces of various (but no less strict) styles according to individual taste can seem in the greatest measure livable and warm." "Das Problem des Stiles," pp.313–14. Frisby stresses Simmel's mention of the plurality of styles in his brief discussion of this essay in *Fragments of Modernity*, pp. 101–2.

NOTES TO CHAPTER II

1. Marianne Weber, *Max Weber: Ein Lebensbild* (Tübingen: J.C.B. Mohr, 1926), p.212; quoted in Lawrence A. Scaff, *Fleeing the Iron Cage: Culture, Politics, and Modernity in the Thought of Max Weber* (Berkeley and Los Angeles: University of California Press, 1989), p. 27.

2. On the founding of the Deutsche Gesellschaft für Soziologie, see Harry Liebersohn, *Fate and Utopia in German Sociology, 1870–1923* (Cambridge: MIT Press, 1988), pp.12, 109–20.

3. The literature on the Verein is substantial. My brief account is based largely on Dieter Lindenlaub, *Richtungskämpfe im Verein für Sozialpolitik: Wissenschaft und Sozialpolitik im Kaiserreich, vornehmlich vom Beginn des "neuen Kurses" bis zum Ausbruch des ersten Weltkrieges (1890–1914)*, Vierteljahrschrift für Sozial- und Wirtschaftsgeschichte, Beihefte 52/53 (Wiesbaden: Steiner, 1967); and Fritz Ringer, *The Decline of the German Mandarins: The German Academic Community, 1890-1933* (Cambridge: Harvard University Press, 1969), chap. 3.

4. See Lindenlaub, *Richtungskämpfe im Verein für Sozialpolitik*, chap. 4; and Dieter Krüger, "Max Weber and the Younger Generation in the Verein für Sozialpolitik" in W.J. Mommsen and J. Osterhammel, eds., *Max Weber and his Contemporaries* (London: Unwin Hyman, 1987), pp.71-87. Naumann was of course not an academic economist but was prominent in the Verein.

5. See James J. Sheehan, *The Career of Lujo Brentano: A Study of Liberalism and Social Reform in Imperial Germany* (Chicago: University of Chicago Press, 1966), pp.143–54, 167–72, 184–5.

6. Fritz Schumacher, *Stufen des Lebens: Erinnerungen eines Baumeisters* (Stuttgart: Deutsche Verlags-Anstalt, 1935), p. 240; and Nicolaus Sombart, *Jugend in Berlin, 1933–1945: Ein Bericht*, rev. ed. (Frankfurt: Fischer, 1991), p.53.

7. Friedrich Naumann, *Deutsche Gewerbekunst: Eine Arbeit über die Organisation des Deutschen Werkbundes* (Berlin, 1908), repr. in Naumann, *Ästhetische Schriften, Werke*, vol.6 (Cologne/Opladen: Westdeutscher Verlag, 1964), p.271.

8. Heinrich Waentig, *Wirtschaft und Kunst: Eine Untersuchung über Geschichte und Theorie der modernen Kunstgewerbebewegung* (Jena: Fischer, 1909), p.414.

9. Ibid., p.411.

10. Karl Ernst Osthaus, discussion comments in *Die Werkbund-Arbeit der Zukunft und Aussprache darüber. . . 7. Jahresversammlung des Deutschen Werkbundes vom 2. bis 6. Juli 1914 in Köln* (Jena: Eugen Diederichs, 1914), p.68.

11. Hermann Muthesius, "Die Bedeutung des Kunstgewerbes: Eröffnungsrede zu den Vorlesungen über modernes Kunstgewerbe an der Handelshochschule in Berlin," *Dekorative Kunst* 10, no.5 (1907): 186.

12. Helmuth Wolff, "Aesthetik und Wirtschaftslehre," *Volkswirtschaftliche Blätter* 9, no. 15/16 (1910): 270–1.

13. Friedrich Naumann, "Das Suchen nach dem Wesen des Kapitalismus," *Die Hilfe* 17 (1911): 578.

14. Joseph A. Schumpeter, *History of Economic Analysis*, ed. E.B. Schumpeter, 4th ed. (London: Allen & Unwin, 1961), p. 815. Schumpeter's classification conforms to Weber's own understanding of his and his colleagues' work: see Wilhelm Hennis, "A Science of Man: Max Weber and the Political Economy of the German Historical School," in Mommsen and Osterhammel, eds., *Max Weber and his Contemporaries*, pp.25–58, esp. p.29.

15. Lindenlaub, *Richtungskämpfe im Verein für Sozialpolitik*,

pp. 96–140; Ringer, *Decline of the German Mandarins*, pp. 152–4.

16. "Political economy on the basis of *Verstehen*." Werner Sombart, *Die drei Nationalökonomien: Geschichte und System der Lehre von der Wirtschaft* (Munich: Duncker & Humblot, 1930), pp.140–276, esp.191–233. *Verstehen* was Dilthey's term for the hermeneutic process of the historian's empathic comprehension of the past.

17. Max Weber, "'Objectivity' in Social Science and Social Policy" (1904), in *The Methodology of the Social Sciences*, ed. and trans. E.A. Shils and H.A. Finch (New York: Free Press, 1949), p.74.

18. Quoted in Scaff, *Fleeing the Iron Cage*, p.84.

19. Weber, "'Objectivity' in Social Sciences," p.65.

20. Quoted in Lindenlaub, *Richtungskämpfe im Verein für Sozialpolitik*, p.14.

21. Johannes Buschmann, "Volkswirtschaftliche Bildung," *Der Kunstwart* 21, no.10 (1908): 259.

22. Sombart, *Der moderne Kapitalismus* (Leipzig: Duncker & Humblot, 1902), 1:378–97.

23. Trans. T. Parsons (London: Allen & Unwin, 1930).

24. Werner Sombart, *Der Bourgeois: Zur Geistesgeschichte des modernen Wirtschaftsmenschen* (Munich: Duncker & Humblot, 1913), pp.441-56.

25. Recounted by Sombart, *Die drei Nationalökonomien*, p.203.

26. Quoted in Hennis, "A Science of Man," p.38. In addition to his *Spätrömische Kunstindustrie* of 1901, Riegl uses the notion of the *Kunstwollen* in an explicitly anti-Semperian argument in *Stilfragen: Grundlegungen zu einer Geschichte der Ornamentik* (Berlin: Siemens, 1893), now translated as *Problems of Style: Foundations for a History of Ornament*, trans. E. Kain (Princeton: Princeton University Press, 1992).

27. Max Scheler, "Der Bourgeois" (1914), in *Vom Umsturz der Werte: Abhandlungen und Aufsätze, Gesammelte Werke*, vol. 3 (Bern: Francke, 1972), p.346.

28. Ibid., pp.351–2. See Worringer's exposition of Riegl's concept of the *Kunstwollen* in terms of *Wollen* and *Können* in *Abstraktion und Einfühlung: Ein Beitrag zur Stilpsychologie* (1908; repr. of 3rd ed. Munich: Piper, 1948), p.21.

29. Sombart, *Der Bourgeois*, p.1.

30. See chap. I above.

31. Sombart, *Die drei Nationalökonomien*, pp.211–13. Sombart refers to Heinrich Wölfflin, "Das Problem des Stils in der bildenden Kunst," *Sitzungsberichte der Königlichen Preussischen Akademie der Wissenschaften* 31 (1912): 572–8.

32. Scheler, "Der Bourgeois," p.351.

33. For an interesting discussion of the role of this tradition in German *political* thought, see Harold James, *A German Identity, 1770–1990* (London: Weidenfeld & Nicolson, 1989), pp.55–87.

34. Georg Simmel, *The Philosophy of Money*, trans. T. Bottomore and D. Frisby (London: Routledge & Kegan Paul, 1978), p.54. On Simmel's first presentation of this material, see David Frisby's introduction to the English translation, p.1.

35. Schmoller, letter to Muthesius of 4 March 1909, Nachlass Muthesius 2.1, Werkbund-Archiv, Berlin.

36. Letter to Schmoller of 7 September 1909, Nachlass Muthesius 2.4, Werkbund-Archiv, Berlin.

37. Muthesius, "Das Kunstgewerbe," *Die Weltwirtschaft* 1, pt. 1 (1906): 312–25; and 2, pt. 1 (1907): 312–25.

38. "Untersuchung über die wirtschaftlichen Bedingungen der Qualitätsarbeit," *Deutscher Werkbund: II. Jahresversammlung zu Frankfurt a. Main . . . vom 30. September bis 2. Oktober 1909* (n.p., n.d. [1909]), p.20.

39. Ibid., p.22.

40. Ibid., p.22–3.

41. On the controversy surrounding Ehrenberg and the suspicions that he represented industrial interests, see Rüdiger vom Bruch, *Wissenschaft, Politik und öffentliche Meinung: Gelehrtenpolitik im wilhelminischen Deutschland (1890–1914)* (Husum: Matthiesen, 1980), pp. 298–300 and 438–9.

42. Letter to Muthesius of 18 October 1909, Nachlass Muthesius 2.1, Werkbund-Archiv, Berlin.

43. Letter to Breuer of 27 October 1909, Nachlass Muthesius 2.4, Werkbund-Archiv, Berlin.

44. Werner Sombart, "Die Entwicklungstendenzen im modernen Kleinhandel," *Schriften des Vereins für Sozialpolitik* 88 (1899): 147.

45. Cornelius Gurlitt, *Im Bürgerhause: Plaudereien über Kunst, Kunstgewerbe und Wohnungs-Ausstattung* (Dresden: Gilgers, 1888), p.68.

46. Ibid., 68–9.

47. Quoted in *Bericht der Geschäftsstelle des Deutschen Werkbundes über die Gründungsversammlung . . .* (Munich, [1907], unpaginated), which is based on uncorrected minutes of the meeting; copy in the Nachlass Ehmcke, Werkbund-Archiv, Berlin. The first sentence was omitted when Schumacher's address was published as "Die Wiedereroberung harmonischer Kultur," *Der Kunstwart* 21, no. 8 (1908): 135-38.

48. Hermann Muthesius, *Wirtschaftsformen im Kunstgewerbe*, Volkswirtschaftliche Zeitfragen, no.233 (Berlin: Simion, 1908), p.11.

49. Bücher develops his theory in "Die Entstehung der Volkswirtschaft," in *Die Entstehung der Volkswirtschaft: Vorträge und Aufsätze*, vol. 1 (1893; 16th ed. Tübingen: H. Laupp, 1919), pp.85-160. On Bücher as the "'head' of the younger economists" of the Verein für Sozialpolitik, see Dieter Krüger, "Max Weber and the Younger Generation in the Verein für Sozialpolitik," p.73.

50. Wolff, "Aesthetik und Wirtschaftslehre," p.271.

51. Karl Scheffler, *Die Architektur der Grossstadt* (Berlin: Bruno Cassirer, 1913), p.8.

52. Ibid.

53. Ibid.

54. Ibid., p.10.

55. One example of the anachronistic, blanket equation of industry and capitalism is Joan Campbell's use of an all-too-common formula: "The Werkbund pioneers addressed themselves to the task of bridging the gulf between *art and industry*." *The German Werkbund: The Politics of Reform in the Applied Arts* (Princeton: Princeton University Press, 1978), p. 3 (emphasis added). That Campbell is not alone is evidenced by the large number of books, articles and exhibition catalogues which deal with the Werkbund under the mottos of "art and industry" or "art and technics." These formulations were of course not unknown at the time, but they were often, as I will suggest, polemical and partisan in a way that has to be explored. Equally common and more neutral were descriptions of the type that appears in a 1907 Werkbund publication, where we read that the Werkbund "seeks to achieve a selection of the best active forces in art, industry, crafts and trade." *Der Deutsche Werkbund, Denkschrift des Ausschusses* (1907), repr. in *Zwischen Kunst und Industrie: Der Deutsche Werkbund*, exh. cat. (Munich: Neue Sammlung, 1975), p.50.

56. See Bücher, "Die Entstehung der Volkswirtschaft," 1:91.

57. Sombart's division of the spirit of capitalism into components is developed in *Die Juden und das Wirtschaftsleben* (Leipzig: Duncker & Humblot, 1911), esp. pp.186–97; and in *Der Bourgeois*. On this aspect of Sombart's work, see

Arthur Mitzman, *Sociology and Estrangement: Three Sociologists of Imperial Germany* (New York: Knopf, 1973), pp. 243-64; and Jeffrey Herf's chapter on Sombart in *Reactionary Modernism: Technology, Culture and Politics in Weimar and the Third Reich* (Cambridge: Cambridge University Press, 1984), pp.130-51.

58. Scheler, "Der Bourgeois," p.353.

59. Sombart, *Die Juden und das Wirtschaftsleben*, p.132, quoted in Herf, *Reactionary Modernism*, p.143.

60. On Sombart's work in the context of contemporary anti-Semitism, see Herf, *Reactionary Modernism*. In relation to issues of art, these view can already be found, for example, in the written work of Richard Wagner. On stereotypes of Jews in general, see George L. Mosse, *The Crisis of German Ideology: Intellectual Origins of the Third Reich* (New York: Schocken, 1981), pp. 126–45; and the chapter "Elemente des Antisemitismus" in Max Horkheimer and Theodor W. Adorno, *Dialektik der Aufklärung: Philosophische Fragmente* (Amsterdam: Querido, 1947); English translation: "Elements of Anti-Semitism," in *Dialectic of Enlightenment*, trans. J. Cumming (New York: Continuum, 1987).

61. Walter Troeltsch, *Volkswirtschaftliche Betrachtungen über die Mode* (Marburg: G. Elwert, 1912), p.17.

62. Friedrich Naumann, "Werkbund und Handel," *JDW* 2 (1913): 6 (emphasis in original).

63. Ibid., p.9.

64. Ibid., p.10.

65. Ibid.

66. Ibid.

67. The 1908 address appeared as *Wirtschaftsformen im Kunstgewerbe*; the 1910 speech was printed in *Volkswirtschaftliche Blätter* 9, no. 15/16 (1910): 260–4.

68. *Wirtschaftsformen im Kunstgewerbe*, p.16 (emphasis added).

69. Ibid., p.19. In an extended reading of a later text by Muthesius (*Handarbeit und Massenerzeugnis* [1917]), Julius Posener also points to Muthesius's identification of *Handel* as the cause of the decline in quality of consumer goods, and his remarks have served as an important inspiration to my discussion. I hope to be able to put this insight into a broader context, to show that Muthesius's attitude was shared by a large group in the Werkbund and was central to their strategies of reform. See *Berlin auf dem Wege zu einer neuen Architektur: Das Zeitalter Wilhelms II.* (Munich: Prestel, 1979), pp.525–30, esp. p.528.

70. Sombart, "Die Entwicklungstendenzen im modernen Kleinhandel," p. 155.

71. Hermann Muthesius, *Handarbeit und Massenerzeugnis* (Berlin: Zentralinstitut für Erziehung und Unterricht, 1917), p.23.

72. Werner Sombart, *Die deutsche Volkswirtschaft im neunzehnten Jahrhundert und im Anfang des 20. Jahrhunderts* (1903; 5th ed. Berlin: Bondi, 1921), p.114.

73. And indeed it could: the slew of writings on advertising was triggered no doubt by the drafting of legislation at the time to limit the placement of billboards in the countryside.

74. Quoted in Ludwig Lindner, "Die 'Reklamepest' in der deutschen Landschaft," *Mitteilungen des Vereins der Plakatfreunde* 3, no. 1 (1912): 6.

75. Werner Sombart, "Die Reklame," *Der Morgen* 2, no. 10 (1908): 282-83.

76. Ibid., p.284. So as to leave no doubt as to who was behind this "most unpleasant machinery," Sombart gives the example of two merchants, each trying to trap a naive farmer and sell him an inferior off-the-rack suit; not incidentally, Sombart gives his peasant the emblematically German name "Michel" and calls his merchants "Levy" and "Cohn" (p.283).

77. Hans Weidenmüller, *Beiträge zur Werbelehre* (Werdau: Werbe-Verlag Oskar Meister, 1912), p.50.

78. Ferdinand Avenarius, "Reklame und Kultur," *Der Kunstwart* 22, no. 5 (1908): 259.

79. Ibid. (emphasis in original).

80. Hermann Muthesius, "Die englische Bewegung gegen die Ausschreitungen des Ankündigungswesens," *Centralblatt der Bauverwaltung*, 26 July 1899, pp.349–50. The diatribe against advertising as a genre that developed first in England, where modern advertising and the commodity culture of which it was a part had the longest history. Muthesius's phobia was a part of his well-known Anglophilia. He would probably have known, for example, Carlyle's oft-cited remarks on the subject. See Carlyle, *Past and Present* (1843, repr. London: Chapman and Hall, 1906), pp.119ff.

81. Richardson Evans, letters to Muthesius of 13 February and 2 June 1906, Nachlass Muthesius 2.1, Werkbund-Archiv, Berlin. Copies of Muthesius's letters to Evans, secretary of the Society, are not preserved in the Werkbund-Archiv.

82. Another reason to avoid public statements on the issue would have been to escape identification with the *Heimatschutz* movement, a group often representing conservative aesthetics and politics which led a particularly bitter campaign against advertising, and with whom Muthesius had other, architectural differences. On the *Heimatschutz* movement, see Christian F. Otto, "Modern Environment and Historical Continuity: The Heimatschutz Discourse in Germany," *Art Journal* 43, no. 2 (1983): 148-57. (It should be noted, however, that the author of this important article on an under-studied subject occasionally exaggerates in describing the broad sympathy for the movement at the time. In particular, he does not note the considerable controversy *Heimatschutz* ideas sparked in the Werkbund, especially Muthesius's stubborn opposition. This controversy is evident behind the forced tact of a discussion at the annual meeting of 1911 that was printed in the first Werkbund *Jahrbuch*: "Wechselrede über ästhetische Fragen der Gegenwart," *JDW* 1 [1912]: 27-36.)

83. Osthaus, letter to Muthesius, 31 December 1912, Karl Ernst Osthaus-Archiv, Hagen, P¹ 447/1–2. The article in question is probably Julius Klinger, "Plakate und Inserate," *JDW* 2 (1913): 109–22 (illustrated section).

84. Anna-Christa Funk describes the purpose of the museum as "the organization of travelling exhibitions of exemplary advertising design . . . and applied arts." She also discusses Muthesius's early involvement in the museum as well as his indignation as an exhibition of advertising material in the Berlin Handelshochschule – for which he had designed the frames – was assumed to have been organized by him. By that time, Muthesius was actually threatening to use his influence to have the exhibition removed from the school if the "overabundance" of the display was not curtailed – quite in line with his critique of advertising in general. Anna-Christa Funk, ed., *Karl Ernst Osthaus gegen Hermann Muthesius: Der Werkbundstreit im Spiegel der im Karl Ernst Osthaus Archiv erhaltenen Briefe* (Hagen: Karl Ernst Osthaus Museum, 1978), p. 2. Funk's conclusions are confirmed by letters in the Handelshochschule archive, now Archiv der Humboldt-Universität, Bestand Wirtschaftshochschule Berlin, file 278. The evolution of the museum and its exhibition policy are traced in great detail in Sebastian Müller, "Deutsches Museum für Kunst in Handel und Gewerbe," in Herta Hesse-Frielinghaus et al., *Karl Ernst Osthaus: Leben und Werk* (Recklinghausen: Bongers, 1971), pp. 259-342. I discuss the museum's approach to advertising in chap. III below.

85. Muthesius, *Handarbeit und Massenerzeugnis*, p.22.

86. Muthesius, "Wo stehen wir?" *JDW* 1 (1912): 24.

87. Karl Lamprecht, *Zur jüngsten deutschen Vergangenheit, Deutsche Geschichte*, supplementary vols. 1 and 2 (Berlin: R. Gaertner, 1901ff.). "Impressionism" in the German criticism of the period has been discussed recently in Lothar Müller, "The Beauty of the Metropolis: Toward an Aesthetic Urbanism in Turn-of-the-Century Berlin," in C.W. Haxthausen and H. Suhr, eds., *Berlin: Culture and Metropolis* (Minneapolis: University of Minnesota Press, 1990), pp.41–7.

88. Richard Hamann, *Der Impressionismus in Leben und Kunst* (Cologne: Dumont-Schauberg, 1907), pp.154–5.

89. Ibid., p.205 (emphasis in original).

90. Ibid., pp.205–6.

91. Ibid., pp.213–16.

92. His student Rudolf Zeitler, a Jew who fled Germany in 1933, writes only of Hamann's "political innocence." See "Richard Hamanns Buch *Der Impressionismus*: Notizen zur Ideengeschichte," in E. Mai, S. Waetzoldt and G. Wolandt, eds., *Ideengeschichte und Kunstwissenschaft: Philosophie und bildende Kunst im Kaiserreich* (Berlin: Gebr. Mann, 1983), p.310.

93. Hamann, *Der Impressionismus*, p.182.

94. The caricature by an unknown artist is actually a self-caricature. It comes from an interesting exhibition project called *Das Überdokument*, a self-parody instigated by members of the Darmstadt artists' colony, of which Behrens was a member, and through which the artists addressed, in good humor, contemporary criticisms of their activities. I discuss the problem of "individualism" and the Darmstadt artists' colony in chap. III below. On Behrens's house see Tilmann Buddensieg, "Das Wohnhaus als Kultbau: Zum Darmstädter Haus von Behrens," in *Peter Behrens und Nürnberg*, exh. cat. (Munich: Prestel, 1980), pp. 37–47; and Alan Windsor, *Peter Behrens, Architect and Designer, 1868–1940* (London: Architectural Press, 1981), pp. 14–26, which also discusses the *Überdokument*.

95. Richard L.F. Schulz, "Beleuchtungskörper," *JDW* 1 (1912): 53.

96. Broder Christiansen, *Philosophie der Kunst* (Hanau: Claus Feddersen, 1909), p.334.

97. Friedrich Naumann, *Der Geist im Hausgestühl* (1906), quoted in Posener, *Berlin*, p.79.

98. Of course, the often marginal status of voices which dissented from this mainstream orthodoxy in no way diminishes their importance. They are discussed in the following chapter.

99. Adolf Vetter, "Die staatsbürgerliche Bedeutung der Qualitätsarbeit," in *Die Durchgeistigung der deutschen Arbeit: Ein Bericht vom Deutschen Werkbund* (Jena: Diederichs, 1911), pp.13-14.

100. Ibid., p.14.

101. Ibid.

102. Ibid., p.16. We should note that for Vetter, the consumer is gendered female.

103. Theodor Fischer, opening address at the 1908 meeting of the Werkbund, in *Die Veredelung der gewerblichen Arbeit*, Verhandlungen des Deutschen Werkbundes zu München am 11. und 12. 1908 (Leipzig: Voigtländer, 1908), pp.12–13.

104. J.A. Lux, *Das neue Kunstgewerbe in Deutschland* (Leipzig: Klinkhardt & Biermann, 1908), p.246.

105. Ibid., p.248.

106. Ibid., p.249.

107. *Die Veredelung der gewerblichen Arbeit*, p.5.

108. Ibid., p.53.

109. See chap. I above.

110. Paul Krais, "Gewerbliche Materialkunde," in *Die*

Durchgeistigung der deutschen Arbeit, p.64. See also Krais's article on the project in *JDW* 1 (1912): 83–4. Two volumes of the *Gewerbliche Materialkunde* appeared: Krais's *Die Hölzer* (Stuttgart: Felix Krais, 1910), and Alfred Eppler, *Die Schmuck- und Edelsteine* (Stuttgart: Felix Krais, 1912).

111. Vetter, "Die staatsbürgerliche Bedeutung der Qualitäts-arbeit," p.12.

112. *Die Veredelung der gewerblichen Arbeit*, p.9 (emphasis in original).

113. Ibid., p.10.

114. Muthesius, *Wirtschaftsformen im Kunstgewerbe*, p.9.

115. Muthesius, *Handarbeit und Massenerzeugnis*, p.4.

116. Ibid., p.6.

117. Ibid., p.9.

118. Ibid., pp.9–10.

119. Ibid., pp.29–30.

120. Lux, *Das neue Kunstgewerbe*, p.246.

121. Sombart, "Die Entwicklungstendenzen im modernen Kleinhandel," pp.149–50 (emphasis in original).

122. Muthesius, "Die Stellung der Kunst in der Volkswirtschaft," report to the Deutscher Volkswirtschaftlicher Verband, in *Volkswirtschaftliche Blätter* 9, no. 15/16 (1910): 263.

123. Naumann, "Werkbund und Handel," pp.11–12.

124. Ibid., p.16.

125. Dr. [Carl] Schaefer, in *Die Veredelung der gewerblichen Arbeit*, p.55.

126. The lecture series is discussed in Sebastian Müller, *Kunst und Industrie: Ideologie und Organisation des Funktionalismus in der Architektur* (Munich: Hanser, 1974), pp.118–19. Müller, who does not mention the involvement of Deutscher Verband für das kaufmännische Unterrichtswesen, notes that the lectures took place in Halle, Halberstadt and Magdeburg. Documents in the archive of the former Berliner Handelshochschule reveal that a similar series was arranged there as well (Archiv der Humboldt-Universität, Bestand Wirtschaftshochschule Berlin, file 278). Dohrn discusses the implications of cooperation with various white-collar employee groups and his choice of the Deutscher Verband in a letter to Osthaus of 3 January 1910, Karl Ernst Osthaus-Archiv, Hagen, DWB 26/3–4.

127. See chap. I above. Because Osthaus's notion of the shop-window leads in a direction different from the one sketched here, it is discussed in greater detail in chap. III below.

128. Lux, *Der Geschmack im Alltag*, p.346.

129. Paul Westheim, "Schaufenster und Schaufenster-dekorateure," *Kunstgewerbeblatt*, n.s., 22, no. 7 (1911): 131–2.

130. See Campbell, *The German Werkbund*, pp.42–3; and Else Oppler-Legband, "Die Höhere Fachschule für Dekorations-kunst," in *Die Durchgeistigung der deutschen Arbeit*, pp.51–5; and her report with the same title in *JDW* 1 (1912): 105–10.

131. On the otherwise common use of detailed figures and busts in shopwindows, see Heidemarie Schade, "'Durch die Kunst blüht das Gewerbe': Fotografien aus dem Nachlass der Wachsfiguren-Fabrik Gebrüder Weber Berlin," *Fotogeschichte* 5, no. 17 (1985): 33–41. My thanks to Bettina Biedermann for this reference.

132. Westheim, "Schaufenster und Schaufensterdekorateure," p.132.

133. Fritz Hellwag, "Neuzeitliche Berliner Architektur," *Kunstgewerbeblatt*, n.s., 23, no. 1 (1911): 3 (emphasis in original).

134. Werner Sombart, *Kunstgewerbe und Kultur* (Berlin: Marquardt, 1908), pp.35–6.

135. Victor Mataja, *Grossmagazine und Kleinhandel* (Leipzig: Duncker & Humblot, 1891), p.61. This was the standard work on the developments in modern commerce at the time.

136. Ibid., p.60.

137. Sombart, *Kunstgewerbe und Kultur*, p.13.

138. Robert Breuer, "Das Kunstgewerbe," *Die Weltwirtschaft* 3, pt. 2 (1908): 203.

139. Gerhard von Schulze-Gaevernitz, *Der Grossbetrieb: Ein wirtschaftlicher und socialer Fortschritt* (Leipzig, 1892). On Schulze-Gaevernitz's role in economic and social policy discussions, see Dieter Krüger, *Nationalökonomen im wilhelminischen Deutschland* (Göttingen: Vandenhoeck & Ruprecht, 1983), chaps. 2–4; and Lindenlaub, *Richtungskämpfe im Verein für Sozialpolitik*, pp.307–14.

140. Schulze-Gaevernitz, "Kultur und Wirtschaft: Die neudeutsche Wirtschaftspolitik im Dienste der neudeutschen Kultur," *Verhandlungen des 18. Evangelisch-Sozialer Kongresses* (Göttingen, 1907), pp.30–1.

141. Karl Scheffler, *Berlin – Ein Stadtschicksal* (1910; repr. Berlin: Fannei & Walz, 1989), p.207.

142. Alexander Schwab, *Möbelkonsumtion und Möbelproduktion in Deutschland* (Berlin: Siemenroth, 1915), pp.59–60.

143. Ibid., pp.60–1.

144. Ibid., pp.61, 58.

145. Richard Calwer, *Kartelle und Trusts* (Berlin: Simon, 1906), pp. 5, 6.

146. Ibid., pp.8–9.

147. Ibid., p.56.

148. Ibid., pp.57–8 (emphasis in original).

149. Johannes Buschmann, "Sozialpolitik und soziale Kultur," *Der Kunstwart* 21, no. 20 (1908): 107–8.

150. Muthesius, "Wo stehen wir?" p.25.

151. Scheffler, *Architektur der Grossstadt*, p.128. Scheffler's positive attitude toward the trust is discussed in Posener, *Berlin*, p. 252; see also the extensive documentation on pp.252–8. For a second time in this chapter I would like to build on Posener's insights, here by exploring the importance other Werkbund figures attributed to economic developments as well their actual economic significance.

152. Scheffler, *Architektur der Grossstadt*, p.14.

153. Karl Scheffler, "Der Fabrikant," *Dekorative Kunst* 7, no. 10 (1904): 406.

154. Bruno Rauecker, review of *Volkswirtschaftliche Betrachtungen über die Mode* by Walter Troeltsch, *Kunstgewerbeblatt*, n.s., 24, no.5 (1913): 139 (emphasis in original).

155. *Die Veredelung der gewerblichen Arbeit*, p.91.

156. Muthesius, "Die Bedeutung des Kunstgewerbes," p.192.

157. John B. Hambrook, "Haus oder Strasse," *JDW* 3 (1914): 25–6.

158. Calwer, *Kartelle und Trusts*, p.59 (emphasis in original).

159. German banks traditionally invested more heavily in industry and trade and were more active in entrepreneurial ventures than Western European banks at the time. See Martin Kitchen, *The Political Economy of Germany, 1815–1914* (London: Croom Helm, 1978), p.133.

160. Rudolf Hilferding, *Das Finanzkapital: Eine Studie über die jüngste Entwicklung des Kapitalismus* (1910; repr. Berlin: Dietz, 1947), pp.282–3.

161. Ibid., p.297.

162. Ibid., p.298.

163. Ibid., p.396.

164. Ibid., pp.248–9.

165. Ibid., p.285.

166. Muthesius, *Wirtschaftsformen im Kunstgewerbe*, pp.16–17.

167. Bruno Rauecker, "Die Bedeutung des Kunstgewerbes für den Gang und Aufbau des deutschen Handels," *Kunstgewerbeblatt*, n.s., 25, no. 1 (1913): 8 (emphasis in original).

168. Scheffler, *Berlin*, p.213.

169. Walter Curt Behrendt, *Der Kampf um den Stil im Kunstgewerbe und in der Architektur* (Stuttgart: Deutsche Verlags-Anstalt, 1920), pp. 93-4.

170. Helmuth Wolff, "Die volkswirtschaftlichen Aufgaben des D.W.B.," pp.88–9 (emphasis in original).

171. Gustav Gericke, address to the Werkbund, in *Die Veredelung der gewerblichen Arbeit*, p.28.

172. Breuer, "Das Kunstgewerbe," p.203.

173. Gericke, in *Die Veredelung der gewerblichen Arbeit*, p. 26. Commenting on this address, Fritz Hellwag of the *Kunstgewerbeblatt* applauded Gericke's attempt to "lead the Werkbund out of abstract aesthetic forms into a more economic organization." "Kunstgewerbliche Rundschau," *Kunstgewerbeblatt*, n.s., 19 (1908): 216.

174. Naumann, *Deutsche Gewerbekunst*, in *Ästhetische Schriften*, p.263.

175. Robert Breuer, "Gildenzeichen," *Das Werkblatt* 1 (1908): 98.

176. Naumann's strong position in favor of the cartels ignited considerable controversy at the 1905 meeting of the Verein für Sozialpolitik, where he challenged Schmoller's support of their close supervision and control by the state. Naumann's views on cartels are discussed in Lindenlaub, *Richtungskämpfe im Verein für Sozialpolitik*, pp. 376–82; on the 1905 contoversy, see pp.409–22.

177. On Schulze-Gaevernitz's positive stance with regard to organized capitalism, see Krüger, *Nationalökonomen im wilhelminischen Deutschland*, chap. 4. Hilferding discusses monopoly capitalism as a transitional stage to communism in *Das Finanzkapital*, pp.509–18.

178. The best account of the founding of the Werkbund, which I largely follow here, is Thiekötter, *Hermann Muthesius im Werkbund-Archiv*, pp.38–44. See also John Heskett, *Design in Germany, 1870–1918* (London: Trefoil, 1986), pp.106–119; and Peter Bruckmann, "Die Gründung des Deutschen Werkbundes 6. Oktober 1907," *Die Form* 10 (1932), repr. in F. Schwarz and F. Gloor, eds., *"Die Form": Stimme des Deutschen Werkbundes, 1925–34* (Gütersloh: Bertelsmann, 1969), pp.82–7.

179. Dr. [Fritz] Schneider, "Kunst und Industrie," address to the Werkbund, in *Deutscher Werkbund: II. Jahresversammlung zu Frankfurt a. Main . . . vom 30. September bis 2. Oktober 1909*, p.10; also quoted in Thiekötter, *Hermann Muthesius im Werkbund-Archiv*, p.38. Thiekötter has found that Bruno Paul, one example of the artist-designer, was guaranteed the extraordinary sum of 75,000 Reichsmarks per year for his work for the Vereinigte Werkstätten (p.39).

180. Campbell, *The German Werkbund*, p.13.

181. Muthesius, "Die Bedeutung des Kunstgewerbes," p.184 (emphasis added).

182. Fachverband für die wirtschaftlichen Interessen des Kunstgewerbes, *Stenographischer Bericht über den 2. Kongress Deutscher Kunstgewerbetreibenden in Düsseldorf am 14. Juni 1907* (n.p., n.d.), pp. 121–2; see also Bruckmann's account of the meeting in "Die Gründung des Deutschen Werkbundes," pp.83–4.

183. Breuer, "Das Kunstgewerbe," pp.206–7.

184. Before the war, Breuer wrote regularly for the SPD daily *Vorwärts*. During the Weimar period he served as an important cultural functionary for the Social Democratic government and was, for a short time, press secretary for Reichspräsident Friedrich Ebert. See Franz Osterroth, *Biographisches Lexikon des Sozialismus* (Hanover: Dietz, 1960), 1:48.

185. Karl Scheffler, "Kunst und Industrie," *Kunst und Künstler* 6, no. 10 (1908): 432.

186. Ch.-E. Jeanneret, *Etude sur le mouvement d'art décoratif en Allemagne* (1912; repr. New York: Da Capo Press, 1980), pp.24, 43.

187. Franz Mannheimer, "A.E.G.-Bauten," *JDW* 2 (1913): 34.

188. Ibid., p.33.

189. Ibid., p.34.

190. Schumacher, "Die Wiedereroberung harmonischer Kultur," p. 138 (emphasis in original).

191. Quoted from the journal *März* in Ernst Jäckh, "5. Jahresbericht des deutschen Werkbundes 1912/13," *JDW* 2 (1913): 101.

192. Hilferding, *Das Finanzkapital*, pp.462–3.

193. Ibid., pp.299–300. Hilferding quotes an American industrialist: "'The day of the individual,' roars Havermeyer at the defenders of the old, 'has passed; if the mass of the people profit at the expense of the individual, the individual should and must go.'"

194. "Monopolist capitalist combines – cartels, syndicates, trusts – divide among themselves, first of all, the whole internal market of a country, and impose their control, more or less completely, upon the industry of that country. . . .

"The famous A.E.G., which grew up in this way, controls 175 to 200 companies (through shareholdings), and a total capital of approximately 1,500,000,000 marks. Abroad, it has thirty-four direct agencies, of which twelve are joint stock companies, in more than ten countries. . . . Needless to say, the A.E.G. is a huge combine. Its manufacturing companies alone number no less than sixteen, and their factories make the most varied articles, from cables and insulators to motor cars and aeroplanes. . . .

"In 1907, the German and American trusts concluded an agreement by which they divided the world between themselves. Competition between them ceased. The American General Electric Company 'got' the United States and Canada. The A.E.G. 'got' Germany, Austria, Russia, Holland, Denmark, Switzerland, Turkey and the Balkans."
V.I. Lenin, *Imperialism: The Highest Stage of Capitalism* (New York: International Publishers, 1939), pp.68–70.

195. Schneider, "Kunst und Industrie," pp.11–12.

196. Schwab, *Möbelkonsumtion und Möbelproduktion in Deutschland*, p. 31. Schwab's findings are also discussed by Uwe Henning, "Ein missglückter Versuch ästhetischer Erziehung von Arbeitern im Wilhelminischen Berlin?" in E. Siepmann and A. Thiekötter, eds., *Packeis und Pressglas: Von der Kunstgewerbebewegung zum Deutschen Werkbund* (Giessen: Anabas, 1987), pp.308 and 310.

197. Henning, "Ein missglückter Versuch," p.308.

198. Schwab, *Möbelkonsumtion und Möbelproduktion in Deutschland*, pp. 31–2.

199. Ibid., p.36.

200. Jürgen Kocka, *Unternehmer in der deutschen Industrialisierung* (Göttingen: Vandenhoeck & Ruprecht, 1975), p.98.

201. Sombart, *Die deutsche Volkswirtschaft im neunzehnten Jahrhundert*, p.317.

202. On the Centralverband Deutscher Industrieller and the Bund der Industriellen, see Hartmut Kaelble, *Industrielle Interessenpolitik in der Wilhelminischen Gesellschaft: Centralverband Deutscher Industrieller, 1895–1914* (Berlin: Walter de Gruyter, 1967); Hans-Peter Ullmann, *Der Bund der Industriellen* (Göttingen: Vandenhoeck & Ruprecht, 1976); and Kitchen, *The Political Economy of Germany*, pp.148 and 223. It should be noted that the newer chemical and electrical industries (such as the AEG) were more closely affiliated with the Bund der Industriellen.

203. Yet existing attempts to consider the Werkbund in light of the economic conditions of the time are based on an uncritical acceptance of Werkbund rhetoric and the assumption that the organization (or at least the Muthesius faction) represented both the interests and ideology of monopolistic capitalist tendencies. Gert Selle situates his discussion in terms of the "swift concentration and monopolizing tendencies" of the furniture industry in the first decade of the twentieth century, giving neither details nor references to support his assumption. "Über bürgerliche Reformversuche der Produktkultur zwischen 1898 und 1912," *Kunst und Alltag um 1900, Werkbund-Archiv Jahrbuch* 3 (1978): 87; see also the discussion of the Werkstätten and the AEG in his *Die Geschichte des Design in Deutschland von 1870 bis heute: Entwicklung der industriellen Produktkultur*, 2nd ed. (Cologne: DuMont, 1978), pp.65–6. Chup Friemert similarly sees the Werkbund as a union of "monopolies and designers" founded with the "decisive involvement of big-capital interests." "Even if," he claims, "the number of highly capitalized concerns in the Werkbund is small, that does not lessen their influence." "Der 'Deutsche Werkbund' als Agentur der Warenästhetik in der Aufstiegsphase des deutschen Imperialismus," in W.F. Haug, ed., *Warenästhetik: Beiträge zur Diskussion, Weiterentwicklung und Vermittlung ihrer Kritik* (Frankfurt: Suhrkamp, 1975), pp.187–90, 192–94, esp.192–93. The only attempt, however brief, to take a critical view of these positions with regard to the putatively "monopolistic" character of the applied arts of the Werkbund period appears in Henning, "Ein missglückter Versuch," pp.308 and 310.

Acceptance of the Werkbund's rhetoric derives from the unnuanced assumption of a monolithic "industry" and of the uniform interests of "industrial capital." Unsupported statements such as the following are typical: "The Werkbund began soon after its founding phase, and unmistakably after ca. 1912, to represent unashamedly the aggressive exploitative interests and expansion politics of German industrial capital." Selle, *Die Geschichte des Designs*, pp.75–6.

204. On Weber's attitude toward the bourgeois renunciation of power, see W.J. Mommsen, *Max Weber and German Politics, 1890–1920*, trans. M. Steinberg (Chicago: University of Chicago Press, 1984), pp.84–90. On Verein members' attitudes toward cartellization, see note 176 above.

205. Its familiarity to Werkbund members is shown by Naumann's comment at the 1914 Cologne meeting in the course of his discussion of exports: "We are facing tariffs these days. [But] I do not mean to start a tariff debate with you. I rejoice for every evening in which I do not have to do so." Naumann, "Werkbund und Weltwirtschaft," in *Ästhetische Schriften*, p.335.

206. On this aspect of Max Weber's free trade position, see Mommsen, *Max Weber and German Politics*, pp.92–3. On Schulze-Gaevernitz's and Naumann's support of export industries which did not have to make political compromises with non-bourgeois powers, see Krüger, *Nationalökonomen in wilhelminischen Deutschland*, pp.44–45; and Lindenlaub, *Richtungskämpfe*, pp.312–13. On the various bourgeois positions of what might be considered a successful "bourgeois revolution," though not in its (perhaps mythical) "liberal democratic form," see Geoff Eley, "The British Model and the German Road: Rethinking the Course of German History Before 1914," in David Blackbourn and Geoff Eley, *The Peculiarities of German History: Bourgeois Society and Politics in Nineteenth-Century Germany* (Oxford: Oxford University Press, 1984), esp.pp. 98–126; on the opposed interests of the

Centralverband Deutscher Industrieller and the Bund der Industriellen, see the brief summary on pp. 113–14 as well as the more detailed accounts in Kaelble, *Industrielle Interessenpolitik in der Wilhelminischen Gesellschaft*; Ullmann, *Der Bund der Industriellen*; and Dirk Stegmann, *Die Erben Bismarcks: Parteien und Verbände in der Spätphase des Wilhelminischen Deutschlands* (Cologne and Bonn: Kiepenheuer & Witsch, 1970), pp. 32–7.

207. Errors resulting from an overgeneralizing approach to the complex and controversial issue of exports in Wilhelmine Germany are as legion as those emerging from the uncritical equation of the Werkbund and "industrial capital," despite the fact that the most politically powerful group of industrial capitalists (in the Centralverband Deutscher Industrieller) sought to curb free international trade. For Selle, the export drive "results directly from the expansion interests of the economic system and complements, at a cultural level, the power politics of the Empire" ("Über bürgerlicher Reformversuche der Produktkultur," p.96). Friemert similarly interprets the "export offensive of German industrialists" in light of his unnuanced assertion that "Capital is forced to conquer the international market" ("Der 'Deutsche Werkbund' als Agentur der Warenästhetik," pp.206, 205). Friemert notes the the position of the Bund der Industriellen with regard to exports, but, apparently unaware of the huge political differences between various industry factions, equates this with "industry" in general (p.197). On the international goals of a "German style" – which as I argue must be separated from any easy equation of exports and "German economic interests" – see Müller, *Kunst und Industrie*, pp.77–84; and Campbell, *The German Werkbund*, pp 18, 49, and 54. Naumann's position on exports, as elaborated in his *Neudeutsche Wirtschaftspolitik* (Berlin, 1902), saw Germany's future as dependent on the export of finished goods. See Posener, "Das Prinzip Wachstum," in *Berlin*, pp.49–54; and Kurt Junghanns, *Der Deutsche Werkbund: Sein erstes Jahrzehnt* (Berlin: Henschelverlag Kunst und Gesellschaft, 1982), pp.10–12. Though an advocate of free trade, Lujo Brentano criticized Naumann's views sharply in an extended review of *Neudeutsche Wirtschaftspolitik* in *Die Nation* 39, 40, 41, 42 (1906).

208. Scheffler, *Berlin*, pp.211–13.

209. "Typen-Schmidt" is the German expression Sombart uses here. *Der moderne Kapitalismus*, 2nd ed., vol. 3 (Munich: Duncker & Humblot, 1927), pp.633–4.

210. "Wechselrede über ästhetische Fragen der Gegenwart," *JDW* 1 (1912): 27.

211. *Die Werkbund-Arbeit der Zukunft*, pp.57–8.

212. Discussions of *Typisierung* in the secondary literature are extremely vague, and there is no serious attempt to define the term precisely in its economic context. Most writers are willing to translate the word simply by recourse to the more general concept of "standardization" – an equation whose inadequacy I will establish – and to take the business advantages as self–evident and not requiring investigation. Thus Heskett writes simply of "standardized forms" (*Design in Germany, 1870–1918*, p.121); Banham of "the establishment of standards (types, norms) of a homogeneous style" (*Theory and Design in the First Machine Age*, p.76); and Campbell calls *Typisierung* "the concentration of design effort on a limited number of generally useful forms" (*The German Werkbund*, p.58). Kurt Junghanns is more expansive but ultimately no more precise, writing of "the necessity of strict discipline of form, the consideration of the mass product and of a closer relationship between artists and industry" (*Der Deutsche Werkbund*, p.42). Selle similarly equates *Typisierung* and standardization and misleadingly

offers an explanation of the latter as a definition of the former: "an adaptation of object design to the demands of machine mass-production (e.g. simplification) and to the demands of economic considerations (e.g. interchangeability of parts)" (*Die Geschichte des Design in Deutschland*, p.223). Only Thiekötter seeks to give a more specific definition in light of a critical reading of the texts (though only the Werkbund texts). She writes that the term did not refer to "the technical conditioning of the product design in production [*die produktionstechnische Konditionierung der Warengestalt*]" but rather "the aesthetic suitability of an article as a repeatable set-piece, fitting seamlessly into various environments on the one hand; on the other, a distinct, easily recognizable and classifiable stylistic characteristic" (Siepmann and Thiekötter, eds., *Packeis und Pressglas*, p. 362). I think, however, that the definition can be pushed even further and given sharper contours.

213. Muthesius's theses or *Leitsätze* are printed in *Die Werkbund-Arbeit der Zukunft*, p.32 and translated in Ulrich Conrads, ed., *Programs and Manifestoes of 20th-Century Architecture*, trans. M. Bullock (Cambridge: MIT Press, 1971), pp.28–9. I have modified Bullock's translation, in particular by retaining the original *Typisierung* in place of the usual English rendering "standardization," which, as we shall see, does not capture the specific meaning of the German term at the time.

214. *Die Werkbund-Arbeit der Zukunft*, p.77. On neo-Kantian "idealism," see Ringer, *Decline of the German Mandarins*, pp. 90–102.

215. Scheffler, *Architektur der Grossstadt*, p.35. Scheffler, we have seen, was an outspoken proponent of a spiritualized economy led by a powerful production sector, and here he also uses the term "type." Yet it must be pointed out that he did not support the program of *Typisierung* in the form presented in 1914 by Muthesius, Naumann and the circle around the Werkstätten. Much of this had no doubt to do with the obvious contrast between Muthesius's triumphant tone and the mediocre quality of the buildings presented as "typical" at the Werkbund Exhibition in 1914 – something Scheffler, the most prominent art critic of the time, clearly had to take into account. But Scheffler did not speak up in the debate; his reaction emerged later. His comments are printed under the editor's title "Über die Auseinandersetzungen im Deutschen Werkbund," in Julius Posener, ed., *Anfänge des Funktionalismus: Von Arts and Crafts zum Deutschen Werkbund* (Berlin: Ullstein, 1964), p.225.

216. Gottfried Semper, *Kleine Schriften*, eds. M. and H. Semper (Berlin, 1884), p.269, quoted in Hans-Joachim Hubrich, *Hermann Muthesius: Die Schriften zu Architektur, Kunstgewerbe, Industrie in der "Neuen Bewegung"* (Berlin: Gebr. Mann, 1981), p.152. Semper also referred to these "types" or "basic ideas" as *Grundformen*, a term Muthesius borrows and gives a technical twist in *Handarbeit und Massenerzeugnis* of 1917, as discussed above. Only in this late text does Muthesius explicitly link the technical basis of Style and the economic basis of the types. For a discussion of Semper's thoughts on *Grundformen* and types, see Heinz Quitzsch, *Die ästhetischen Anschauungen Gottfried Sempers* (Berlin: Akademie-Verlag, 1962), pp.39–53; and Heidrun Laudel, *Gottfried Semper: Architektur und Stil* (Dresden: Verlag der Kunst, 1991), pp.37–57.

217. The address in which Muthesius presented his theses is peppered with denials of the desire to establish a fixed canon of forms, for example: "Art is free and must remain free. It has the right to make mistakes; to a certain extent they serve only to confirm its freedom and otherwise tend to summon forth salutary reactions." Muthesius, "Die Werkbundarbeit

der Zukunft," repr. in *Zwischen Kunst und Industrie*, p. 93.

A fine discussion of the type in the academic tradition is Anthony Vidler, "The Idea of Type: The Transformation of the Academic Ideal, 1750–1830," *Oppositions*, no. 8 (Spring 1977): 95–115. See also Demetrius Porphyrios, "The 'End' of Styles," *Oppositions*, no. 8 (Spring 1977): 119–33. Hubrich makes an extended attempt (quoting some of the same material as I do here) to identify the ideas that could have fed into Muthesius's conception of the type, but he does not critically evaluate the role of the sources he identifies (Hubrich, *Hermann Muthesius*, pp. 151–63). Banham writes quite pertinently of the role of Berlage as a possible mediator between Semper's and Muthesius's notion of the type (*Theory and Design in the First Machine Age*, pp.143–33). The strongest case for a flexible, Semperian interpretation of Muthesius's use of the concept of the type in the debate is made by Stanford Anderson in "Deutscher Werkbund – the 1914 Debate: Hermann Muthesius versus Henry van de Velde," in B. Farmer and H. Louw, eds., *Companion to Contemporary Architectural Thought* (London: Routledge, 1993), pp. 462–67. Finally, it is important to point out that the fusion of an economic (not technical) notion of the type with the academic tradition occurs first in the writings of Le Corbusier, which should not be read back in their entirety into the Werkbund discussions, as these represent only one of Le Corbusier's sources.

218. *Die Werkbund-Arbeit der Zukunft*, pp.64–5.
219. On the *Maschinenmöbel*, see Muthesius, "Maschinenmöbel," in *Das deutsche Hausgerät: Preisbuch 1912*, catalogue for the Deutsche Werkstätten Hellerau/Berlin/Dresden/Munich/Hannover, pp.10–14; Hans Wichmann, *Aufbruch zum neuen Wohnen: Deutsche Werkstätten und WK-Verband (1898–1970)* (Basel: Birkhäuser, 1978), pp.59–65; and Sonja Günther, "Richard Riemerschmid und die Dresdener Werkstätten für Handwerkskunst," in W. Nerdinger et. al., *Richard Riemerschmid: Vom Jugendstil zum Werkbund*, exh. cat. (Munich: Prestel, 1982), pp.34–8, as well as the entries on pp.194–205 of the same catalogue.
220. *Das deutsche Hausgerät: Preisbuch 1912*, p.7.
221. See "Bruno Pauls Typenmöbel," *Dekorative Kunst* 12, no. 2 (1908): 86–87; Hermann Post, "Typenmöbel," *Dekorative Kunst* 12, no. 6 (1909): 258–64; and Sonja Günther, "Typenmöbel von Bruno Paul," *Kunst und Alltag um 1900*, pp. 265–77.
222. Letters to Else Meissner of 30 June and 5 August 1916, Nachlass Meissner WB-SII 47, 49, Werkbund-Archiv, Berlin.
223. Bruno Czolbe, "Die wirtschaftlichen Funktionen der Normalisierung in der deutschen Maschinenindustrie," *Archiv für exakte Wirtschaftsforschung (Thünen-Archiv)* 7 (1915/16): 1–118; here 48-9.
224. Ibid., p.65.
225. Ibid.
226. Of course, this makes Schmidt's positive comments on Czolbe's article problematic, for Schmidt clearly has the reduction of models, among other kinds of standardization, in mind; see his comments quoted below. But it is unlikely that Schmidt – no theoretician – read the entire lengthy text. In his letter, he mentions only the introduction to the article (letter of 30 June 1916, Nachlass Meissner WB-SII 47, Werkbund-Archiv, Berlin).
227. Hilferding, *Das Finanzkapital*, p.272 n.2.
228. Conrads, ed., *Programs and Manifestoes on 20th-Century Architecture*, p.28 (translation modified, emphasis added).
229. Karl Schmidt, "Gedanken für eine neue Ausstellung," *Der Kunstwart* 27, no.1 (1913/14): 21.

230. Bücher, "Das Gesetz der Massenproduktion," in *Die Entstehung der Volkswirtschaft*, vol. 2, 7th ed. (Tübingen: H. Laupp, 1922), p.107. Bücher's article was originally published in the *Zeitschrift für die gesamte Staatswissenschaft* 66 (1910): 429–44; the passages quoted here are from his "Spezialisierung, Normalisierung, Typisierung," *Zeitschrift für die gesamte Staatswissenschaft* 76 (1921): 427–39, which was appended to the anthologized version of the original article.
231. Ibid. (emphasis added).
232. Ibid., p.109.
233. Ibid., pp.109–10.
234. Ibid., p.107.
235. Muthesius, "Wo stehen wir?" p.25.
236. Lux, *Das neue Kunstgewerbe*, pp.249–50 (emphasis added).
237. Karl Schmidt, letters to Else Meissner of 10 and 14 March 1916, Nachlass Meissner WB-SII 20, 22; and Meissner, letter to Schmidt of 10 March 1916, WB-SII 21, Werkbund-Archiv, Berlin.
238. Fritz Hellwag, "Peter Behrens und die A.E.G.," *Kunstgewerbeblatt*, n.s., 22, no. 8 (1911): 150.
239. Muthesius, *Wirtschaftsformen im Kunstgewerbe*, p.28.
240. Lux, *Das neue Kunstgewerbe*, p.246 (emphasis added).
241. Breuer, "Das Kunstgewerbe," p.203.
242. Naumann, "Kunst und Industrie," *Der Kunstwart* 22, no. 2 (1906): 70 (emphasis added).
243. Schwab, *Möbelkonsumtion und Möbelproduktion in Deutschland*, pp. 61–2. Following Schwab's lead, Angelika Thiekötter notes the correspondence between the type and the *Marke* in Siepmann and Thiekötter, eds., *Packeis und Pressglass*, p.365. See also Friemert, "Der 'Deutsche Werkbund' als Agentur der Warenästhetik," pp.198-9.
244. Words with common trade meanings that could apply or refer to the products of more than a single manufacturer could not be registered. (This aspect of the trademark is explored in greater detail in chap. III below.) The term *DeWe* and its signet (designed by Lucian Bernhard) were registered in 1911 (Deutsches Patentamt, Dienststelle Berlin, Warenzeichenrolle, class 42, no. 155500); the word *Typenmöbel* and signet were registered in 1910 (Warenzeichenrolle, class 24, no. 139115).
245. This is the essence of the system, which was and is regulated by laws; but there are exceptions. For example, a manufacturer could continue to produce a wide variety of similar goods under different trademarks, or sell some to distributors who marketed them. Furthermore, distributors could also apply their trademarks to goods they bought – this was the common practice with foodstuffs and was traditional with most wines.
246. Victor Mataja, *Die Reklame: Eine Untersuchung über Ankündigungswesen und Werbetätigkeit im Geschäftsleben* (1910; 2nd ed. Munich: Duncker & Humblot, 1916), p.412.
247. Ibid., pp.413–14.
248. Schwab, *Möbelkonsumtion und Möbelproduktion in Deutschland*, pp. 61–2.
249. Mataja, *Die Reklame*, p.415.
250. Bücher, "Der Handel," in *Die Entstehung der Volkswirtschaft*, 2:239.
251. Mataja, *Die Reklame*, p.418.
252. Ibid., pp.418, 428.
253. Bücher, "Der Handel," p.239.
254. Obviously the brand system did not serve the interests of traditional wholesalers, but here too the Werkbund sought to proselytize, particularly in branches where the brand system was not widely developed and where wholesalers remained an important factor. In the 1913 Werkbund

Jahrbuch, Peter Bruckmann wrote an article in which he sought to argue that the presence of the manufacturer's mark was an incentive to high quality, and that branded goods were easier to market to retailers. "The wholesaler is supported in his efforts to distribute high quality goods quite considerably by the 'brand'. . . . Buyer and seller reach agreement quickly when a 'brand' is in question." The article does not represent the experience of businessmen at the time but is instead an attempt to convince the wholesaler to accept the brand and thus a new economic role. Bruckmann, "Marke und Zwischenhandel," *JDW* 2 (1913): 75.

255. Bücher, "Der Handel," p.238.
256. Fritz Hoeber, *Peter Behrens* (Munich: Müller & Rentsch, 1913), p.155. Gabriele Heidecker discusses Behrens's showroom design but is silent of the business function of such commissions; see "Peter Behrens's Publicity Material for the AEG," in T. Buddensieg, ed., *Industriekultur: Peter Behrens and the AEG*, trans. I.B. Whyte (Cambridge: MIT Press, 1984), pp.173–7.
257. This shopfront by Richard Riemerschmid, based on Johann Vincenz Cissarz's trademark design of 1905, is illustrated in Hans Wichmann, *Aufbruch zum neuen Wohnen*, p. 26. On the Werkstätten's circumvention of traditional retail institutions through affiliates, see Muthesius, *Wirtschaftsformen im Kunstgewerbe*, p.17.
258. From the bibliophile magazine *Der Zwiebelfisch*, quoted in the unsigned article "Reklamewut," *Seidels Reklame* 1 (1913): 125. The same passage is slightly misquoted and incorrectly attributed to the *Seidels Reklame* writer (who takes issue with it) by Henriette Väth-Hinz in the otherwise excellent monograph, *Odol: Reklame-Kunst um 1900* (Giessen: Anabas-Verlag/Werkbund-Archiv, 1985), p.12.
259. On the *Sachplakat*, see Hanna Gagel, "Studien zur Motivgeschichte des deutschen Plakats, 1900–14" (Ph.D. diss., Freie Universität Berlin, 1971); and Jürgen Krause, "Reklame-Kultur," in *1910 – Halbzeit der Moderne: Van de Velde, Hoffmann und die anderen*, exh. cat. (Münster: Westfälisches Landesmuseum für Kunst und Kulturgeschichte, 1992), pp.185–91.
260. See, for example, E. Hertel, "Aus der Werkstatt des Plakatzeichners," *Das Plakat* 3, no. 1 (1912): 17.
261. Sombart, "Ihre Majestät die Reklame," *Die Zukunft* 16, no.39 (1908): 480.
262. Hellwag, review of *Vom sprachlichen Kunstgewerbe* by Hans Weidenmüller, *Kunstgewerbeblatt*, n.s., 20, no.8 (1908): 139.
263. *Seidels Reklame* 1:6 (1913): 169.
264. Scheffler, "Kunst und Industrie," p.434.
265. The Romantic symbol is discussed as a "sign" or *Zeichen* in, for example, Wilhelm Wackenroder's *Herzensergiessungen eines kunstliebenden Klosterbruders* of 1797. See Udo Kultermann, *Kleine Geschichte der Kunsttheorie* (Darmstadt: Wissenschaftliche Buchgesellschaft, 1987), pp.136–8.
266. *III. Jahresbericht des Deutschen Werkbundes 1910/11* (n.p., n.d.), p.13.
267. *IV. Jahresbericht des Deutschen Werkbundes 1911/12* (n.p., n.d.), p.19.
268. *Neunzehn Bundeszeichen nach Entwürfen von Julius Klinger, J.V. Cissarz, F.H. Ehmcke, F.H. Ernst Schneider zur Verwendung auf Drucksachen der dem Deutschen Werkbund angehörigen Firmen* (Hellerau: Werkbund Geschäftstelle, 1911).
269. *IV. Jahresbericht des Deutschen Werkbundes 1911/12* (n.p., n.d.), p.19.
270. Werkbund charter (*Bundessatzung*), §1 (repr. as an appendix to *JDW* 2 [1913]).
271. Josef Popp, introduction to *Deutsches Warenbuch* (Hellerau: Dürerbund-Werkbund Genossenschaft, 1915), p.xvii. Avenarius gives a short history of the project in "Das 'Deutsche Warenbuch,'" *Der Kunstwart* 29, no. 1 (1915): 19–22. Avenarius was of course prominent in the Werkbund, and the overlap of members between the Werkbund and the Dürerbund was considerable. Among the elected directors of the latter in 1912 were Werkbund members Eugen Diederichs, Muthesius, Naumann, Hans Poelzig, Riemerschmid, Hans Schliepmann, and Heinrich Tessenow. On Avenarius, the Dürerbund and the *Kunstwart*, see Gerhard Kratzsch, *Kunstwart und Dürerbund: Ein Beitrag zur Geschichte der Gebildeten im Zeitalter des Imperialismus* (Göttingen: Vandenhoeck & Ruprecht, 1969); on the *Warenbuch*, pp.266–7. The project is mentioned by Campbell, *The German Werkbund*, pp.43–4, 84–5; and Heskett, *Design in Germany, 1870–1918*, p. 127.
272. Ernst Jäckh, "6. Jahresbericht des Deutschen Werkbundes 1913/14," *JDW* 3 (1914): 100.
273. The term "type" is used, for example, in Bruno Rauecker, "Der soziale Gedanke des 'Deutschen Warenbuches,'" *Kunstgewerbeblatt*, n.s., 27, no.6 (1916): 118; and the critique of Fashion was a central theme in Popp's introduction to the *Warenbuch*, pp.xxv–xxvii.
274. A critic in the *Münchner Neueste Nachrichten* remarked drily that "[o]n the basis of the title we will not err to see in the book something like an *industrial arts gospel* that will teach what mass-produced products in German lands are beautiful and good, and at the same time just as clearly tells what is not beautiful and good." "Deutsche Kunst- und Geschäftsfragen II," *Münchner Neueste Nachrichten*, 19 December 1915, p.3. Supporters of the *Warenbuch* did not hesitate to strike the biblical tone. Behrendt, for example, writes that "it is thanks to the work of the Werkbund that there exists in Germany a book, the likes of which no other people [*Volk*] of the world possesses . . . a so-called Book of Commodities, a richly illustrated register of the best and most genuine products of the present." Behrendt, *Der Kampf um den Stil*, p.96.
275. *Deutsches Warenbuch*, p.iii.
276. Quoted in Avenarius, "Ein 'Gewaltstreich gegen das deutsche Wirtschaftsleben,'" *Der Kunstwart* 29, no.10 (1916): 125.
277. Avenarius, "Das 'Deutsche Warenbuch,'" p.19.
278. The four groups that joined the Genossenschaft were the Verband Deutscher Glas-, Porzellan- und Luxuswarenhändler, Nürnberg; Nord und Süd, Berlin; Verband Deutscher Eisenwarenhändler, Mainz; and the Reichsverband Deutscher Spezialgeschäfte in Porzellan, Glas, Haus- und Küchengeräten, Berlin ("6. Jahresbericht," p.100).
279. Letter of 3 April 1913, marked "*Vertraulich*" (confidential); copy in Werkbund-Archiv, Berlin.
280. *Deutsches Warenbuch*, p.xix.
281. Letter to Riemerschmid of 17 March 1913, copy in Werkbund-Archiv, Berlin.
282. "Deutsche Kunst- und Geschäftsfragen II," p.3. A letter of 7 February 1916 from Osthaus to the business office of the Werkbund suggests that the granting of exclusive franchises might indeed have been an unspoken policy; Karl Ernst Osthaus-Archiv, Hagen, DWB 87/17-18.
283. Avenarius, "Ein 'Gewaltstreich,'" p.122 (emphasis in original).
284. Ibid., p.123.
285. "Deutsche Kunst- und Geschäftsfragen II," p.3.
286. Ibid., and Rauecker, "Der soziale Gedanke des 'Deutschen Warenbuches,'" p.120.

287. Avenarius, "Das 'Deutsche Warenbuch,'" p.19.

288. Avenarius, "Ein 'Gewaltstreich,'" p.122.

289. A lecture invitation is discussed in a letter from Schmidt to Muthesius of 25 September 1903, Nachlass Muthesius 2.1, Werkbund-Archiv, Berlin. Schmidt discusses or invokes Bücher's work in a letter to Else Meissner of 10 March 1916, Nachlass Meissner WB-SII 20, Werkbund-Archiv; and in another letter to Muthesius of 20 December 1907, Nachlass Muthesius 2.1. The curriculum for workers and apprentices at the Deutsche Werkstätten included lectures on "Die Entstehung der Volkswirtschaft" (the title of Bücher's major work) and "the characteristics of earlier economic stages." See Bruno Rauecker, *Das Kunstgewerbe in München* (Stuttgart: J.G. Cotta, 1911), pp.143-4.

290. In an article which alludes to the planned exhibition in Cologne, Schmidt writes: "We should petition a brief expert opinion on the idea of creating types, and request permission to publish them in the newspapers, from such man as Avenarius, Behrens, Robert Bosch, Karl Bücher, Theodor Fischer, Cornelius Gurlitt, Adolf Hildebrand, Joseph Hoffmann, Krupp, Karl Lamprecht, Muthesius, Friedr. Naumann, Ostwald, Bruno Paul, Rathenau, R. Riemerschmid, Schumacher, Stinnes, and Adolf Vetter." "Gedanken für eine neue Ausstellung," p.24. Bücher, Lamprecht and Ostwald were all part of what Woodruff Smith has called the "Leipzig Circle" of cultural scientists, to which Schmidt was clearly seeking access. See *Politics and the Sciences of Culture in Germany, 1840-1920* (Oxford and New York: Oxford University Press, 1991), pp. 204-18.

291. Bücher, "Das Gesetz der Massenproduktion," p.111.

292. Ibid., p.115.

293. Ibid., pp.110–11.

294. Ibid., p.110.

295. Ibid., p.109.

NOTES TO CHAPTER III

1. Letter to Bruno Rauecker of 19 October 1915, Karl Ernst Osthaus-Archiv, Hagen, A 1846/24.

2. Both the theses and the countertheses are printed in *Die Werkbund-Arbeit der Zukunft und Aussprache darüber. . . 7. Jahresversammlung des Deutschen Werkbundes vom 2. bis 6. Juli 1914 in Köln* (Jena: Eugen Diederichs, 1914) and translated in Ulrich Conrads, ed., *Programs and Manifestoes of 20th-Century Architecture*, trans. M. Bullock (Cambridge: MIT Press, 1971), here p.28 (translation modified).

3. *Programs and Manifestoes*, p.29 (translation modified).

4. Ibid., pp.28, 29 (translation modified).

5. Ibid., pp.28, 30 (translation modified).

6. Ibid., p.30.

7. Gropius was scheduled to speak at the debate but ceded his time to allow Endell to address the assembly at greater length. On the roles of Gropius and Osthaus as organizers of the opposition to Muthesius, see Anna-Christa Funk, ed., *Karl Ernst Osthaus gegen Hermann Muthesius: Der Werkbundstreit im Spiegel der im Karl Ernst Osthaus Archiv erhaltenen Briefe* (Hagen: Karl Ernst Osthaus Museum, 1978).

8. See the following accounts, which are listed roughly in order of their positions moving from the former to the latter view. Reyner Banham writes that the attitude developed by Muthesius with regard to standardization and industrial production "remained good, for the most part until 1914 and far beyond," while van de Velde's position was "a spirited rearguard action by an outgoing type of designer." *Theory and Design in the First Machine Age*, 2nd ed.

(Cambridge: MIT Press, 1981), p.78. Julius Posener judges the two positions as "progressive" or "retardataire" based on the reduction of the argument to the issue of mass production; see *Berlin auf dem Wege zu einer neuen Architektur: Das Zeitalter Wilhelms II.* (Munich: Prestel, 1979), pp. 11–32 and 525–30. Gert Selle writes of Muthesius's "economic realism" in *Ideologie und Utopie des Design: Zur gesellschaftlichen Theorie der industriellen Formgebung* (Cologne: DuMont, 1973), p.83; he contrasts this with van de Velde's "craft production" stance in *Die Geschichte des Design in Deutschland von 1870 bis heute: Entwicklung der industriellen Produktkultur*, 2nd ed. (Cologne: DuMont, 1978), pp. 62–77, esp. p.70. A similar view is presented in Sebastian Müller, *Kunst und Industrie: Ideologie und Organisation des Funktionalismus in der Architektur* (Munich: Hanser, 1974), pp.109–11. Finally, see Karl-Heinz Hüter's account of the debate and his conclusion that "developments have proven Muthesius right," in *Das Bauhaus in Weimar: Studie zur gesellschaftspolitischen Geschichte einer deutschen Kunstschule* (Berlin: Akademie-Verlag, 1976), pp.109–12. It should be pointed out that the myth of the "left wing" of the Werkbund – a phrase used, for example, by van de Velde (*Geschichte meines Lebens* [1959; rev. ed. Munich: Piper, 1986], p. 360) – represents a retrospective view developed in the years after World War I, when the left (whether radical or not) was a viable standpoint from which to engage in mainstream discussions of design. This holds even though the myth can draw support from certain statements made during the immediate pre-war months with their general antibusiness atmosphere, the start-up phase of a nationalistic wartime ideology.

9. In subtle discussions of the work of Eugène Atget and, more generally, the debates over photography and other modern techniques in France, Molly Nesbit has demonstrated the quiet but crucial cultural role played by copyright law. My consideration of the legal aspects of the applied arts in Germany is directly inspired by and indebted to Nesbit's important work. See the chapter "The Author" in *Atget's Seven Albums* (New Haven and London: Yale University Press, 1992), pp. 90–101; and "What Was an Author?" *Yale French Studies* 73 (1987): 229–57. See also Bernard Edelman, *Ownership of the Image: Elements for a Marxist Theory of Law*, trans. E. Kingdom (London: Routledge & Kegan Paul, 1979); as well as Max Weber's comments on the non-juridical study of laws in his *Rechtssoziologie*, ed. J. Winckelmann (Neuwied: Luchterhand, 1960).

10. Wilhelm Kimbel, "Der Einfluss der modernen Raumkünstler auf die künstlerischen und wirtschaftlichen Interessen des Kunstgewerbes," in Fachverband für die wirtschaftlichen Interessen des Kunstgewerbes, *Stenographischer Bericht über den 2. Kongress deutscher Kunstwerbetreibenden in Düsseldorf am 14. Juni 1907* (n.p., n.d.), p. 70.

11. Ferdinand Avenarius, "Das Urheberrecht geht uns alle an," *Der Kunstwart* 19, no. 2 (1906): 625 (emphasis in original).

12. Hermann Muthesius, *Wirtschaftsformen im Kunstgewerbe*, Volkswirtschaftliche Zeitfragen, no. 233 (Berlin: Simion, 1908), p. 21 (emphasis added).

13. The best discussion of the Dresden exhibition appears in John Heskett, *Design in Germany, 1870–1918* (London: Trefoil, 1986), pp. 106–18. See also my introduction and chap. II, pt. 4 above.

14. J.A. Lux, "Künstler und Fabrikanten," *Der Kunstwart* 20, no. 14 (1907): 113 (emphasis in original).

15. Hermann Muthesius, "Das Kunstgewerbe," *Die Weltwirtschaft* 2, pt. 1 (1907): 317, 320 (emphasis added).

16. Albert Osterrieth, "Das Werk der angewandten Kunst als

Gegenstand des Urherberrechts," *Kunstgewerbeblatt*, n.s., 17, no. 7 (1906): 125–26. On French copyright law, which differs from the earlier German laws only in details on this matter, Nesbit writes that "[t]he *droits d'auteur* were applied to any work done in the designated media, writing, music composition, painting, drawing, and engraving, basically those media that could be worked up into forms of high culture like poems, sonatinas, and red chalk sketches." This paragraph is based on Nesbit, "What Was an Author?" pp. 230–5, here p. 233.

17. See Amtsgerichtsrat Riss, "Urheberrecht und Eigentum," *Dekorative Kunst* 17, no. 2 (1913): 66–73.

18. Copyright law "meant to distinguish a particular kind of labor from another, the cultural from the industrial." Nesbit, "What Was an Author?" p.234. It is not incidental to the flavor or the content of applied arts discussions in Germany that the juridical word for "intellectual" is "*geistig*," which also means "spiritual."

19. "The copyright law regulated the market economy for culture at the same time that it set it apart from the regular economy." Ibid., p. 235.

20. Johannes Neuberg, *Gesetz, betreffend das Urheberrecht an Mustern und Modellen vom 11. Januar 1876* (Berlin: J. Guttentag, 1911), pp.16–17 (hereafter cited as *Musterschutzgesetz*).

21. Lux, "Künstler und Fabrikanten," p.114.

22. Neuberg, *Musterschutzgesetz*, p.34.

23. Osterrieth, "Das Werk der angewandten Kunst als Gegenstand des Urherberrechts," p.125.

24. This was the title of Avenarius's article, from which one of the epigraphs above was taken: "Das Urheberrecht geht uns alle an," pp. 625–30. In the current literature on the applied arts movement, only Gert Selle notes the "intense discussions on the problem of copyright," without relating it to legislative developments at the time . See *Jugendstil und Kunstindustrie: Zur Ökonomie und Ästhetik des Kunstgewerbes um 1900* (Ravensburg: Otto Maier, 1974), p. 34. On the issue of artists' rights in France at the time, see Nancy Troy, *Modernism and the Decorative Arts in France: Art Nouveau to Le Corbusier* (New Haven and London: Yale University Press, 1991), pp. 54–5.

25. Paul Daude, *Gesetz, betreffend das Urheberrecht an Werken der bildenden Künste und der Photographie vom 9. Januar 1907* (Stuttgart: Deutsche Verlags-Anstalt, 1907), pp.13–15 (hereafter cited as *Kunstschutzgesetz*).

26. Stadtrat Sahm, "Das neue Gesetz über das Urheberrecht," *Kunstgewerbeblatt*, n.s., 18, no. 8 (1907): 167.

27. Daude, *Kunstschutzgesetz*, p.17 (commentary); Henry van de Velde, "Allgemeine Bemerkungen zu einer Synthese der Kunst" (1898), repr. in *Zum neuen Stil*, ed. Hans Curjel (Munich: Piper, 1955), p. 37.

28. Daude, *Kunstschutzgesetz*, pp.17–18 (commentary).

29. Osterrieth, "Das Werk der angewandten Kunst als Gegenstand des Urheberrechts," p.126 (emphasis in original).

30. Adolf Vogt, "Folgen des neuen Kunstschutzgesetzes für das Kunstgewerbe," *Innen-Dekoration* 19, no. 8 (1908): 269–70.

31. Carl Behr, "Der Wert der Tradition und der historischen Stile im Kunstgewerbe," *Stenographischer Bericht über den 2. Kongress deutscher Kunstwerbetreibenden*, p.37 (emphasis in original).

32. Ibid., p.38 (emphasis added).

33. Ibid., p.46 (emphasis added).

34. Hermann Muthesius, "Die Bedeutung des Kunstgewerbes: Eröffnungsrede zu den Vorlesungen über modernes Kunstgewerbe an der Handelshochschule in Berlin," *Dekorative Kunst* 10, no. 5 (1907): 177 (emphasis added).

35. Hermann Obrist, "Der 'Fall Muthesius' und die Künstler," *Dekorative Kunst* 11, no. 1 (1907): 44.

36. Behr, "Der Wert der Tradition und der historischen Stile im Kunstgewerbe," p.41 (emphasis in original).

37. J.A. Lux, discussion comments to "Der Fall Muthesius," *Stenographischer Bericht über den 2. Kongress deutscher Kunstwerbetreibenden*, p.128.

38. Quoted in *Zwischen Kunst und Industrie: Der Deutsche Werkbund*, exh. cat. (Munich: Neue Sammlung, 1975), p.30 (emphasis added).

39. Lux, discussion comments to "Der Fall Muthesius," *Stenographischer Bericht über den 2. Kongress deutscher Kunstwerbetreibenden*, p.129.

40. Letter to Bruno Rauecker of 26 October 1915, Karl Ernst Osthaus-Archiv, Hagen, A 1846/33.

41. Hermann Muthesius, "Wo stehen wir?" *JDW* 1 (1912): 15.

42. *Stenographischer Bericht über den 2. Kongress deutscher Kunstgewerbetreibenden*, p.85; and Fachverband, *Stenographischer Bericht über den 6. Kongress deutscher Kunstgewerbetreibenden* (1912), p. 72.

43. Karl Gross, "Kunstgewerbliche Zeit- und Streitfragen," *Kunstgewerbeblatt*, n.s., 19, no. 6 (1908): 115.

44. Neuberg, *Musterschutzgesetz*, p.14 (commentary). See also Dr. Hedinger, "Die Wirkung des neuen Kunstschutz-Gesetzes vom 9. Januar 1907 auf die Praxis," in Fachverband, *Stenographischer Bericht über den 6. Kongress deutscher Kunstgewerbetreibenden*, pp.61–2.

45. Osterrieth, "Das Werk der angewandten Kunst als Gegenstand des Urheberrechts," p.129.

46. Karl Gross, "Das Ornament," *JDW* 1 (1912): 60.

47. Obrist, "Der 'Fall Muthesius' und die Künstler," p.43.

48. "Die Vereinigten Werkstätten für Kunst im Handwerk zu München," *Deutsche Kunst und Dekoration* 8 (1901): 432.

49. Neuberg, *Musterschutzgesetz*, p.21. In order to preserve the resonances of the German vocabulary used, I have translated this legal term literally. In English the term would be "fair use."

50. Karl Scheffler, "Eine Bilanz," *Dekorative Kunst* 6, no. 7 (1903): 252–3.

51. See the artist's own account of the use of his name: "*Van-de-Velde-Stil* or, for short, *Veldescher Stil*! This . . . cost the producers nothing. On the contrary: it was by improperly using my name that they made their profits. Under this 'brand' they offered senseless and ugly imitations for sale, which the public bought in good faith as originals. And I had no legal possibility of opposing this misuse." *Geschichte meines Lebens*, p.185.

52. For the former view, see Julius Posener, "Werkbund and Jugendstil," in Lucius Burckhardt, ed., *The Werkbund: Studies in the History and Ideology of the Deutscher Werkbund, 1907–1933* (London: The Design Council, 1980), pp. 18–20. For the latter view, see the section "Louis-Philippe or the Interior" in Walter Benjamin's 1935 exposé of his Arcades Project titled "Paris – the Capital of the Nineteenth Century," in *Charles Baudelaire: A Lyric Poet in the Era of High Capitalism*, trans. H. Zohn (London: Verso, 1983), pp. 167–9; as well as Dolf Sternberger, "Jugendstil: Begriff und Physiognomik," *Die neue Rundschau* 45, no. 9 (1934), 2:255–71, repr. in J. Hermand, ed., *Jugendstil* (Darmstadt: Wissenschaftliche Buchgesellschaft, 1971), pp. 27–56.

53. Scheffler, "Eine Bilanz," p.246.

54. On Morris's inspiration of the *Werkstättenbewegung*, see Heskett, *Design in Germany*, p.93.

55. Scheffler, "Sozial angewandte Kunst," *Dekorative Kunst* 3, no. 4 (1900): 129 (emphasis added).

56. "Die Vereinigten Werkstätten für Kunst im Handwerk zu München," p.428.

57. Hermann Muthesius, "Kunst und Volkswirtschaft," *Dokumente des Fortschritts* 1, no. 3 (1908): 118.
58. Anton Jaumann, "Vom künstlerischen Eigentumsrecht," *Innen-Dekoration* 19, no. 8 (1908): 248.
59. Vogt, "Folgen des neuen Kunstschutzgesetzes für das Kunstgewerbe," p.266.
60. Daude, *Kunstschutzgesetz*, p.37.
61. Vogt, "Folgen des neuen Kunstschutzgesetzes für das Kunstgewerbe," p.266.
62. Jaumann, "Vom künstlerischen Eigentumsrecht," p.251.
63. Gustav Gericke, in *Die Veredelung der gewerblichen Arbeit*, Verhandlungen des Deutschen Werkbundes zu München am 11. und 12. 1908 (Leipzig: Voigtländer, 1908), p.25.
64. Vogt, "Folgen des neuen Kunstschutzgesetzes für das Kunstgewerbe," p.266.
65. Hermann Muthesius, "Die Werkbundarbeit der Zukunft," repr. in *Zwischen Kunst und Industrie*, p.87.
66. Ernst Jäckh, "6. Jahresbericht des Deutschen Werkbundes 1913/14," *JDW* 3 (1914): 87.
67. Franz Servaes, "Der Wille zum Stil," *Die neue Rundschau* 16, no. 1 (1905): 107–8.
68. Quoted in Hans Wichmann, *Aufbruch zum neuen Wohnen: Deutsche Werkstätten und WK-Verband (1898–1970)* (Basel: Birkhäuser, 1978), p. 52.
69. Jaumann, "Vom künstlerischen Eigentumsrecht," p.251.
70. Review of *JDW* 2 (1913), in *Seidels Reklame* 1, no. 12 (1913): 438.
71. Friedrich Naumann, "Kunst und Volkswirtschaft" (1912), repr. in *Ästhetische Schriften, Werke*, vol. 6 (Cologne/Opladen: Westdeutscher Verlag, 1964), p.302.
72. Paul Mahlberg, review of the *Monographien deutscher Reklamekünstler, Kunstgewerbeblatt*, n.s., 24, no. 8 (1913): 155.
 The wild card in the 1914 debate is Robert Breuer, who spoke out for van de Velde, though we have often noted his views on capital, spirit and discipline which would clearly lead to the support of *Typisierung*. It is revealing, however, that Breuer's support at Cologne was as unwelcome as it was surprising to the Osthaus faction: a letter of 13 July 1914 from Osthaus to Behrens complains that Breuer's unsolicited comments actually hurt their position. Karl Ernst Osthaus-Archiv, Hagen, Kü 332; repr. in Funk, ed., *Karl Ernst Osthaus gegen Herman Muthesius*, p.15.
73. On the granting of commissions, see Angelika Thiekötter, "Der Werkbund-Streit," in *Die Deutsche Werkbund-Ausstellung Cöln 1914*, exh. cat. (Cologne: Kölnischer Kunstverein, 1984), pp. 82–8.
74. On the wide range of Osthaus's patronage, see the essays collected in Herta Hesse-Frielinghaus et al., *Karl Ernst Osthaus: Leben und Werk* (Recklinghausen: Bongers, 1971); on the Deutsches Museum, see Sebastian Müller's contribution "Deutsches Museum für Kunst in Handel und Gewerbe," pp.259–342.
75. [Signed] Folkwang Museum für Kunst und Wissenschaft, "Ist die Kunst eine Gefahr für die Berufsinteressen?" *Zeitschrift für moderne Reklame*, no. 3/4 (1904): 105–7.
76. Karl Ernst Osthaus, "Gründung eines Deutschen Museums für Kunst in Handel und Gewerbe in Hagen," *Hagener Zeitung*, 9 August 1909, quoted in Müller, "Deutsches Museum," p.267.
77. Ibid., p.268.
78. Letter to Julius Klinger of 25 May 1910, Karl Ernst Osthaus-Archiv, Hagen, A 788/44; quoted in Müller, "Deutsches Museum," p. 320.
79. See Müller, "Deutsches Museum," pp.265–6.
80. An idea apparently discussed with Ernst Growald, head of the agency Hollerbaum & Schmidt (for whom Bernhard, Gipkens, and Klinger worked), who replied to the idea at great length in a letter to August Kuth of 2 July 1910, Karl Ernst Osthaus-Archiv, Hagen, A 606/14–18.
81. Hans Weidenmüller, "Die Durchgeistigung der geschäftlichen Werbearbeit," *JDW* 2 (1913): 70.
82. Ibid.
83. Julius Posener, "Der Deutsche Werkbund," *Werk und Zeit Texte*, supplement vol. 5 (1970): 1.
84. Letter of 30 June 1911 from the Deutsches Museum to Ausstellungshalle G.m.b.H. Berlin, describing an "Ausstellung künstlerischer Reklameflächen," Karl Ernst Osthaus-Archiv, Hagen, DWB 1/60/1-
85. Karl Ernst Osthaus, "Wanderausstellung des Deutschen Museums für Kunst in Handel und Gerwerbe, Hagen. Industriebauten und Reklamewesen in Deutschland," manuscript, Karl Ernst Osthaus-Archiv, Hagen, A 1088/4.
86. Karl Ernst Osthaus, "Peter Behrens," *Kunst und Künstler* 6, no. 3 (1907): 123.
87. On the development of the liberal capitalist public sphere and its overlap with the realm of commodity exchange, see Jürgen Habermas, *The Structural Transformation of the Public Sphere: An Inquiry into a Category of Bourgeois Society*, trans. T. Burger (Cambridge: MIT Press, 1989; original German 1962); on citizenship in particular, see p. 83.
88. Anton Jaumann, "Neues von Peter Behrens," *Deutsche Kunst und Dekoration* 23 (1908/9): 343.
89. Karl Ernst Osthaus, "Das Schaufenster," *JDW* 2 (1913): 69.
90. On the genius, see Raymond Williams, *Culture and Society: 1780–1950* (New York: Columbia University Press, 1983), pp.xvi, 39, 44; on the individual, see his *Keywords: A Vocabulary of Culture and Society* (London: Fontana, 1976), pp.135–6. Individualism, the market and the origins of liberal political thought are discussed critically in C.B. Macpherson, *The Political Theory of Possessive Individualism: Hobbes to Locke* (Oxford: Oxford University Press, 1962). On the vicissitudes of liberal-democratic thought in Germany, see David Blackbourn and Geoff Eley, *The Peculiarities of German History: Bourgeois Society and Politics in Nineteenth-Century Germany* (Oxford and New York: Oxford University Press, 1984).
91. The idea of an artistic "dictator" was brought up by Bruno Taut at the 1914 meeting in Cologne. See his discussion comments in *Die Werkbund-Arbeit der Zukunft*, p. 76.
92. Consider Rudolf Bosselt's comment in the Werkbund *Jahrbuch*, which would have been read at the time as a strong statement of cultural laissez-faire: "What we consider perhaps the strongest spiritual characteristic of our age, what strikes most people at least as the most important, is our ability in organization. Here we pat ourselves on the back. We can organize everything. There is only one thing we cannot organize: that the right man comes to the right job in artistic matters." "Verkehr: Geld u. Münzkunst," *JDW* 3 (1914): 69.
93. Fritz Meyer-Schönbrunn, *Peter Behrens* (Hagen: Deutsches Museum für Kunst in Handel und Gewerbe, 1911), p.3.
94. Ibid.
95. Ibid., p.4.
96. Ibid.
97. Osthaus, "Das Schaufenster," p.59.
98. Ibid.
99. Ibid., p.61.
100. Ibid. (emphasis added).
101. Ibid., p.62.
102. Georg Simmel, "Der Bildrahmen: Ein ästhetischer Versuch" (1902), in *Zur Philosophie der Kunst: Philosophische und Kunstphilosophische Aufsätze* (Potsdam: Kiepenheuer,

1922), pp. 46–7 (emphasis in original).

103. Osthaus, "Das Schaufenster," p.63.

104. Ibid.

105. Ibid.

106. On the Mathildenhöhe, see the Festschrift for its opening, *Ein Dokument deutscher Kunst: Die Ausstellung der Künstler-Kolonie in Darmstadt 1901* (Munich: F. Bruckmann, 1901); also Alexander Koch, ed., *Grossherzog Ernst Ludwig und die Ausstellung der Künstlerkolonie in Darmstadt* (Darmstadt: A. Koch, 1901); and Hanno-Walter Kruft, "The Artists' Colony on the Mathildenhöhe," in Burckhardt, ed., *The Werkbund*, pp. 25–34 for further references.

107. Kruft, "The Artists' Colony on the Mathildenhöhe," p.26.

108. "Das Zeichen: Festliche Dichtung von Georg Fuchs," in Koch, ed., *Grossherzog Ernst Ludwig und die Ausstellung der Künstler-Kolonie in Darmstadt*, pp. 63–6, here pp. 65–6.

109. The importance of crystal imagery in Behrens's early work is well documented. See Standford Anderson, "Behrens's Changing Concept," *Architectural Design* 39 (1969): 73–4; Rosemarie Haag Bletter, "The Interpretation of the Glass Dream–Expressionist Architecture and the History of the Crystal Metaphor," *Journal of the Society of Architectural Historians* 40, no. 1 (1981): 30-32; Tilmann Buddensieg, "Das Wohnhaus als Kultbau: Zum Darmstädter Haus von Behrens," in *Peter Behrens und Nürnberg*, exh. cat. (Munich: Prestel, 1980), pp. 39–40; and most recently Regine Prange, *Das Kristalline als Kunstsymbole: Bruno Taut und Paul Klee* (Hildesheim: Georg Olms, 1991) pp.47–8.

110. My equation of the "Zeichen" and the AEG logo has grown out of the discussions of the importance of crystal imagery in Behrens's work cited in nt. 106 above – none of which, however, makes the connection. I have also found Joseph Masheck's broader discussion in "Crystalline Form, Worringer and the Minimalism of Tony Smith," in *Building-Art: Modern Architecture Under Cultural Construction* (Cambridge: Cambridge University Press, 1993), pp. 143–61, to be helpful. My thanks to Professor Masheck for making a copy of his article available to me before its publication.

Though Buddensieg does not make the connection proposed here, his comments on the hexagon logo should be noted: "Behrens offered a geometrical figure – the hexagon – as an analogy to the technological commerce of the AEG. . . . Behrens assembled the AEG's hexagonal trademark in just the same way as the firm's products were themselves assembled. The evocatively crystalline form of this sign, composed of exactly calculated empty areas within the framed plane, conveys a profound sense of perfection. It promotes a mood of contemplation in the observer akin to that generated by 'art.' In this moment of artistic pleasure, Behrens did not miss the opportunity to include the name AEG, thus investing the industrial and technical associations of the firm's trademark with the aura of artistic perfection." In Buddensieg, ed., *Industriekultur: Peter Behrens and the AEG*, trans. I.B. Whyte (Cambridge: MIT Press, 1984), p. 31.

111. Alois Riegl, *Spätrömische Kunstindustrie* (1901; repr. Vienna: Österreichische Staatsdruckerei, 1927), p.343. This passage from Riegl is discussed by Masheck in the context of the general importance of crystalline form at the time. See "Crystalline Form, Worringer and the Minimalism of Tony Smith." p.148.

112. The six-sided ring structure of the benzene molecule was first suggested by August Kekulé von Stradonitz in 1865. The benzene ring hypothesis is another relevant development mentioned by Masheck, who sees in it an example of the organic crystalline. See "Crystalline Form, Worringer and the Minimalism of Tony Smith," p. 147.

113. Osthaus, "Das Schaufenster," p.63.

114. Behrens's writings on the stage include "Die Dekoration der Bühne," *Deutsche Kunst und Dekoration* 6 (1900): 401–5; and "Über die Kunst auf der Bühne," *Frankfurter Zeitung*, 20 March 1910. Behrens sent Osthaus a copy of this latter article; see his letter of 12 April 1910, Karl Ernst Osthaus-Archiv, Hagen, Kü 419/1. On Behrens's involvement through the AEG with developments in stage illumination, see the unsigned article "Moderne Bühnenbeleuchtung," *AEG-Zeitung* 12, no. 7 (1911): 5–7.

115. Peter Behrens, "Die Dekoration der Bühne," p.402.

116. From the title of Behrens's *Feste des Lebens und der Kunst: Eine Betrachtung des Theaters als höchsten Kultursymbols* (Leipzig: Eugen Diederichs, 1900).

117. Osthaus, "Das Schaufenster," p.69.

118. "The elevated, sacerdotal tone which appears in passages of the catalogue [*Ein Dokument deutscher Kunst*] and which often appears in Behrens's literary works of the time, for example . . . 'Feste des Lebens und der Kunst' is something we can no longer really understand." Fritz Hoeber, *Peter Behrens* (Munich: Müller & Rentsch, 1913), p. 15.

119. Osthaus, "Industriebauten und Reklamewesen," manuscript, Karl Ernst Osthaus-Archiv, Hagen, A 1088/6.

120. Jaumann, "Neues von Peter Behrens," p.353.

121. Ibid., p.343.

122. Weidenmüller, "Die Durchgeistigung der geschäftlichen Werbearbeit," p.73.

123. Ibid., pp.71, 73.

124. Sombart, *Die Juden und das Wirtschaftsleben* (Leipzig: Duncker & Humblot, 1911), pp.129–32.

125. For a long time it was simply assumed that Gropius stood on Muthesius's side; see, for example, Nikolaus Pevsner, *Pioneers of Modern Design: From William Morris to Walter Gropius*, rev. ed. (Harmondsworth: Penguin, 1975), p. 38. As the details of Gropius's position have became known, the tendency has been to relativize the stance to maintain the generally assumed trajectory of the early Werkbund through the "classic" Bauhaus of 1923–8 – something that has been encouraged by statements made by Gropius in the 1960s. Reginald Isaacs, for example, writes that "[i]f Gropius fought for the artist's freedom and thus stood on van de Velde's side in Cologne, he nonetheless directed his attacks more against the person of Muthesius than against his theses, and these attacks in no way imply an unqualified agreement with van de Velde's countertheses." *Walter Gropius: Der Mensch und sein Werk* (Frankfurt: Ullstein, 1985), 1:125.

126. Walter Gropius, "Der stilbildende Wert industrieller Bauformen," *JDW* 3 (1914): 29.

127. Walter Gropius, "Monumentale Kunst und Industriebau," lecture held on 10 April 1911 at the Folkwang Museum, Hagen, manuscript, Bauhaus-Archiv, Berlin, Gropius-Sammlung 20/3. Repr. in Hartmut Probst and Christian Schädlich, eds., *Ausgewählte Schriften, Walter Gropius*, vol. 3 (Berlin: Verlag für Bauwesen, 1987), p.29.

128. Walter Gropius, "Zur Wanderausstellung moderner Fabrikbauten," *Der Industriebau* 2 (1911): 47.

129. Gropius, "Die Entwicklung moderner Industriebaukunst," *JDW* 2 (1913): 20.

130. "Concerning your inquiry about billboard space [*Reklameflächen*] [on the Factory and Office Building for the 1914 Werkbund Exhibition], I can give you for the time being no definite information, of course. But the question interests me very much, and I will think about it when working out the project. It could perhaps be dealt with by treating a few large empty planes on one of the long sides in

a poster-like way [*Es könnte sich vielleicht darum handeln, einige grosse Füllungsflächen einer Langseite plakatmässig auszubilden*]. Neon . . . would be quite agreeable to me. I would be happy to work on the sketches and suggestions for this last question personally in connection with my project." Letter from Gropius to Osthaus of 7 August 1913, Karl Ernst Osthaus-Archiv, Hagen, Kü 328/2.

131. It is worth noting that, according to the engineer who assisted Behrens in this design, the vault was given this form "for artistic reasons." Karin Wilhelm, "Fabrikenkunst: The Turbine Hall and What Came of It," in Buddensieg, ed., *Industriekultur*, Eng. trans., p.143. Gropius attrubutes the expression "cathedral of labor" to describe the *Turbinenfabrik* to Karl Scheffler; see "Monumentale Kunst und Industriebau" (1911), in Gropius, *Ausgewählte Schriften*, p.48. The term is also used by Ch.-E. Jeanneret (later Le Corbusier) in *Etude sur le mouvement d'art décoratif en Allemagne* (1912; repr. New York: Da Capo Press, 1980), p. 44.

132. Wolf Dohrn, "The Example of the AEG," *März 3*, no. 17 (1909), repr. and trans. in Buddensieg, ed., *Industriekultur*, Eng. trans., p. 237.

133. Hoeber, *Peter Behrens*, p.107.

134. On the commission from the Träger-Verkaufs-Kontor Berlin G.m.b.H, see Franziska Bollerey and Kristiana Hartmann, "Bruno Taut: Vom phantastischen Ästheten zum ästhetischen sozial(ideal)isten," in *Bruno Taut, 1880–1938*, exh. cat. (Berlin: Akademie der Künste, 1980), p. 41.

135. Annette Ciré, "Exponat und Monument: Bildbeispiele zur Bautypologie des Glashauses," in Angelika Thiekötter et al., *Kristallisationen, Splitterungen: Bruno Tauts Glashaus*, exh. cat. (Berlin: Werkbund-Archiv/Birkäuser Verlag, 1993), p.128. The Monument to Steel was commissioned by the Deutscher Stahlwerksverband and the Verein Deutscher Brücken- und Eisenbau-Fabriken for the Internationale Baufach-Ausstellung in Leipzig. See *Bruno Taut, 1880–1938*, pp.41–3.

136. *Bruno Taut, 1880–1938*, pp.42–7. The most complete account of the project appears in the catalogue accompanying a recent exhibition on the Glass House: *Kristallisationen, Splitterungen*, as in nt. 135 above. The Luxfer Prism companies and their involvement in the innovative architecture of the time, especially exhibition pavilions, are discussed in Dietrich Neumann, "'The Century's Triumph in Lighting': The Luxfer Prism Companies and their Contribution to Early Modern Architecture," *Journal of the Society of Architectural Historians* 54, no. 1 (1995): 24–53, esp. 43–6. It is worth noting that Taut was only able to build the Glass House thanks to the influence of Karl Ernst Osthaus, who was on the steering committee of the Cologne exhibition. See *Kristallisationen, Splitterungen*, p.15; and Kurt Junghanns, *Bruno Taut, 1880-1938*, 2nd ed. (Berlin: Henschelverlag Kunst und Gesellschaft, 1983), p. 27.

137. Banham, *Theory and Design in the First Machine Age*, p.79.

138. On Taut's collaboration with Scheerbart and the interior of the Glass House, see two articles by Rosemarie Haag Bletter: "Paul Scheerbart's Architectural Fantasies," *Journal of the Society of Architectural Historians* 34, no. 2 (1975): 83–97, and "The Interpretation of the Glass Dream – Expressionist Architecture and the History of the Crystal Metaphor," *Journal of the Society of Architectural Historians* 40, no. 1 (1981): 20–43. See also Wolfgang Pehnt, *Expressionist Architecture* (London: Thames and Hudson, 1973), pp.73–7, and Thiekötter et al., *Kristallisationen, Splitterungen*.

139. For example: "Ohne einen Glaspalast/ ist das Leben eine Last" ("Without a glass palace/ life is a burden") or "Das bunte Glas/ zerstört den Hass" ("Colored glass/ destroys hatred"). Scheerbart wrote fourteen aphorisms, of which eight were inscribed on the band beneath the dome. They are discussed in Matthias Schirren, "Ironie und Bewegung: Die Sprüche Paul Scheerbarts," in Thiekötter et al., *Kristallisationen, Splitterungen*, pp. 89–91. In 1920 Taut published his correspondence about the verses in his journal *Frühlicht*, repr. in Taut, *Frühlicht 1920–1922: Eine Folge für die Verwirklichung des neuen Baugedankens*, ed. U. Conrads (Berlin: Ullstein, 1965), pp.19–23. The verses are translated in Dennis Sharp, ed., *"Glass Architecture" by Paul Scheerbart and "Alpine Architecture" by Bruno Taut* (New York: Praeger, 1972), p.14.

Before the First World War, the overlap between the commercial and the artistic was challenged in the literary as well as the visual arts. Scheerbart's aphorisms should be looked at in the context of the so-called "*Werbewortkunst*" of the time. See Hans-Ulrich Simon, *Sezessionismus: Kunstgewerbe in literarischer und bildender Kunst* (Stuttgart: Metzler, 1976), pp.106–7.

140. Taut and his partner Franz Hoffmann had to cover this shortfall, 20,000 Reichsmarks, out of their own pockets. This important information has been brought to light by Angelika Thiekötter in Thiekötter et al., *Kristallisationen, Splitterungen*, pp.15–16.

141. The building of the Fagus-Werk has been exhaustively researched and is documented in two books: Helmut Weber, *Walter Gropius und das Faguswerk* (Munich: Callwey, 1961), and Karin Wilhelm, *Walter Gropius, Industriearchitekt* (Braunschweig: Vieweg, 1983), pp. 41–59. The following interpretation is based on these accounts. See also Reyner Banham's consideration of the Fagus-Werk as a case study of "modernism and Americanism" in *A Concrete Atlantis: U.S. Industrial Building and European Modern Architecture* (Cambridge: MIT Press, 1986), pp.181–94, which summarizes Weber's and Wilhelm's findings concerning the commission.

142. The relation between the Fagus-Werk and Behrens's Turbine Factory is discussed in great detail in Julius Posener, *Berlin auf dem Wege zu einer neuen Architektur* (Munich: Prestel, 1979), pp.564–70, and Wilhelm, *Walter Gropius*, pp. 50–5.

143. Weber cites some of the more prominent examples of this error to appear in print at the time of his own book. See Weber, *Walter Gropius und das Faguswerk*, p.57. This error is still widespread.

144. From Benscheidt's confirmation of the terms of the contract in a letter to Gropius of 13 May 1911; quoted in Weber, *Walter Gropius und das Faguswerk*, p. 30.

145. Ibid., pp.43–7.

146. According to Dr. Annemarie Jaeggi, the archive of the Fagus-Werk contains American shoe-industry publications (acquired by Benscheidt in his travels in the United States in 1910–11) in which articles on the importance of merchandising appear. The archive is now housed in the Bauhaus-Archiv, Berlin, but has not been made available to outside scholars as this book is going to press. See the exhibition catalogue edited by Dr. Jaeggi on the work of Walter Gropius, Adolf Meyer, and the Bauhaus for the Benscheidt family in Alfeld (Berlin: Bauhaus-Archiv, forthcoming). My thanks to Dr. Jaeggi for sharing this information with me.

147. Hertwig's image is prominently illustrated in E. Beutinger, "Die Faguswerke in Alfeld a. L.," *Der Industriebau* 4, no. 2 (1913): 11, and, according to Karl Schürnemann of Fagus-GreCon, Alfeld (the successor firm to the original Fagus G.m.b.H.), it was widely used by Benscheidt in trade publi-

cations of the shoe industry.

148. Lothar Brieger, "Das käufende Publikum," *Seidels Reklame* 1, no. 2 (1913): 43.

149. On the history of the 1894 law, see Arnold Seligsohn, *Gesetz zum Schutz der Warenbezeichnungen*, 2nd ed. (Berlin: J. Guttentag, 1905), pp.17–22.

150. Martin Wassermann, "Die Bedeutung des Markenschutzes," *Volkswirtschaftliche Blätter* 9, no. 9/10 (1910): 156.

151. Chr. Finger, *Das Reichsgesetz zum Schutz der Waarenbezeichnungen vom 12. Mai 1894, nebst Ausführungsbestimmungen* (Berlin: F. Vahlen, 1895), p.1. (I cite the 1894 law from this edition, though the text of the law appears in all the annotated versions cited here.)

152. W. Rhenius, *Gesetz zum Schutz der Warenbezeichnungen vom 12. Mai 1894*, 2nd ed. (Berlin: C. Heymann, 1908), p.3 (commentary). A trademark had also to be *flat*: "The sign consisting of a figurative representation is, due to its nature, *planar* in form, as only planar marks can be contained in the registry." Seligsohn, *Gesetz*, p. 41.

153. Finger, *Das Reichsgesetz*, p.62.

154. Thus the makers of *Odol* mouthwash registered the following marks with the sole intention of preventing others from doing the same: Odo, Ordol, Odentol, Odilol, Usoodol, Odola, Odole, Odolin, Odolina, Odolol, Odolum, Odon, Ohool, Udol, Idol, Lodol, Ozol, Otol, Oudol, Odot, Olol, Odontol, Odovol. See Wassermann, "Die Bedeutung des Markenschutzes," p. 160.

155. Rhenius, *Gesetz*, p.3 (commentary).

156. Chr. Finger, "Beurteilung der Unterscheidungskraft von Warenzeichen, besonders von Buchstabenzeichen; Bedeutung langjährigen Gebrauchs," *Markenschutz und Wettbewerb* 13 (1913/14): 11–12.

157. Finger, *Das Reichsgesetz*, p.34. I simplify here in terminology: the law further distinguishes between 1) "free signs" (*Freizeichen*), or signs that in theory could be registered but had already achieved general use in a branch; and 2) "inadmissable signs" which, due to their necessary communicative function, had to be available for the "free use" (*freier Gebrauch* or *freie Benutzung*) of all.

158. Paul Schultze-Naumburg, "Der 'Urheberschutz' an Bauten," *Der Kunstwart* 19, no. 11 (1906): 616.

159. Ibid., pp.617–18 (emphasis in original).

160. Rhenius, *Gesetz*, pp.3–4 (commentary, emphasis in original).

161. Seligsohn, *Gesetz*, p.15 (commentary).

162. Finger, *Das Reichsgesetz*, p.31 (commentary).

163. Ibid., p.32 (commentary).

164. Paul Westheim, "Anpassung oder Typenschöpfung? Entwicklungsperspektiven des Kunstgewerbes," *Sozialistische Monatshefte* 20, no. 15 (1914): 987.

165. It should be noted that the owner of the trademark need not be the producer of the merchandise marked with it. Nothing prevented a business from buying unmarked objects and reselling them with a trademark.

166. From the AEG's application of 31 January 1908 for the registration of the trademark, Deutsches Patentamt, Dienststelle Berlin, Warenzeichen Abteilung, application 110446.

167. Seligsohn, *Gesetz*, p.14 (introduction).

168. Rhenius, *Gesetz*, p.3.

169. Wassermann, "Die Bedeutung des Markenschutzes," p.157.

170. Finger, *Das Reichsgesetz*, p.34 (commentary, emphasis added).

171. Hugo Hillig, "Wortzeichen," *Die Welt des Kaufmanns* 5, no. 10 (1909): 442–3 (emphasis added).

172. Seligsohn, *Gesetz*, p.40 (commentary).

173. Sapiens [pseud.], "Reklamekritik," *Mitteilungen des Vereins deutscher Reklamefachleute*, no. 32 (1912): 7.

174. Graphic artists would have been well informed not only about the basics of the trademark law but also about recent court decisions from the regular reports appearing in their trade journals: *Das Plakat, Zeitschrift moderner Reklame, Seidels Reklame*, and the *Mitteilungen des Vereins deutscher Reklamefachleute*, as well as from the more general articles appearing in *Werkstatt der Kunst* and its supplement *Wirtschaft und Recht des Künstlers*.

175. Finger, *Das Reichsgesetz*, p.118.

176. Rhenius, *Gesetz*, p.33 (commentary, emphasis in original).

177. Ibid., p.68 (commentary, emphasis in original).

178. Wassermann, "Die Bedeutung des Markenschutzes," p.160 (emphasis added).

179. Rhenius, *Gesetz*, p.7 (commentary, emphasis added).

180. Finger, *Das Reichsgesetz*, p.4 (commentary).

181. Seligsohn, *Gesetz*, p.12 (commentary).

182. Richard Hamann, *Der Impressionismus in Leben und Kunst* (Cologne: Dumont-Schauberg, 1907), pp.31–3 (emphasis in original).

183. Peter Behrens, "Kunst und Technik" (1910), repr. in Tilmann Buddensieg, ed., *Industriekultur: Peter Behrens und die AEG* (Berlin: Gebr. Mann, 1979), p. D284.

184. Ibid.

185. Wilhelm Worringer, "Entstehung und Gestaltungsprinzipien in der Ornamentik," *Kongress für Ästhetik und allgemeine Kunstwissenschaft, Berlin 7.– 9. Oktober 1913, Bericht* (Stuttgart: Ferdinand Enke, 1914), p. 224.

186. Wilhelm Worringer, "Zum Problem der modernen Architektur," *Neudeutsche Bauzeitung* 7 (1911): 498, quoted in Magdalena Bushart, *Der Geist der Gotik und die expressionistische Kunst* (Munich: Schreiber, 1990), p. 46.

187. It is interesting to note in this context that Behrens had originally been asked to draw up the program for the 1914 Werkbund Exhibition. Though the exhibition ultimately developed into a forum from which to call for the development of types, Behrens had originally suggested an emblematically even-handed and conciliatory organization in three sections: "I. Production. II. The Market. III. Form." On Behrens's plan see *Die Wiener (5.) Jahresversammlung des Deutschen Werkbundes vom 6. bis 9. Juni 1912* (Deutscher Werkbund: Geschäftstelle, 1912), pp.16–19. Behrens's plan was not followed, of course. From a bitter letter Behrens wrote to Carl Rehorst, the Cologne city official in charge of the plans with the Werkbund, it appears that Muthesius and perhaps other members of the Werkbund board claimed that allowing Behrens to organize the exhibition represented a conflict of interest and would turn it into an exhibition of the artist's own work. Letter of 21 February 1913, Karl Ernst Osthaus-Archiv, Hagen, Kü 428/11-13.

188. Response to Peter Behrens, "Über den Zusammenhang des baukünstlerischen Schaffens mit der Technik," in *Kongress für Ästhetik . . . 1913, Bericht*, pp.259–60.

189. Ibid., p.262 (emphasis added).

190. Ibid., p.264. The description of Behrens appears in Karl Scheffler, *Die fetten und die mageren Jahre: Ein Arbeits- und Lebensbericht* (Leipzig/Munich: Paul List, 1946), p.35.

191. Peter Behrens, "Einfluss von Zeit- und Raumausnutzung auf moderne Formentwicklung," *JDW* 3 (1914): 7.

192. Ibid., p.10.

193. Ibid.

194. Ibid.

195. August Endell, *Die Schönheit der grossen Stadt* (Stuttgart: Strecker & Schröder, 1908), p.5. Endell discusses the other "accusations against the age" on pp.5–13.

196. Ibid., pp.28–9.

197. Ibid., p.69.

198. Ibid., pp.30–1.

199. Ibid., p.30.

200. Walter Benjamin, "Der Geschmack," in *Gesammelte Schriften*, vol. 1., ed. R. Tiedemann and H. Schweppen-häuser (Frankfurt: Suhrkamp, 1974), pp. 1167-68; trans. in *Charles Baudelaire: A Lyric Poet in the Era of High Capitalism*, trans. H. Zohn (London: Verso, 1973), pp.104–5.

201. Benjamin, "Der Geschmack," in *Gesammelte Schriften*, vol. 1, p.1168; trans. in Benjamin, *Charles Baudelaire*, p.105.

202. Georg Simmel, *The Philosophy of Money*, trans. T. Bottomore and D. Frisby (London: Routledge & Kegan Paul, 1978), p. 175. Hamann discusses Simmel's philosophy as an example of "Impressionism" in *Der Impressionismus in Leben und Kunst*, esp. chap. 7. The issue is a central theme of David Frisby's study *Sociological Impressionism: A Reassessment of Georg Simmel's Social Theory* (London: Heinemann, 1981).

Notes to the Epilogue

1. Walter Gropius, *Grundsätze der Bauhausproduktion* (Dessau: Bauhaus, 1926), trans. in Hans M. Wingler, ed., *The Bauhaus: Weimar, Dessau, Berlin, Chicago*, tr. W. Jabs and B. Gilbert (Cambridge: MIT Press, 1978), p.109.

2. Ibid.

3. Adolf Behne, *Der moderne Zweckbau* (written 1923, published Munich: Drei Masken Verlag, 1926), p. 65.

4. Kurt Schwitters, "Watch Your Step!," *Merz* 6 (1923), repr. in Schwitters, *Das literarische Werk*, vol. 5 (Cologne: DuMont, 1981), pp.167–70, here p.168. Schwitters continues, mixing the philosophical and the burlesque (and Behne follows him): "But since most people – and even a few artists too, here and there – are idiots, and since the idiots are most convinced of their cause, and agreement of all can only be reached at a line in the middle, Style is usually a compromise of art and non-art, of play and function."

5. *Idee und Aufbau des Staatlichen Bauhauses Weimar* (Weimar: Bauhaus, 1923), trans. in Herbert Bayer et al., eds., *Bauhaus 1919-1928*, exh. cat. (New York: The Museum of Modern Art, 1938), p. 20. Of course, the clichés did not fade so quickly. For one prominent example of the Style-Fashion distinction applied to the architecture of the 1920s, see Gustav Adolf Platz, *Die Baukunst der neuesten Zeit* (1927; 2nd ed. Berlin: Propyläen-Verlag, 1930), pp. 162-3.

6. Lewis Mumford, "'Modern' als Handelsware," *Die Form*, n.s., 5, no. 8 (1930).

7. Johannes Molzahn, "Oekonomie der Reklame-Mechane," *Die Form* n.s., 1, no. 7 (1925/26), trans. in Tim Benton, Charlotte Benton and Dennis Sharp, *Form and Function: A Source Book for the History of Architecture and Design 1890–1939* (London: Crosby Lockwood Staples, 1975), p.225.

8. Peter Meyer, "Typisierung und Normung," in *Moderne Architektur und Tradition* (Zurich, 1928), repr. in Kristiana Hartmann, *Trotzdem modern* (Braunschweig: Vieweg, 1994), p.179.

9. The Werkbund, writes Joan Campbell, was becoming much like an ordinary professional organization. Joan Campbell, *The German Werkbund: The Politics of Reform in the Applied Arts* (Princeton: Princeton University Press, 1978), p.183.

 Attempts were still being made to recapture the scope of pre-war design discussions. At the 1928 meeting of the Werkbund, a sociologist, Alfred Weber, and an art historian, Wilhelm Pinder, spoke along with the graphic artist Emil Preetorius and the architect Theodor Fischer, and top-
ics such as "The Problem of Quality" and "Technique and the Expression of Culture" were discussed. But it is interesting that the Werkbund artists who spoke were of the earlier generation, maturing before the war; none of the younger generation was represented on the panel. And the distance between this sort of discussion and the more vigorous architectural discourse of the younger avant-garde is striking. The discussions at this meeting seemed to have had no resonance whatsoever beyond the event. See *Werkbundfragen: Reden der Münchner Tagung 1928*, *Flugschriften der "Form" 1* (1928).

10. The emergence of mass cultural forms themselves is also traditionally associated with the post-World War I period, yet important research has begun to stress the importance of a longer perspective. Jürgen Habermas seeks to historicize the phenomenon of the "culture industry," dating its emergence out of a liberal public sphere to the Wilhelmine period. See *The Structural Transformation of the Public Sphere: An Inquiry into a Category of Bourgeois Society*, trans. T. Burger (Cambridge: MIT Press, 1989; original German 1962), esp. sections V and VI. An important impetus to my reflections here has been Andreas Huyssen's exploration of the inscription of the nineteenth-century commodification of culture in the work of Adorno. See "Adorno in Reverse: From Hollywood to Richard Wagner," in *After the Great Divide: Modernism, Mass Culture, Postmodernism* (Bloomington: Indiana University Press, 1986), pp. 16–43. The important work of Russell Berman in German literature and Miriam Hansen in film studies should also be mentioned in this context: see Berman's "Writing for the Book Industry: The Writer in Organized Capitalism," in *Modern Culture and Critical Theory: Art, Politics, and the Legacy of the Frankfurt School* (Madison: University of Wisconsin Press, 1989), pp.54–69; and Hansen's "Early Silent Cinema: Whose Public Sphere?" *New German Critique*, no. 29 (1983): 147–84.

11. On the circles in which Lukács and Bloch moved, see Eva Karadi, "Ernst Bloch and Georg Lukács in Max Weber's Heidelberg," in W.J. Mommsen and J. Osterhammel, eds., *Max Weber and his Contemporaries* (London: Unwin Hyman, 1987), pp. 499–514; and K.A. Kutzbach, ed., *Paul Ernst und Georg Lukács: Dokumente einer Freundschaft* (Düsseldorf: Paul Ernst Gesellschaft, 1973), passim.

12. Max Horkheimer and Theodor W. Adorno, *Dialektik der Aufklärung: Philosophische Fragmente* (Amsterdam: Querido, 1947), p. 144. See also the English translation by John Cumming, *Dialectic of Enlightenment* (New York: Continuum, 1987), p. 120. Though all translations from Adorno and Horkheimer are my own, I will continue to cite page numbers from the generally serviceable English translation in parentheses.

13. Ibid., p.149 (124).

14. Ibid., p.152 (127).

15. Heinrich Wölfflin, *Die klassische Kunst* (1899, 4th ed. Munich: F. Bruckmann, 1908), p.217; trans. as *Classic Art*, trans. P. and L. Murray (London: Phaidon, 1952), p.231; and Walter Gropius, "Der stilbildende Wert industrieller Bauformen," *JDW* 3 (1914): 29–32.

16. Ibid.

17. Ibid., p.153 (128).

18. Ibid., p.160 (134).

19. Ibid.

20. Ibid., p.155 (130).

21. One should note, however, how the oxymoron in the title of one of Adorno's best-known essays echoes the thesis of the culture industry chapter: "Timeless Fashion: On Jazz." (The usual translation, "Perennial Fashion," blunts the con-

frontation of mutually exclusive terms.) See "Zeitlose Mode: Zum Jazz," in *Prismen: Kulturkritik und Gesellschaft* (Frankfurt: Suhrkamp, 1955), pp.144–61; trans. by Samuel and Shierry Weber in *Prisms* (Cambridge: MIT Press, 1981), pp.119–32.

22. "The more firmly the culture industry is established, the more summarily it can deal with the consumers' needs, producing, steering, disciplining them." Horkheimer and Adorno, *Dialektik der Aufklärung*, p. 171 (144). On Sombart's analysis of Fashion's unification of demand, see chap. I above.

23. Walter Benjamin, "Der Geschmack," in *Gesammelte Schriften*, vol. 1, ed. R. Tiedemann and H. Schweppen-häuser (Frankfurt: Suhrkamp, 1974), p. 1169; trans. in *Charles Baudelaire: A Lyric Poet in the Era of High Capitalism*, trans. H. Zohn (London: Verso, 1973), p.106 (trans. modified).

24. Benjamin, *Gesammelte Schriften*, vol. 1, p.1168; *Charles Baudelaire*, p.105. It is worth noting the pivotal organizational importance this material may have had in Benjamin's planned book on Baudelaire drawing on the material of the Arcades Project. The fragment may have been part of a planned methodological introduction to the book. It is seen as such by Rosemarie Heise, editor of the edition of the essay "The Paris of the Second Empire in Baudelaire" in which the fragment was first published. See Benjamin, *Das Paris des Second Empire bei Baudelaire*, ed. R. Heise (Berlin and Weimar, 1971), p. 11. Rolf Tiedemann and Hermann Schweppenhäuser, however, the editors of Benjamin's *Gesammelte Schriften*, see the two-page hand-written fragment as separate from a preceeding page which is more obviously such an introduction. See Benjamin, *Gesammelte Schriften*, vol. 1, pp.1159–60.

25. Walter Benjamin, "Zentralpark," in *Gesammelte Schriften*, vol. 1, p.681; translated by Lloyd Spencer as "Central Park," *New German Critique*, no. 34 (1985), p.49.

26. Benjamin, "Paris – the Capital of the Nineteenth Century," in *Charles Baudelaire*, p.166.

27. Benjamin, "Zentralpark," p.677; "Central Park," p.46.

28. Benjamin, *Charles Baudelaire*, p.165.

29. Ibid., p.159.

30. Ibid. (trans. modified).

31. Ibid.

32. From Benjamin's early notes for the Arcades Project: "'*Mode und Zynismus*' [by F.T. Vischer] – from the [Berlin] Staatsbibliothek's copy, one sees how often it was once read." "Pariser Passagen I," in *Das Passagen-Werk*, *Gesammelte Schriften*, vol. 5, ed. R. Tiedemann (Frankfurt: Suhrkamp, 1983), p.1019.

33. Benjamin's third chief source on Fashion was the work of Eduard Fuchs.

34. See chap. I above.

35. This is Benjamin's characterization of André Breton, though the interests are just as much his own. See "Surrealism," in *Reflections: Essays, Aphorisms, Autobiographical Writings*, trans. E. Jephcott (New York: Schocken, 1986), p.181.

36. Letter of 23 February 1939, quoted in Perry Anderson, Rodney Livingstone, and Francis Mulhern, eds., *Aesthetics and Politics* (London: New Left Books, 1977), p.104.

 There is much more to say about the way the idea of Fashion functioned in Benjamin's thought, beyond its root-edness in earlier cultural criticism and applied arts discourse. On the centrality of Fashion in the Arcades Project, see Susan Buck-Morss, *The Dialectics of Seeing: Walter Benjamin and the Arcades Project* (Cambridge: MIT Press, 1989), esp. pp.96–101.

37. Benjamin, "Surrealism," p.189.

38. Benjamin, *Gesammelte Schriften*, vol. 5, p. 235 [G 1a, 2].

Bibliography

A. ARCHIVES AND PUBLIC DOCUMENTS

Bauhaus-Archiv, Berlin.

Deutsches Patentamt, Dienststelle Berlin. Warenzeichen Abteilung.

Humboldt Universität, Berlin. Archiv, Bestand Wirtschaftshochschule Berlin. Includes the archive of the former Handelshochschule Berlin.

Karl Ernst Osthaus-Archiv, Hagen.

Werkbund-Archiv, Berlin. Includes the Nachlass Muthesius and the Nachlass Meissner.

B. WERKBUND PUBLICATIONS

Bericht der Geschäftstelle des Deutschen Werkbundes über die Gründungsversammlung am 5. und 6. Oktober 1907 zu München im Hotel "Vier Jahreszeiten." Nach dem unkorrigierten Stenogramme.

Die Veredelung der gewerblichen Arbeit im Zusammenwirken von Kunst, Industrie und Handwerk. Verhandlungen des deutschen Werkbundes zu München am 11. und 12. Juli 1908. Leipzig: Voigtländer, 1908.

Erster Jahresbericht des Deutschen Werkbundes. Geschäftsjahr 1908/9.

II. Jahresversammlung zu Frankfurt a. Main in der Akademie für Sozialwissenschaften vom 30. September bis 2. Oktober 1909. Verhandlungsbericht.

II. Jahresbericht des Deutschen Werkbundes (E.V.). Geschäftsjahr 1909/10.

Die Durchgeistigung der deutschen Arbeit. Bericht über die 3. Jahresversammlung des DWB vom 10-12. Juni 1910. Jena: Eugen Diederichs, 1912.

III. Jahresbericht des Deutschen Werkbundes (E.V.). Geschäftsjahr 1910/11.

Neunzehn Bundeszeichen nach Entwürfen von Julius Klinger, J.V. Cissarz, F.H. Ehmcke, F.H. Ernst Schneider zur Verwendung auf Drucksachen der dem Deutschen Werkbund angehörigen Firmen. Hellerau: Geschäftsstelle, 1911.

IV. Jahresbericht des Deutschen Werkbundes (E.V.). Geschäftsjahr 1911/12.

Die Wiener (5.) Jahresversammlung des Deutschen Werkbundes vom 6. bis 9. Juni 1912.

Zur fünften Tagung des Deutschen Werkbundes. Wien 6-9. Juni 1912.

Die Durchgeistigung der deutschen Arbeit. Jahrbuch des deutschen Werkbundes 1 (1912). Jena: Eugen Diederichs, 1912.

Die Kunst in Industrie und Handel. Jahrbuch des deutschen Werkbundes 2 (1913). Jena: Eugen Diederichs, 1913.

Der Verkehr. Jahrbuch des deutschen Werkbundes 3 (1914). Jena: Eugen Diederichs, 1914.

Articles appearing in the *Jahrbücher* (yearbooks) are listed separately in section C below. The yearbooks are cited *JDW*.

Die Werkbund-Arbeit der Zukunft und Aussprache darüber. . . . 7. Jahresversammlung des Deutschen Werkbundes vom 2. bis 6. Juli 1914 in Köln. Jena: Eugen Diederichs, 1914.

Dürerbund-Werkbund Genossenschaft. *Deutsches Warenbuch.* Introduction by Josef Popp. Hellerau: Dürerbund-Werkbund Genossenschaft, 1915.

C. BOOKS, ARTICLES, PUBLISHED CONFERENCE PROCEEDINGS, AND UNPUBLISHED MANUSCRIPTS

Adorno, Theodor W. *Prisms.* Translated by S. and S. Weber. Cambridge: MIT Press, 1981.

Anderson, Perry, Rodney Livingstone, and Francis Mulhern, eds. *Aesthetics and Politics.* London: New Left Books, 1977.

Anderson, Stanford. "Peter Behrens and the New Architecture of Germany, 1900–1917." Ph.D. diss., Columbia University, 1968.

—. "Behrens' Changing Concept." *Architectural Design* 39 (Feb. 1969): 72–8.

—. "Deutscher Werkbund – the 1914 Debate: Hermann Muthesius versus Henry van de Velde." In *Companion to Contemporary Architectural Thought.* Edited by B.

Farmer and H. Louw. London: Routledge, 1993.

Arato, Andrew. "The Neo-Idealist Defense of Subjectivity." *Telos*, no. 21 (1974): 108–61.

Avenarius, Ferdinand. "Das Urheberrecht geht uns alle an." *Der Kunstwart* 19, no. 2 (1906): 625–30.

—. "Reklame und Kultur." *Der Kunstwart* 22, no. 5 (1908): 257-66.

—. "Das 'Deutsche Warenbuch.'" *Der Kunstwart* 29, no. 1 (1915): 19–22.

—. "Ein 'Gewaltstreich gegen das deutsche Wirtschaftsleben.'" *Der Kunstwart* 29, no. 10 (1916): 121–5.

Banham, Reyner. *Theory and Design in the First Machine Age*. 2nd ed. Cambridge: MIT Press, 1981.

—. *A Concrete Atlantis: U.S. Industrial Building and European Modern Architecture*. Cambridge: MIT Press, 1986

Baudrillard, Jean. *For a Critique of the Political Economy of the Sign*. Translated by C. Levin. St. Louis, Mo.: Telos Press, 1972.

—. *The Mirror of Production*. Translated by M. Poster. St. Louis, Mo.: Telos Press, 1975.

—. *Selected Writings*. Edited by M. Poster. Stanford: Stanford University Press, 1988.

Bayer, Herbert, Walter Gropius, and Ise Gropius, eds. *Bauhaus 1919–1938*. Exh. cat. New York: The Museum of Modern Art, 1938.

Behne, Adolf. *Der moderne Zweckbau*. Munich: Drei Masken Verlag, 1926.

Behrendt, Walter Curt. *Die einheitliche Blockfront als Raumelement im Städtebau: Ein Beitrag zur Stadtbaukunst der Gegenwart*. Berlin: Bruno Cassirer, 1912.

—. *Der Kampf um den Stil im Kunstgewerbe und in der Architektur*. Stuttgart: Deutsche Verlags-Anstalt, 1920.

Behrens, Peter. "Die Dekoration der Bühne." *Deutsche Kunst und Dekoration* 6 (1900): 401–5.

—. *Feste des Lebens und der Kunst: Eine Betrachtung des Theaters als höchsten Kultursymbols*. Leipzig: Eugen Diederichs, 1900.

—. "Professor Peter Behrens über Aesthetik in der Industrie." *AEG-Zeitung* 11, no. 12 (1909): 5–7.

—. "Über die Kunst auf der Bühne." *Frankfurter Zeitung*, 20 March 1910.

—. "Kunst und Technik." Lecture of 1910. Reprinted in *Industriekultur: Peter Behrens und die AEG*. Edited by T. Buddensieg. Berlin: Gebr. Mann, 1979.

—. "Über den Zusammenhang des baukünstlerischen Schaffens mit der Technik." In *Kongress für Ästhetik und allgemeine Kunstwissenschaft, Berlin 7–9. Oktober 1913, Bericht*. Stuttgart: Ferdinand Enke, 1914.

—. "Einfluss von Zeit- und Raumausnutzung auf moderne Formentwicklung." *JDW* 3 (1914): 7–10.

Benjamin, Walter. *Gesammelte Schriften*, vol. 1. Edited by R. Tiedemann and H. Schweppenhäuser. Frankfurt: Suhrkamp, 1974.

—. *Das Passagen-Werk. Gesammelte Schriften*, vo. 5. Edited by R. Tiedemann. Frankfurt: Suhrkamp, 1983.

—. *Charles Baudelaire: A Lyric Poet in the Era of High Capitalism*. Translated by H. Zohn. London: Verso, 1983.

—. "Central Park." Translated by Lloyd Spencer. *New German Critique*, no. 34 (1985): 32–58.

—. *Reflections*. Edited by Peter Demetz and translated by Edmund Jephcott. New York: Schocken, 1986.

Beutinger, E. "Die Faguswerke in Alfeld a.L." *Der Industriebau* 4, no. 1 (1913): 11–19.

Blackbourn, David, and Geoff Eley. *The Peculiarities of German History: Bourgeois Society and Politics in Nineteenth-Century Germany*. Oxford: Oxford University Press, 1984.

Bletter, Rosemarie Haag. "Paul Scheerbart's Architectural Fantasies." *Journal of the Society of Architectural Historians* 34, no. 2 (1975): 83–97.

—. "The Interpretation of the Glass Dream – Expressionist Architecture and the History of the Crystal Metaphor." *Journal of the Society of Architectural Historians* 40, no. 1 (1981): 20–43.

Bloch, Ernst. *Geist der Utopie. Werkausgabe*, vol. 3. Frankfurt: Suhrkamp, 1964. Originally published 1918.

Bollenbeck, Georg. "Stilinflation und Einheitsstil: Zur Funktion des Stilbegriffs in den Bemühungen um eine industrielle Ästhetik." In *Stil: Geschichte und Funktionen eines kulturwissenschaftlichen Diskurselements*. Edited by H.U. Gumbrecht and K.L. Pfeiffer. Frankfurt: Suhrkamp, 1986.

Bosselt, Rudolf. "Verkehr: Geld und Münzkunst." *JDW* 3 (1914): 67–71.

Bovenschen, Silvia, ed. *Die Listen der Mode*. Frankfurt: Suhrkamp, 1986.

Bramsted, Ernest K. *Aristocracy and the Middle-Classes in Germany: Social Types in German Literature, 1830–1900*. Rev. ed. Chicago: University of Chicago Press, 1964.

Breckman, Warren G. "Disciplining Consumption: The Debate about Luxury in Wilhelmine Germany, 1890-1914." *Journal of Social History* 24, no. 3 (1991): 485-505.

Breuer, Robert. "Das Kunstgewerbe." *Die Weltwirtschaft* 3, pt. 2 (1908): 203–12.

—. "Kunstgewerbe und Wirtschaft: Als Anmerkung zu dem kürzlich erschienenen Buch: Werner Sombart, 'Kunstgewerbe und Kultur.'" *Deutsche Kunst und Dekoration* 22 (1908): 304–6.

—. "Die Würde des Werkes." *Das Werkblatt* 1 (1908): 1–5.

—. "Gildzeichen." *Das Werkblatt* 1 (1908): 98.

Brieger, Lothar. "Das kaufende Publikum." *Seidels Reklame* 1, no. 2 (1913): 43–4.

Bruch, Rüdiger vom. *Gelehrtenpolitik im wilhelminischen Deutschland (1890-1914)*. Husum: Matthiesen, 1980.

Bruckmann, Peter. "Marke und Zwischenhandel." *JDW* 2 (1913): 75–8.

—. "Die Gründung des Deutschen Werkbundes 6. Oktober 1907." *Die Form* 10 (1932). Reprinted in *"Die Form": Stimme des Deutschen Werkbundes, 1925-34.* Edited by F. Schwarz and F. Gloor. Gütersloh: Bertelsmann, 1969.

"Bruno Pauls Typenmöbel." *Dekorative Kunst* 12, no. 2 (1908): 86–7.

Bruno Taut, 1880–1938. Exh. cat. Berlin: Akademie der Künste, 1980.

Buck-Morss, Susan. *The Dialectics of Seeing: Walter Benjamin and the Arcades Project.* Cambridge: MIT Press, 1989.

Buddensieg, Tilmann. "Riegl, Behrens, Rathenau." *Kunstchronik*, no. 23 (1970): 282–3.

—. "Das Wohnhaus als Kultbau: Zum Darmstädter Haus von Behrens." In *Peter Behrens und Nürnberg.* Exh. cat. Munich: Prestel, 1980.

Buddensieg, Tilmann, ed. *Industriekultur: Peter Behrens und die AEG.* Berlin: Gebr. Mann, 1979. References also to the English translation by I.B. Whyte: *Industriekultur: Peter Behrens and the AEG.* Cambridge: MIT Press, 1984.

Bücher, Karl. *Die Entstehung der Volkswirtschaft.* 2 vols. Tübingen: H. Laupp, 1893ff.

Burckhardt, Lucius, ed. *The Werkbund: Studies in the History and Ideology of the Deutscher Werkbund, 1907-1933.* Translated by Pearl Sanders. London: The Design Council, 1980.

Buschmann, Johannes. "Volkswirtschaftliche Bildung." *Der Kunstwart* 21, no. 10 (1908): 258–60.

—. "Sozialpolitik und soziale Kultur." *Der Kunstwart* 21, no. 20 (1908): 106-9.

Bushart, Magdalena. *Der Geist der Gothik und die expressionistische Kunst.* Munich: Schreiber, 1990.

Cacciari, Massimo. *Architecture and Nihilism: On the Philosophy of Modern Architecture.* Translated by Stephen Sartarelli. New Haven and London: Yale University Press, 1993.

Calwer, Richard. *Kartelle und Trusts.* Berlin: Simon, 1906.

Campbell, Joan. *The German Werkbund: The Politics of Reform in the Applied Arts.* Princeton: Princeton University Press, 1978.

Christiansen, Broder. *Philosophie der Kunst.* Hanau: Claus Feddersen, 1909.

Colze, Leo. *Berliner Warenhäuser.* Reprint Berlin: Fannei & Walz, 1989. Originally published 1908.

Claussen, Horst. *Walter Gropius: Grundzüge seines Denkens.* Hildesheim: Olms, 1986.

Conrads, Ulrich, ed. *Programs and Manifestoes of 20th-Century Architecture.* Translated by M. Bullock. Cambridge: MIT Press, 1971.

Czolbe, Bruno. "Die wirtschaftlichen Funktionen der Normalisierung in der deutschen Maschinenindustrie." *Archiv für exakte Wirtschaftsforschung (Thünen-Archiv)* 7 (1915/16): 1–118.

Dal Co, Francesco. "The Remoteness of *die Moderne*." *Oppositions*, no. 22 (Fall 1980): 75–95.

—. *Figures of Architecture and Thought: German Architecture Culture, 1880–1920.* Translated by Stephen Sartarelli. New York: Rizzoli, 1990.

Daude, Paul. *Gesetz, betreffend das Urheberrecht an Werken der bildenden Künste und der Photographie vom 9. Januar 1907.* Stuttgart: Deutsche Verlags-Anstalt, 1907.

Debord, Guy. *Society of the Spectacle.* Detroit: Black and Red, 1977. Original French 1967.

"Deutsche Kunst- und Geschäftsfragen." Parts 1–3. *Münchner Neueste Nachrichten*, 17, 19, and 23 December 1915.

Die Deutsche Werkbund-Ausstellung Cöln 1914. Cologne: Kölnischer Kunstverein, 1984.

Deutscher Volkswirtschaftlicher Verband, Berlin. Conference on "Die Stellung der Kunst in der Volkswirtschaft." *Volkswirtschaftliche Blätter* 9, no. 15/16 (1910).

Dilthey, Wilhelm. *Selected Writings.* Edited and translated by H.P. Rickmann. Cambridge: Cambridge University Press, 1976.

Dohrn, Wolf. "The Example of the AEG." *März* 3, no. 17 (1909). Reprinted and translated in *Industriekultur: Peter Behrens and the AEG.* Edited by T. Buddensieg and translated by I.B. Whyte. Cambridge: MIT Press, 1984.

Ein Dokument Deutscher Kunst: Die Ausstellung der Künstler-Kolonie in Darmstadt 1901. Munich: F. Bruckmann, 1901.

Eckstein, Hans, ed. *50 Jahre Deutscher Werkbund.* Frankfurt: Alfred Metzner, 1958.

Edelman, Bernard. *Ownership of the Image: Elements for a Marxist Theory of Law.* Translated by E. Kingdom. London: Routledge & Kegan Paul, 1979.

Ehmcke, F.H. *Wahrzeichen, Warenzeichen.* Berlin: Werbedienst, 1921.

Elias, Norbert. *Über den Prozess der Zivilisation.* 2 vols. Basel: Haus zum Falken, 1939.

Elster, Alexander. "Über die Bedeutung der Mode im Wirtschaftsleben." *Kunstgewerbeblatt*, n.s., 24, no. 11 (1913): 208–10.

—. "Wirtschaft und Mode." *Jahrbücher für Nationalökonomie und Statistik*, 3rd series, 46 (1913): 172–203.

Endell, August. *Die Schönheit der grossen Stadt.* Stuttgart: Strecker & Schröder, 1908.

Erben, Walter. "Karl Ernst Osthaus, Lebensweg und Gedankengut." In Herta Hesse-Frielinghaus et al., *Karl Ernst Osthaus: Leben und Werk.* Recklinghausen: Bongers, 1971.

Fachverband für die wirtschaftlichen Interessen des Kunstgewerbes. *Der "Deutsche Werkbund" und seine Ausstellung Köln 1914: Eine Sammlung von Reden und Kritiken vor und nach der "Tat."* Berlin: Fachverband, 1915.

—. *Stenographischer Bericht über den 2. Kongress Deutscher Kunstgewerbetreibenden in Düsseldorf am 14. Juni 1907.* N.p.

—. *Stenographischer Bericht über den 6. Kongress Deutscher*

Kunstgewerbetreibenden . . . 1912. N.p.

Fausch, Deborah, *et al. Architecture: In Fashion.* Princeton: Princeton Architectural Press, 1994.

Finger, Chr. *Das Reichsgesetz zum Schutz der Waarenbezeichnungen vom 12. Mai 1894, nebst Ausführungsbestimmungen.* Berlin: F. Vahlen, 1895.

——. "Beurteilung der Unterscheidungskraft von Warenzeichen, besonders von Buchstabenzeichen; Bedeutung langjährigen Gebrauchs." *Markenschutz und Wettbewerb* 13 (1913/14): 10-12.

Fletcher, Roger. *Revisionism and Empire: Socialist Imperialism in Germany, 1897-1914.* London: Allen & Unwin, 1984.

Folkwang Museum für Kunst und Wissenschaft. "Ist die Kunst eine Gefahr für die Berufsinteressen?" *Zeitschrift für moderne Reklame,* no. 3/4 (1904): 105–7.

Foucault, Michel. *The Archaeology of Knowledge and the Discourse on Language.* Translated by A.M. Sheridan Smith. New York: Pantheon, 1972.

Franciscono, Marcel. *Walter Gropius and the Creation of the Bauhaus in Weimar.* Urbana: University of Illinois Press, 1971.

Friemert, Chup. "Der 'Deutsche Werkbund' als Agentur der Warenästhetik in der Aufstiegsphase des deutschen Imperialismus." In *Warenästhetik: Beiträge zur Diskussion, Weiterentwicklung und Vermittlung ihrer Kritik.* Ed. W.F. Haug. Frankfurt: Suhrkamp, 1975.

Frisby, David. *Sociological Impressionism: A Reassessment of Georg Simmel's Social Theory.* London: Heinemann, 1981.

——. *Fragments of Modernity: Theories of Modernity in the Work of Simmel, Kracauer and Benjamin.* Cambridge: MIT Press, 1986.

Funk, Anna-Christa, ed. *Karl Ernst Osthaus gegen Hermann Muthesius: Der Werkbundstreit im Spiegel der im Karl Ernst Osthaus Archiv erhaltenen Briefe.* Hagen: Karl Ernst Osthaus Museum, 1978.

Gadamer, Hans-Georg. *Truth and Method.* New York: Crossroad, 1986.

Gagel, Hanna. "Studien zur Motivgeschichte des deutschen Plakats, 1900-14." Ph.D. dissertation, Freie Universität Berlin, 1971.

Gaughan, Martin. "The Cultural Politics of the German Modernist Interior." In *Modernism in Design.* Edited by Paul Greenhalgh. London: Reaktion Books, 1990.

Gaulke, Johannes. "Die Mode in sexueller und wirtschaftlicher Beleuchtung." *Das Blaubuch* 2, no. 45 (1907): 1361–6.

——. *Die ästhetische Kultur des Kapitalismus.* Berlin-Tempelhof: Freier Literarischer Verlag, 1909.

Giedion, Siegfried. *Space, Time and Architecture: The Growth of a New Tradition.* 5th edition. Cambridge: Harvard University Press, 1967.

Glaser, Curt. "Stil oder Mode." *Neue Revue und Morgen,* no. 21 (1909): 731–5.

Göhre, Paul. *Drei Monate Fabrikarbeiter und Handwerksbursche: Eine praktische Studie.* Leipzig: F.W. Grunow, 1891.

——. *Das Warenhaus.* Frankfurt: Rütten & Loenig, 1907.

Gombrich, E.H. *Art and Illusion: A Study in the Psychology of Pictorial Representation.* Oxford: Phaidon, New York: Pantheon, 1960.

——. *Aby Warburg: Eine intellektuelle Biographie.* Translated by M. Fienbork. Frankfurt: Suhrkamp, 1984.

Gronert, Siegfried. "Das Schöne und die Ware: Zur Produktion von Gebrauchsgegenständen und Waren." In *Die Margaretenhöhe, Das Schöne und die Ware.* Essen: Museum Folkwang, 1984.

Gropius, Walter. "Zur Wanderausstellung moderner Fabrikbauten." *Der Industriebau* 2 (1911): 46–7.

——. "Die Entwicklung moderner Industriebaukunst." *JDW* 2 (1913): 17–22.

——. "Der stilbildende Wert industrieller Bauformen." *JDW* 3 (1914): 29–32.

——. *Ausgewählte Schriften.* Vol. 3 of Hartmut Probst and Christian Schädlich. *Walter Gropius.* 3 vols. Berlin: Verlag für Bauwesen, 1987.

Gross, Karl. "Kunstgewerbliche Zeit- und Streitfragen." *Kunstgewerbeblatt,* n.s., 19, no. 6 (1908): 115–16.

——. "Das Ornament." *JDW* 1 (1912): 60–5.

Günther, Sonja. "Typenmöbel von Bruno Paul." In *Kunst und Alltag um 1900. Werkbund-Archiv Jahrbuch* 3 (1978): 265–77.

——. "Richard Riemerschmid und die Dresdener Werkstätten für Handwerkskunst." In *Richard Riemerschmid: Vom Jugendstil zum Werkbund.* Exh. cat. Munich: Prestel, 1982.

Gurlitt, Cornelius. *Im Bürgerhause: Plaudereien über Kunst, Kunstgewerbe und Wohnungs-Ausstattung.* Dresden: Gilgers, 1888.

Habermas, Jürgen. *The Structural Transformation of the Public Sphere: An Inquiry into a Category of Bourgeois Society.* Translated by T. Burger. Cambridge: MIT Press, 1989.

Hamann, Richard. *Der Impressionismus in Leben und Kunst.* Cologne: Dumont-Schauberg, 1907.

Hamann, Richard, and Jost Hermand. *Stilkunst um 1900. Epochen Deutscher Kultur von 1870 bis zur Gegenwart,* vol. 4. Frankfurt: Fischer, 1977.

Hambrook, John B. "Haus oder Strasse?" *JDW* 3 (1914): 24–8.

Haug, W.F. *Warenästhetik, Sexualität und Herrschaft: Gesammelte Aufsätze.* Frankfurt: Fischer, 1972.

——. *Critique of Commodity Aesthetics: Appearance, Sexuality and Advertising in Capitalist Society.* Translated by R. Bock. Minneapolis: University of Minnesota Press, 1986.

Hauser, Arnold. *The Philosophy of Art History.* Cleveland: Meridian, 1958.

Heidecker, Gabriele. "Peter Behrens's Publicity Material for the AEG." In *Industriekultur: Peter Behrens and the AEG.* Edited by T. Buddensieg and translated by I.B. Whyte. Cambridge: MIT Press, 1984.

Hellwag, Fritz. Review of *Vom sprachlichen Kunstgewerbe*, by Hans Weidenmüller. *Kunstgewerbeblatt*, n.s., 20, no. 8 (1908): 139.

—. "Peter Behrens und die A.E.G." *Kunstgewerbeblatt*, n.s. 22, no. 8 (1911): 149–51.

—. "Neuzeitliche Berliner Architektur." *Kunstgewerbeblatt*, n.s., 23, no. 1 (1911): 2–4.

Henning, Uwe. "Ein missglückter Versuch ästhetischer Erziehung von Arbeitern im Wilhelminischen Berlin?" In *Packeis und Pressglass: Von der Kunstgewerbebewegung zum deutschen Werkbund*. Edited by E. Siepmann and A. Thiekötter. Geissen: Anabas, 1987.

Hennis, Wilhelm. "A Science of Man: Max Weber and the Political Economy of the German Historical School." In *Max Weber and his Contemporaries*. Edited by W.J. Mommsen and J. Osterhammel. London: Unwin Hyman, 1987.

Henry van de Velde: Ein europäischer Künstler seiner Zeit. Exh. cat. Cologne: Wienand, 1992.

Herf, Jeffrey. *Reactionary Modernism: Technology, Culture and Politics in Weimar and the Third Reich*. Cambridge: Cambridge University Press, 1984.

Hermand, Jost. "Der gründerzeitliche Parvenü." In Jost Hermand et al., *Aspekte der Gründerzeit*. Berlin: Akademie der Künste, 1974.

Hermann Muthesius im Werkbund-Archiv. Exh. cat. Berlin: Werkbund-Archiv, 1990.

Hertel, E. "Aus der Werkstatt des Plakatzeichners." *Das Plakat* 3, no. 1 (1912): 15–21.

Heskett, John. *Design in Germany, 1870–1918*. London: Trefoil, 1986.

Hesse-Frielinghaus, Herta, et al. *Karl Ernst Osthaus: Leben und Werk*. Recklinghausen: Bongers, 1971.

Hilferding, Rudolf. *Das Finanzkapital: Eine Studie über die jüngste Entwicklung des Kapitalismus*. Reprint Berlin: Dietz, 1947. Originally published 1910.

Hillig, Hugo. "Wortzeichen." *Die Welt des Kaufmanns* 5, no. 10 (1909): 441–4.

Hoeber, Fritz. "Der kollektivistische Charakter der griechischen Kunst." *Sozialistische Monatshefte* 2 (1910): 705–8.

—. *Peter Behrens*. Munich: Müller & Rentsch, 1913.

Holz, Hans Heinz. *Vom Kunstwerk zur Ware: Studien zur Funktion des ästhetischen Gegenstands im Spätkapitalismus*. Neuwied: Luchterhand, 1972.

Horkheimer, Max, and Theodor W. Adorno. *Dialektik der Aufklärung: Philosophische Fragmente*. Amsterdam: Querido, 1947. References also to the English translation by John Cumming: *Dialectic of Enlightenment*. New York: Continuum, 1987.

Hubrich, Hans-Joachim. *Hermann Muthesius: Die Schriften zu Architektur, Kunstgewerbe, Industrie in der "Neuen Bewegung."* Berlin: Gebr. Mann, 1981.

Hüter, Karl-Heinz. *Das Bauhaus in Weimar: Studie zur gesellschaftspolitischen Geschichte einer deutschen Kunstschule*. Berlin: Akademie-Verlag, 1976.

Huyssen, Andreas. *After the Great Divide: Modernism, Mass Culture, Postmodernism*. Bloomington: Indiana University Press, 1986.

Iggers, Georg. *The German Conception of History: The National Tradition of Historical Thought from Herder to the Present*. Rev. ed. Middletown, Conn.: Wesleyan University Press, 1983.

Isaacs, Reginald. *Walter Gropius: Der Mensch und sein Werk*. 2 vols. Frankfurt: Ullstein, 1985.

Iversen, Margaret. *Alois Riegl: Art History and Theory*. Cambridge: MIT Press, 1993.

Jäckh, Ernst. "5. Jahresbericht des Deutschen Werkbundes 1912/13." *JDW* 2 (1913): 97–108.

—. "6. Jahresbericht des Deutschen Werkbundes 1913/14." *JDW* 3 (1914): 87–102.

James, Harold. *A German Identity, 1770–1990*. London: Weidenfeld & Nicolson, 1989.

Jarzombek, Mark. "The *Kunstgewerbe*, the *Werkbund*, and the Aesthetics of Culture in the Wilhelmine Period." *Journal of the Society of Architectural Historians* 53, no. 1 (1994): 7–19.

Jaumann, Anton. "Vom künstlerischen Eigentumsrecht." *Innen-Dekoration* 19, no. 8 (1908): 245–51.

—. "Neues von Peter Behrens." *Deutsche Kunst und Dekoration* 23 (1908/9): 343–57.

Jeanneret, Charles-Edouard [later Le Corbusier]. *Etude sur le mouvement d'art décoratif en Allemagne*. Reprint New York: Da Capo Press, 1980. Originally published 1912.

Junghanns, Kurt. *Bruno Taut, 1880-1938*. 2nd ed. Berlin: Henschelverlag Kunst und Gesellschaft, 1983.

—. *Der Deutsche Werkbund: Sein erstes Jahrzehnt*. Berlin: Henschelverlag Kunst und Gesellschaft, 1982.

Kaelble, Hartmut. *Industrielle Interessenpolitik in der Wilhelminischen Gesellschaft: Centralverband Deutscher Industrieller, 1895-1914*. Berlin: de Gruyter, 1969.

Kallen, Peter. *Unter dem Banner der Sachlichkeit: Studien zum Verhältnis von Kunst und Industrie am Beginn des 20. Jahrhunderts*. Cologne: dme-Verlag, 1987.

Karadi, Eva. "Ernst Bloch and Georg Lukács in Max Weber's Heidelberg." In *Max Weber and his Contemporaries*. Edited by W.J. Mommsen and J. Osterhammel. London: Unwin Hyman, 1987.

Kemp, Wolfgang. "Alois Riegl." In *Altmeister moderner Kunstgeschichte*. Edited by H. Dilly. Berlin: Reimer, 1990.

Kitchen, Martin. *The Political Economy of Germany, 1815–1914*. London: Croom Helm, 1978.

Klinger, Julius. "Plakate und Inserate." *JDW* 2 (1913): 109–22 (illustrated section.)

Koch, Alexander, ed. *Grossherzog Ernst Ludwig und die Ausstellung der Künstlerkolonie in Darmstadt*. Darmstadt: A. Koch, 1901.

Kocka, Jürgen. *Unternehmer in der deutschen Industrialisierung*. Göttingen: Vandenhoeck & Ruprecht, 1975.

Kongress für Ästhetik und allgemeine Kunstwissenschaft, Berlin 7–9. Oktober 1913, Bericht. Stuttgart: Ferdinand Enke, 1914.

Kratzsch, Gerhard. *Kunstwart und Dürerbund: Ein Beitrag zur Geschichte der Gebildeten im Zeitalter des Imperialismus.* Göttingen: Vandenhoeck & Ruprecht, 1969.

Krause, Jürgen. *"Märtyrer" und "Prophet": Studien zum Nietzsche-Kult in der bildenden Kunst der Jahrhundertwende.* Berlin: de Gruyter, 1984.

—. "Reklame-Kultur." In *1910–Halbzeit der Moderne: Van de Velde, Hoffmann und die anderen.* Exh. cat. Münster: Westfälisches Landesmuseum für Kunst und Kulturgeschichte, 1992.

Kristallisationen, Splitterungen: Bruno Tauts Glashaus. Exh. cat. Berlin: Werkbund-Archiv/Birkhäuser Verlag, 1993.

Krüger, Dieter. *Nationalökonomen im wilhelminischen Deutschland.* Göttingen: Vandenhoeck & Ruprecht, 1983.

—. "Max Weber and the Younger Generation in the Verein für Sozialpolitik." In *Max Weber and his Contemporaries.* Edited by W.J. Mommsen and J. Osterhammel. London: Unwin Hyman, 1987.

Kruft, Hanno-Walter. "The Artists' Colony on the Mathildenhöhe." In *The Werkbund: Studies in the History and Ideology of the Deutscher Werkbund, 1907-1933.* Edited by Lucius Burckhardt and translated by Pearl Sanders. London: The Design Council, 1980.

"Die Kunst in Industrie und Handel." Review of *JDW* 2 (1913). *Seidels Reklame* 1, no. 12 (1913): 437–8.

Kutzbach, K.A., ed. *Paul Ernst und Georg Lukács: Dokumente einer Freundschaft.* Düsseldorf: Paul Ernst Gesellschaft, 1973.

Lamprecht, Karl. *Zur jüngsten deutschen Vergangenheit. Deutsche Geschichte,* supplememtary vols. 1 and 2. Berlin: R. Gaertner, 1901ff.

[Langbehn, Julius.] *Rembrandt als Erzieher.* 24th ed. Leipzig: Hirschfeld, 1890.

Laudel, Heidrun. *Gottfried Semper: Architektur und Stil.* Dresden: Verlag der Kunst, 1991.

Lenin, V.I. *Imperialism: The Highest Stage of Capitalism.* New York: International Publishers, 1939.

Lieber, Hans-Joachim. *Kulturkritik und Lebensphilosophie: Studien zur Philosophie der Jahrhundertwende.* Darmstadt: Wissenschaftliche Buchgesellschaft, 1974.

Liebersohn, Harry. *Fate and Utopia in German Sociology, 1870-1923.* Cambridge: MIT Press, 1988.

Lindenlaub, Dieter. *Richtungskämpfe im Verein für Sozialpolitik: Wissenschaft und Sozialpolitik im Kaiserreich, vornehmlich vom Beginn des "neuen Kurses" bis zum Ausbruch des ersten Weltkrieges (1890–1914).* Vierteljahrschrift für Sozial- und Wirtschaftsgeschichte, Beihefte 52/3. Wiesbaden: Steiner, 1967.

Lindner, Ludwig. "Die 'Reklamepest' in der deutschen Landschaft." *Mitteilungen des Vereins der Plakatfreunde* 3, no. 1 (1912): 4–10.

Löwy, Michael. *Georg Lukács: From Romanticism to Bolshevism.* Translated by P. Camiller. London: New Left Books, 1979.

Lukács, Georg. *Theory of the Novel.* Translated by Anna Bostock. Cambridge: MIT Press, 1971. Original German 1920.

—. *History and Class Consciousness: Studies in Marxist Dialectics.* Translated by R. Livingstone. Cambridge: MIT Press, 1971. Original German 1923.

Lux, Joseph August. "Künstler und Fabrikanten." *Der Kunstwart* 20, no. 14 (1907): 113–14.

—. *Der Geschmack im Alltag: Ein Buch zur Pflege des Schönen.* Dresden: Ges. Kühtmann, 1908.

—. *Das neue Kunstgewerbe in Deutschland.* Leipzig: Klinkhardt & Biermann, 1908.

Mahlberg, Paul. Review of the *Monographien deutscher Reklamekünstler,* published by the Deutsches Museum für Kunst in Handel and Gewerbe. *Kunstgewerbeblatt,* n.s., 24, no. 8 (1913): 155–6.

Mannheim, Karl. "On the Interpretation of 'Weltanschauung.'" In *Essays on the Sociology of Knowledge.* Translated and edited by P. Kecksemeti. New York: Oxford University Press, 1952. Original German 1921/2.

Mannheimer, Franz. "A.E.G.-Bauten." *JDW* 2 (1913): 33–42.

Markus, György. "The Soul and Life: The Young Lukács and the Problem of Culture." *Telos,* no. 32 (Summer 1977): 95–115.

Masheck, Joseph. "Crystalline Form, Worringer, and the Minimalism of Tony Smith." In *Building-Art: Modern Architecture Under Cultural Construction.* Cambridge: Cambridge University Press, 1993.

Mataja, Victor. *Grossmagazine und Kleinhandel.* Leipzig: Duncker & Humblot, 1891.

—. *Die Reklame: Eine Untersuchung über Ankündigungswesen und Werbetätigkeit im Geschäftswesen.* 2nd ed. Munich: Duncker & Humblot, 1916.

Meyer-Schönbrunn, Fritz. *Peter Behrens.* Hagen: Deutsches Museum für Kunst in Handel und Gewerbe, 1911.

—. "Karl Ernst Osthaus und sein Werk." *Westermanns Monatshefte* 121, no. 233 (1917): 797–810.

Mitzman, Arthur. *Sociology and Estrangement: Three Sociologists of Imperial Germany.* New York: Knopf, 1973.

"Moderne Bühnenbeleuchtung." *AEG-Zeitung* 12, no. 7 (1911): 5–7.

Moeller, Gisela. *Peter Behrens in Düsseldorf: Die Jahre von 1903 bis 1907.* Weinheim: VCH, 1991.

Mommsen, W.J. *Max Weber and German Politics, 1890–1920.* Translated by M. Steinberg. Chicago: University of Chicago Press, 1984.

Mommsen, W.J., and J. Osterhammel, eds. *Max Weber and his Contemporaries.* London: Unwin Hyman, 1987.

Mosse, George. *The Crisis of German Ideology: Intellectual Origins of the Third Reich.* New York: Grosset & Dunlap, 1964.

Müller, Lothar. "The Beauty of the Metropolis: Toward an Aesthetic Urbanism in Turn-of-the-Century Berlin." In

Berlin: Culture and Metropolis. Edited by C.W. Haxthausen and H. Suhr. Minneapolis: University of Minnesota Press, 1990.

Müller, Michael. *Die Verdrängung des Ornaments: Zum Verhältnis von Architektur und Lebenspraxis.* Frankfurt: Suhrkamp, 1977.

Müller, Sebastian. "Deutsches Museum für Kunst in Handel und Gewerbe." In Herta Hesse-Frielinghaus et al., *Karl Ernst Osthaus: Leben und Werk.* Recklinghausen: Bongers, 1971.

—. *Kunst und Industrie: Ideologie und Organisation des Funktionalismus in der Architektur.* Munich: Hanser, 1974.

Muthesius, Hermann. "Die englische Bewegung gegen die Ausschreitungen des Ankündigungswesens." *Centralblatt der Bauverwaltung,* 26 July 1899, 349–51.

—. *Stilarchitektur und Baukunst: Wandlungen der Architektur im neunzehnten Jahrhundert und ihr heutiger Standpunkt.* Mülheim-Ruhr: K. Schimmelpfeng, 1902. References also to 2nd ed.: Mülheim-Ruhr: K. Schimmelpfeng, 1903.

—. "Das Kunstgewerbe." *Die Weltwirtschaft* 1, pt. 1 (1906): 312–25.

—. "Architektur und Publikum." *Die neue Rundschau* 18 (1907): 204–7.

—. "Die Bedeutung des Kunstgewerbes: Eröffnungsrede zu den Vorlesungen über modernes Kunstgewerbe an der Handelshochschule in Berlin." *Dekorative Kunst* 10, no. 5 (1907): 177–92.

—. "Das Kunstgewerbe." *Die Weltwirtschaft* 2, pt. 1 (1907): 312–25.

—. *Kunstgewerbe und Architektur.* Jena: Eugen Diederichs, 1907.

—. "Kunst und Volkswirtschaft." *Dokumente des Fortschritts* 1, no. 3 (1908): 115-18.

—. *Wirtschaftsformen im Kunstgewerbe.* Volkswirtschaftliche Zeitfragen, no. 233. Berlin: Simion, 1908.

—. "Die Stellung der Kunst in der Volkswirtschaft." Report to the Deutscher Volkswirtschaftlicher Verband. *Volkswirtschaftliche Blätter* 9, no. 15/16 (1910): 260–4.

—. "Maschinenmöbel." In *Das deutsche Hausgerät: Preisbuch 1912.* Catalog for the Deutsche Werkstätten Hellerau/Berlin/ Dresden/Munich/Hannover.

—. "Wo stehen wir?" *JDW* 1 (1912): 11–26.

—. *Handarbeit und Massenerzeugnis.* Berlin: Zentralinstitut für Erziehung und Unterricht, 1917.

Naumann, Friedrich. "Berliner Gewerbe-Ausstellung 1896." In *Ausstellungsbriefe.* Berlin-Schöneberg: Buchverlag der "Hilfe," 1909. Originally published 1896.

—. *Der Geist im Hausgestühl: Ausstattungsbriefe.* Supplement to *Dresdener Hausgerät: Preisbuch 1906.* Dresden: Dresdener Werkstätten, 1906.

—. "Kunst und Industrie." Parts 1 and 2. *Der Kunstwart* 22, no. 2 (1906): 66–73; no. 3 (1906): 128–31.

—. "Das Suchen nach dem Wesen des Kapitalismus." *Die Hilfe* 17 (1911): 578–9.

—. "Werkbund und Handel." *JDW* 2 (1913): 5–16.

—. *Ästhetische Schriften. Werke,* vol. 6. Cologne/Opladen: Westdeutscher Verlag, 1964.

Nerdinger, Winfried, *et al. Richard Riemerschmid: Vom Jugendstil zum Werkbund.* Exh. cat. Munich: Prestel, 1982.

Nesbit, Molly. "What Was an Author?" *Yale French Studies* 73 (1987): 229–57.

—. *Atget's Seven Albums.* New Haven and London: Yale University Press, 1992.

Neuberg, Johannes. *Gesetz, betreffend das Urheberrecht an Mustern und Modellen vom 11. Januar 1876.* Berlin: J. Guttentag, 1911.

Nietzsche, Friedrich. "Unzeitgemässe Betrachtung I: David Strauss der Bekenner und der Schriftsteller." In *Kritische Studienausgabe.* 2nd ed. Berlin: dtv/de Gruyter, 1988.

—. *Untimely Meditations.* Translated by R.J. Hollingdale. Cambridge: Cambridge University Press, 1983.

Obrist, Hermann. "Der 'Fall Muthesius' und die Künstler." *Dekorative Kunst* 11, no. 1 (1907): 42–4.

Oppler-Legband, Else. "Die Höhere Fachschule für Dekorationskunst." *JDW* 1 (1912): 105–10.

Osterrieth, Albert. "Das Werk der angewandten Kunst als Gegenstand des Urheberrechts." *Kunstgewerbeblatt,* n.s., 17, no. 7 (1906): 125–32.

Osthaus, Karl Ernst. "Peter Behrens." *Kunst und Künstler* 6, no. 3 (1907): 116–24.

—. "Die Gartenvorstadt an der Donnerkuhle." *JDW* 1 (1912): 93–6.

—. "Das Schaufenster." *JDW* 2 (1913): 59–69.

—. *Grundzüge der Stilentwicklung.* Hagen: Hagener Verlagsanstalt, 1918.

Otto, Christian F. "Modern Environment and Historical Continuity: The Heimatschutz Discourse in Germany." *Art Journal* 43, no. 2 (1983): 148–57.

Pächt, Otto. "Alois Riegl." In *Methodisches zur kunsthistorischen Praxis.* Munich: Prestel, 1977.

Panofsky, Erwin. "The Concept of Artistic Volition." Translated by K. Northcott and J. Snyder. *Critical Inquiry* 8, no. 1 (1981): 17–33. Original German 1920.

Pascal, Roy. *From Naturalism to Expressionism: German Literature and Society, 1880–1918.* New York: Basic Books, 1973.

Pehnt, Wolfgang. *Expressionist Architecture.* Translated by J.A. Underwood and E. Küstner. London: Thames and Hudson.

Peter Behrens: "Wer aber will sagen, was Schönheit sei?" Exh. cat. Düsseldorf: Beton-Verlag, 1990.

Pevsner, Nikolaus. *Pioneers of Modern Design: From William Morris to Walter Gropius.* Rev. ed. Harmondsworth: Penguin Books, 1975. Originally published in 1936 as *Pioneers of the Modern Movement.*

Porphyrios, Demetrius. "The 'End' of Styles." *Oppositions,* no. 8 (Spring 1977): 119–33.

Posener, Julius. "Der Deutsche Werkbund." In *Werk und Zeit Texte*, supplement vol. 5 (1970).

—. *Berlin auf dem Wege zu einer neuen Architektur: Das Zeitalter Wilhelms II*. Munich: Prestel, 1979.

—. "Werkbund and Jugendstil." In *The Werkbund: Studies in the History and Ideology of the Deutscher Werkbund, 1907–1933*. Edited by Lucius Burckhardt and translated by Pearl Sanders. London: The Design Council, 1980.

Posener, Julius, ed. *Anfänge des Funktionalismus: Von Arts and Crafts zum Deutschen Werkbund*. Berlin: Ullstein, 1964.

Post, Hermann. "Typenmöbel." *Dekorative Kunst* 12, no. 6 (1909): 258–64.

Prange, Regine. *Das Kristalline als Kunstsymbol: Bruno Taut und Paul Klee*. Hildesheim: Georg Olms, 1991.

Pudor, Heinrich. "Praktische Vorschläge zur Erzielung von Qualitätswaren." *Volkswirtschaftliche Blätter* 9, no. 15/16 (1910): 280–3.

Quitzsch, Heinz. *Die ästhetischen Anschauungen Gottfried Sempers*. Berlin: Akademie-Verlag, 1962.

Rauecker, Bruno. *Das Kunstgewerbe in München*. Stuttgart: J.G. Cotta, 1911.

—. *Die wirtschaftlichen Grundlagen des modernen Kunstgewerbes in London*. Munich: M. Rieger, 1912.

—. "Über einige Zusammenhänge zwischen Qualitätsarbeit und Sozialpolitik." *Kunstgewerbeblatt*, n.s., 24, no. 1 (1913): 5–8.

—. Review of *Volkswirtschaftliche Betrachtungen über die Mode*, by Walter Troeltsch. *Kunstgewerbeblatt*, n.s., 24, no. 5 (1913): 138–9.

—. "Die Bedeutung des Kunstgewerbes für den Gang und Aufbau des deutschen Handels." *Kunstgewerbeblatt*, n.s., 25, no. 1 (1913): 4–10.

—. "Der Krieg als Erzieher zur Type II." *Kunstgewerbeblatt*, n.s., 27, no. 2 (1915): 26–8.

—. "Der soziale Gedanke des 'Deutschen Warenbuches.'" *Kunstgewerbeblatt*, n.s., 27, no. 6 (1916): 118–19.

"Reklamewut." *Seidels Reklame* 1 (1913): 12.

Reuleaux, Franz. *Briefe aus Philadelphia*. Braunschweig: Vieweg, 1877.

Reynolds, Sir Joshua. *Discourses on Art*. Edited by R. Wark. New Haven and London: Yale University Press, 1975.

Rhenius, W. *Gesetz zum Schutz der Warenbezeichnungen vom 12. Mai 1894*. 2nd edition. Berlin: C. Heymann, 1908.

Riegl, Alois. *Stilfragen: Grundlegungen zu einer Geschichte der Ornamentik*. Berlin: Siemens, 1893.

—. *Spätrömische Kunstindustrie*. 2nd ed. Vienna: Österreichische Staatsdruckerei, 1927. Originally published 1901. References also to the English translation by R. Winkes: *Late Roman Art Industry*. Rome: G. Brentschneider, 1985.

Ringer, Fritz K. *The Decline of the German Mandarins: The German Academic Community, 1890–1933*. Cambridge: Harvard University Press, 1969.

Riss, Amtsgerichtsrat. "Urheberrecht und Eigentum." *Dekorative Kunst* 17, no. 2 (1913): 66–73.

Ruskin, John. *The Stones of Venice*. Vol. 2. London: Smith, Elder and Co., 1874.

Sahm, [Stadtrat]. "Das neue Gesetz über das Urheberrecht." *Kunstgewerbeblatt*, n.s., 18, no. 8 (1907): 166–8.

Sapiens [pseud.]. "Reklamekritik." *Mitteilungen des Vereins deutscher Reklamefachleute*, no. 32 (1912): 6–11.

Sayre, Robert, and Michael Löwy. "Figures of Romantic Anti-Capitalism." *New German Critique*, no. 32 (Spring-Summer 1984): 42–92.

Scaff, Lawrence A. *Fleeing the Iron Cage: Culture, Politics and Modernity in the Thought of Max Weber*. Berkeley and Los Angeles: University of California Press, 1989.

Scheffler, Karl. "Sozial angewandte Kunst." *Dekorative Kunst* 3, no. 4 (1900): 129–31.

—. "Eine Bilanz." *Dekorative Kunst* 6, no. 7 (1903): 243–56.

—. "Der Fabrikant." *Dekorative Kunst* 7, no. 10 (1904): 399–407.

—. "Kunst und Industrie." *Kunst und Künstler* 6, no. 10 (1908): 430–34.

—. *Berlin – Ein Stadtschicksal*. Reprint Berlin: Fannei & Walz, 1989. Originally published 1910.

—. *Die Architektur der Grossstadt*. Berlin: Bruno Cassirer, 1913.

—. "Gute und schlechte Arbeiten im Schnellbahngewerbe." *JDW* 3 (1914): 42–7.

—. *Die fetten und die mageren Jahre: Ein Arbeits- und Lebensbericht*. Leipzig/Munich: Paul List, 1946.

Scheler, Max. *Vom Umsturz der Werte: Abhandlungen und Aufsätze. Gesammelte Werke*, vol. 3. Bern: Francke, 1972.

Schmidt, Karl. "Gedanken für eine neue Ausstellung." *Der Kunstwart* 27, no. 1 (1913/14): 21–4.

Schultze-Naumburg, Paul. "Der 'Urheberschutz' an Bauten." *Der Kunstwart* 19, no. 11 (1906): 616–18.

Schulz, Richard L.F. "Beleuchtungskörper." *JDW* 1 (1912): 53–9.

Schulze-Gaevernitz, Gerhard von. "Kultur und Wirtschaft: Die neudeutsche Wirtschaftspolitik im Dienste der neudeutschen Kultur." *Verhandlungen des 18. Evangelisch-Sozialer Kongresses* (Göttingen, 1907), pp. 12–32.

Schumacher, Fritz. *Im Kampfe um die Kunst: Beiträge zu architektonischen Zeitfragen*. Strasbourg: Heitz, 1899.

—. "Die Wiedereroberung harmonischer Kultur." *Der Kunstwart* 21, no. 8 (1908): 135–8.

—. *Stufen des Lebens: Erinnerungen eines Baumeisters*. Stuttgart: Deutsche Verlags-Anstalt, 1935.

Schumpeter, Joseph A. *History of Economic Analysis*. Edited by E.B. Schumpeter. 4th ed. London: Allen Unwin, 1961.

Schwab, Alexander. *Möbelkonsumtion und Möbelproduktion in Deutschland*. Berlin: Siemenroth, 1915.

Schwartz, Frederic J. "Commodity Signs: Peter Behrens, the AEG, and the Trademark." *Journal of Design History* 9,

no. 3 (1996): 153–84.

Sedlmayr, Hans. "Die Quintessenz der Lehren Riegls." Introduction to Alois Riegl, *Gesammelte Aufsätze*. Edited by K.M. Swoboda. Augsburg: Filser, 1929.

Seligsohn, Arnold. *Gesetz zum Schutz der Warenbezeichnungen*. 2nd ed. Berlin: J. Guttentag, 1905.

Selle, Gert. *Ideologie und Utopie des Design: Zur gesellschaftlichen Theorie der industriellen Formgebung*. Cologne: DuMont, 1973.

—. *Jugendstil und Kunstindustrie: Zur Ökonomie und Ästhetik des Kunstgewerbes um 1900*. Ravensburg: Otto Maier, 1974.

—. *Die Geschichte des Design in Deutschland von 1870 bis heute: Entwicklung der industriellen Produktkultur*. 2nd ed. Cologne: DuMont, 1978.

—. "Über bürgerliche Reformversuche der Produktkultur zwischen 1898 und 1912." In *Kunst und Alltag um 1900*. *Werkbund-Archiv Jahrbuch* 3 (1978): 58–116.

Semper, Gottfried. *The Four Elements of Architecture and other Writings*. Edited and translated by H.F. Mallgrave and W. Herrmann. Cambridge: Cambridge University Press, 1989.

—. *Kleine Schriften*. Edited by M. and H. Semper. Berlin, 1884.

Servaes, Franz. "Der Wille zum Stil." *Die neue Rundschau* 16, no. 1 (1905): 105–18.

Sheehan, James J. *The Career of Lujo Brentano: A Study of Liberalism and Social Reform in Imperial Germany*. Chicago: University of Chicago Press, 1966.

Siegfried Kracauer, 1889–1966. Edited by I. Belke and I. Renz. *Marbacher Magazin* 47 (1988).

Siepmann, Eckhard, and Angelika Thiekötter, eds. *Packeis und Pressglas: Von der Kunstgewerbebewegung zum deutschen Werkbund*. Giessen: Anabas, 1987.

Simmel, Georg. "Berliner Gewerbe-Ausstellung." *Die Zeit* (Vienna), 25 July 1896, pp.59–60.

—. *The Philosophy of Money*. Translated by T. Bottomore and D. Frisby. London: Routledge & Kegan Paul, 1978. Originally published as *Philosophie des Geldes* (1900; 2nd ed. Leipzig: Duncker & Humblot, 1907).

—. "Der Bildrahmen: Ein ästhetischer Versuch." In *Zur Philosophie der Kunst: Philosophische und Kunstphilosophische Aufsätze*. Potsdam: Kiepenheuer, 1922. Original text 1902.

—. "The Metropolis and Mental Life." Translated in *The Sociology of Georg Simmel*. Edited by K.H. Wolff. New York: Free Press, 1950. Original German 1902.

—. "Über die dritte Dimension in der Kunst." *Zeitschrift für Ästhetik und allgemeine Kunstwissenschaft* 1 (1906): 65–9.

—. "Das Problem des Stiles." *Dekorative Kunst* 11, no. 7 (1908): 307–16.

—. "Psychologie des Schmuckes." *Der Morgen* 2, no. 15 (1908): 454–9.

—. "Die Mode." In *Philosophische Kultur*. Reprint Berlin: Wagenbach, 1986. First ed. 1911. Revised version of an essay originally published in 1895. References also to the English translation: "Fashion." In *Georg Simmel on Individuality and Social Forms*. Edited by Donald Levine. Chicago: University of Chicago Press, 1971.

Smith, Woodruff. *Politics and the Sciences of Culture in Germany, 1840-1920*. Oxford and New York: Oxford University Press, 1991.

Sombart, Nicolaus. *Jugend in Berlin, 1933–1945: Ein Bericht*. Rev. ed. Frankfurt: Fischer, 1991.

Sombart, Werner. "Die Entwicklungstendenzen im modernen Kleinhandel." *Schriften des Vereins für Sozialpolitik* 33 (1899): 137–57, 246–54.

—. *Der moderne Kapitalismus*. 2 vols. Leipzig: Duncker & Humblot, 1902.

—. *Wirthschaft und Mode: Ein Beitrag zur Theorie der modernen Bedarfsgestaltung*. Wiesbaden: J.F. Bergmann, 1902.

—. *Die deutsche Volkswirtschaft im neunzehnten Jahrhundert und im Anfang des 20. Jahrhunderts*. 5th ed. Berlin: Bondi, 1921. Originally published 1903.

—. *Kunstgewerbe und Kultur*. Berlin: Marquardt, 1908.

—. "Die Reklame." *Der Morgen* 2, no. 10 (1908): 281–6.

—. "Ihre Majestät die Reklame." *Die Zukunft* 16, no. 39 (1908): 475–87.

—. *Die Juden und das Wirtschaftsleben*. Leipzig: Duncker & Humblot, 1911.

—. *Der Bourgeois: Zur Geistesgeschichte des modernen Wirtschaftsmenschen*. Munich: Duncker & Humblot, 1913.

—. *Luxus und Kapitalismus. Studien zur Entwicklungsgeschichte des modernen Kapitalismus*, vol. 1. Munich: Duncker & Humblot, 1913.

—. *Der moderne Kapitalismus*. 2nd ed. 3 vols. Munich: Duncker & Humblot, 1916–27.

—. *Die Drei Nationalökonomien: Geschichte und System der Lehre von der Wirtschaft*. Munich: Duncker & Humblot, 1930.

Stegmann, Dirk. *Die Erben Bismarcks: Parteien und Verbände in der Spätphase des Wilhelminischen Deutschlands*. Cologne and Bonn: Kiepenheuer & Witsch, 1970.

Stern, Fritz. *The Politics of Cultural Despair: A Study in the Rise of the Germanic Ideology*. Berkeley and Los Angeles: University of California Press, 1961.

Sternberger, Dolf. "Jugendstil: Begriff und Physiognomik." *Die neue Rundschau* 45, no. 9 (1934): 2:255–71. Reprinted in *Jugendstil*. Edited by J. Hermand. Darmstadt: Wissenschaftliche Buchgesellschaft, 1971.

Stürzebecher, Peter. *Das Berliner Warenhaus: Bautypus, Element der Stadtorganisation, Raumsphäre der Warenwelt*. Berlin: Archibook, 1979.

Thiekötter, Angelika. "Studien zur Werkbund-Ausstellung in Köln 1914." Master's thesis, Technische Universität Berlin, 1980.

Tönnies, Ferdinand. *Community and Society*. Translated by Charles P. Loomis. East Lansing: Michigan State

University Press, 1957. Originally published as *Gemeinschaft und Gesellschaft: Grundbegriffe der reinen Soziologie* (Leipzig, 1887).

—. *Die Sitte*. Frankfurt: Rütten & Loenig, 1909.

Troeltsch, Walter. *Volkswirtschaftliche Betrachtungen über die Mode*. Marburg: G. Elwert, 1912.

Ullmann, Hans-Peter. *Der Bund der Industriellen*. Göttingen: Vandenhoeck & Ruprecht, 1976.

Utitz, Emil. "Georg Simmel und die Philosophie der Kunst." *Zeitschrift für Ästhetik und allgemeine Kunstwissenschaft* 14 (1919): 1–41.

Väth-Hinz, Henriette. *Odol: Reklame-Kunst um 1900*. Giessen: Anabas-Verlag/Werkbund-Archiv, 1985.

Van de Velde, Henry. *Zum neuen Stil*. Edited by Hans Curjel. Munich: Piper, 1955.

—. *Geschichte meines Lebens*. Rev. ed. Munich: Piper, 1986.

Veblen, Thorstein. *The Theory of the Leisure Class*. Reprint London: Penguin, 1979. Originally published 1899.

"Die Vereinigten Werkstätten für Kunst im Handwerk zu München." *Deutsche Kunst und Dekoration* 8 (1901): 428–37.

Vidler, Anthony. "The Idea of Type: The Transformation of the Academic Ideal, 1750-1930." *Oppositions*, no. 8 (Spring 1977): 95–115.

Vogt, Adolf. "Folgen des neuen Kunstschutzgesetzes für das Kunstgewerbe." *Innen-Dekoration* 19, no. 8 (1908): 266–70.

Wasserman, Martin. "Die Bedeutung des Markenschutzes." *Volkswirtschaftliche Blätter* 9, no. 9/10 (1910): 155–60.

Waentig, Heinrich. *Wirtschaft und Kunst: Eine Untersuchung über Geschichte und Theorie der modernen Kunstgewerbebewegung*. Jena: Fischer, 1909.

Weber, Helmut. *Walter Gropius und das Faguswerk*. Munich: Callwey, 1961.

Weber, Max. *The Protestant Ethic and the Spirit of Capitalism*. Translated by T. Parsons. New York: Schribner's, 1958. Original German 1904–5.

—. *The Methodology of the Social Sciences*. Edited and translated by E.A. Shils and H.A. Finch. New York: Free Press, 1949.

—. *Rechtssoziologie*. Edited by J. Winckelmann. Neuwied: Luchterhand, 1960.

—. *Gesammelte Aufsätze zur Wissenschaftslehre*. 3rd ed. Edited by J. Winckelmann. Tübingen: J.C.B. Mohr, 1968.

"Wechselrede über ästhetische Fragen der Gegenwart." *JDW* 1 (1912): 27–36.

Weidenmüller, Hans. *Beiträge zur Werbelehre*. Werdau: Werbe-Verlag Oskar Meister, 1912.

—. "Die Durchgeistigung der geschäftlichen Werbearbeit." *JDW* 2 (1913): 70–4.

Westheim, Paul. "Schaufenster und Schaufensterdekorateure." *Kunstgewerbeblatt*, n.s, 22, no. 7 (1911): 131–2.

—. "Anpassung oder Typenschöpfung? Entwicklungsperspektiven des Kunstgewerbes." *Sozialistische Monatshefte* 20, no. 15 (1914): 979–89.

Widmer, Karl. "Mode und Kunstgewerbe." *Deutsche Kunst und Dekoration* 8, no. 4 (1905): 252–4.

Wichmann, Hans. *Aufbruch zum neuen Wohnen: Deutsche Werkstätten und WK-Verband (1898-1970)*. Basel: Birkhäuser, 1978.

Wiener, Alfred. "Das Warenhaus." *JDW* 2 (1913): 43–54.

Wilhelm, Karin. *Walter Gropius, Industriearchitekt*. Braunschweig: Vieweg, 1983.

Wilhelm, Sibylle. *"Kunstgewerbebewegung": Ästhetische Welt oder Macht durch Kunst?* Frankfurt: Peter Lang, 1991.

Windsor, Alan. *Peter Behrens: Architect and Designer, 1868–1940*. London: Architectural Press, 1981.

Wingler, Hans M, ed. *The Bauhaus: Weimar, Dessau, Berlin, Chicago*. Translated by W. Jabs and B. Gilbert. Cambridge: MIT Press, 1978.

Wölfflin, Heinrich. *Die klassische Kunst*. 4th ed. Munich: F. Bruckmann, 1908. Originally published 1899. *Classic Art*. Translated by P. and L. Murray. London: Phaidon, 1952.

—. *Kleine Schriften*. Edited by J. Gantner. Basel: Schwabe, 1946.

Wolff, Helmuth. *Die Volkskunst als wirtschaftsästhetisches Problem*. Halle: Deutscher Kunstgewerbeverein, 1909.

—. "Aesthetik und Wirtschaftslehre." *Volkswirtschaftliche Blätter* 9, no. 15/16 (1910): 270–4.

—. "Die volkswirtschaftlichen Aufgaben des D.W.B." *JDW* 1 (1912): 86–92.

Worringer, Wilhelm. *Abstraktion und Einfühlung: Ein Beitrag zur Stilpsychologie*. Reprint of 3rd ed. Munich: Piper, 1948. Originally published 1908.

—. "Zum Problem der modernen Architektur." *Neudeutsche Bauzeitung* 7 (1911): 496-500.

—. "Entstehung und Gestaltungsprinzipien in der Ornamentik." In *Kongress für Ästhetik und allgemeine Kunstwissenschaft, Berlin 7-9. Oktober 1913, Bericht*. Stuttgart: Ferdinand Enke, 1914.

Wyss, Beat. Introduction to Georg Simmel, *Rembrandt: Ein kunstphilosophischer Versuch* (1916). Reprint Munich: Matthes & Seitz, 1985.

Zeitler, Rudolf. "Richard Hamanns Buch *Der Impressionismus*: Notizen zur Ideengeschichte." In *Ideengeschichte und Kunstwissenschaft: Philosophie und bildende Kunst im Kaiserreich*. Edited by E. Mai, S. Waetzoldt, and G. Wolandt. Berlin: Gebr. Mann, 1983.

Zerner, Henri. "Alois Riegl: Art, Value, and Historicism." *Daedalus* 105, no. 1 (1976): 177–88.

Zwischen Kunst und Industrie: Der Deutsche Werkbund. Exh. cat. Munich: Neue Sammlung, 1975.

Index